The Apocalyptic Sublime

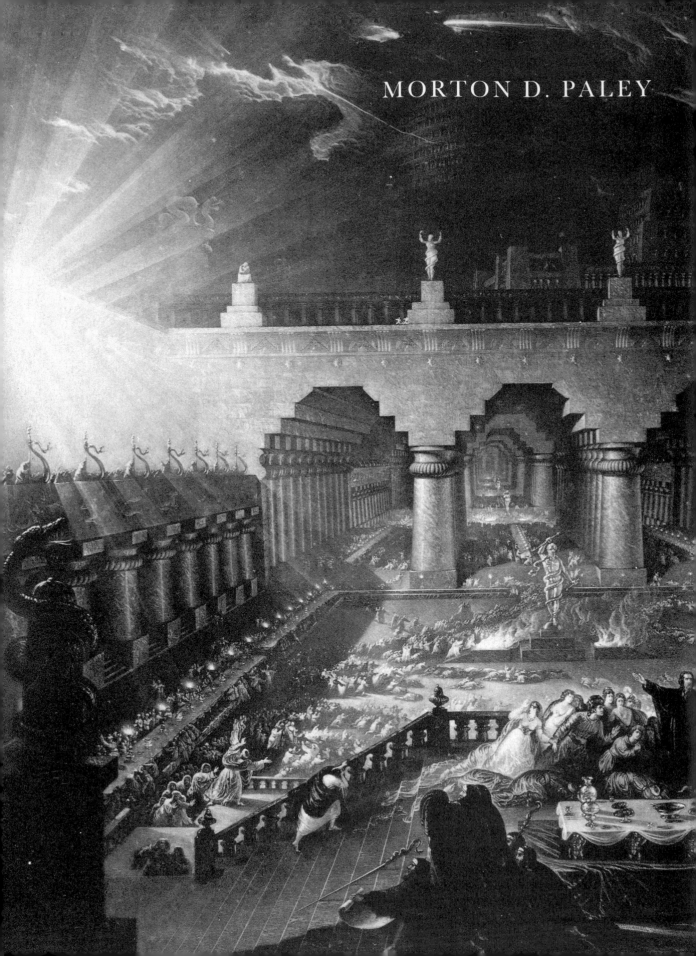

MORTON D. PALEY

The Apocalyptic Sublime

Yale University Press
New Haven and London · 1986

For Gunnel

Designed by Gillian Malpass
Set, printed and bound in Great Britain
at The Bath Press, Avon

Library of Congress Cataloging-in-Publication Data

Paley, Morton D.
 The apocalyptic sublime.
 "Originated as a paper presented at a symposium in
honor of Northrop Frye at the Art Gallery of Ontario" –
Foreword.
 1. Painting, British. 2. Painting, Modern – 17th–18th
centuries – Great Britain. 3. Painting, Modern – 19th
century – Great Britain. 4. Sublime, The, in art.
5. Apocalyptic art – Great Britain. I. Frye, Northrop.
II. Title.
ND432.G73P34 1986 759.2 86–1706
ISBN 0–300–03674–4

Frontispiece. John Martin. *Belshazzar's Feast* (detail of Pl. 65).

PREFACE

The Apocalyptic Sublime originated as a paper presented at a symposium in honor of Northrop Frye at the Art Gallery of Ontario. My chosen subject was Blake's apocalyptic art in relation to that of his contemporaries, and this led me to consider the entire phenomenon of art on apocalyptic subjects in eighteenth- and nineteenth-century Britain. The subject soon outgrew the confines of an essay, but I have nevertheless limited its scope to representations of divine revelation. The rule-proving exception, the Deluge, is, I hope, sufficiently accounted for in the first chapter. Although I have not attempted to present an exhaustive account of art on apocalyptic subjects in the period, I have tried to include all examples of any considerable importance.

In writing this book, my greatest debt has been to Martin Butlin, whose invaluable criticisms of the first draft have been of indispensable importance. I am also very grateful to David Bindman, to Anne K. Mellor, and to Detlef W. Dörrbecker, each of whom commented on several chapters. For the original impetus as well as for helpful suggestions, I am grateful to G.E. Bentley, Jr. I have profited from discussions with John Sunderland about John Hamilton Mortimer, with Robert N. Essick about Blake, with Andrew Wilton about Turner, and with Bo Ossian Lindberg about Christian iconography. Rudiger Joppien kindly answered questions in correspondence concerning P.J. de Loutherbourg, as did Allen Staley with respect to Benjamin West. Margaret Whidden generously shared with me the results of her research on Samuel Colman. I received information about Hebrew inscriptions from Robert Alter and from Ariel Bloch, about French quotations from Patricia Ekstein, about astrology from Dena Taylor and from Wayne Schumaker, and about the Kabbala from Sheila Spector.

During the revision of the manuscript, my colleague Alan Nelson gave generously of his expertise concerning word-processing. John Nicoll's much appreciated encouragement helped me toward a timely conclusion, and I owe numerous clarifications of detail to the expert copy-editing of Gillian Malpass.

For access to pictures in private collections I am grateful to John Mayfield of Noortman and Brod, to Robert K. Rosenblum, and to Thomas McCormick; and for special help in using public collections I wish to thank Shelley Bennett, Carol Osborne, Patrick Noon, A.I. Wareing, and Reginald Williams. Without attempting to list all the museums and libraries I visited, I would like to make special mention of those whose staffs enabled me to see pictures in storage or to consult rare books or manuscripts, as

follows: Bancroft Library, University of California; British Library; British Museum, Dept. of Prints and Drawings; Boston Museum of Fine Arts; Fogg Art Museum; Henry E. Huntington Library and Art Gallery; Metropolitan Museum of Art; New York Public Library; Newcastle City Library; Oldham Art Gallery; Pierpont Morgan Library; Stanford University Art Museum; Tate Gallery; Victoria and Albert Museum; Witt Library (Courtauld Institute); Yale Center for British Art. I am grateful to each of the owners for permission to reproduce pictures, and for help in obtaining certain photographs I would like to thank Ruth Fine, Thomas McCormick, Allen Staley, Robert N. Essick and C. Michael Kauffmann.

One month of my research was spent as a Fellow in the stimulating atmosphere of the Yale Center for British Art. The Regents of the University of California provided a partial sabbatical and grants in aid. Trips to London collections while I was Fulbright Professor at the University of Heidelberg were made possible by the Fulbright–Kommission, Bonn, and by the U.K.–U.S. Fulbright Commission. To all these, my heartfelt thanks.

Morton D. Paley
Berkeley, California
30 May 1985

CONTENTS

LIST OF ILLUSTRATIONS

Marino, California, Henry E. Huntington Library and Art Gallery.

25. Philippe Jacques de Loutherbourg. *The Vision of the White Horse*. 1798. Oil on canvas. 48 × 31 in. London, Tate Gallery.

26. Philippe Jacques de Loutherbourg. *The Angel Binding Satan*. About 1792. Oil on canvas. $17\frac{3}{4}$ × $14\frac{3}{4}$ in. New Haven, Conn., Yale Center for British Art, Paul Mellon Collection.

27. John Landseer. *The Angel Binding Satan*. Engraving after Philippe Jacques de Loutherbourg. 1797. $12\frac{1}{4}$ × $9\frac{1}{2}$ in. San Marino, California, Henry E. Huntington Library and Art Gallery.

28. Anonymous. *St. Michael*. Engraving after Guido Reni. Undated. $10\frac{1}{4}$ × 15 in. San Marino, California, Henry E. Huntington Library and Art Gallery.

29. J. Heath. Tailpiece to Revelation. Engraving after Philippe Jacques de Loutherbourg. About 1800. $12\frac{1}{4}$ × 11 in. San Marino, California, Henry E. Huntington Library and Art Gallery.

30. John Landseer. Headpiece to The Song of the Three [Holy] Children. Engraving after Philippe Jacques de Loutherbourg. Published 1816. $8\frac{1}{2}$ × $8\frac{1}{2}$ in. San Marino, California, Henry E. Huntington Library and Art Gallery.

31. John Landseer. Headpiece to Ecclesiasticus. Engraving after Philippe Jacques de Loutherbourg. Published 1816. 9 × 10 in. San Marino, California, Henry E. Huntington Library and Art Gallery.

32. William Blake. *War unchained by an Angel*. About 1780. Pen and indian ink. 7 × $8\frac{11}{16}$ in. Coll. Robert N. Essick.

33. William Blake. Young's *Night Thoughts*: Night III, title page. About 1795–97. Pen and indian ink and water color over pencil. $16\frac{1}{2}$ × $12\frac{7}{8}$ in. British Museum.

34. William Blake. Young's *Night Thoughts*: Night VIII, title page. About 1795–97. Water color with pen and ink over pencil. $16\frac{1}{2}$ × $12\frac{7}{8}$ in. British Museum.

35. Albrecht Dürer. *The Woman Clothed With the Sun*. *Apocalypsis cum figuris*. 1511. Woodcut. $15\frac{3}{8}$ × 11 in. San Marino, California, Henry E. Huntington Library and Art Gallery.

36. William Blake. *The Vision of the Seven Golden Candlesticks*. Engraving after Bernard Picart. 1782. $6\frac{5}{16}$ × $4\frac{3}{16}$ in. Coll. Robert N. Essick.

37. William Blake. *Death on a Pale Horse*. About 1800. Water color with pen and ink over pencil. $15\frac{1}{2}$ × $12\frac{1}{4}$ in. Cambridge, Fitzwilliam Museum.

38. William Blake. "*He Cast Him Into the Bottomless Pit and Shut Him Up*". About 1800. Water color with pen and ink. $14\frac{1}{8}$ × $12\frac{3}{4}$ in. Cambridge, Mass., Fogg Art Museum.

39. J. Fittler. *Satan seized by the Angel*. Engraving after Edward Francis Burney. About 1802. $6\frac{1}{2}$ × 5 in. London, Victoria and Albert Museum.

40. William Blake. "*And the Angel Which I Saw Lifted Up His Hand to Heaven*." About 1805. Pen and water color over pencil. $15\frac{7}{6}$ × $10\frac{5}{16}$ in. New York City, Metropolitan Museum of Art, Rogers Fund, 1914.

41. William Blake. *The Great Red Dragon and the Woman Clothed with the Sun*. About 1803–5. Pen, black chalk, and water color. $17\frac{1}{8}$ × $13\frac{1}{2}$ in. Brooklyn Museum.

42. William Blake. *The Great Red Dragon and the Beast from the Sea*. About 1803–5. Pen and water color. $15\frac{13}{16}$ × 14 in. Washington, D.C., National Gallery of Art, Lessing J. Rosenwald Collection.

43. William Blake. *The Number of the Beast Is 666*. About 1805. Pen and water color. $16\frac{3}{16}$ × $13\frac{3}{16}$ in. Philadelphia, Rosenbach Museum and Library.

44. William Blake. *The Spiritual Form of Nelson guiding Leviathan*. About 1805–9. Tempera on canvas. 30 × $24\frac{5}{8}$ in. Tate Gallery.

45. Henry Howard. *The Sixth Trumpet Soundeth* (also known as "*Loose the Four Angels from the Great River Euphrates*"). 1804. $35\frac{1}{2}$ × $27\frac{1}{2}$ in. Oil on canvas. London, Royal Academy.

46. Louis Schiavonetti. Robert Blair's *The Grave: The Day of Judgment*. Engraving after William Blake. 1808. $10\frac{13}{16}$ × $8\frac{3}{4}$ in. San Marino, California, Henry E. Huntington Library and Art Gallery.

47. William Blake. *The Last Judgment*. 1806. Pen and water color over pencil. $19\frac{1}{2}$ × $15\frac{5}{16}$ in. Glasgow, Pollok House.

48. William Blake. *The Last Judgment*. 1808. Pen and water color over pencil. 20 × $15\frac{1}{2}$ in. National Trust, Petworth House, Sussex.

49. William Blake. *The Last Judgment*. About 1809. Pen and wash over pencil. $17\frac{1}{2}$ × $13\frac{5}{16}$ in. Washington, D.C., National Gallery of Art, Lessing J. Rosenwald Collection.

50. J.M.W. Turner. *An Avenging Angel*. About 1800–5. Pen and brown ink over pencil. 5 × 6 in. British Museum.

51. Richard Wilson. *The Destruction of Niobe's Children*. About 1760. Oil on canvas. 58 × 74 in. New Haven, Conn., Yale Center for British Art, Paul Mellon Collection.

52. J.M.W. Turner. *The Tenth Plague of Egypt*. 1802. Oil on canvas. $56\frac{1}{2}$ × 93 in. London, Tate Gallery.

53. J.M.W. Turner and Charles Turner. *The Fifth Plague of Egypt*. Engraving after J.M.W. Turner. 1808. $7\frac{7}{16}$ × $10\frac{1}{8}$. New Haven, Conn., Yale Center for British Art.

54. I.P. Quilley. *The Deluge*. Engraving after J.M.W. Turner. 1828. $14\frac{15}{16}$ × $22\frac{11}{16}$. British Museum.

55. J.M.W. Turner. *Snowstorm: Hannibal and His Army Crossing the Alps*. 1812. Oil on canvas. $57\frac{1}{2}$ × $93\frac{1}{2}$ in. London, Tate Gallery.

56. J.M.W. Turner. *Shade and Darkness – the Evening of the Deluge*. 1843. Oil on canvas. 31 × $30\frac{1}{4}$. London, Tate Gallery.

57. J.M.W. Turner. *Light and Colour (Goethe's*

Theory) – the Morning after the Deluge – Moses writing the Book of Genesis. 1843. Oil on canvas. 31 × 31 in. London, Tate Gallery.

58. E. Goodall. Samuel Rogers's *The Voyage of Columbus: A Tempest*. Engraving after J.M.W. Turner. 1833. $3\frac{5}{16}$ × $2\frac{13}{16}$ in. British Museum.

59. W. Miller. Milton's *Poetical Works: Shipwreck of Lycidas*. Engraving after J.M.W. Turner. 1835. $4\frac{3}{4}$ × $3\frac{3}{8}$ in. British Museum.

60. Valentine Greene. *Belshazzar's Feast*. Engraving after Benjamin West. 1777. $18\frac{3}{8}$ × 26 in. British Museum.

61. Washington Allston. Sketch for *Belshazzar's Feast*. 1817. Oil on millboard. 25 × 34 in. Cambridge, Massachusetts, Fogg Art Museum.

62. Washington Allston. Sketch for *Belshazzar's Feast*. 1817. Oil on millboard. $25\frac{1}{2}$ × $34\frac{1}{4}$. Boston Museum of Fine Arts.

63. Washington Allston. Study for *Belshazzar's Feast*: Belshazzar's right hand. About 1821–28. Black chalk highlighted with white on blue paper. $10\frac{5}{16}$ × $12\frac{1}{6}$ in. Cambridge, Mass., Fogg Art Museum.

64. Washington Allston. Study for *Belshazzar's Feast*: Belshazzar's left hand. About 1821–28. Charcoal and white chalk on gray-green paper. $9\frac{1}{8}$ × $12\frac{3}{8}$. Cambridge, Mass., Fogg Art Museum.

65. John Martin. *Belshazzar's Feast*. 1826. Mezzotint engraving. 21 × 30 in. British Museum.

66. John Martin. *The Deluge*. 1834. Oil on canvas. $66\frac{1}{4}$ × $101\frac{3}{4}$ in. New Haven, Conn., Yale Center for British Art, Paul Mellon Collection.

67. John Martin. *"And a mighty angel took up a stone like a great millstone, and cast it into the sea."* 1826. Mezzotint engraving. $4\frac{1}{16}$ × $2\frac{1}{2}$ in. British Museum.

68. C. Gray. *The Angel with the Book*. 1836. Wood engraving after John Martin. $2\frac{1}{2}$ × 4 in. British Library.

69. John Martin. *The Opening of the Seventh Seal*. 1837. Mezzotint engraving. $15\frac{1}{2}$ × $19\frac{3}{4}$ in. New Haven, Conn., Yale Center for British Art, Paul Mellon Collection.

70. Charles Mottram. *The Last Judgment*. Engraving after John Martin. Published 1857. 28 × $40\frac{1}{2}$ in. New Haven, Conn., Yale Center for British Art, Paul Mellon Collection.

71. Charles Mottram. *The Great Day of His Wrath*. Mezzotint engraving after John Martin. Published 1857. 28 × $40\frac{1}{2}$ in. New Haven, Conn., Yale Center for British Art, Paul Mellon Collection.

72. Samuel Colman. *St. John Preaching in the Wilderness*. 1821. Oil on canvas. $34\frac{1}{2}$ × $46\frac{3}{4}$ in. Bristol, Art Gallery.

73. Samuel Colman. *The Deluge*. Undated. Water color on paper. $10\frac{3}{4}$ × $14\frac{3}{4}$ in. Coll. Mrs. Alison Palmer.

74. Samuel Colman. *Vision of St. John*. Undated. Water color on paper. $13\frac{1}{4}$ × $14\frac{3}{4}$ in. Andrew Wyld.

75. Samuel Colman. *The Coming of the Messiah and the Destruction of Babylon*. About 1828–31. Oil on canvas. 54 × 75 in. Bristol Art Gallery.

76. Samuel Colman. *The Delivery of Israel Out of Egypt*. 1830. Oil on canvas. $53\frac{3}{4}$ × $78\frac{3}{4}$ in. Birmingham, City Art Gallery.

77. Samuel Colman. *The Destruction of the Temple*. About 1835. Oil on canvas. $53\frac{1}{3}$ × $77\frac{1}{3}$ in. Tate Gallery.

78. Samuel Colman. *The Edge of Doom*. 1836/1838. Oil on canvas. 54 × $78\frac{1}{2}$ in. Brooklyn Museum.

79. G.H. Phillips. *An Attempt to Illustrate the Opening of the Sixth Seal*. Mezzotint engraving after Francis Danby. 1828. $19\frac{1}{4}$ × 27 in. British Museum.

80. Francis Danby. *Subject from Revelations*. 1829. Oil on canvas. $24\frac{1}{4}$ × $30\frac{1}{4}$ in. Coll. Robert Rosenblum.

81. Francis Danby. *The Deluge*. 1837–40. 112 × 178 in. London, Tate Gallery.

82. Frederic, Lord Leighton. *"And the Sea Gave Up the Dead Which Were in It."* 1892. Oil on canvas. Diameter 90 in. London, Tate Gallery.

83. James Gillray. *Presages of the Millennium*. 1795. Etching, aquatint, and water color. $12\frac{13}{16}$ × $14\frac{5}{8}$ in. New Haven, Conn., Yale Center for British Art.

84. J. Fittler. *Satan Being Bound by the Angel*. Engraving after Edward Francis Burney. About 1802. $6\frac{1}{4}$ × 5 in. London, Victoria and Albert Museum.

85. J. Fittler. *Satan Confined*. Engraving after Edward Francis Burney. About 1802. $6\frac{1}{4}$ × 5 in. London, Victoria and Albert Museum.

COLOUR PLATES

I. Benjamin West. *The Woman Cloathed with the Sun Fleeth from the Persecution of the Dragon*. 1797–98. Oil on paper laid on panel. $56\frac{3}{4}$ × 25 in. Noortman and Brod.

II. Benjamin West. *The Beast Riseth Out of the Sea*. 1797. Oil on panel. $31\frac{1}{2}$ × 21 in. Coll. Thomas and Margaret McCormick.

III. William Blake. *The Great Red Dragon and the Woman Clothed with the Sun: "The Devil Is Come Down."* About 1805. $16\frac{1}{16}$ × $11\frac{1}{4}$ in. Washington, D.C., National Gallery of Art, Lessing J. Rosenwald Collection.

IV. J.M.W. Turner. *The Angel standing in the Sun*. 1846. Oil on canvas. 31 × 31 in. London, Tate Gallery.

V. John Martin. *The Last Judgment*. 1851. Oil on canvas. 78 × 128 in. London, Tate Gallery.

VI. John Martin. *Belshazzar's Feast*. 1821. Oil on canvas. $31\frac{1}{2}$ × $47\frac{1}{2}$ in. New Haven, Conn., Yale Center for British Art, Paul Mellon Collection.

VII. Samuel Colman. *Belshazzar's Feast*. About 1833. Oil on canvas. $34\frac{1}{2}$ × $46\frac{3}{4}$. Oldham, City Art Gallery.

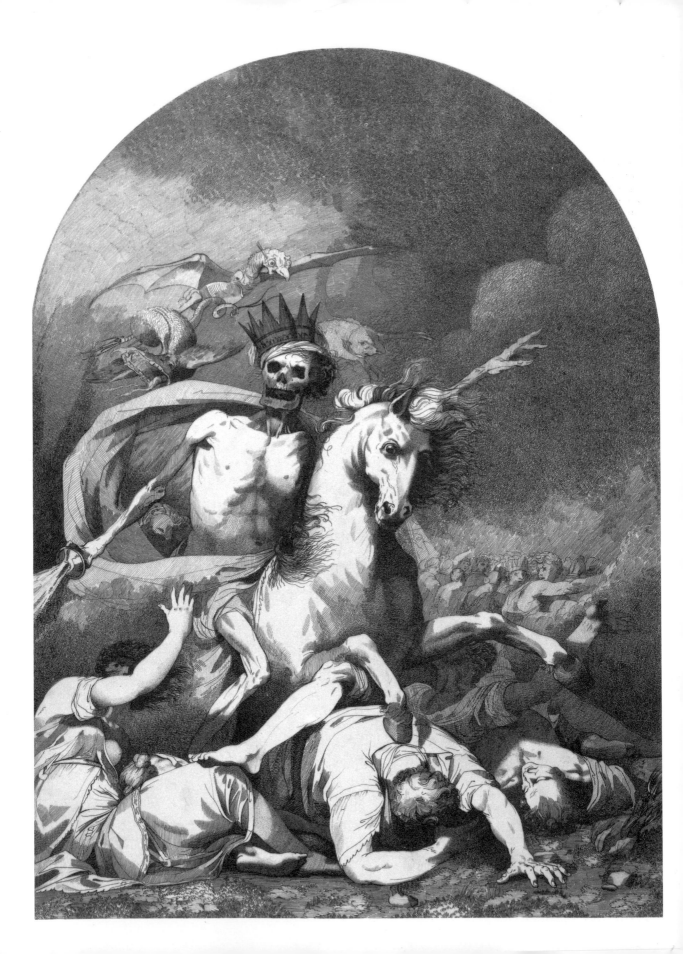

CHAPTER I

The Sublime in British Art

SELDOM IN THE HISTORY OF TASTE can a single work be identified as the forerunner of a long line of others to the extent of John Hamilton Mortimer's *Death on a Pale Horse* (Pl. 1), a drawing exhibited at the Royal Academy in 1775. Mortimer's subject is apocalyptic in the true sense of the word: not a mere catastrophe but a divine revelation, a lifting of the veil. It is sublime in the new, psychological sense of the word that Edmund Burke had established in 1756 in his *Philosophical Enquiry into the Origin of Our Ideas of the Sublime and the Beautiful*. The chief characteristic of the Burkean sublime is described under the heading of "Terror":

> No passion so effectually robs the mind of all its powers of acting and reasoning as fear; for fear being an apprehension of pain or death, it operates in a manner that resembles actual pain. Whatever is terrible, therefore, with regard to sight, is sublime, too.[1]

Mortimer had probably read Burke's book,[2] but by 1775 Burke's ideas were as generally familiar as Freud's are today, and what is more important is that he had absorbed Burke's lesson. Appealing to the new, psychologically self-aware aesthetic of Mortimer's time, this picture inaugurates a type of art in which the terror of divine revelation becames the object of a *nouveau frisson*. Mortimer's *Death on a Pale Horse* thus initiates the apocalyptic sublime, a mode that subsequently effloresced during the period of the French Revolution, the Napoleonic Wars, and the agitation for Reform. Among its major practitioners were, each in his characteristic way, Benjamin West, P.J. de Loutherbourg, William Blake, J.M.W. Turner, John Martin, Samuel Colman, and Francis Danby. No such development occurred outside of England, and the apocalyptic sublime is therefore a subject of exceptional interest in the study not only of British art but also of aesthetic taste, critical and popular, from the late eighteenth century through the Victorian period.

It is not, of course, possible to discuss *Death on a Pale Horse* and its successors in

1. Edmund Burke, *A Philosophical Enquiry into the Origin of Our Ideas of the Sublime and the Beautiful*, ed. James T. Boulton (Notre Dame, Ind.: University of Notre Dame Press, 1968 [1958]), p. 57. This edition will be cited subsequently as *Enquiry*.

2. It is worth noting that, according to a "Life of Mortimer" signed "Libra" and published in the *Monthly Magazine* for 1796, "His conversation frequently turned on allusions to the politest writers, expressed in the most forcible terms" (p. 25).

1

1. Joseph Haynes after John Hamilton Mortimer. *Death on a Pale Horse.*

isolation from other types of sublime painting. Landscape, natural catastrophes, and "Gothic" supernatural subjects were all considered as potentially sublime in the late eighteenth century, as was, in a somewhat different sense, history. Furthermore, one popular sublime subject, the Deluge, is of special importance in that it forms a bridge between natural catastrophe and apocalypse by showing divine forces virtually breaking through nature. In order to understand the apocalyptic sublime we must first consider its place in relation to other current modes of sublime art.

The nature of the sublime was established much earlier in literature than in art. In both theory and practice, the sublime mode was well established in the Augustan age. The source of most discussion of the sublime in this period was Longinus, "Whose *own Example* strengthens all his Laws," wrote Pope, "And *Is himself* that great *Sublime* he draws."[3] Longinian theory, as elaborated by John Dennis, Joseph Addison, and other early eighteenth-century writers, was primarily rhetorical; it could provide a means for appreciating poetry and so prepare a later public to appreciate the blank verse of Thomson and the Pindaric odes of Collins and of Gray shortly to come. But it was not until mid-century that a theory of the sublime appeared which had equal importance for painting. It is true that the *term* appears in writing about art earlier in the century, but then it is usually associated with the type of majestic idealization represented by the frescoes and cartoons of Raphael.[4] According to such a notion, "the sublime," as Anthony Blunt remarks, "is really a form of the beautiful."[5] By putting forward a theory that essentially distinguished the sublime from the beautiful, Burke, without particularly wishing to do so, taught his contemporaries to snatch a fearful joy from the experience of art.

It is not that Edmund Burke had painting particularly in mind in his *Enquiry* – he did not; nor is it that artists read Burke and applied his theory to their own work – though some of them certainly did. Rather, Burke's notion of the sublime passed into the general intellectual currency of the age, and it turned out to be as applicable to the visual arts as it was to the literary texts that Burke himself used as examples. The sublime was now considered to lie in the perception of subjects that the mind could not entirely comprehend or contain; its chief source was power, its chief subject matter, terror, its identifying response, astonishment. While older views of the sublime continued to exist alongside the new, it was the Burkean idea that became intellectually dominant. By 1794 Sir Uvedale Price could simply assert: "The principles of those two leading characters in nature – the sublime and the beautiful – have been fully illustrated and discriminated by a great master."[6]

3. *An Essay on Criticism, The Poems of Alexander Pope* [Twickenham Edition], vol. I, ed. E. Audra and Aubrey Williams (New Haven: Yale University Press, 1961), p. 316 [ll. 679–80].

4. See Samuel H. Monk, *The Sublime: A Study of Critical Theories in XVIII-Century England* (Ann Arbor, Mich.: University of Michigan Press, 1960 [1935]), pp. 164–202.

5. Anthony Blunt, *The Art of William Blake* (New York and London: Columbia University Press, 1959), p. 15. See also David Irwin, *English Neoclassical Art* (Greenwich, Conn.: New York Graphic Art Society, 1966), pp. 135–8.

6. Uvedale Price, *Essay on the Picturesque*, (Edinburgh: Caldwell, Lloyd, and Co., 1842), p. 79.

As Burkean theory centered on the perceiving mind's response to representations of the external world, sublime art was not limited to any one artistic genre. One that received greatly increased attention was landscape. What may be called the natural sublime represented scenes of great heights and depths which in nature produced the effect Burke termed "astonishment." "In this case," wrote Burke, "the mind is so entirely filled with its object, that it cannot entertain any other, nor by consequence reason on that object which employs it."[7] There are numerous candidates among artists for priority in the natural sublime. Burke's disciple George Barrett painted the torrential cascade of Powerscourt Waterfall in Ireland in 1764;[8] Richard Wilson showed an aerial view of the glacial tarn at Cader Idris c. 1774;[9] the Alpine water colors of William Pars attracted connoisseurs in the early 1770s[10] and were soon followed by those of John Robert Cozens and Francis Towne. What these landscapes have in common is the frightening imminence of the object viewed from a perspective that virtually compels us to imagine ourselves as powerless.

Perhaps Francis Towne's magnificent water color of 1781, *The Source of the Arveiron* (Victoria and Albert Museum), epitomizes this type of picture. Towne presents his subject as a blue mountain against a light blue sky with white clouds. Mont Blanc with its glaciers is a massive presence filling almost the entire picture space, causing more than one modern critic to recall Shelley's "Mont Blanc":

> Far, far above, piercing the infinite sky,
> Mont Blanc appears, – still, snowy and serene –
> Its subject mountains their unearthly forms
> Pile around it, ice and rock; broad vales between,
> Of frozen floods, unfathomable deeps,
> Blue as the overhanging heaven, that spread
> And wind among the accumulate steeps ...[11]

Towne, working two generations before Shelley, captures a similar sense of "the aesthetics of the infinite" that had in his day only recently become associated with "mountain glory."[12] Nevertheless, *The Source of the Arveiron* is a water-color drawing in which masses are firmly contained by ink outlines, and it therefore does not fully suggest the potentially cataclysmic release of the forces it contains. This possibility was in the eighteenth century left to oil painting, although Turner would develop it in water colors not much later.

In works such as Joseph Wright of Derby's early drawings and paintings of Vesuvius

7. *Enquiry*, p. 57.

8. See Robert Rosenblum, "The Dawn of British Romantic Painting," in *The Varied Pattern: Studies in the 18th Century* (Toronto: A.M. Hakkert, 1971), p. 192 and plate 13 (version in the Walker Art Gallery, Liverpool). A note in volume I of the Anderdon Catalogues (British Museum) says Barrett was considered "the best Landscape painter of the time he lived in ..." (p. 202, citing Sir James Prior's *Life of Burke* [2nd ed., 1828], vol. I, p. 202).

9. See Rosenblum, "The Dawn of British Romantic Painting," pp. 191–2; and Joseph Burke, *English Art*

1714–1800 (Oxford: the Clarendon Press, 1976), pp. 229–30.

10. See Louis Hawes, *Presences of Nature: British Landscape 1780–1830* (New Haven: Yale Center for British Art, 1982), pp. 5–8.

11. *Shelley's Poetry and Prose*, ed. Donald H. Reiman and Sharon R. Powers (New York and London: W.W. Norton, 1977), p. 9.

12. The expressions are Marjorie Hope Nicolson's in *Mountain Gloom and Mountain Glory: the Development of the Aesthetics of the Infinite* (Ithaca, N.Y.: Cornell University Press, 1959).

in eruption,[13] the catastrophic possibilities of the natural sublime become manifest. Wright had climbed Vesuvius in 1774 and appears to have witnessed a lava flow. His attempts to picture the volcano in full eruption are startling in the vividness of their colors and in their sense of tumultuous movement of fiery lava and smoke. Although Wright was not the first artist to engage this subject, there is, as Benedict Nicolson says, little object in looking for "influences" on his early Vesuvius views.[14] Wright brought to the subject a remarkable freshness of conception, sometimes viewing the mountain from a distance (Pl. 2) and once (*c.* 1774–75, Derby Museum and Art Gallery) from the very edge of the crater looking down into the lurid goings-on within. These pictures are forerunners of later catastrophic scenes like de Loutherbourg's *An Avalanche or Ice Fall in the Alps* (1803, Tate Gallery), where the disaster is still safely distanced, and Turner's *The Fall of an Avalanche in the Grisons* (1810, Tate Gallery) in which the forces pictured seem almost too intense to be natural.

A scene perhaps even more immediately evocative of the Burkean sublime of terror is George Stubbs's enormously powerful *Lion Attacking a Horse* (*c.* 1762, Yale Center for British Art) (Pl. 3), the largest (96 × 131 in.) rendition of a theme to which the artist almost obsessively returned over a period of more than twenty-five years. It is a nearly perfect illustration of the Burkean sublime of terror, especially if we consider what Burke has to say under the heading of "Power":

> The horse in the light of an useful beast fit for the plough, the road, the draft, in every social useful light the horse has nothing of the sublime; but is it thus that we are affected with him *whose neck is cloathed with thunder, the glory of whose nostrils is terrible, who swalloweth the ground with fierceness and rage, neither believeth that it is the sound of the trumpet?*[15]

Stubbs's horse is terrified rather than enraged, as is that in chapter xxxix of the Book of Job; but Stubbs's memorable image, nostrils flaring, sinews bulging, mane streaming, seems the very incarnation of the Burkean sublime of terror. "In this description," as Burke says of the passage in Job, "the useful character of the horse entirely disappears, and the terrible and the sublime blaze out together."[16]

A Lion Attacking a Horse is known to be based on an antique sculpture that Stubbs would have seen while in Rome,[17] but the differences between the two are instructive. By raising the horse to its feet and turning its head toward its attacker, Stubbs creates a vortex of agonized and agonizing energy, involving the viewer in a way that neither the Capitoline prototype (itself a copy of a Pergamese original) nor Pieter Scheemakers' version of the subject at Rousham (*c.* 1740) does.[18] These works strike the viewer as

13. See Benedict Nicolson, *Joseph Wright of Derby: Painter of Light* (London: The Paul Mellon Foundation for British Art, 1968), vol. I, pp. 10, 279–85.

14. *Ibid.*, p. 78. Nicolson reproduces earlier pictures of the subject by Thomas Wyck and by Pierre-Jacques Volaire in his figs. 96 and 97. Rosenblum mentions two views of Vesuvius exhibited by William Marlow (1740–1813) at the Society of Artists in 1768 ("The Dawn of British Romantic Painting," p. 193).

15. *Enquiry*, pp. 65–6. J.T. Boulton's note points out that the passage from Job is slightly misquoted.

16. *Ibid.*, p. 66.

17. As pointed out in Basil Taylor, *Stubbs* (London: Phaidon, 1974), p. 34. The sculpture (Museo del Palazzo dei Conservatori) is reproduced as Taylor's fig. 14.

18. See Taylor, pp. 33–4. The sculpture is reproduced in Edward Hyams, *The English Garden* (London: Thames and Hudson, 1966 [1964]), fig. 47.

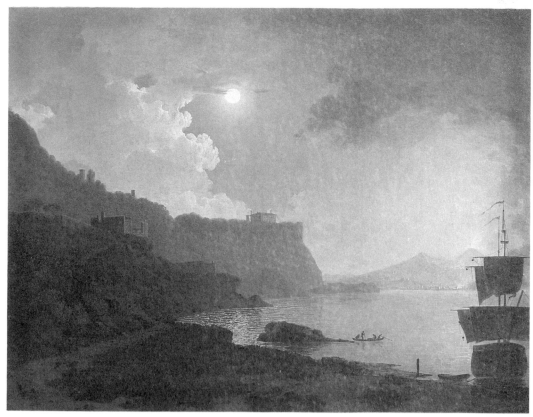

2. Joseph Wright of Derby. *Vesuvius from Posilippo*.

3. George Stubbs. *A Lion Attacking a Horse*.

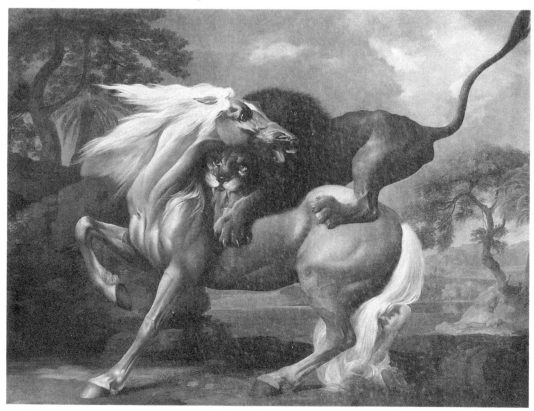

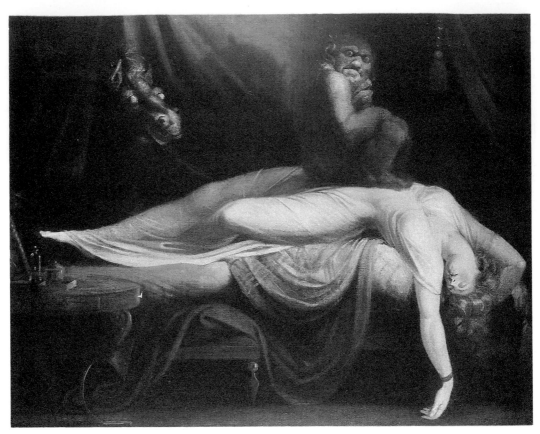

4. Henry Fuseli. *The Nightmare.*

self-contained, maintaining their aesthetic distance; Stubbs's is genuinely disturbing, creating for the viewer a sense of vicarious participation in a horrifying struggle, and so producing the sensation characterized by Burke: "Whatever is filled in any sort to excite the idea of pain, and danger, that is to say, whatever is in any sort terrible, or is conversant with terrible objects, or operates in a manner analogous to terror, is a source of the *sublime*; that is, it is productive of the strongest emotion which the mind is capable of feeling."[19]

So far, all the pictures discussed have as their ostensible reference the natural world, however much they may also suggest inner, psychological states. Henry Fuseli's *The Nightmare* (1781, Detroit Institute of Arts) (Pl. 4) is radically different in that it conveys the sublime not through the mediation of nature but in a dream image. Here we see precociously accomplished the displacement of the locus of reality from the external world to the psyche, something that would also happen to the sublime poem by the end of the century in, for example, the stolen boat episode of Wordsworth's *Prelude*. The passivity of the sleeping figure, who lies in a position suggestive of a Manneristically distorted classical naiad, invites the viewer to identify with her; the visual pun based

19. *Enquiry*, p. 39.

on a false etymology[20] introduces a sense of absurdity that somehow increases the anxiety generated by the scene rather than alleviating it. Another paradoxically disturbing quality, as Gert Schiff points out in his magisterial Fuseli catalogue,[21] is conveyed by the sleeper's healthy-looking skin, lustrous hair, sumptuous bedclothes, and orderly dressing table. It is as if these qualities invited their opposites in the gargoyle-like succubus and goggle-eyed horse. Of this proximity of the sublime to the grotesque, which seems not incidental but a structural relation, more must be said later. Fuseli himself seems to have wanted to tone down the terrifying aspect of this picture, for in his later version of the oil painting (before 1790, Goethe Museum, Frankfurt[22]) he made the "Alp" more whimsical and less threatening. The original of 1781 not only is a more powerful picture but also bears with it a fascinating clue as to the origin of this celebrated example of the sublime of terror.

When *The Nightmare* was examined after its acquisition by the Detroit Institute of Arts, it was found to have on its back, concealed by a piece of pasted-on canvas, a portrait (Schiff no. 759) that could serve as an excellent example of the Burkean beautiful. It is an alluring image of a young woman with fine features and delicately rounded shoulders. The only disquieting detail is the fingers, curiously elongated in a way that may perhaps be put down to Mannerist influence or to the unfinished state of the painting but that nevertheless conveys an implication of menace. The subject, as H.W. Janson ingeniously suggests, may be the niece of Fuseli's friend Johann Caspar Lavater, Anna Landolt, with whom Fuseli vainly fell in love in Zurich in 1799.[23] The intensity of the artist's unsatisfied longing is conveyed in a letter written to Lavater after Fuseli returned to London. "Last night I had her in bed with me – tossed my bedclothes hugger-mugger – wound my hot and tight-clasped hands about her – fused her body and her soul together with my own – poured into her my spirit, breath, and strength."[24] The relation of the two sides of the *Nightmare* canvas thus seems almost an allegory of the Freudian dream-work. An image of unattainable desire, causing agonizing frustration, is blocked off from sight to emerge in a terrifying fantasy in which the artist's desire is accommodated, but only at the cost of his own grotesque transformation. It is not without interest that Sigmund Freud had an engraving of *The Nightmare* hanging in his Vienna apartment.[25]

Fuseli's *Nightmare*, while an instance of what Burke meant by the sublime of terror, is not apocalyptic, even though its qualities of mystery and intensity can also be those of the apocalyptic sublime. A subject occupying an even closer relation to the apocalyptic is the Deluge, which enjoyed an extraordinary vogue in Britain in the late eighteenth

20. An unusually learned artist and a frequent illustrator of Shakespeare, Fuseli probably had in mind Edgar's lines in *King Lear*, III, iv, 123–4:

> Swithold footed thrice the old;
> He met the night-mare, and her nine-fold ...

As the editors of the Arden edition point out, "nightmare" means an incubus, derived from the Old English *mare*, and has nothing to do with the word for a female horse (*King Lear*, ed. Kenneth Muir, based on the edition of W.J. Craig [Cambridge, Mass.: Harvard University Press, 1959], p. 124.)

21. Gert Schiff, *Johann Heinrich Füssli, 1741–1825. Text und Oeuvrekatalog* (Zurich: Verlag Berichthaus; München: Prestel-Verlag, 1973), vol. I, p. 153. The picture is no. 757.

22. Schiff, no. 758.

23. H.W. Janson, "Fuseli's *Nightmare*," *Arts and Sciences*, II (1963), 27–8; see also Schiff, p. 153–4, and Nicolas Powell, *Fuseli: The Nightmare* (New York: The Viking Press, 1972), p. 60.

24. Janson, p. 28.

25. Janson, p. 28; Powell, pp. 15, 105.

and early nineteenth centuries. Involving by definition a divinely sent, universal catastrophe, employing by necessity the most powerful natural forces, the Deluge scene can make the transition from the natural to the apocalyptic sublime. To a remarkable degree, such scenes had a single prototype for British artists, whether they imitated, deviated from or challenged it: Nicolas Poussin's painting entitled *Winter* or *The Flood* (Louvre). One of a series of Four Seasons painted between 1660 and 1664,[26] this picture became for English artists and connoisseurs simply *The Deluge* – the title by which it will be identified here – and not merely *The Deluge* but *the* Deluge, a picture that had immense consequences for some of those who saw it and even some who did not.

What was exceptional about Poussin's *Deluge*? In illustrating the biblical story, early Christian artists had generally made Noah the central figure, often presenting him as a type of the resurrected Christ, sometimes accompanied by a disproportionately small Ark suggestive of the tomb.[27] By the high Middle Ages a number of group scenes had become standard in the depiction of the Flood, but these still centered on Noah and his family, their building of the Ark, and their subsequent history. It was Michelangelo in his Sistine Chapel ceiling who, in Don Cameron Allen's words, "dared to push the Ark to the rear of the scene and make the intense sufferings of the doomed the essential artistic focus."[28] Poussin followed a number of other artists who presented the Deluge in such a way, and he also introduced a motif that was to be widely imitated: the inundated family group spanning three generations. What turned out to be particularly appropriate to the aesthetics of the next century, however, is that Poussin's *Deluge* is a *landscape* as none of its predecessors is,[29] and an atmospheric landscape with jagged rocks, convoluted trees, and water moving turbulently in the center of the painting. While the figures of the victims are clear, the light in the picture is dim, anticipating Burke's later dictum that obscurity is a source of the sublime. Indeed, just as Joseph Addison discovered that *Paradise Lost* was a sublime poem, so did later art critics find Poussin's *Deluge* a sublime painting.

The Deluge, as Richard Verdi has demonstrated, was admired from the first and enjoyed a remarkable continuity of prestige through several dramatically differing periods of artistic taste.[30] It seems to have cut across lines of periodization for British as well as French commentators. Horace Walpole, in advising his friend Seymour Henry Conway about what to see in Paris, wrote in 1774: "At the Luxembourg are some [of the King's pictures] hung up, and one particularly is worth going to see alone: it is the Deluge by Nicolo Poussin, as Winter."[31] James Barry, who would have seen the picture during his stay in Paris of 1765–66, later told his Royal Academy students: "Nothing can be more condensed and vehement in its address . . . than the Plague and Deluge of

26. See Anthony Blunt, *The Paintings of Nicolas Poussin: A Critical Catalogue* (London: Phaidon, 1966), pp. 9–10.

27. See Don Cameron Allen, *The Legend of Noah* (Urbana, Ill.: University of Illinois Press, 1963 [1949]), pp. 155–73.

28. *Ibid.*, p. 169.

29. See Lynn R. Matteson, *Apocalyptic Themes In British Landscape Painting*, Doctoral dissertation, University of California, Berkeley, 1975, pp. 98–9; Richard Verdi, "Poussin's 'Deluge': the Aftermath," *The Burlington Magazine*, CXXIII (1981), 389.

30. Verdi, pp. 389–400.

31. *Horace Walpole's Correspondence* (New Haven and London: Yale University Press, 1974), vol. 39, ed. W.S. Lewis, Lars E. Troide, Edwine M. Marz, and Robert A. Smith, pp. 201–2.

Poussin."[32] Henry Fuseli, who made observations on a number of pictures seen at the Louvre during the Peace of Amiens in 1802, remarked:

"The Winter, or Deluge" . . . places Poussin in the first rank of art. It is easier to feel than to describe its powers . . . What we see before us is the element itself, and not its image; its reign is established, and by calm degrees ingulphs the whole; it "mocks the food it feeds on." Its lucid haze has shorn the sun of its beams; Hope is shut out, and Nature expires.[33]

William Hazlitt painted a copy of *The Deluge* at the Louvre in the winter of 1802–3[34] and later wrote a fervent description of it, calling it "in truth the very poetry of painting."[35] The young Percy Bysshe Shelley, who visited Paris in 1814, wrote:

At the Louvre we saw one picture, apparently of the Deluge, which was terribly impressive. It was the only remarkable picture which we had time to observe.[36]

John Constable, lecturing in Hampstead in 1833, said of Poussin:

. . . in the awful sublimity of the conception of his picture of Winter, generally known as the Deluge, he has surpassed every other painter, who has attempted the subject; nor can there be a greater proof of the effective power of landscape than that this portentous event should have been best told by landscape alone, the figures being few and entirely subordinate.[37]

What these views of *The Deluge*, spanning some six decades, have in common, in addition to their use of the vocabulary of the sublime, is that the painting is seen not as the best of its kind but as one of a kind: it is the only picture worth seeing, unparalleled and indescribable.

One further characteristic of Poussin's painting that was seen as unique and peculiarly appropriate was its stony coloration. John Opie, who succeeded Barry as Professor of Painting at the Royal Academy, told his students:

In this work there appears neither white nor black, nor blue, nor red, nor yellow: the whole mass is, with little variation, of a sombre gray, the true resemblance of a dark and humid atmosphere, by which every object is rendered indistinct and almost colourless. This is both a faithful and a poetical concept of the subject; nature seems faint, half dissolved, and verging on annihilation, and the pathetic solemnity, grandeur, and simplicity of the effect, which can never be exceeded, is entirely derived

32. *The Works of James Barry, Esq.* (London: Cadell and Davies, 1809), vol. I, p. 457. From Lecture IV, "on Composition."

33. *The Life and Writings of Henry Fuseli, M.A. R.A.*, ed. John Knowles, F.R.S. (London: H. Colburn and R. Bentley, 1831), vol. I, p. 272.

34. See William Carew Hazlitt, *The Hazlitts* (Edinburgh: Ballantyne, Hanson, and Co., 1911), p. 116. Hazlitt's copy is untraced.

35. *The Complete Works of William Hazlitt*, ed. P.P. Howe (London and Toronto: J.M. Dent and Sons, 1932), vol. X, p. 109.

36. *Mary Shelley's Journal*, ed. Frederick L. Jones (Norman, Oklahoma: University of Oklahoma Press, 1947), entry for 5 August 1814, p. 5. See Ilse O'Sullivan, *Shelley und die bildende Kunst* (Bad Salzungen: L. Scheermessers Hofbuchhandlung, 1927), p. 18.

37. C.R. Leslie, *Memoirs of the Life of John Constable Esq., R.A.* (London: John Lehmann, 1948 [1843]), p. 316.

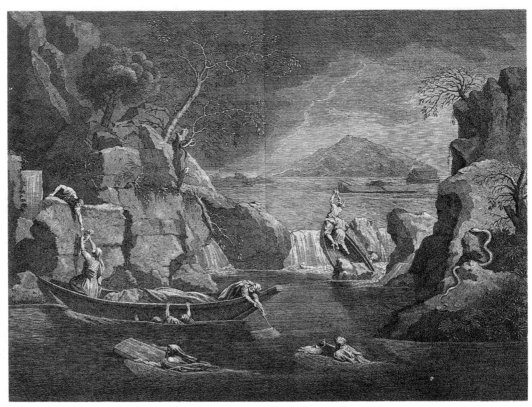

5. Jean Audran after Nicolas Poussin. *Winter, or The Deluge.*

from the painter's having departed from, and gone in direct opposition to, general practice.[38]

Opie's remarks are entirely consonant with Part II, section xvi of Burke's *Enquiry*, entitled "COLOUR considered as productive of the SUBLIME." Burke says that bright colors are to be avoided in the presentation of the sublime – "An immense mountain covered with a shining green turf, is nothing in this respect, to one dark and gloomy; the cloudy sky is more grand than the blue; and night more solemn than day."[39] Burke's words for sublime coloration in architecture, "sad and fuscous," are equally applicable to *The Deluge*. Even Turner, who thought the picture "unworthy of the mind of Poussin" and challenged it with his own *Deluge* (1805, Tate Gallery), wrote: "But the colour is sublime. It is natural, is what a creative mind must be imprest with by sympathy and horror."[40]

It was also particularly important to British artists and critics that *The Deluge* represented a scene from sacred history, as emphasized by the Ark floating off in the background and by the· enormous serpent – an especially characteristic touch[41] – slithering away at the left. These images of salvation and Fall, along with general

38. John Opie, *Lectures on Painting* (London: Longman, Horst, Rees, and Orme, 1809), pp. 120–21.

39. *Enquiry*, pp. 81–2.

40. See A.J. Finberg, *The Life of J.M.W. Turner, R.A.* (Oxford: the Clarendon Press, 1939), p. 90.

41. See Anthony Blunt, *Nicolas Poussin* (New York: Pantheon Books, 1958), p. 334.

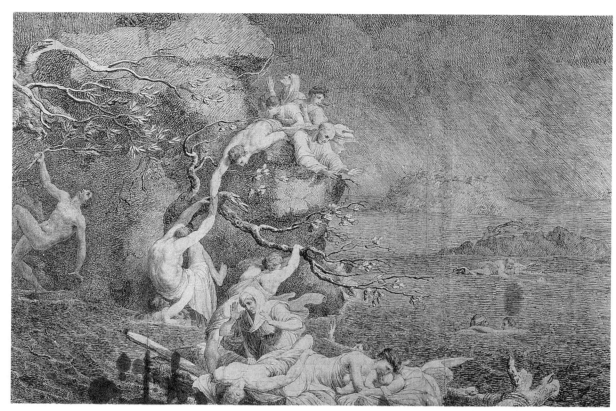

6. James Jefferys. *The Deluge.*

associations with the most "sublime" of books, take Poussin's *Deluge* to a threshold beyond the natural sublime. In this painting the veil, although not raised, trembles. Poussin's *Deluge*, as may be seen from its subsequent influence on British art, is the forerunner of the apocalyptic sublime.

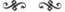

Even those artists who had not been to France could have been familiar with *The Deluge* through the engraving by Jean Audran (Pl. 5) or one of the engravings that followed it. Such seems to have been the case with James Jefferys, whose *Deluge* was exhibited at the Royal Academy in 1775.[42] Jefferys is a figure whose artistic identity has only recently been established,[43] and this painting is one of those that remain untraced. There is, however, a large ($26\frac{1}{4} \times 39\frac{5}{8}$ in.), highly finished pen-and-ink wash drawing of the subject, squared in red chalk as if for transfer (Maidstone Museum and Art Gallery) (Pl. 6). It may have been this picture that in 1774 won Jefferys the gold palette

42. See Timothy Clifford and Susan Legouix, "James Jefferys, Historical Draughtsman," *Burlington Magazine*, CXVIII (1976), 152 and fig. 26.
43. See also Timothy Clifford and Susan Legouix, *The Rediscovery of an Artist: The Drawings of James Jefferys* (London: Victoria and Albert Museum exhibition catalogue, 1976) and exhibition review by Martin Butlin, "The Rediscovery of an Artist: James Jefferys 1751–1784," *Blake*, XL (1977), 123–4.

of the Society of Arts.[44] Although Timothy Clifford and Susan Legouix remark on the influence of Michelangelo's Sistine-ceiling *Universal Flood* on this drawing, the Jefferys design seems even closer to Poussin's both in tonality and in composition. It is a dark picture because of the very large number of pen strokes shading sky, rocks, and water. Formally, it seems an inversion of Poussin's design, with a relatively small number of figures dispersed horizontally across the foreground and then going up to the left instead of (as in the Poussin) to the right. If Jefferys was familiar with Jean Audran's engraving after the Poussin, in which the painting is reversed, his drawing would have paralleled Poussin's composition as he knew it.

While the wildness of the scene and Jefferys's energy of handling recall Mortimer,[45] and there is a family group in the picture as in the Poussin, something of Jefferys's own appears in this tangle of defeated figures. The drawing is if anything more pessimistic than its French prototype: the naked man who clutches a broken branch as he falls at the left seems almost an emblem of failed hope; a group of people is stranded on an island in the middle distance; and the Ark is shunted over to the extreme right of the horizon, with half of it already out of the picture as if to carry to its most extreme the forlornness of the subjects' situation.

Another early, British Deluge painting, also now lost, is that of Mauritius Lowe. Lowe was a pupil of Giovanni Battista Cipriani ("but improved little under his tuition," according to James Northcote[46]), and one of the first pupils to enter the Royal Academy schools. His oil painting was shown at the Royal Academy exhibition of 1783 – after having been rejected by the Hanging Committee – as a result of the intercession of Samuel Johnson, who wrote to Reynolds and to Barry on Lowe's behalf. James Boswell recorded Lowe's claim that Dr. Johnson had pronounced his painting "noble and probable."[47] However, as Northcote acidulously observed, Johnson's appeal to the Academicians was on compassionate not aesthetic grounds. "Of his work I can say nothing," wrote Johnson to Barry, "I pretend not to judge of painting; and this picture I never saw: but I conceive it extremely hard to shut any man out from the possibility of success . . ."[48] Northcote's judgment was that "it had been much better for Mr. Lowe if he had complied with the first decree of the council, for if the conception of the picture had been good, as Dr. Johnson insinuates, yet the execution of it was execrable beyond belief."[49]

This hapless picture, as William T. Whitley observes, did find a buyer, and an inscription at the base of its frame was transcribed by a visitor to Sutton Place, Guildford, in 1834:

In the Deluge, the most powerful of the human race and the strongest of the animal creation, may be supposed to be perishing last on the mountain; likely thus to be

44. See Clifford and Legouix, "James Jefferys, Historical Draughtsman," p. 152. The authors note that verso bears an inscription in ink: "Presented by J. Jefferys Esq.," and one in pencil: "Received January 2/1 large/Mr. J. Jefferys/1772, but perhaps Jefferys sold the drawing in 1772 and then borrowed it back for exhibition.

45. *Ibid.*, p. 152.

46. See James Northcote, *Memoirs of Sir Joshua Reynolds,*

Knt. (London: Henry Colburn, 1813) pp. 294–7. Northcote's description of the painting agrees with Boswell's and with Lowe's own.

47. *Boswell's Life of Johnson*, ed. George Birckbeck Hill, rev. L.F. Powell (Oxford: the Clarendon Press, 1934), vol. IV, p. 202.

48. *Ibid.*, p. 202.

49. Northcote, *Memoirs*, p. 297.

rescued from the wreck of the universe is a beautiful little female. In this picture, therefore, while the solitary summit of the last mountain remains uncovered by the water, one of the gigantic antediluvian princes gains his last refuge with his little daughter, and a hungry lion who has swum thither for shelter, springing on the maiden, the father, conscious of his own strength and superiority, expresses indignation rather than contempt.[50]

The conception does sound unpromising. What we can see from the description is that Lowe's picture concentrated on a fragmented family group but otherwise departed from Poussin in attempting to achieve its effect through larger-than-life-size figures and domestic pathos. Even a sympathetic reviewer in the *Morning Chronicle* remarked: "If it has failed, as we fear it has, it fails with that respect attending great endeavours."[51]

Yet another lost Deluge picture, but reportedly a more successful one, was by the Scottish painter Jacob More (also called Moore), who painted also an *Eruption of Vesuvius* (1780, National Gallery of Scotland). This time the description of the painting is not by the artist but by no less a figure than Goethe, who saw the picture in More's studio in Rome in 1787:

Among his paintings, he has one of the Flood which is unique. While other artists have painted the open sea, which conveys the idea of a vast watery expanse but cannot show that the waters are rising, he has depicted a secluded valley into which the waters are rushing and filling it up. The shapes of the rocks show that the water level has nearly risen to the summit, and since the valley is closed off diagonally in the background and all the cliffs are steep, the total effect is one of terror. All the tones in the picture are gray; the muddy, churning water and the pouring rain blend intimately: the water cascades and drips from the rocks as if their enormous masses were about to dissolve themselves into the universal element, and the sun, lacking all radiance, looks like a wan moon through the water haze, although it is not yet night. In the centre of the foreground, some human beings have taken refuge on an isolated plateau, at the very moment when the rising flood threatens to overwhelm them. It is a huge picture, seven or eight feet long and five or six feet high.[52]

In some respects this painting too seems to have been indebted to Poussin, as Goethe's remarks about the sun, the water dripping from rocks, and the gray coloration indicate. More seems to have increased the scale of the landscape, however, and to have concentrated the human interest in the center. His conception of the Deluge apparently incorporated the vastness of the Burkean sublime as well as its obscurity and, most of all, its appeal to "the passions which concern self-preservation."[53] Even the size of the painting, like that of Lowe's with its huge figures, appears to be related to Burke's idea that "Greatness of dimension, is a powerful cause of the sublime."[54] Again like Lowe's *Deluge*, More's seemingly lacked the element of hope conveyed by the Ark in earlier

50. William T. Whitley, *Artists and Their Friends in England 1700–1799* (London and Boston: The Medici Society, 1928), vol. I, p. 391.

51. Quoted by Whitley, p. 391.

52. J.W. Goethe, *Italian Journey (1786–1788)*, trans. W.H. Auden and Elizabeth Mayer (New York: Pantheon Books, 1962), p. 357.

53. *Enquiry*, p. 38.

54. *Ibid.*, p. 72.

treatments of the subject as well as in some later ones, and so was closer to the natural, catastrophic sublime.

A Deluge painting that has, fortunately, survived is that of Philippe Jacques de Loutherbourg (Victoria and Albert Museum), exhibited at Macklin's Poets Gallery in 1790 and engraved by Thomas Milton in 1797 (Pl. 7) for Macklin's great illustrated Bible (published 1800). De Loutherbourg moves closer in to his suffering subjects than any of his predecessors, and he limits them to three figures. The despairing father's upraised arm forms the apex of a pyramid that seems to look forward to Géricault's *Raft of the Medusa*; at the same time the picture as a type is, as Rüdiger Joppien comments,[55] reminiscent of de Loutherbourg's own shipwreck scenes – a popular sub-genre in which this amazingly versatile artist was also proficient.[56] There is, however, something beyond shipwreck in de Loutherbourg's picture. The setting seems peculiarly amorphous: the water foams white but is generally dark, as are the rocks, the clouded sky, and even the Ark itself. The flesh tones of the human figures, especially of the pudgy child, make them seem terribly vulnerable in contrast, as does the delicate blue-and-white coloring of the mother's dress. These figures convey, as Joppien puts it, an "almost hysterical overtone,"[57] while the serpent at the right, which might almost have slithered out of Poussin's *Deluge*, adds a suggestion of meaning beyond the natural.

The Deluge was a considerable success in de Loutherbourg's time. The contemporary artist and critic Edward Dayes called it "the very best [painting] that he produced."[58] An anonymous critic reviewing the Academy exhibition of 1790 wrote:

> The fancy displayed in the selection of this situation is highly picturesque ... The grouping of the figures is admirable ... The introduction of the serpent is highly appropriate ... he seems to contemplate the destruction, of which allegorically he might be considered as the cause. The Ark, dimly appearing through the spray of the sea, is also of the happiest effect.[59]

De Loutherbourg had by 1789 also begun to paint overtly apocalyptic subjects for the Macklin Bible, and these will concern us later.

In Benjamin West's *Deluge*, exhibited at the Academy in 1791 but now known only through a retouched oil sketch (coll. Dr. Robert Erwin Jones),[60] the Ark virtually dominates the scene. The rainbow above the Ark, signifying God's covenant with Noah, further emphasizes an optimistic meaning in this picture, making the drowned family group in the foreground of only secondary interest. This subject was intended

55. Rüdiger Joppien, *Philippe Jacques de Loutherbourg, R.A. 1740–1812* (London: Greater London Council [Kenwood House exhibition catalogue], 1973), no. 63.

56. Nancy Pressly compares the composition with de Loutherbourg's own *Shipwreck of St. Paul*; see *Revealed Religion: Benjamin West's Commissions for Windsor Castle and Fonthill Abbey* (San Antonio, Texas: San Antonio Museum of Art, 1983), p. 36 n. 9. On the popularity of shipwreck scenes, see Hawes, *Presences of Nature*, pp. 22–3.

57. Joppien, no. 63.

58. *The Works of the Late Edward Dayes* (London, 1805), p. 337.

59. Press Cuttings from English Newspapers on Matters of Artistic Interest, 1686–1825, Victoria and Albert Museum, vol. II, p. 551.

60. West retouched the smaller picture in 1803 and exhibited it at the Royal Academy in 1805. Information from Allen Staley, private communication.

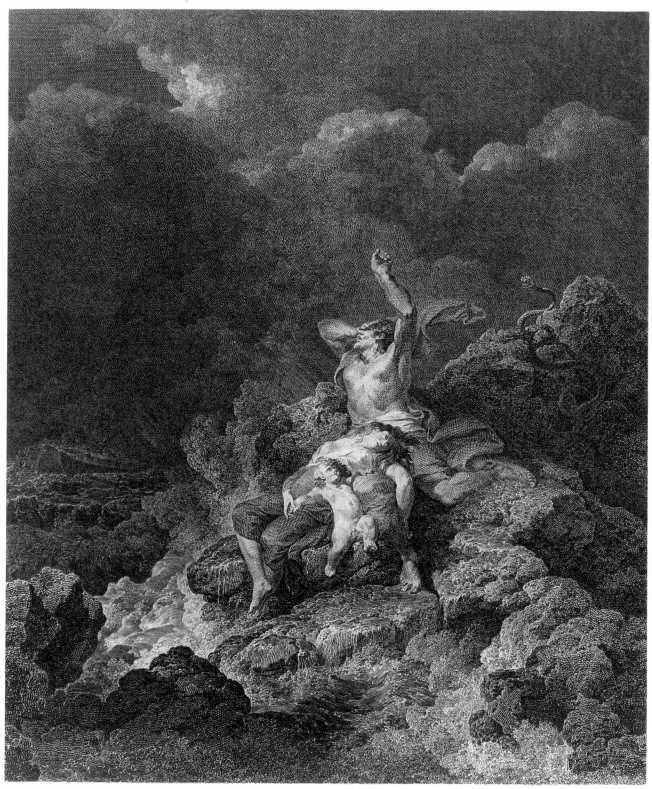

7. Thomas Milton after Philippe Jacques de Loutherbourg, *The Deluge*.

for the Chapel of Revealed Religion at Windsor, and some of its details have iconographical meanings as part of West's projected cycle of sacred history. Nancy Pressly convincingly suggests that the Ark is "a heroic image of the church where man finds salvation" and that the rainbow looks forward to the one "round about the throne" that West also intended to include among scenes from the Book of Revelation.[61]

West's picture was later imitated by Joshua Shaw, whose *Deluge* was exhibited at the British Institution in 1813.[62] Shaw's work is, however, much more pessimistic than West's in that the Ark is merely a small dark rectangle at the meeting of sea and sky. The most impressive aspect of this painting is the very large breakers spuming whitish-gray in the foreground. Birds in the air are white against the dark sky. There are dead bodies in the foreground, no less than three serpents, and an abandoned dog howling on a rock. The last detail was compared by a contemporary reviewer to what remained the touchstone of all "Deluges": "This pathetic incident is exceeded in its impressiveness only by an admirable conception of Poussin – namely, the horse and lion standing quiescently together in his *Deluge*."[63] With Shaw's *Deluge* we are in the nineteenth century, by which time the subject had become established as one of special importance. Ambitious "Deluges" were produced also by J.M.W. Turner, John Martin, and Francis Danby, but these are best discussed in connection with other works by each of these artists.

<div align="center">⚜ ⚜</div>

Mortimer's *Death on a Pale Horse* is now known only through a preliminary drawing (British Museum) and an etching by Joseph Haynes published on 1 January 1784 (Pl. 1).[64] The text illustrated is one of the most familiar in Revelation:

> And I looked, and behold a pale horse: and his name that sat on him was Death, and Hell followed with him. And power was given unto him over the fourth part of the earth, to kill with sword, and with hunger, and with death, and with the beasts of the earth. (vi. 8)

Mortimer was of course indebted to Dürer's great woodcut (Pl. 8), and the influence of a seventeenth-century etching. *Death on Horseback* by Stefano della Bella, has also been suggested;[65] but the most striking aspect of Mortimer's design is not its indebtedness but its originality. *Death on a Pale Horse* is a nearly perfect realization of the Burkean sublime of terror in the terrible grandeur of its central figure's white, emaciated body and white horse set against a dark, swirling background. The powerless figures trodden

61. Pressley, pp. 31–2.
62. See Jerry D. Meyer, "Benjamin West's Chapel of Revealed Religion: A Study of Protestant Religious Art," *Art Bulletin*, LVII (1975), 258–60; and Albert Ten Eyck Gardner and Stuart P. Feld, *American Paintings: A Catalogue of the Collection of the Metropolitan Museum of Art* (New York: Metropolitan Museum of Art, 1965), vol. I, pp. 130–33. Shaw's *Deluge* was once attributed to Washington Allston.
63. Press Cuttings, Victoria and Albert Museum, vol. III, p. 871.
64. See Benedict Nicolson, *John Hamilton Mortimer A.R.A./1740–1779* (London: Iveagh Bequest, Kenwood, 1968), no. 44.
65. See Norman D. Ziff, "Mortimer's *Death on a Pale Horse*," *Burlington Magazine*, CXII (1970), 531–2.

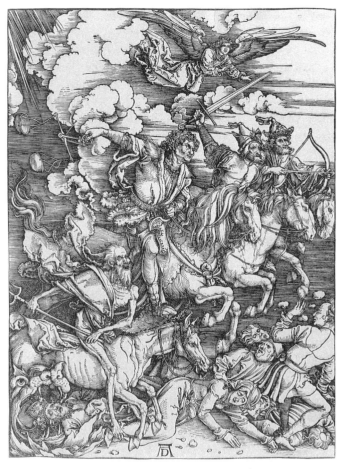

8. Albrecht Dürer. *The Four Horsemen of the Apocalypse.*

down in the foreground contribute further to this effect. There is also a strong suggestion of the traditional motif of Death the Leveller, and this may have associations with the radical political sympathies that have been attributed to Mortimer.[66] A near-grotesque touch is provided by the monsters flying through the air; these have only the slightest justification in the text ("and Hell followed with him"). The whole provides an example of what Edward Edwards meant when he wrote that among Mortimer's favorite subjects were "scenes that personify 'horrible imaginings.'"[67]

When *Death on a Pale Horse* was first exhibited at the Society of Artists, it had a pendant, now also untraced and likewise known through an etching by Haynes dated 1 January 1784. This etching, referred to in the 1968 Kenwood exhibition catalogue as *A Monumental Design*,[68] bears a text from I Cor. xv. 55: "O DEATH WHERE IS THY STING/O GRAVE WHERE IS THY/VICTORY?" The subject is resurrected Man rising above the skeletal figure of Death. The design area of this etching, as that of *Death on a Pale Horse*,

66. See John Sunderland, "Mortimer, Pine, and Some Political Aspects of English History Painting," *Burlington Magazine*, XXVI (1794), 321.

67. Edward Edwards, *Anecdotes of Painters* (London,

1808), p. 63. *Cf. Macbeth*, I, iii, 137–8: "Present fears/Are less than horrible imaginings."

68. See Nicolson, *John Hamilton Mortimer*, no. 45.

17

is rounded at the top and itself suggestive of a tombstone. The two designs, exhibited together and published together, were meant to make contrasting statements, and the last word was not to be the triumph of Death but the triumph over Death. The celebrity of the first design, however, obviated this meaning for later viewers.

While *Death on a Pale Horse* became Mortimer's most famous image, *A Monumental Design* remained virtually unknown. In 1795 James Gillray could use Mortimer's Revelation design as the basis of his satirical caricature *Presages of the Millennium* in the confident expectation that the source, nowhere named in Gillray's print, would be recognized.[69] Mortimer's *Death on a Pale Horse* certainly provided the original impetus for Benjamin West's several treatments of the subject and probably for Blake's as well.[70] (It also inspired one of the poems in Baudelaire's *Fleurs du Mal*.[71]) The reception of a work of art continues independently of the artist's original intention, and for British artists of the Romantic era *Death on a Pale Horse*, untempered by the optimism of *A Monumental Design*, was seen as an independent work: the first example of the apocalyptic sublime.

69. Gillray shows only a single rider on a white horse, as does Mortimer, and the caricature is also compositionally more like Mortimer's than like West's *Triumph of Death* of 1783/84. See further, Appendix I, "The Apocalyptic Grotesque."

70. Blake several times expresses his admiration for Mortimer; see, for example, his Annotations to Rey-nold's *Discourses* in *The Complete Poetry and Prose of William Blake*, ed. David V. Erdman, with a Commentary by Harold Bloom (Berkeley and Los Angeles: University of California Press, 1983), p. 636.

71. See Ziff, "Mortimer's *Death on a Pale Horse*," p. 532.

CHAPTER II

Benjamin West

IN 1784 Benjamin West exhibited at the Royal Academy a large drawing entitled *The Triumph of Death*,[1] the first of his three exhibited versions of *Death on the Pale Horse*. Apparently executed on brownish sheets of paper irregularly joined, its color is mostly light sepia, but there is a blue-gray wash in the sky, and a small amount of whitening in the clouds. The horse's mane and foreparts are also whitened, as are the mother and child in the foreground. These touches of color may have been put in when the picture was retouched in 1803. The dynamism of the design is not at all impeded by the pen-and-ink outlines of the figures, and the drawing as a whole is a very powerful one.

For the inception of this idea West was obviously indebted to Mortimer, as is even more evident in a preliminary sketch in pen and brown ink over black chalk (Pierpont Morgan Library) (Pl. 9). Here Death is the sole horseman: a crowned skeleton as in Mortimer's design, he rides down an interlaced group of naked victims while wild beasts attack others. A father and a mother carrying a child flee at the lower right – the "family group" that West had also used in *The Deluge* and that Blake too would employ in a number of his apocalyptic designs. The 1783 drawing keeps the central idea of this sketch but expands its scope in a number of ways.

In *The Triumph of Death* (Pl. 10) there are (as in Dürer) four horsemen. To the left of Death is the Black Horse of Rev. vi. 6: "and he that sat on him had a pair of balances in his hand." Further to the right is the Rider on the White Horse of Rev. vi. 2, wielding his bow, and beside him is the Rider on the Red Horse of vi. 4 ("and power was given to him that sat thereon to take peace from the earth, and that they should kill one another"). The latter wears a helmet and armor in addition to wielding the "great sword" of the text. Death on his Pale Horse dominates the picture, with a serpent wreathing round his right forearm. Both his hands clasp Jovian thunderbolts from which issue arrow-headed darts (a device later employed by Blake in *The Spiritual Form of Nelson guiding Leviathan*).[2] The family group that was escaping in the Morgan Library drawing is now trapped in the path of Death's veering horse. One child is already dead and a second holds her dying mother while their father makes an impotent gesture towards Death. The left side of the design is devoted to other victims of carnage –

1. Coll. Royal Academy, signed and dated "B West 1783 retouched 1803." 2. See discussion below, Chapter IV.

9. Benjamin West. Preliminary sketch for *The Triumph of Death*.

10. Benjamin West. *The Triumph of Death*.

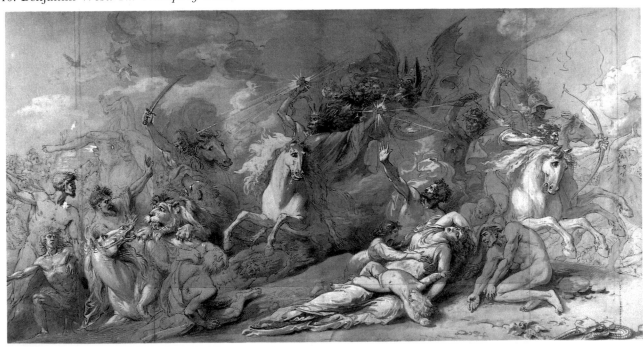

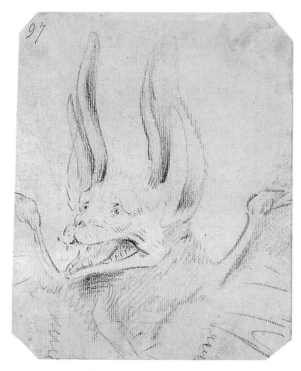

11. Benjamin West. Study for a monster in *The Triumph of Death*.

human beings vainly trying to defend themselves against the attacks of wild beasts that had been only roughly indicated in the Morgan Library drawing. In the sky behind Death fly a horde of demonic figures and, to the left, two eagles killing a heron. In the right foreground a white dove stands beside his dead mate. Next to them is the only optimistic image in the picture: a serpent that has been killed by a stone.

We can see that West did not feel bound to adhere to the text in all details but rather felt free to add to or depart from it in various ways. The Rider on the Black Horse looks bewildered, and his balances swing crazily in the air; he seems incapable of carrying out the injunction "see thou hurt not the oil and wine" (vi. 6). The Rider on the White Horse does not wear the "crown that was given to him" (vi. 2). As in Mortimer's picture, the crowd of grotesque flying demons has as its only justification the text: "and Hell followed with him" (vi. 8), but West evidently felt a great interest in this aspect of the picture,[3] drawing in black chalk a preliminary study for a bat-like demon with sharp teeth (British Museum) (Pl. 11). West has emphasized throughout the *triumph* of Death, as his original title indicates, and "Triumph" here has something of the meaning of a pageant or masque, as in the Triumph of Death frescoes, then attributed to Orcagna, that West could have seen at Orvieto.[4] Perhaps the most powerful contribution to this effect is not any individual figure but the overall composition, which has two aspects. A triangle is formed in the center of the design, defined by the upraised arms of male victims at the right and left and culminating in the right hand of Death above and between them. There is also a rush of action from left to right, indicated by the swinging-around of the Pale Horse and continued by the two riders

3. See Robert Rosenblum, Review of *Benjamin West and the Taste of His Times* by Grose Evans, *Art Bulletin*, XLII (1960), 76–8.

4. West spent the years 1760–63 in Italy.

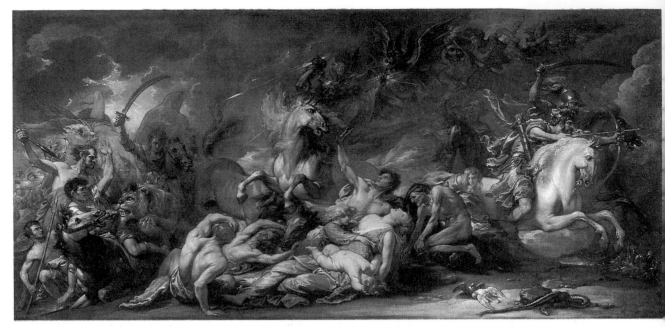

12. Benjamin West. *The Opening of the [Four] Seals.*

galloping furiously further to the right. The oblong shape of the picture ($21\frac{1}{2} \times 44$ in) accentuates this effect, which is like that of a cavalry charge.

In 1796 it was reported in the press that West was preparing "a spirited sketch for a large Altar Piece picture of DEATH, trampling under foot the KINGS of the Earth!"[5] This no doubt referred to the picture exhibited at the Royal Academy in 1796 as *The Opening of the Four Seals* (Pl. 12) and identified in the exhibition catalogue (no. 247) as "a sketch for His Majesty's Chapel, Windsor." The total effect is even more "terrible" than that of the earlier drawing, and it was praised by one reviewer as "a spirited and sublime composition, that will long remain a monument of Mr. WEST's genius . . ."[6] West took advantage of the oil medium to give his figures more mass and brighter coloring. Death's head has become more grotesque, with black skin taut over a skull-like face; the rider on the left wears a brilliant red cloak and a blue shirt; the living child in the center foreground is further accentuated by her red dress. Evidently not all critics admired these color contrasts, for one of West's defenders wrote:

> Objections have been made to the *colouring* of this picture; but we consider those objections a result of narrow judgment. In a scene of this kind, a deviation from the hues of mere life and nature is suitable to the subject. Perhaps the effect of the whole would have been better, if the figure of *Death* had been more elevated in the canvas, or less obscured by the interposition of his horse. One of the white horses is out of *drawing*, as we conceive no horse can be found so long in the body: but such objections vanish before the general impression of the piece.[7]

5. Press Cuttings, Victoria and Albert Museum, vol. III, p. 726.

6. *Ibid.*, p. 769.

7. *Ibid.*, p. 761.

The background is very dark, and the riders come out of it in a swirl of motion that has led to apt comparisons with Rubens's hunting scenes.[8] (The young Leigh Hunt saw an engraving after Rubens's *Lion Hunt* on West's wall.[9]) In the far distance we now see soldiers fighting, some on horseback and wearing red plumes, and ships at the lower right. The violent energies displayed throughout seem if anything more unbridled than in the drawing, and it is possible to see in this a reflection of the Continental war in which England had been engaged since the winter of 1793–94. It may also be this aspect of West's picture – its appeal to a public aware of battles being fought on a scale inconceivable earlier in the century – that made it become one of the most celebrated British paintings of its period and perhaps the only one to be exhibited on both sides of the Channel.

When, during the Peace of Amiens of 1802, British artists rushed to see the works of art that Bonaparte had installed in the Louvre, West seems to have been the only one who came as an exhibitor as well. In the words of William Dunlap, one of West's American students, "He visited Paris, and took with him his sublime composition, on a small scale, of 'Death on a Pale Horse.'"[10] On 1 September 1802 Farington reported: "Mr. West has chosen a place in the exhibition room for the picture He brought 'Death upon the White Horse', and the Artists are preparing a frame for it."[11] The fact that West chose this single painting tells us more about his own view of it than any verbal statement. Although David is said to have dismissed the picture as "a caricature of Rubens,"[12] the *Journal des Arts* published a highly favorable review, later reprinted in translation in *Public Characters of 1805*:

This sketch reminds us of those many fine compositions with which Mr. West has enriched his country. We trace in it his acknowledged genius and enthusiasm. He has judiciously chosen the moment at which Death appears upon the earth. The poetical figure of scripture has received from his pencil an aspect still more terrible. Every thing in nature is devoured and destroyed: the innocent dove and the wily serpent are re-united by Death.

Mr. West has represented death by sword, under a hord of armed robbers pursuing the unfortunate over the country. Death by famine is represented under the symbol of a man, ghastly, ethereal, and digging with skinny fingers the barren soil for sustenance. Death by pestilence is represented by a woman expiring by the plague,

8. See Grose Evans, *Benjamin West and the Taste of His Times* (Carbondale, Ill.: Southern Illinois University Press, 1959), p. 74; and Allen Staley, "West's *Death on the Pale Horse*," *Bulletin of the Detroit Institute of Arts*, LVIII (1980), 144–6.

9. *The Autobiography of Leigh Hunt*, ed. Roger Ingpen (London: Archibald Constable, 1903), vol. I, p. 98.

10. William Dunlap, *A History of the Rise and Progress of the Arts of Design in the United States*, ed. Frank W. Bayley and Charles E. Goodspeed (Boston: C.E. Goodspeed & Co., 1918 [1834]), vol. I, pp. 87–8. The identity of the picture that West took was at one time in question, and it was argued by Fiske Kimball that the oil sketch was one of two in the Philadelphia Museum of Art. (See "Benjamin West au Salon de 1802,"

Gazette des Beaux-Arts, 6me période, VII [1932], 403–10.) Allen Staley, however, has determined that both these oil sketches are copies after West and that the picture shown at the Salon is that formerly in the collection of the Earl of Egremont and now in the Detroit Art Institute ("West's *Death on the Pale Horse*," pp. 137–49).

11. *The Diary of Joseph Farington* (New Haven and London: Yale University Press), vol. V, ed. Kenneth Garlick and Angus Macintyre, 1979, p. 1820.

12. *Farington Diary*, vol. V, 13 January 1803, quoted by Staley, "West's *Death on the Pale Horse*, p. 142. On other occasions, however, David spoke favorably of West; see Robert C. Alberts, *Benjamin West A Biography* (Boston: Houghton Mifflin, 1978), p. 340.

one son already dead by her side, and another, somewhat older, flying into her arms.[13] Death by wild beasts is represented by a group of men pursued by, and defending themselves against, lions and tigers, which at once destroy, and are in turns destroyed themselves.

Such is the composition of Mr. West. The day of universal destruction is arrived: he is fully impressed by the idea, and his genius lends its force to his will.

If Mr. West possessed the colouring of Reubens, his sketch would have produced an effect more decided; but he appears to have inclined more to the sombre hues of Poussin; his designs have even some resemblance to those of this great master. The figure of Famine who digs the earth with her fingers,[14] would have done honor to the French painter, and is as well designed as executed. We think that the figure of the woman expiring by the plague, having one son dead by her side, and another flying into her arms, somewhat reminds us of the *group in the plague* of the Philistines, by Poussin.[15]

To be compared favorably with Poussin was high praise indeed from a French journal, but even more important to West must have been the opinion of France's leading non-professional critic. Farington recorded on 24 September 1802:

> West told me that He was introduced to Bonaparte in the Exhibition room by the Minister of the Interior. It was when Bonaparte came to *His Picture* and asked who it was painted by that the Minister introduced him. Bonaparte spoke to him in Italian, hoped he had found Paris agreeable and expressed his approbation of the merit of his picture. – West then continued with those who attended the Consul and went through the Exhibition room of drawings and Models – and down stairs to the Gallery of Statues.[16]

After returning to England, West was informed that he had been elected a foreign member of the French National Institute in the class of fine arts and that Bonaparte had "fully approved" of the reason for this honor.[17]

Now known as *Death on the Pale Horse*, West's oil sketch had become one of the most celebrated pictures of his long career. In 1806 it was shown at the opening exhibition of the British Institution. An unsigned engraving after it was published by Bell in 1807 (Pl. 13), and the same plate was used in the following year for one of the two illustrations accompanying an article on West in *La Belle Assemblée* (alternatively known as *Bell's Court and Fashionable Magazine*).[18] In the accompanying text, the anonymous author seems to be striving to establish a category something like the apocalyptic sublime:

13. The older child appears female to me and also to all those, as far as I know, who have commented on the picture.

14. This figure was male in the 1783 drawing but has become female in 1796 and will remain so in 1817.

15. "Mr. West," *Public Characters of 1805*, [vol. VII], note to pp. 555–7. The reference is to Poussin's *Plague at Ashdod* (Louvre).

16. Farington *Diary*, vol. V, p. 1875.

17. Farington *Diary*, vol. VI, ed. Garlick and Macintyre, 1979, p. 2208 (1 January 1804).

18. *La Belle Assemblée or Bell's Court and Fashionable Magazine*, V (1808), 55.

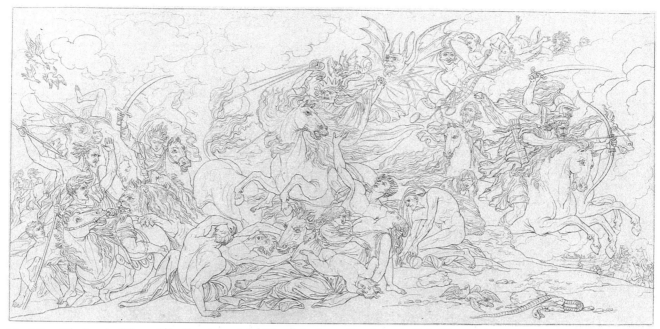

13. After Benjamin West. *The Opening of the [Four] Seals, or Death on the Pale Horse.*

The class of subjects to which this noble sketch belongs, cannot, with propriety, be denominated the historical; as such, therefore, the same principles of criticism are not to be employed in our examination of it; it belongs to an order of composition which embraces the loftier subjects of fancy and the divine flights of inspired poetry; in a word, those subjects, which having their basis in Revelations, are of a class to which the most exalted imagination can hardly be expected to rise.[19]

The author also describes the picture in words with inescapable Burkean associations:

His [Death's] form, in the language of Milton is "without form." – It is dissolving into darkness – it is in awful and terrible obscurity – All the legions of hell are in his train, they are seen in the opening perspective, and terminate the distances almost in the immensity of space.[20]

Of course when Burke cited Milton's Death as an example of sublime obscurity in which "all is dark, uncertain, confused, terrible, and sublime to the last degree,"[21] his main point was that the figure was assigned no distinct image, while West had to lessen the mystery by representing Death in some form. Most of those who commented on the oil sketch thought he had succeeded. The brilliant American painter Washington Allston wrote that he had been prejudiced against West's art but had changed his mind when he saw West's gallery, and he singled out *Death on the Pale Horse*:

19. *Ibid.*, p. 55. 21. *Enquiry*, p. 59.
20. *Ibid.*, p. 55.

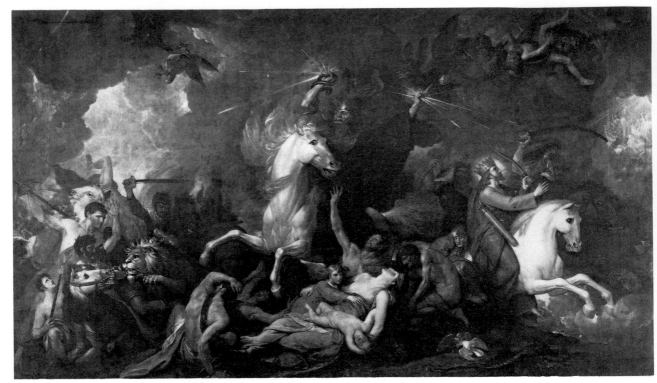

14. Benjamin West. *Death on the Pale Horse*.

No fancy could have better conceived and no pen more happily embodied the visions of sublimity than he has in his inimitable picture from Revelation. Its subject is the opening of the seven seals,[22] and a more sublime and awful picture I never beheld. It is impossible to conceive anything more terrible than Death on the white horse, and I am certain no painter has exceeded Mr. West in the fury, horror, and despair which he has represented in the surrounding figures.[23]

Even Allan Cunningham, who sneered at the grandiosity of some of West's Revelation pictures ("With such magnificence and sublimity who but Michael Angelo could cope?"[24]), made an exception for this one:

In his Death on the Pale Horse, and more particularly in the sketch of that picture, he has more than approached the masters and princes of the calling. It is, indeed, irresistibly fearful to see the triumphant march of the terrific phantom, and the dissolution of all that earth is proud of beneath his tread. War and peace, sorrow and joy, all who love and all who hate, seem planet-struck.[25]

22. Allston appears to have been mistaken as to the number of seals opened, since West's original title specifies four.

23. Letter to Charles Fraser dated 25 August 1801, in Jared B. Flagg, *The Life and Letters of Washington Allston* (New York: Kennedy Galleries/Da Capo Press, 1969 [repr. New York: Charles Scribner's Sons, 1892]), pp. 43–4.

24. Allan Cunningham, *Lives of the Most Eminent British Sculptors and Painters* (New York: Harper and Brothers, 1868 [London, 1833]), vol. II, pp. 52–3; see also Dunlap, vol. I, p. 97.

25. Cunningham, pp. 52–3.

Considering the critical success of the 1796 picture and West's personal attachment to it – he evidently did not sell it until 1819[26] – it is understandable that he chose this subject for repetition on a much larger scale in his old age.

The large *Death on the Pale Horse* (Pennsylvania Academy of Fine Arts) (Pl. 14), now alternatively titled *The Opening of the First Five Seals*,[27] was exhibited in 1817, accompanied by a seven-page descriptive pamphlet by West's friend and biographer John Galt.[28] From Galt's first sentence, we are in no doubt that this enormous picture is to be appreciated in Burkean terms: "The general effect proposed to be excited by this picture is the terrible sublime and its various modifications, until lost in the opposite extremes of pity and horror ..."[29] Galt goes on to make a comparison previously suggested in *La Belle Assemblée*: "Mr. WEST was of opinion, that, to delineate a physical form, which in its moral impression would approximate to that of the visionary DEATH of Milton, it was necessary to endow it if possible with the appearance of superhuman strength and energy ..."[30] William Paulet Carey, who independently published a book on West's painting in 1817,[31] considered West's Death "an image of terrific sublimity, which vies with any appalling invention of the pencil; and is not surpassed by the tremendous spectre in MILTON's immortal poem."[32] He praised West for not representing Death in "the stale form of *a fleshless skeleton*, an *image of powerless being*,"[33] but as a gigantic, muscular, superhuman figure.

Galt's and Carey's praises of West's Death are so close to being hyperbolical that they seem to conceal some disquietude, some fear that West's gigantic monster might be found not frightening but ridiculous. This again points up the inadequacy of the Burkean–Miltonic comparison, for what Burke had praised about Death in *Paradise Lost*, II, 666–73 was the *lack* of an image. Burke thought Milton's passage successful in the "significant and expressive uncertainty" it possessed;[34] West's swathing Death in a black robe is hardly equivalent to this. William Hazlitt took up this point in his review of the picture:

> It will hardly be contended ... that the account of Death on the Pale Horse in the book of Revelations, never produced its due effect of the *terrible sublime*, till the deficiences of the pen were supplied by the pencil. Neither do we see how the

26. See Staley, "West's *Death on the Pale Horse*," p. 149, n. 28.

27. According to the American painter Robert Leslie, West's son Raphael executed the large picture using the oil sketch as a guide. See Dunlap, vol. II, p. 290. The extent of Raphael's contribution has been disputed, but it seems likely that he was responsible for much of the coloring.

28. John Galt, *A Description of Mr. West's Picture of Death on the Pale Horse or the Opening of the First Five Seals* (London, 1817), p. 4. (This pamphlet is signed only "J.G.", but it appears certain that Galt was the author).

29. *Ibid.*, p. 4.

30. *Ibid.*, p. 4.

31. William Paulet Carey, *Critical Description and Analytical review of "Death on the Pale Horse" Painted by Benjamin West, P.R.A. With Desultory References to the Works of Some Ancient Masters, And Living British Artists* (London, 1817). This book is also important for its extensive, highly favorable remarks on Blake's designs for Blair's *Grave*, one of the few favorable published criticisms that Blake received in his lifetime. Lynn Matteson (*Apocalyptic Themes*, p. 219) points out that Carey was the author of an apocalyptic poem, "The Descent of the Avenger," published in *The Dying Peasant and Other Poems*, 1826.

32. Carey, p. 117.

33. Carey, p. 15. Carey may have been thinking of the skeletal figures of Death in Hogarth's *Satan, Sin, and Death* (Tate Gallery) and/or in Wright of Derby's *The Old Man and Death* (Hartford, Wadsworth Athenaeum).

34. *Enquiry*, p. 59.

endowing a physical form with superhuman strength, has any necessary connection with the *moral impressions of the visionary Death of Milton*. There seems to be here some radical mistake in Mr. West's theory.[35]

As for Galt's contention that West "depicted the King of Terrors with the physiognomy of the dead in a charnel-house,"[36] this is true only if one has in mind a conventionalized graveyard image. If, however, what is meant is an animated corpse, one need only compare the central figure of Washington Allston's *Dead Man Restored to Life* (Pennsylvania Academy of Fine Arts) to see the inadequacy of West's. Allston's dead man, probably derived from the sketching of dead bodies, gives his painting a genuinely disquieting effect; West's grotesque rider carries no more conviction than a fleshless skeleton. "His presence," as Hazlitt complained, "does not make the still air cold."[37]

The most important compositional change in the 1817 picture is what has happened to the fierce bowman at the right of the two previous versions. "The Artist's more mature perusal of the Revelation," wrote Carey, "induced him, in the large picture, to substitute for that figure the Messiah going forth on a mission of love, and bearing a peaceful bow and arrows, as types of the arguments of reason and religion, by which he is conquering and to conquer."[38] It has been suggested that West's reason for this change may actually have been the popularity of de Loutherbourg's *Opening of the Second Seal* (itself surely indebted to West's original conception), engraved by R. Page for the Macklin Bible of 1800.[39] West may indeed have wanted to distance his design from de Loutherbourg's, but there is probably a further reason in the changed international circumstances of the post-Napoleonic period. *The Opening of the Seals* had been painted in the early years of Britain's long wars with France, wars that would extend with only two respites until 1815. It may well have been that West thought his painting in its definitive form should embody the relief felt at the establishment of peace. Whether this attempt was artistically successful is another matter.

Galt indicates West's intention in representing Christ as the Rider on the White Horse:

> He is ... painted with a solemn countenance, expressive of a mind filled with thoughts of great enterprise; and he advances onward in his sublime career with that serene majesty in which Divine Providence continues through the storms and commotions of the temporal world, to execute its eternal purposes. He is armed with a bow and arrows, the force and arguments of truth, and leaves behind him as passing vapour all those terrible tumults and phantoms which make up the auxiliaries and retinues of Death.[40]

35. "West's Picture of Death on the Pale Horse," *The Complete Works of William Hazlitt*, vol. XVIII, p. 137. This review was first published in the *Edinburgh Magazine* for December 1817.

36. Galt, *Description*, p. 4.

37. "West's Picture of Death on the Pale Horse," p. 138. Hazlitt is evidently quoting from memory the description of Life-in-Death in Coleridge's *Ancient Mariner*. "Her flesh makes the still air cold," Coleridge wrote in the first, *Lyrical Ballads* version; he later changed this to "Who thicks men's blood with cold." See *The Poems of Samuel Taylor Coleridge*, ed. Ernest Hartley Coleridge (London: Oxford University Press, 1960), p. 194.

38. Carey, p. 115.

39. On de Loutherbourg's painting, also known as *The Vision of the White Horse* (Tate Gallery), see Joppien, *Philippe Jacques de Loutherbourg*, no. 69; for further discussion, see Chapter IV, below.

40. Galt, *Description*, p. 5.

There is, of course, nothing wrong *per se* in representing Christ armed with bow and arrows signifying spiritual things. Blake, for example, makes frequent use of such symbolism – "Bring me my Bow of burning gold: / Bring me my arrows of desire";[41] and in his *Paradise Lost* water color "The Rout of the Rebel Angels" (versions in the Huntington Art Gallery and the Boston Museum of Fine Arts), Jesus draws an enormous bow to drive Satan's legions down to the lower part of the design. Blake's composition is a strikingly successful one, with the two contrasting worlds of the picture both linked and divided by the tensile strength of the weapon. In West's painting, however, Christ seems unrelated to anything else, vapid rather than "solemn," riding off out of the picture. Worst of all, as far as the artist's intention is concerned, Christ is less dramatic and occupies a less important position than Death. One senses a defensive note in Galt's explanation: "At the first view he seems only to be a secondary character, but on considering the business of the scene, it will be obvious that he is the great leader, and that all the others but follow in his train."[42] Unfortunately, this is not at all obvious, and the strongest aspect of the two earlier designs – their overall composition – is much weakened by this change.

There would be little point in discussing every other change in the 1817 painting, but some further details do bear comment. West has taken advantage of the vastly increased size of his canvas to introduce both heavenly and earthly events in the background. In the upper right, the direction in which Christ is gazing, appears a celestial vision of white-clad figures with rays of light emanating from them. Lower, the military action suggested in the oil sketch is elaborated: now we see Roman warships with soldiers aboard, a red banner with the letters SPQR, and nearer, Roman soldiers, a golden menorah with twelve candles, and a golden eagle; further to the right is a figure wearing red toga and holding a scroll. It was Carey who first pointed out that these earthly details reflect the interpretation of Revelation made by Moses Lowman in the eighteenth century.[43] Revelation vi, according to Lowman, contained a description of the state of the Church under the early Roman Empire, and therefore the destruction of Jerusalem by Titus, says Carey, is pictured in the background.[44] The supernal vision in the upper part of the picture would then be a foil to this action, presenting the element of eschatalogical hope that is also embodied by Christ in the foreground. The presence of such elements gives the 1817 painting a religious content, a "message," that is absent from the earlier versions, but at the expense of vitiating the formal intensity that had made those designs memorable.

Perhaps the best-known comment on the large *Death on the Pale Horse* is that of John Keats to his brothers: "It is a wonderful picture, when West's age is considered; But there is nothing to be intense upon; no women one feels mad to kiss; no face swelling

41. *Milton*, in *Complete Poetry and Prose*, p. 95. For further discussion of Blake's symbol, see S. Foster Damon, *A Blake Dictionary* (Providence: Brown University Press, 1965), p. 55.

42. Galt, *Description*, p. 5.

43. Carey, pp. 5–6. Carey summarizes Lowman's view that Revelation vi "contains the first period of prophecy and a description of the state of the Church, under the Heathen Roman empire," and he adds "Each of the prophetical descriptions is, in part, some figurative or hieroglyphical picture ..." See Moses Lowman, *A Paraphrase and Notes on the Revelation of St. John* (London, 1737).

44. The Rider on the Black Horse is said to figure the period of the reign of Septimus Severus and his family (about 42 years), that of the Rider on the Red Horse the period from Trajan to Commodus (about 95 years) (Carey, pp. 50–61).

into reality." Keats then goes on to test West's painting against a touchstone of the true sublime and finds it wanting:

> The excellence of every Art is its intensity, capable of making all disagreeable evaporate, from their being in close relationship with Beauty and Truth – Examine King Lear and you will find this exemplified throughout; but in this picture we have unpleasantness without any momentous depth of speculation excited, in which to bury its repulsiveness . . .[45]

Keats, who distrusted poetry that has a palpable design on the reader, was also no doubt put off by the moralistic quality of the 1817 painting. No matter how pertinent his and Hazlitt's strictures, however, the earlier versions, and particularly the oil sketch, occupied a remarkable position in the taste of their time. The reasons for this appeal may cast light not only on *Death on the Pale Horse* but also on the apocalyptic sublime in general.

The underlying motive for the drawing of 1783 has been linked by Allen Staley to West's response to the American War of Independence, which was negotiated to a close only in that year, a suggestion that seems convincing, in view of West's deep ties to America which were indicated by the American students in his studio[46] and by his correspondence with friends and relatives in his native land. If Blake, in autobiographical verses written in 1800, could write "The American War began All its dark horrors passed before my face,"[47] what must West have felt? It seems reasonable to suppose that he sublimated his feelings about the war in the grim and agitated *Triumph of Death*. Furthermore, by the time West reworked the subject in oils in 1796, Britain had been at war with France for about three years, and the war, beginning with enormous losses in the Netherlands campaign of 1793–94, must have seemed on a scale consonant with chapter vi of Revelation. In France, the early 1790s were the years of the September Massacres and then of the Reign of Terror, events that were of course well publicized in England. This is not necessarily to argue that West consciously intended his painting to have the meaning that was assigned to the Pale Horse of Revelation by the prophet Richard Brothers in 1794: "the present War, its causes and consequences."[48] Nevertheless, the *Opening of the Seals* embodies, however subconsciously, a response to contemporary events, and a sense of this latent content must have engaged viewers of this picture in England and in France. William Beckford, ever a writer to make the latent manifest, was one such viewer. Deeply depressed by the war, and especially by events such as the bombardment of Copenhagen in which there was considerable loss of civilian lives, Beckford had a fantasy that is illuminating not only for this picture but also for some of West's other Revelation designs:

45. Letter dated 22 December 1817, *The Letters of John Keats*, ed. Hyder Edward Rollins, (Cambridge, Mass.: Harvard University Press, 1958), vol. I, p. 192.

46. See "West's *Death on the Pale Horse*." p. 147. On West's continuing contact with America, see Dorinda Evans, *Benjamin West and His American Students* (Published for the National Portrait Gallery by the Smithsonian Institution Press, Washington, D.C., 1980).

47. Letter postmarked 12 September 1800, *Complete Poetry and Prose*, p. 708.

48. See Pressly, *Revealed Religion*, p. 64. On Brothers, see my essay "William Blake, the Prince of the Hebrews, and the Woman Clothed with the Sun," *William Blake: Essays in Honor of Sir Geoffrey Keynes* (Oxford: Clarendon Press, 1973), pp. 272–98.

For the future I discover only phantoms stranger and more terrifying than those in the Apocalypse. Where is the mountain that will hide us from the wrath of a God justly angered by the massacres and ravages caused by our Cabinet, so coldly hypocritical and basely mercantile? At the recollection of Quiberon and Copenhagen, of the siege of Saragossa and the sack of Evora, on imagining the Russian horrors in Finland, we are forced to expect a day of vengeance. I see this terrible day issuing from the sanctuary of Divine Justice. It will not dawn on Windsor or London, for the Bank, Palace, and cathedrals all will have vanished. Over deserted, smoking plains pale Napoleon will be seen galloping. It will be West's Apocalypse, his Triumph of Death, painted in the same terrible colours, a mingling of mire and blood.[49]

Death on the Pale Horse was conceived as part of West's plan for a series of paintings illustrating the progress of revealed religion, to be executed under royal patronage and placed in a chapel at Windsor Castle.[50] Some of the facts about this project are either obscure or disputed, but it is clear that it had begun by 1780 and was ordered terminated in 1801, although West's hopes for it persisted for some years afterward. In West's plan the paintings were to be grouped under four "Dispensations": the Antediluvian and Patriarchal, the Mosaical, the Gospel, and the Revelation. What is striking about this scheme is the prominence of Revelation in it, and although various parallels have been suggested,[51] there appears to be no distinct theological source for this arrangement. We must assume that West himself found it particularly appropriate to his intentions. It is, however, significant that Richard Hurd, the only bishop actually named in John Galt's account of the inception of this project,[52] had an interest in the Book of Revelation unusual for an Anglican divine of his period, as evidenced by his collection of sermons published in 1772 under the title *An Introduction to the Study of the Prophecies Concerning the Christian Church*.[53]

Hurd says of Revelation: "This book contains a detailed account of what would befall mankind in this last and so much magnified dispensation."[54] The "dispensation"

49. 10 November 1810, to the Chevalier Gregorio Fellipe Franchi, in *Life at Fonthill*, trans. and ed. Boyd Alexander (London: Rupert Hart-Davis, 1957), p. 96.

50. A good deal has been written on this subject, but certain problems remain unresolved. See Jerry D. Meyer, "Benjamin West's Chapel of Revealed Religion: a Study in Eighteenth-century Protestant Religious Art," *Art Bulletin*, LVII (1975), 247–65; letter by K. Porter Aichele and Reply by Jerry D. Meyer, *Art Bulletin*, LVIII (1976), 474–7; John Dillenberger, *Benjamin West: The Context of His Life's Work with Particular Attention to Paintings with Religiousd Subject Matter* (San Antonio, Texas: Trinity University Press, 1977), pp. 1–108; Review of Dillenberger's *Benjamin West* by Allen Staley, *Burlington Magazine*, CXXIII (1981), 307–9; Pressly, *Revealed Religion*, pp. 15–55. My discussion will be limited to West's apocalyptic pictures, but for obvious reasons cognizance must be taken of the existence of the overall scheme.

51. See Meyer, "Benjamin West's Chapel of Revealed Religion, pp. 253–4; Porter, p. 475; and Meyer's "Reply," p. 477.

52. As recounted in the expanded edition of Galt's work: *The Life, Studies, and Works of Benjamin West, Esq.* (London, 1820), vol. II, p. 53. See also *Conversations of James Northcote, R.A. with James Ward on Art and Artists*, ed. Ernest Fletcher (London: Methuen & Co., 1901), pp. 154–5.

53. As noted by Meyer, "Reply," p. 477.

54. Richard Hurd, *An Introduction to the Study of the Prophecies Concerning the Christian Church* (1772), p. 414.

in this context is the entire Christian Era, of which Hurd says: "It shews, that the *end* of this dispensation is to promote virtue and happiness."[55] Hurd does display an uneasy awareness of what he calls the "prejudices" against the study of Revelation caused, according to his point of view, by seventeenth-century chiliasts. All the same, he affirms "the utility of studying this prophecy of Revelations,"[56] and he also shows an awareness of the tradition of millenarian interpretation, citing Joseph Mede as "a sublime genius," and even referring to Joachim of Fiore.[57] It may be that Hurd's view of the status of Revelation helped West to define the importance he wanted to give the Apocalypse in the Chapel of Revealed Religion.

Four Revelation subjects are indicated in a diagram of the Chapel scheme dated 16 August 1801 (Friends Historical Library, Swarthmore).[58] The first three are specified as "designed": *The Son of Man seen by John in Revelations, Death on a Pale Horse,* and *The Destruction of the old Beast and false Prophet.* The fourth is *The Day of Judgment,* which may never have been painted.[59] This diagram was executed exactly one day after the King ordered work on the Chapel stopped, so it may represent West's final intention. However, it is only one of several plans produced over a period of many years. A design for the south wall of the Chapel (Royal Collection, Windsor)[60] shows five Revelation subjects: the three later indicated as "designed," plus *Saints Prostrating themselves Before the Throne of God* and *The New Jerusalem* (but no *Last Judgment*). These five plus *The Last Judgment* appear in Galt's catalogue of West's works,[61] although Galt mentions no Revelation Dispensation, and the same six subjects appear in West's own list drawn up for the Royal Academy in 1804, in *Public Characters of 1805,* and in *La Belle Assemblée* in 1808. Joel Barlow's list in *The Columbiad* (Philadelphia, 1807), "furnished me by Mr. West himself in the year 1802,"[62] has seven subjects, the additional one being either *Christ's Second Coming* or *General Resurrection, the End of Death,* depending on which of these pictures is the one otherwise called *The Last Judgment.*[63]

Thus there could have been as many as seven pictures intended for the Revelation Dispensation, of which only two were ever exhibited – *Death on the Pale Horse* (1796) and *The Destruction of the Old Beast and False Prophet* (1804). Neither of these, moreover, can have been the pictures characterized by the various catalogs as finished, since their dimensions are nothing like the dimensions generally given as 6 by 9 feet for the Chapel paintings.[64] It is questionable whether any of the Apocalyptic paintings actually meant to hang in the Chapel were finished, and so what we do have are preliminary sketches ranging from very rough drawings to finished oils. In addition to these, there are

55. *Ibid.,* p. 414.

56. *Ibid.,* p. 327.

57. *Ibid.,* p. 235.

58. Reproduced in Pressly, *Revealed Religion,* p. 18.

59. However, Pressly (*Revealed Religion,* p. 24, n. 5) notes the existence of a ceiling design by West showing the Last Judgment (coll. Erving and Joyce Wolf).

60. See Pressly, *Revealed Religion,* no. 4.

61. *Life of West,* 1820, pp. 218–34.

62. See pp. 430–36.

63. West did produce a design for a stained glass window, showing the Resurrection, which was exhibited at the Royal Academy in 1783, and this window (no longer extant) was installed in St. George's Chapel, Windsor, in 1786. There are three preliminary drawings for *The Resurrection* in the Pierpont Morgan Library. See Ruth S. Kraemer, *Drawings by Benjamin West and His Son Raphael Lamar West* (New York: David R. Godine and the Pierpont Morgan Library, 1975), pp. 19–21 and plates 17 and 18.

64. Barlow reverses the dimensions by mistake; *La Belle Assemblée* (IV, 1808, p. 14) gives them as 6 × 8 ft. Galt (*Life of West,* 1820, vol. II, p. 219) gives dimensions only for one: *John called to write the Revelation,* 6 × 10 ft.

pictures that may have been conceived for the Chapel but that were completed independently of it.

Of the seven potential subjects, one, *John Called to Write the Revelations*, was later executed for William Beckford (see below). *Saints Prostrating themselves Before the Throne of God*, a subject later to be treated memorably by Blake,[65] got no further than the vignette in the wall design of 1779–81 and a black-and-white chalk sketch on blue-gray paper (Pierpont Morgan Library).[66] *The Last Judgment* also exists as such a sketch (Pierpont Morgan Library),[67] displaying the traditional division of the saved rising on the viewer's left and the damned falling on the right with Christ enthroned between and above them. Since West did not even designate this picture as "designed" in 1801, it may have gone no further.[68] *The New Jerusalem*, dropped by 1801, may exist only in the vignette of 1779–81, in which the pictorial emphasis is not on the city itself but on the angel showing it to John. Because *Christ's Second Coming* appears as a title only in Barlow's list, in which all seven pictures are optimistically described as finished, we might be tempted to consider it unrealized. However, appended to Galt's *Death on the Pale Horse Pamphlet* of 1817 is a list of twelve "Subjects of Pictures and Sketches, Painted by Mr. West," and number 3 is *The Messiah*, with reference made to Rev. i. 7 – "Behold, he cometh with clouds; and every eye shall see him, and they also which pierced him: and all kindreds of the earth shall wail because of him." This probably refers to an oil painting dated 1814 (Paul Thompson, London), long after the Chapel plan had been abandoned, in which Christ is shown riding on a cloud, an angel at his right, a lion, a bull, and other beasts below, and Roman soldiers recoiling in the foreground.

As the only exhibited picture of the Revelation Dispensation other than *Death on the Pale Horse*, *The Destruction of the Old Beast and False Prophet* (Minneapolis Institute of Art) has a special claim to our attention (Pl. 15). Like several other Revelation subjects, this one was first sketched in chalk on blue-gray paper.[69] It was then executed as an oil sketch measuring 39 by 56½ inches and was shown at the Royal Academy in 1804. Although not identified in the exhibition catalog as intended for the King's Chapel (as *The Opening of the Seals* had been), it must nevertheless have been an expression of persisting hope on West's part. West later wrote to the eminent collector Sir Fleming Leicester, who purchased the picture from him in 1818: "This Composition is one of the subjects in Revelation, which I composed to paint a large picture after for that great work of Revealed Religion – of which that Picture of Death on the Pale Horse was another."[70] According to the 1801 diagram, the (much larger) finished painting would have occupied a position following – that is, to the viewer's right of – *Death on the Pale Horse*, but separated from it by *The Ascension*, measuring 12 by 18 feet. This spatial relationship is important because it would have emphasized certain parallels and contrasts between the two Revelation pictures.

As in *Death on the Pale Horse*, the principal figure of *The Destruction* is a horseman with upraised arms. This time, however, it is the heroic rider of Rev. xix. 11–15:

65. See Chapter IV below. The title as given by Barlow is "The Throne Surrounded by the Four Beasts, and Saints laying down their crowns."
66. See Kraemer, *Drawings*, no. 71 and plate 42.
67. *Ibid.*, no. 72 and plate 43.

68. But see note 59 above.
69. Kraemer, *Drawings*, no. 70 and plate 41.
70. See Douglas Hall, "The Tabley House Papers," *The Thirty-Eighth Volume of the Walpole Society* (Glasgow: Printed for the Walpole Society, 1962), p. 101.

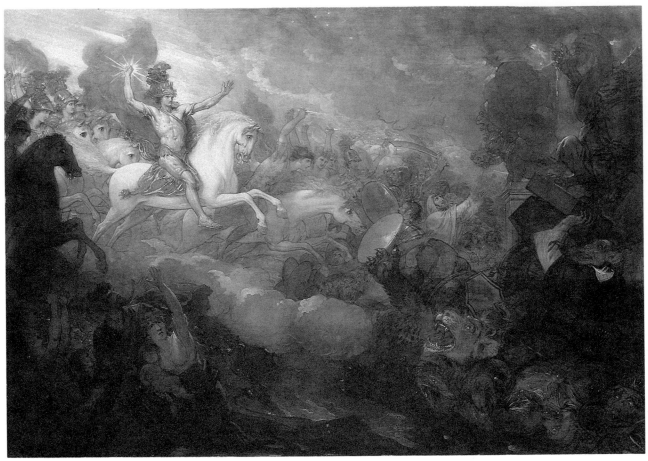

15. Benjamin West. *The Destruction of the Old Beast and False Prophet.*

And I saw heaven opened, and behold a white horse; and he that sat upon him was called Faithful and True, and in righteousness he doth judge and make war.

His eyes were as a flame of fire, and on his head were many crowns; and he had a name written, that no man knew, but he himself.

And he was clothed with a vesture dipped in blood: and his name is called the Word of God.

And the armies which were in heaven followed him upon white horses, clothed in fine linen, white and clean.

And out of his mouth goeth a sharp sword, that with it he should smite the nations: and he shall rule them with a rod of iron; and he treadeth the winepress of the fierceness and wrath of the Almighty God.

West, who did not scruple to render the most literal details of Revelation in some of his pictures, this time chose to take certain liberties with the text. No sword comes out of the messianic figure's mouth, and he wears only one crown (although he has "many crowns" in the Morgan Library drawing), which is fitted to a plumed helmet otherwise similar to those worn by the warriors behind him. From his right fist emanate rays of power, which the spectator in the Chapel could have contrasted to the darts emanating from the fists of Death. The grotesque elements occupying the center of the *Pale Horse*

34

are here pushed off to the lower right by the triumphant armies of the Word. Verses 17 and 18, devoted to the Angel Standing in the Sun and summoning the fowls of the midst of heaven, are not illustrated, no doubt because a second heroic figure would have presented difficult if not insoluble compositional problems. (West did, however, paint this angel for William Beckford; see below). Likewise no place is found for the treading of the winepress of wrath; instead West goes on to verse 19: "And I saw the beast, and the kings of the earth, and their armies, gathered together to make war against him that sat on the horse, and on his army." These elements are placed in the lower right of the picture, with a premonition of verse 20:

> And the beast was taken, and with him the false prophet that wrought miracles before him, with which he deceived them that had received the mark of the beast, and those that worshipped his image. These both were cast alive into a lake burning with brimstone.

Since the actual casting into the lake cannot be shown at the same moment as the preceding clash of armies, the false prophet is shown vainly imploring the graven image of the beast as a foreshadowing of that event.

The Destruction of the Old Beast and False Prophet tests the extent to which the sublime of terror can include the grotesque without being absorbed by it.[71] This effect is in part created by the contrast of light and dark areas in the picture, corresponding to the disposition of the celestial cavalry and its demonic opponents. In the shadowy part of the painting the presence of dark, demonic heads crowded into a relatively small space,[72] baffling the viewer's desire to make out their forms, is an exemplification of Burkean obscurity:

> To make any thing very terrible, obscurity seems in general to be necessary. When we know the full extent of any danger, when we can accustom our eyes to it, a great deal of apprehension vanishes.[73]

The anonymous writer of *Public Characters of 1805* characterizes this picture in appropriately "sublime" language: "In the destruction of the old beast, the swiftness of the divine agents pass like lightning, and all is overwhelmed."[74]

By 1804 West's plan for a chapel illustrative of the progress of revealed religion was dead to all practical purposes. The history of West's decline in the royal favor has been amply chronicled.[75] The King had become increasingly suspicious of West as a "Democrat,"[76] a supposed sympathizer with French radicalism, an admirer of Bonaparte, and an encourager of independent views among Royal Academicians. West thought he had regained the George III's patronage in 1801 when, after receiving orders through the King's new architect, James Wyatt, to discontinue work on the

71. As Meyer observes, this is "a sublime picture in the Burkean tradition." ("Benjamin West's Chapel of Revealed Religion," p. 258).

72. See Evans, *Benjamin West and the Taste of His Times*, p. 79.

73. See *Enquiry*, p. 58.

74. "Mr. West," p. 557.

75. See note 1 above.

76. "In the year 1792 or 3 the king speaking of the Democrats of that Day mentioned West and said to J. Boydell who would have thought he could be one of them." (*Farington Diary*, vol. VII, ed. K. Cave, 1982, p. 2675 [26 January 1806].)

Chapel, he was told by the King himself to "go on."[77] But West's success in Paris can hardly have helped him at Windsor. He was reported in the press during his visit abroad to have given a breakfast for French artists at which the great civil libertarian Erskine was toasted as "the defender of liberty";[78] he accepted an honor from the government-sponsored French Academy, and he spoke loosely, according to Farington's *Diary*, "of his partiality for Bonaparte."[79] Dillenberger's summary of how West's artistic achievement must have looked to the Crown is an accurate one: "It reflected a sectarian outlook, it presented a destructive paradigm alongside an established order, and it received public acclaim by unacceptable foreign powers."[80]

Part of the original attraction of West's plan for King and bishops was that it was supposedly *not* sectarian but something, according to Galt's account, that would not offend even a Quaker. There is, however, something odd about this statement, for of course West had been raised as a Quaker. To compliment him on a program that would not have offended even himself seems a way of answering Claudius's questions to Hamlet about *The Murder of Gonzago*: "Have you heard the argument? Is there no offence in't?" There was no offence, the bishops seem to have believed, in West's program because in it the Apocalypse appeared to have been purged of any reference to the destruction of an existing order and its replacement by a new one. Such may not have been the King's view after West's return from France. Furthermore, the Book of Revelation, in addition to being somewhat suspect politically, seems to have put the King in mind of his own periods of derangement (now thought to have been caused by porphyria). On 1 December 1804 Farington noted: "The King told Lysons that the pictures which West had painted for the Chapel at Windsor should not be put up, except the Altar piece, and *that* should *not be a Bedlamite scene from the Revelations*."[81]

Although he lost the King as a patron, West was fortunate to have already found a successor in William Beckford, "England's Wealthiest Son,"[82] author of the brilliant Gothic romance *Vathek*, social outcast, and proprietor of the great neo-Gothic extravaganza Fonthill Abbey. Beckford's patronage of West appears to have begun in 1796, which was also the year in which construction at Fonthill began. 1797–98 was a period of intense activity on apocalyptic subjects for West: in that time he produced all six of the Revelation paintings he was to execute for Beckford. Subsequently, Beckford conceived the idea for a Revelation Chamber at Fonthill, an architectural fantasy worthy of Vathek himself.

The plan is first mentioned, though not yet named, in Farington's diary just after Beckford departed for Portugal, where he was to stay for two years while James Wyatt presided over building operations. On 16 November 1798, Farington wrote of Fonthill:

– the Spire to be 17 feet higher than the top of St. Peters at Rome. – the Abbey to be

77. See Galt, *Life of West*, 1820, vol. II, p. 192.

78. Press Cuttings, Victoria and Albert Museum, vol. III, p. 811.

79. According to Farington, two of West's friends wanted Farington to advise West of his imprudence, but Farington said "West has not an *English mind* & is kept in this country only by the Income he receives from the King and by his sons having married here ..." (*Farington Diary*, vol. VIII, ed. Kathryn Cave, p. 2908 [16 November 1806].)

80. *Benjamin West*, p. 93.

81. *Farington Diary*, vol. VI, p. 2461.

82. See Boyd Alexander's biography of that title (London: Centaur Press, 1962).

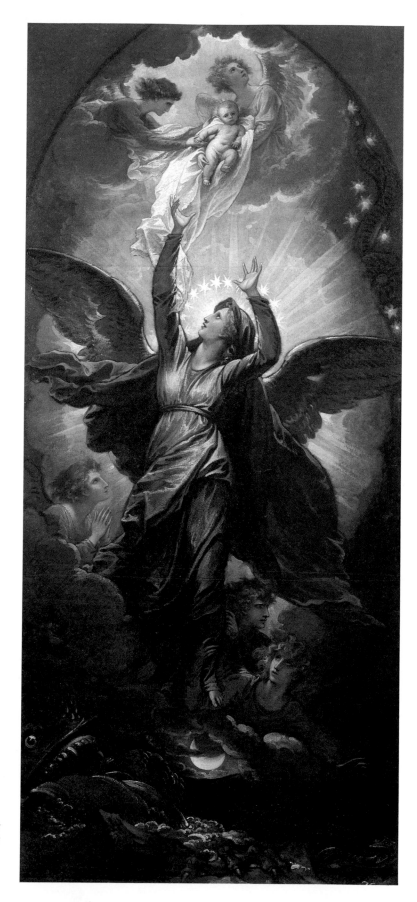

I. Benjamin West. *The Woman Cloathed with the Sun Fleeth from the Persecution of the Dragon.*

endowed, & Cathedral Service to be performed in the most splendid manner that the Protestant religion will admit – A gallery leading from the top of the Church to be decorated with paintings the works of English Artists. – Beckfords *own tomb* to be placed at the end of this gallery, – As having been an encourager of Art.[83]

On 22 December, Farington first mentions the Revelation Chamber by name and elaborates the scheme. There would be a gallery 125 feet long and 12 feet wide, wainscotted with ebony, with compartments containing history paintings by British artists. At the end of this gallery would be a sort of New Jerusalem in miniature, paved with semi-precious stone and containing a few chosen residents:

> – The Revelation Chamber is to have walls 5 feet thick in which are to be recesses to admit coffins. Beckfords Coffin is to be placed opposite the door. The room is not to be entered by strangers, to be viewed through wire gratings. The floor is to be Jaspar. This Gallery and room are to be over the Chapel. West is to paint all the pictures for this room, and is now limited to £1000 a year while He is proceeding with the pictures.[84]

Once more, West's Revelation compositions were to be featured in an architectural setting. Previously, they were intended to be the Omega of a cycle of sacred history in the King's Chapel, and their apocalyptic content would have appeared as the culmination of the Progress of Revealed Religion. Now they were to become part of a unique structure embodying the architectural fantasy of one man. However, like the Chapel project, the Revelation Chamber was never realized. Even during Beckford's occupancy of Fonthill, West's six apocalyptic designs[85] were not gathered together in one part of the Abbey. In *A Description of Fonthill Abbey* (London, 1812), James Storer mentions the pictures while leading the visitor around the building.[86] "Two pictures by West from the Revelations" hung in the northern tribune room, reached by ascending the large staircase that crossed the Octagon and so entering the first room of the Lancaster apartments. One then went through the Lancaster gallery to a dressing room leading to the state bed-chamber, where there was "a picture of Michael overcoming the dragon."[87] In another dressing room, reached via the staircase that led to the great tower were "two pictures from the Revelations by West."[88] Thus five of the six are accounted for, albeit not very specifically, and are seen to be widely dispersed. It is not known why further progress was not made on the Revelation Chamber – Beckford certainly had no aversion to Bedlamite scenes from Revelation – but West seems to have stopped receiving commissions from Beckford within a few years of the latter's return from Portugal in 1799.

83. *Farington Diary*, vol. III, ed. Garlick and Mcintyre, 1979, p. 1091.

84. *Ibid.*, p. 1117.

85. There also appear to be one or two ghosts. In the Beckford sale of 1845 there appeared as lot 237 "The Opening of the Seventh Seal" (931 × 20 ins.) purportedly by West; see Dillenberger, p. 209. This picture has been neither traced nor identified. Also untraced and unidentified is a picture supposedly by West that, according to Boyd Alexander, was called *The Opening of the Sixth Seal* and was owned by Beckford until his death (see *England's Wealthiest Son*, p. 160). Of course, Beckford did own Francis Danby's *An Attempt to Illustrate the Opening of the Sixth Seal*.

86. Pp. 18–19.

87. P. 19.

88. P. 20.

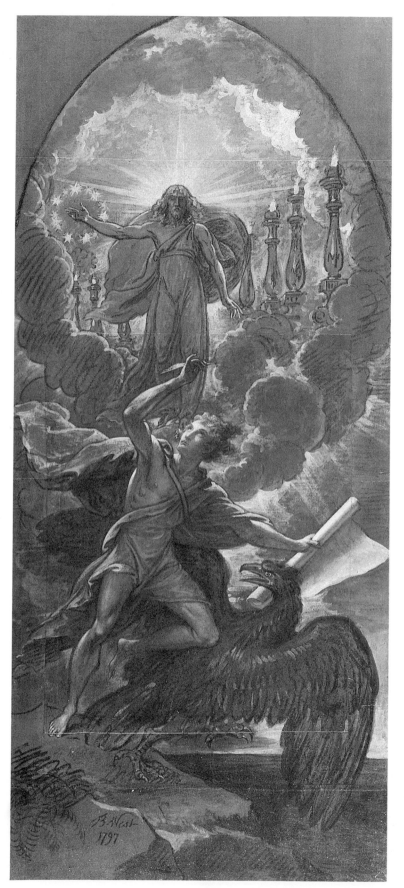

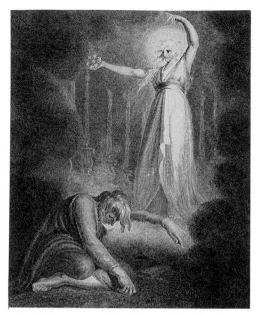

17. J. Thomson after Henry Fuseli. *Vision of St. John.*

16 (left). Benjamin West. *The Son of Man, in the midst of the Seven Golden Candlesticks, appearing to John the Evangelist, and commanding him to write.*

18. P. Rothwell after Thomas Stothard. *St. John's Vision in the Isle of Patmos.*

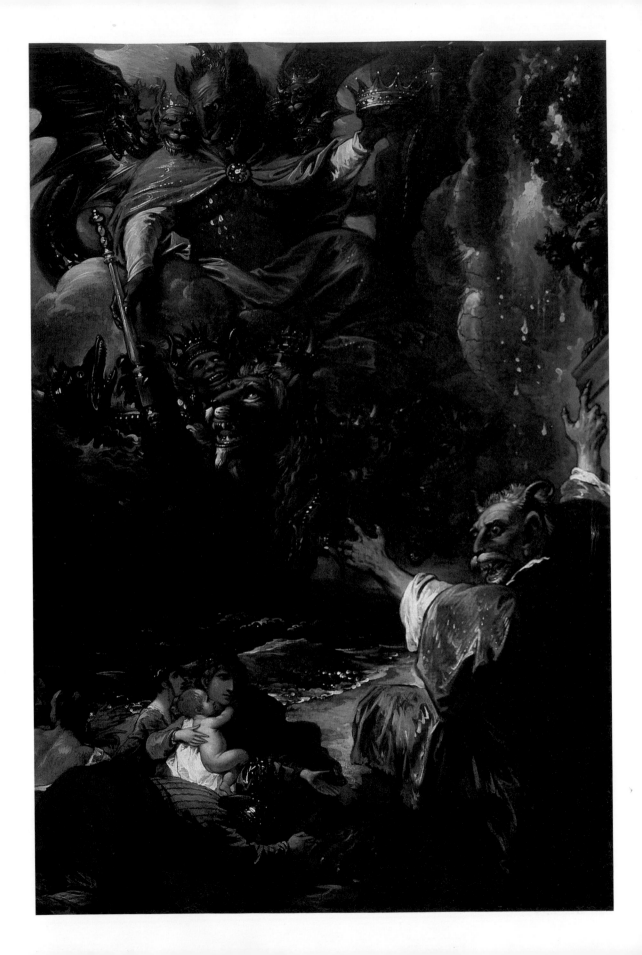

Two of West's designs for Beckford were probably intended as cartoons for painted glass windows, as each culminates in an arch at the top and is painted on several sheets of paper pasted together. One of these is on the subject of John's vision in Revelation i. West had proposed such a scene for the Chapel of Revealed Religion, but the picture he exhibited at the Royal Academy in 1798 (no. 219), *The Son of Man, in the midst of the Seven Golden Candlesticks, appearing to John the Evangelist, and commanding him to write* (Noortman and Brod) (Pl. 16), was identified as intended for Beckford. This subject appears to have been considered sublime *per se*: Henry Fuseli wrote of his choice of it for the Macklin Bible, "Of the several moments before me I have taken what appeared to me the most Sublime, the Sudden apparition and trance of John."[89] Fuseli, as one would expect, emphasizes the terrifying nature of the vision, with John drooping passively, the Son of Man luminous and androgynous-looking, and the "sharp twoedged sword" (Rev. i. 16) coming out of his mouth indicated by lines of light (Pl. 17). West's John is an athletic young man, in keeping with the tradition that the author of the fourth Gospel was the Beautiful Apostle. Another link with the Gospel of John is the enormous eagle, symbol of the fourth evangelist, that stands beside John, one leg upraised, on a rock in the foreground. The island locale is indicated by the sea below. John's right hand is poised holding a quill pen, a frequently encountered detail, as for example in a side panel of Hans Memling's famous altarpiece (St. John's Hospital, Bruges). His left hand unfolds the scroll on which he will record his vision. West faithfully shows the seven stars and seven candlesticks of i. 12 and i. 16 but ignores the sword. He probably regarded this detail as too difficult to render pictorially, and indeed it creates difficulties in the designs engraved by Blake (1782)[90] and after Stothard (engraved by Rothwell in 1817) (Pl. 18)[91] illustrating this passage.

West also exhibited his other design for a window, *The Woman Cloathed with the Sun Fleeth from the Persecution of the Dragon* (Noortman and Brod) (Col. Pl. I) at the Royal Academy in 1798 (no. 232). This design has much in common with Rubens's treatment of the subject, of which West owned an engraving.[92] One can see why this subject would be suitable for a transparency – John Martin would later execute it on glass[93] – owing to the intense light and color effects called for by "a woman clothed with the sun, and the moon under her feet, and upon her head a crown of twelve stars" as well as by a "great red dragon" (xii. 1, 3). West's woman wears a red dress over a blue and grayish cowl; her nimbus is intensely radiant, nearly orange. True to the biblical text, she has a diadem of twelve stars and stands with the moon under her feet. The graceful beauty of

89. Letter to William Roscoe postmarked 15 June 1796, in *The Collected English Letters of Henry Fuseli*, ed. David H. Weinglass (Millwood, New York: Kraus International Publications, 1982), pp. 149–50. Fuseli originally proposed the subject in a letter to Roscoe postmarked 4 April 1796; his second choice was "the Pope Spitting frogs" (p. 147). The Fuseli painting, *The Vision of the Seven Candlesticks* (Zurich, Kunsthaus; Schiff, no. 931) was engraved by J. Thomson for Macklin in 1796.

90. See Chapter IV, below.

91. An engraving entitled *St. John's Vision in the Isle of Patmos*, published by Rothwell, is in the Kitto Bible (Henry E. Huntington Library). I have not been able to locate the original painting.

92. This print was offered for sale with the rest of West's collection as *The Fall of the Dragon*; according to the catalogue description "the group is beautifully contrasted by the woman and child encompassed by angels." (*A Catalogue of the Truly Capital Collection of Italian, French, Flemish, and Dutch Pictures . . .* [2nd West Sale catalogue], Christie's, 23–24 June 1820, no. 75.)

93. See below, Chapter V.

II. Benjamin West. *The Beast Riseth Out of the Sea.*

the woman, her baby, and her attendant angels are, as in the Rubens picture, strongly contrasted with the demonic forms below.

For the dragon, West freely indulged his feeling for the grotesque, already manifested in the train of monsters following Death on the Pale Horse. The open-jawed monster is seen at the lower left with water pouring from his mouth toward the center foreground, where one of his huge talons can be seen. His coils go across to the right and disappear out of the picture space. There is also in the foreground a serpent with bat wings. A similar contrast between the beautiful and the grotesque is seen in Blake's frontispiece to Night III of Young's *Night Thoughts*, in which the imagery of Rev. xii. 1–3 is superimposed upon Young's subject matter (see Chapter IV). Another interesting similarity is with Blake's frontispiece for Night VIII, where, as in West's picture, the dragon's tail undulates against a background of stars. It is likely that West knew these magnificent water colors, for on 19 February 1796 Farington recorded a dispute about Blake's artistic merits in which "West, Cosway, & Humphry spoke warmly of the designs of Blake the Engraver, as works of genius and imagination."[94] Blake had at this time been working on the *Night Thoughts* designs for over a year and this enormous task gave him time for little else, so if artists were talking about Blake's work in February 1796 these pictures are the likeliest candidates. West also shares with Blake an intense artistic interest in illustrating chapters xii and xiii of Revelation. *The Woman Cloathed with the Sun* conflates Rev. xii. 1–3 (where the woman gives birth and the dragon appears) and xii. 14 (where the woman is given the eagle wings she has in this picture). Between these episodes occurs Michael's casting out of Satan, and then, at the beginning of chapter xiii, there appears the Beast from the Sea – both subjects of paintings by West for Fonthill.

West's first apocalyptic design for Beckford was probably the *St. Michael and his Angels fighting and casting out the Red Dragon and his Angels*, completed in 1797 and exhibited at the Royal Academy in 1798 (Pl. 19).[95] This was probably the most popular Revelation subject, next to the Last Judgment, in Renaissance and Baroque art: among the grand prototypes are those of Raphael, Guido Reni, Rubens, and Luca Giordano.[96] West would also have known the heroic image of Michael in James Barry's large etching *The Fall of Satan* (1777), the design for which was conceived as part of the Royal Academy's abortive plan to decorate St. Paul's Cathedral.[97] Twenty years before the Beckford commission, West had painted an altarpiece of Michael and Satan for St. Michael's Chapel at Trinity College, Cambridge. An oil sketch for this (coll. James Ricau) was exhibited in 1776, and the altarpiece the following year. The latter is an extremely impressive, large (172 × 80 in) painting in which Michael is shown wear-

94. See G.E. Bentley, Jr., *Blake Records* (Oxford: the Clarendon Press, 1969), p. 50. The few substantiated links between West and Blake are positive ones. West's name more than once headed lists of signers of testimonials to the quality of Blake's *Grave* designs. And according to Frederick Tatham, who may well have had the story from Blake himself, "West, the great history painter, admired much the form of his limbs." (*Blake Records*, p. 529.)

95. Toledo Museum of Art. The cumbersome title is presumably West's, although Pressly's *Michael Casteth Out the Dragon and His Angels* is more serviceable (*Revealed Religion*, no. 39).

96. In West's time it was also a frequent Miltonic subject. For these, see Marcia Pointon, *Milton and English Art* (Manchester: Manchester University Press, 1970).

97. See William L. Pressly, *The Life and Art of James Barry* (New Haven and London: Yale University Press, 1981), figs. 33 and 34.

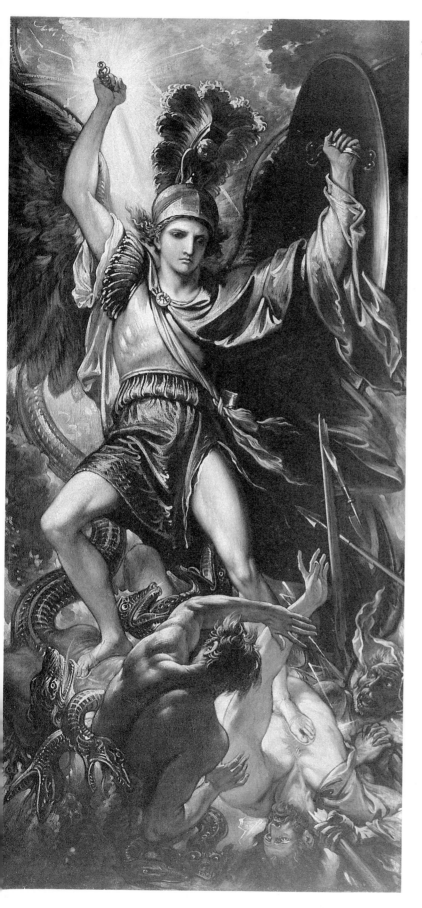

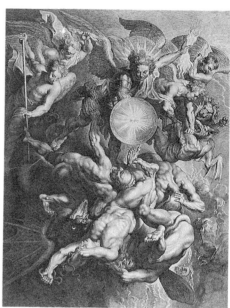

19. Benjamin West. *St. Michael and his Angels fighting and casting out the Red Dragon and his Angels.*

20. Lucas Vorsterman asfter Peter Paul Rubens. *The Fall of the Rebel Angels.*

ing a golden cuirass and flourishing in his outflung left hand a chain. His defeated adversary is given bat wings that contrast with Michael's great angelic wings as well as a subhuman head and a spiralling tail. Rather than the defeat and fall of the rebel angels (Rev. xii. 7–9), the text illustrated, as indicated by the chain,[98] is the binding of Satan in Rev. xx. 1–3, later to be illustrated also by de Loutherbourg, by Edward Francis Burney, and by Blake.

The Trinity College altarpiece[99] is heavily indebted to Guido Reni's *St. Michael* (Pl. 28), which West would have seen in the Church of Sta. Maria della Concezione while he was in Rome.[100] It has a calm, Apollonian quality which is far different from that of the picture West produced for Beckford twenty years later. The Beckford *Michael* is full of furious dynamism, and the dominant influence is that of Rubens's *Fall of the Rebel Angels* (Pinakotek, Munich). West owned four of Rubens's chalk studies for this painting, and he was no doubt familiar with the engraving by Lucas Vorsterman (Pl. 20).[101] The triumphant angel is also reminiscent of one of the giant angelic guards in James Barry's *Elysium and Tartarus*, one of the Adelphi series.[102] His plumed helmet links him also to the Rider on the White Horse in West's own *Destruction of the Old Beast and False Prophet*, which likewise centers on a violent conflict between idealized male beauty and extreme grotesqueness. Once more, the lower part of the picture is dominated by the grotesque elements. The seven-headed dragon that writhes there may also owe something to the one in Dürer's Apocalypse. Three evil angels fall helter-skelter, one of them a baboon-like figure similar to that in the lower right of *The Destruction of the Old Beast and False Prophet*. This curious anthropoid form, as distinctive in its way as Fuseli's succubus, seems to be West's original contribution to demonology. The highly dramatic nature of the picture as a whole would have been in keeping with its function, for it was to preside over the entire gallery named for it; in addition, as Willard F. Rogers, Jr. points out, the name had a special meaning for Beckford, whose birthday coincided with the Feast of St. Michael.[103]

Another angelic subject for Fonthill is *A Mighty Angel Standeth Upon the Land and on the Sea* (unlocated), exhibited at the Royal Academy in 1798.[104] For the most part West faithfully follows the text of Rev. x. 1–5, placing a rainbow over the angel, the sun directly behind his head, and a book in his hand. He stands in a contraposto position

98. Barry, however, combines both elements, giving his angel a conventionalized thunderbolt in his right hand (as in Vorsterman's engraving; see note 101 below) and a chain in his left. In Barry's sketch (Ashmolean Museum) for this painting, however, the chain is absent.

99. This splendid painting was recently restored to its place in the Chapel. There are drawings related to it at the Friends Historical Library (Swarthmore) and the Pierpont Morgan Library; see Kraemer, *Drawings*, no. 13. A sepia drawing that may be a study for it is in the collection of the Yale Center for British Art.

100. See Millard F. Rogers, Jr., "Benjamin West and the Caliph: two paintings for Fonthill Abbey," *Apollo*, LXXXIII (1966), 422.

101. This was probably executed not after the original painting but after a drawing, differing from the painting in many details. See Max Rooses, *L'oeuvre de P.P. Rubens* (Anvers: Jos. Maes, 1886), vol. I, no. 86.

102. West owned Barry's etchings after the Adelphi series, but he would of course have been familiar with the originals.

103. "Benjamin West and the Caliph," p. 442.

104. Sees Dillenberger, p. 194. The painting, now untraced, was last known to be in the collection of Mrs. Linden T. Harris, Drexel Hill, Pa. It is reproduced by Evans, *Benjamin West and the Taste of His Times*, Plate 41, but with the incorrect title "The Archangel Gabriel." According to Pressly, *Life and Art of Barry*, no. 36, there is a preparatory drawing in the collection of Erving and Joyce Wolf.

with his left arm raised, at the moment described in x. 5: "And the angel which I saw stand upon the sea and upon the earth lifted his hand to heaven . . ."[105] An interesting comparison is provided by Blake's water color of *c.* 1805 illustrating the same text (Pl. 39): Blake's picture is conspicuously less dramatic, presenting the angel in firmly outlined clarity rather than amid tumultuously swirling clouds. However, the attitudes of the two angels are remarkably similar. This may be because of the direct influence of West on Blake, as Nancy Pressly suggests,[106] or it may have to do with a common influence via an engraving after Fischer von Erlach.[107] West liked the basic design so much that he repeated it for Beckford in *The Angel in the Sun,* in which he depicted the passage that he had passed over in *The Destruction of the Old Beast and False Prophet* — "And I saw an angel in the sun; and he cried with a loud voice" (xix. 17).[108]

The companion piece to *A Mighty Angel* was *The Beast Riseth Out of the Sea* (coll. Thomas and Margaret McCormick) (Col. Pl. II), which the painter Ozias Humphry referred to as "finest conception ever come from mind of man."[109] It is certainly the strangest of West's apocalyptic designs. As we have seen, West sometimes avoided rendering what would have been awkward to visualize. Sometimes he did this by omission, as in *The Destruction of the Old Beast and False Prophet* or as in *A Mighty Angel,* where no attempt is made to represent the feet as "pillars of fire" (x. 1). At other times the choice of one subject over another is significant: West shows the angel with the book but not John eating the book (a scene included by Dürer). In *The Beast Riseth Out of the Sea,* however, he seems to have chosen – unless the choice was Beckford's – a grotesque episode (xiii. 1–2) and to have rendered it as literally as he could:

> And I stood upon the sand of the sea, and saw a beast rise up out of the sea, having seven heads and ten horns, and upon his horns ten crowns, and upon his heads the name of blasphemy.
>
> And the beast which I saw was like unto a leopard, and his feet were as the feet of a bear, and his mouth as the mouth of a lion: and the dragon gave him power, and his seat, and great authority.

West even went so far as to move from the beginning of chapter xiii to verses 11–12 in order to include "another beast coming up out of the sea" which had "two horns like a lamb," and which "spake as a dragon."

West places the new arrival in the lower right foreground and clothes him in a gold-colored robe like a surplice. He has a taloned foot and the baboon-like head, its appearance not improved by the addition of two horns, that we have encountered before. It is turned toward a woman holding a child, possibly the Woman Clothed with the Sun of chapter xii, who holds one palm out toward him, as if beseeching mercy, with a sorrowful countenance. Two kings nearby abase themselves before this creature, who

105. One may well agree with Grose Evans's contention that this picture "is eminently sublime in all the terms Burke established." (*Benjamin West and the Taste of His Times,* p. 61.)

106. *Revealed Religion,* p. 61.

107. See my essay, 'The Fourth Face of Man': Blake and Architecture," in *Articulate Images: the Sister Arts from Hogarth to Tennyson,* ed. Richard Wendorf (Minneapolis: University of Minnesota Press, 1983), pp. 186–7 and plates 8–1 and 8–2.

108. The painting is untraced. An impressively energetic preparatory drawing is in the Toledo Museum of Art; see Pressly, *Life and Art of Barry,* no. 41 and fig. 72.

109. *Farington Diary,* vol. III, p. 982 (12 February 1798).

with one clawed hand points upward to the fire and brimstone falling. Above a wall more monster heads and a clawed foot can be glimpsed.

The Beast from the Sea, represented with seven heads as in the text, reaches upward with a bear paw to receive a scepter being offered by the Great Red Dragon. Bat-winged as in Blake's pictures of him, the dragon displays the full glory of his seven heads and ten horns. His tail swirls out to the left, then back behind his body, finally going down toward his knee. He holds a crown elevated in his left hand while he lets the scepter descend with his right, rendering in pictorial terms "the dragon which gave power unto the beast" (xiii. 4).

The most striking aspect of this painting is the way in which West puts outrageously grotesque images into nearly palpable form. When Blake illustrates this same passage (see Chapter IV), the three monsters, as all Blake's monsters, are demi-caricatures. They are like two-dimensional cut-outs whose status as such calls attention to the illusory nature of their power in Blake's eyes. West, in contrast, through contour and coloration gives his subjects as much illusory reality as their numerous heads and horns will permit. The effect is like that of a science-fiction film where animation techniques allow us to perceive Godzilla as on the same plane as the human actors.

According to Richard Hurd's interpretation, Revelation xiii is an anti-papal allegory. The Beast with Horns like a Lamb has taken on the attributes of Christ but is really "the old Roman Government in its pagan, persecuting state."[110] This beast and the Beast from the Sea are to Hurd "symbolic terms" signifying "That Antichrist was to be a religious person, acting in the spirit of a secular tyrant."[111] This is indeed a common Protestant interpretation, and there is every reason to believe it was known to West. Did he consciously intend anything further? Nancy Pressly suggests that the prominent lion head in the picture could represent the British Empire (the text says merely "his mouth as the mouth of a lion"), and she compares Richard Brothers's identification of this beast as such.[112]

Symbolism like this could indeed have struck a responsive chord in Beckford, whose correspondence, as we have seen, shows increasing despondency over the Government's war policy. He actually attempted to end the war on his own initiative, with near-disastrous results. In the same diary entry that records Beckford's plan for a Revelation Chamber, Farington writes:

> His late French negotiation was an ill-judged measure. A messenger dispatched from Paris by his agent, Mr. Williams, was arrested at Dover, by order of Government. His papers taken from him, & he was obliged to return immediately . . . Lord Thurlow having been referred to Beckford on this occasion, called on him in Grosvenor Square, and condemned his conduct, telling him He had made himself liable to be indicted for treason for corresponding with his Majesty's enemies.[113]

This humiliating failure can only have increased Beckford's sense of isolation, encour-

110. *An Introduction to the Study of the Prophecies*, p. 365.

111. *Ibid.*, p. 367.

112. *Revealed Religion*, p. 64.

113. *Farington Diary*, vol. III, p. 1117 (22 December 1798).

Almost a year before, Farington reported that "West felt the King's mind on the subject but found him violent – hoped never to hear of peace with such a people." (*Farington Diary*, vol. III, p. 948 [17 December 1797].)

aging him to reify his fantasies further in the Brobdingnagian structure of Fonthill and in apocalyptic scenes like *The Beast Riseth Out of the Sea*.

ॐ ॐ

Although *The Opening of the Seals* was exhibited in 1784 and the large *Death on the Pale Horse* in 1817, the great majority of West's apocalyptic works belong to the years 1796–1804. What was the cause of this extraordinary surge of activity on apocalyptic subjects? Mere patronage cannot be the answer, since the Revelation Dispensation was apparently West's own idea and we have seen that it was eventually far from pleasing to his royal patron. Beckford came to West *because of* the artist's success with apocalyptic subject matter. West's choice of such subjects as Death on the Pale Horse and the Beast from the Sea may partially be explained as a displacement of anxieties generated by an epoch of revolution and war. This still leaves open the question of why West responded to these events as he did, and here two other factors should be considered: the millenarian expectations in certain circles with which he had associations and his own Quaker background.

Any proclivity West may have had for viewing contemporary events as apocalyptic manifestations would have been strengthened by his association with members of the millenarian circle of the Reverend Jacob Duché. West and Duché had, according to Galt, been close friends at school in Philadelphia.[114] Duché, after a brief period as Chaplain of the first Continental Congress, changed his mind about the necessity of the War of Independence. He was allowed to return to England after the British occupation of Philadelphia. Although Galt says that "Duchey [*sic*] came to England, and was allowed to pine unnoticed by the Government, and was heard of no more,"[115] that is not the case. A post was found for him as Chaplain to the Asylum for the Reception of Orphan Girls in Lambeth, and there he became host to the Theosophical Society, the first Swedenborgian group in England, which began meeting in 1783 for the purpose of promoting the writings of Emanuel Swedenborg. Among the other members were the painter P.J. de Loutherbourg, the sculptor John Flaxman, and the engraver William Sharp. Although Duché did not become a public advocate of Swedenborgianism, he was evidently outspoken about it in private and was, moreover, attached to the millenarian aspect of the doctrines. "The New Church from above," he wrote in a letter, "the Jerusalem of the Revelation, is come down upon earth. Look henceforward for an *Internal Millennium*."[116]

That West had re-established contact with his old friend by 1779 is shown by the publication in that year of Duché's two-volume *Discourses on Various Subjects*[117] with frontispieces after paintings by West. The first of these, showing angels singing at the

114. See John Galt, *The Life and Studies of Benjamin West* (London, 1816), p. 41.
115. *Ibid.*, p. 43.
116. Quoted from a letter dated 5 May 1785 by Clarke Garrett, "The Spiritual Odyssey of Jacob Duché," *Proceedings of the American Philosophical Society*, CXIX (1975), 151.

117. Among the subscribers to the *Discourses* were William Blake and the Rev. Thomas Hartley, translator of Swedenborg's *Heaven and Its Wonders and Hell* and author of *Paradise Restored: Or a Testimony to the Doctrine of the Blessed Millennium* (London, 1764).

21. William Sharp after Benjamin West.
Frontispiece to volume I of *Discourses on Various
Subjects* by Jacob Duché.

birth of Christ (Luke ii. 13) has considerable interest in its context here (Pl. 21). The
design shows male and female angels, and thus it correlates with a Swedenborgian
doctrine – the existence of sex in Heaven – that had occasioned both interest and
embarrassment in the Theosophical Society. The engraver was the millenarian radical
William Sharp, and his role was not that of an employee, for it was he who paid the
printer of the *Discourses*. In 1782 Sharp engraved after Stothard an elaborate em-
blematic *Declaration of Rights* for the Society for Constitutional Information;[118] he
became a disciple of Richard Brothers and engraved his portrait in 1794; and in 1795 he
was arrested on a warrant from the Secretary of State, but then released.[119] The links
between painter and engraver continued throughout this period: Sharp engraved the
highly successful print after West's Rosa-esque *Saul and the Witch of Endor* in 1788, and
they were both in Paris in 1802, commenting on the improved state of the French since
the Revolution, to the displeasure of Farington.[120]

118. See David Bindman, *Blake As an Artist* (Oxford:
Phaidon, 1977), p. 27 and fig. 16.

119. Press Cuttings, Victoria and Albert Museum,
vol. III, p. 680. Dated 20 May 1794.

120. *Farington Diary*, vol. V, p. 1853 (14 September 1802).

Another link between West and the Duché circle was Jacob's son Thomas Spence Duché,[121] who became an art student in West's studio by 1783. Thomas, like his father, was a Swedenborgian – he seems to have attempted a translation of an unspecified work by Swedenborg[122] – and a millenarian. The relationship between teacher and student appears to have been a warm one.[123] In 1786 Thomas paid William Sharp to engrave his striking portrait of the Reverend Samuel Seabury (Trinity College, Hartford) and dedicated the plate to West, "affectionately inscribed by His grateful Friend & Pupil."[124] In 1788, travelling in France for his health, Thomas seems to have visited one of the most esoteric of millenarian groups, *les Illuminés d'Avignon*, called in England the Prophets of Avignon. (Two English millenarians, John Wright and William Bryan, had consulted the Holy Word at Avignon and had asked whether the younger Duché was to be sent for.[125])

West's association with millenarians like Sharp and the two Duchés may have made him recall some aspects of the religious atmosphere of his childhood. West's Quaker background has perhaps been too much dismissed in reaction to Galt's idealization of it in his authorized biography. It is, of course, true that West was not a Quaker in England; as Dillenberger points out, West attended an Anglican church and had his children baptized.[126] It is also true that West seems to have encouraged Galt to portray him as a Quaker version of the Young Man from the Provinces, much as the aging Walt Whitman encouraged his admirers to represent him as the Good Gray Poet. Nevertheless, the experience of anyone's formative years must remain powerful in later life, and West's were spent in a Quaker community near Springfield, Pennsylvania. He must have retained more of his upbringing than merely the tendency, noticed by Leigh Hunt, to pronounce some words "with a puritanical barbarism, such as *haive* for *have*, as some people pronounce when they sing psalms."[127] The presentation of Pennsylvania as a pastoral utopia in *William Penn's Treaty with the Indians* (Pennsylvania Academy of Fine Arts) represents one aspect of West's continued contact with his Quaker past, as does his superb *The Artist's Family* (Yale Center for British Art). But there is another, more turbulent side to the religious ambiance of West's childhood, and that aspect is conveyed in Galt's account of a sermon delivered by a visiting preacher, Edmund Peckover, "a celebrated Orator among the Quakers,"[128] in a meeting house built by Mrs. West's father.

Peckover, according to Galt, predicted the future greatness of America "with an

121. See Dunlap, vol. I, pp. 271–2; W. Roberts, "Thomas Spence Duché," *Art in America*, VI (1918), 273–5; Albert Frank Gegenheimer, "Artist in Exile: the Spiritual Odyssey of Thomas Spence Duché," *Pennsylvania Magazine of History and Biography*, LXXIX (1955), 3–26; Evans, *Benjamin West and His American Students*, pp. 106–10.

122. On 22 February 1786, Thomas's mother Elizabeth wrote that this translation "is now in the press"; see Gegenheimer, p. 17. I have not been able to identify any such translation of Swedenborg.

123. Jacob Duché wrote to Benjamin Franklin on 22 April 1783: "My Son, who is now in his 20th year is a Pupil of my good Friend West, and most enthusiastically devoted to the Art, in which he promises to make no

inconsiderable Figure . . . His Passion for Painting is irresistible. West feeds the Flame with the Fuel of Applause . . ." (quoted by Gegenheimer, p. 9).

124. See Dunlap, I, p. 272; Evans, *Benjamin West and His American Students*, p. 108.

125. See Robert Southey, *Letters from England by Don Manuel Alvarez Espriella* (London, 1807), vol. III, p. 246.

126. *Benjamin West*, pp. 3–4. Dillenberger also notes that neither of West's parents was a Quaker in good standing, but he nevertheless says "West did grow up in a Quaker setting and ethos."

127. *Autobiography*, p. 96.

128. Galt, *Life of West*, 1816, p. 6.

enthusiastic eloquence which partook of the sublimity and vehemence of the prophetic spirit."[129] The preacher went on to denounce the atheism of the court of France, and, Galt continues:

> ... elevated by the importance of his subject, he described the Almighty as Mustering his wrath to descend on the nation, and disperse it as chaff in a whirlwind. He called on them to look towards their home of England, and to see with what eager devotion the inhabitants of that illustrious country worshipped the golden image of Commerce, and laid the tribute of all their thoughts on its altars; believing that with the power of the idol alone, they should be able to encounter all calamities. "The day and the hour are, however, hastening on, when the image shall be shaken from its pedestal by the tempest of Jehovah's descending vengeance, its altars shall be overturned, and the worshippers terribly convinced that without the favour of the Almighty God there is no wisdom in man! But," continued this impassioned orator, "from the woes and crimes of Europe let us turn aside our eyes; let us turn from the worshippers of Commerce, clinging round their idols of gold and silver, and, amidst the wrath, the storm, and the thunder, endeavouring to support them; let us not look at the land of blasphemies; for in the crashing of engines, the gushing of blood, and the shriek of witnesses more to be pitied than the victims, the activity of God's purifying displeasure will be heard; while turning our eyes towards the mountains of this New World, the forests shall be seen fading away, cities rising along the shores, and the terrified nations of Europe flying out of the smoke and the burning to find refuge here."[129]

Mrs. West, hearing this sermon, reportedly went into labor on the spot and was carried home and delivered of Benjamin. Peckover's language, with its apocalyptic imagery and tenor, shows something of the religious atmosphere in which West was raised, and it seems likely that such sermons sowed seeds in good ground for paintings like *The Beast Riseth Out of the Sea* and *The Destruction of the Old Beast and False Prophet*.

129. *Ibid.*, p. 6. 130. *Ibid.*, pp. 7–8.

CHAPTER III

Philippe Jacques de Loutherbourg

OF ALL THE ARTISTS of the apocalyptic sublime, P.J. de Loutherbourg[1] was the only thorough-going occultist. Born in Strasbourg, de Loutherbourg was educated to become either an engineer, according to his father's wishes, or a Lutheran minister, according to his mother's. In the end, he chose neither profession but followed his father's career as an artist. Brilliantly precocious, he impressed Diderot in Paris, was elected to the Académie Royale at the age of 26, and then emigrated to England, where he effected a revolution in stage scenery and costuming under David Garrick at the Drury Lane Theatre. As de Loutherbourg's occultist interests deeply influenced his art, they must be discussed as a background to his apocalyptic illustrations to the Macklin Bible, a project in which he was intermittently engaged from 1789 until his death in 1812.

De Loutherbourg was involved in alchemical research while living in Paris; according to his early Strasbourg acquaintance J.-F. Hermann, "Il y avait plutôt prodigué que dépensé ce que son talent lui avoit fait gagner: il l'avait dissiper à la recherche de la pierre philosophale."[2] He amassed a considerable collection of books on alchemy[3] and in London continued to pursue his alchemical interests. There he also became associated with the Swedenborgian Theosophical Society.[4] His connection with Swedenborg may have been closer still, for he is supposed to have painted a portrait of him from life (Swedenborg Society, London). This striking picture departs entirely from the convention established by Per Krafft (National Portrait Gallery of Sweden, Gripsholm) and also seems to have been the basis for a number of later engravings of Swedenborg.[5] The

1. See Genevieve Levallet-Haug, "Philippe Jacques Loutherbourg 1740–1812," *Archives Alsaciennes*, XVI (1948), 77–134; Rüdiger Joppien, *Die Szenenbilder Philippe Jacques de Loutherbourgs: Eine Untersuchung zu ihrer Stellung zwischen Malerei und Theatre* (Cologne, 1972).

2. See J.F. Hermann, *Note historique, statistique, et littéraire sur la ville de Strasbourg* (Strasbourg, 1819), vol. II, pp. 346–7.

3. In the de Loutherbourg sale following the artist's death in 1812, numerous books on alchemy, beginning with *Hermetischer Rosenkranz Chymische*

(Frankfurt, 1747), appear as items 11, 12, and 13 (*A Catalogue of All the Valuable Drawings, Sketches, Sea Views, and Studies of that Celebrated Artist James Philip De Loutherbourg, R.A.* [London: Peter Coxe, 18–20 June 1812]).

4. See Robert Hindmarsh, *The Rise and Progress of the New Jerusalem Church* (London: Hodson and Son, 1861), p. 23.

5. Several engraved portraits of Swedenborg are reproduced with my article "'A New Heaven Is Begun': Blake and Swedenborgianism," *Blake: an Illustrated Quarterly*, XIII (1979), 64–90.

luminous, hazel-brown eyes, nimbus-like white wig against a black background, and faint smile give this portrait, whether painted from life or not,[6] an effect at the same time authentic and mysterious.

De Loutherbourg's occultism must have received an enormous stimulus from the arrival in London of Alessandro Cagliostro in 1786. The Grand Cophte and his wife Serafina were invited to stay with the de Loutherbourgs at their house in Hammersmith Terrace, and there Cagliostro gave the artist instruction in the occult sciences.[7] One of the few artistic products of this association was a series of water colors of Freemasonic subjects, evidently executed by de Loutherbourg as representations of Cagliostro's Egyptian Rite. These drawings (County Borough of Torbay)[8] in some ways look back to de Loutherbourg's stage designs, but at least one of them, showing a human figure whose way to the celestial city is barred by a serpent, anticipates some of de Loutherbourg's work for the Macklin Bible a few years later.

June 1787 found the Cagliostros and the de Loutherbourgs together in Switzerland, where Cagliostro hoped to found a new Masonic lodge.[9] De Loutherbourg later described his own motive in a letter, dated 17 January 1788, to an unknown correspondent. Cagliostro, he wrote, "me proposa de faire commune de fortune ensemble, de lui donner la moitié du produit de mes tableaux et que lui voulait me communiquer, tout ce qu'il sçavait et me donner la moitié du produit des Medicines qu'il vendait."[10] This partnership, however, degenerated into bitter squabbling and ended with de Loutherbourg's challenging Cagliostro to a duel at which the latter failed to appear.[11] Early in 1788 the de Loutherbourgs returned to London, where they attempted to put into effect the marvellous cures that Cagliostro had taught them.

"Loutherbourg the painter," wrote Horace Walpole on 2 July 1789, in a paragraph beginning with remarks on the "combustion" in France, "is turned an inspired physician, and has three thousand patients: his sovereign panacea is barley-water."[12] Actually, this was old news, for the de Loutherbourgs had been practising their cures without medicine since the previous December. For details about the supposed cures effected we have only the account of a believer named Mary Pratt, who styled herself "A Lover of the Lamb of God."[13] Mary Pratt was a member of the circle of Behmenists

6. If this was a life portrait executed in London, it had to be painted in the short period between de Loutherbourg's arrival there on 1 November 1771 and just before Christmas 1771, when Swedenborg suffered the paralytic stroke that led to his death on 29 March 1772. The painting bears neither date nor signature. It was formerly in the possession of J. Bragg of Handsworth, Birmingham, who may be the person who wrote on the back of the frame: "The late George Wallis FSA, Keeper of the art collection South Kensington pronounced this a portrait from life by Philip de Loutherbourg RA, a friend & contemporary of Swedenborg." In 1871 Bragg published a letter in the *Intellectual Repository*, vol. XLI (XVIII of the enlarged series), p. 353, saying that the picture was discovered by a Mr. J. Hardy of New Church College, Islington, "in Little Gray's Inn Lane, Clerkenwell," a few minutes' walk from Swedenborg's last London residence.

7. See Constantin Photiades, *Les vies du comte de Cagliostro* (Paris: Éditions Bernard Grasset, 1932), pp. 47–9, 346–7.

8. See Joppien, *Philippe Jacques de Loutherbourg*, no. 62.

9. See Photiades, p. 350; Levallet-Haug, pp. 89–90.

10. Quoted by Joppien, *Szenenbilder*, p. 10, from a letter in the Cabinet des Estampes, Strasbourg.

11. For an account based on contemporary documents, see Niklaus Heilmann, "Histoire du duel du Comte de Cagliostro," in *Neues Berner Taschenbuch* (Bern, 1901), pp. 110–18.

12. *Horace Walpole's Correspondence*, vol. 34, ed. W.S. Lewis and A. Dayle Wallace, 1965, pp. 50–51.

13. *A List of a Few Cures Performed by Mr. and Mrs. De Loutherbourg of Hammersmith Terrace, Without Medicine* ... (London, 1789).

around Richard Clarke, and she shocked Clarke's friend Henry Brooke by declaring, in Brooke's words, "that she is the very first that has had the seventh seal opened; the first that enjoyed the resurrection Life, and the first that had entered Paradise, and had free access to the Tree of Life, &c., &c."[14] One can see why she would have become a disciple of de Loutherbourg's. Although she herself was hostile to Swedenborgianism, complaining that her husband was "a strict follower of Swedenborg, that deluded society [that] is spreading contagion in London,"[15] the diction of her pamphlet also suggests a continuation of de Loutherbourg's Swedenborgian interests. She writes that the de Loutherbourgs receive "heavenly and divine Influx," and divine influx is a conception of Swedenborg's, though discussed by him without reference to curing illness.[16]

The de Loutherbourgs evidently considered the result a universal panacea, for Pratt reports that they cured "all manner of Diseases incident to the human Body, such as Blindness, Deafness, Lameness, Cancers, Ruptures, Fistulas, loss of Speech, Palsies in every stage, etc., etc."[17] Unfortunately, Pratt gives no details about the de Louther-bourgs' practice other than what seem to be sensible dietary orders and the laying on of hands. Her account does, however, tell us three things that stand out about de Loutherbourg's patients. First, although they were admitted by ticket, they paid no fees; the tickets were, however, sometimes obtained and hawked by unscrupulous persons. Second, they consisted of all classes: among Pratt's examples are those of an apprentice suffering from the King's evil and a news-carrier of Chelsea with an abscess in his side. (A journalist acidulously noted: "LOUTHERBOURG gives up Painting for other *Arts*: – He practises Physic, and the *groups* of his Patients, which are to be seen at Hammersmith Terrace, would furnish hints to the fanciful *Rowlandson!*")[18] Third, they were large in number: three thousand according to Walpole, while Pratt's figure is "two thousand since Christmas,"[19] a period comprising less than six months. The congestion at Hammersmith Terrace must have been enormous, lending itself to the "tumultuous riotous Proceedings" that, according to Pratt, caused the de Louther-bourgs to retire to the country. When they returned to London in the autumn, they announced they had given up the healing arts, although it is clear from a manuscript letter in the Pierpont Morgan Library that the artist was practising his cures in private as late as 1804.

A reviewer of the Royal Academy's exhibition of 1790 wrote: "LOUTHERBOURG has fortunately been brought from raving about holy inspiration, to delineate the sublimities of Scripture."[20] This remark, occasioned by the painting *The Deluge*,

14. See Désirée Hirst, *Hidden Riches* (London: Eyre & Spotiswoode, 1964), p. 260. Hirst suggests that Pratt had been reading Jane Lead, the "Philadelphian" mystic of the late seventeenth century. It is worth noting that de Loutherbourg owned Jane Lead's *Fountains of Gardens*, six books by Richard Clarke, and the "Law edition" of Boehme (Peter Coxe Sale Catalogue, lots 66, 70, and 126).

15. Hirst, p. 260.

16. *Theosophical Lucubrations on the Nature of Influx, As It respects the Communication and Operations of Soul and Body*, trans. Thomas Hartley (London, 1770).

17. *A List of a Few Cures*, p. 3.

18. Press Cuttings, Victoria and Albert Museum, vol. II, p. 502 (1789).

19. *A List of a Few Cures*, p. 7.

20. Press Cuttings, Victoria and Albert Museum, vol. III, p. 565.

discussed in Chapter I, recognizes that de Loutherbourg's occultist preoccupations had been projected into his designs for the Macklin Bible, and we shall see more specific evidence of this in discussing his treatment of apocalyptic subjects. Although de Loutherbourg seems never to have lacked willing clients, it was fortunate for him that, after three largely unproductive years beginning with his association with Cagliostro, he received a major commission from Thomas Macklin. Although other artists, including Reynolds, West, Fuseli, Stothard, Opie, Artaud, and William Hamilton, executed paintings for Macklin's project, de Loutherbourg was by far the major contributor, producing 22 of the 71 full-page pictures and approximately 125 vignettes.[21] The paintings were exhibited at Macklin's Poets Gallery every year, and engravings after them appeared in the six-volume *Holy Bible*, completed in 1800, and in an additional volume of the Apocrypha, published by Cadell and Davies in 1816. As T.S.R. Boase remarks of de Loutherbourg's contribution, "No other group of paintings exemplify so clearly the early stages of the Romantic Movement in England."[22]

Early in his career, de Loutherbourg had painted religious subjects such as *The Angel Appearing to the Shepherds* (Ashmolean Museum, Oxford) and *Hagar Watching Her Son Drink after the Discovery of the Spring* (Musée des Beaux-arts, Angers), both painted while the artist was still in France. These are, however, representations of charming figures in "Dutch" landscapes.[23] Prior to his Macklin Bible pictures, perhaps the closest de Loutherbourg came to the apocalyptic sublime was in his eidophusikon, the celebrated pre-cinematic device that thrilled the London art world when it was first displayed in February 1781. The fifth and climactic episode, illustrated in Edward Francis Burney's water color of 1781 (British Museum)[1] and reconstructed for the Kenwood exhibition of 1973, was taken from Book II of *Paradise Lost*. A contemporary account of it appeared in the *European Magazine* for March 1782:

> It is a view of the Miltonic Hell, cloathed in all its terrors. The artist has given shape and body to the imaginations of the immortal bard, and presents to the wrapt and astonished sense, the fiery lake bounded by burning hills. He follows closely the description of the poet. Beelzebub and Moloch, rise from the horrid lake, and Pandemonium appears gradually to rise, illuminated with all the grandeur bestowed by Milton, and even with additional properties, for serpents twine around the doric pillars, and the intense red changes to a transparent white, expressing thereby the effect of fire upon metal. Thousands of Demons are then seen to rise, and the whole brightens into a scene of magnificent horror. The lightning exhibits all the varied and vivid flashes of the natural phenomenon, and the thunder includes every vibration of air, and shock of element which so often in its prototype, strikes terror and admiration on the mind.[25]

Here is the Burkean sublime in all its "magnificent horror," as well as a striking

21. See Joppien, *Philippe Jacques de Loutherbourg*, n.p.

22. T.S.R. Boase, "Macklin and Bowyer," *Journal of the Warburg and Courtauld Institutes*, XXVI (1963), 148–77.

23. See Joppien, *Philippe Jacques de Loutherbourg*, nos. 55 and 56.

24. *Ibid.*, no. 87, *Satan arraying his troops on the banks of the fiery lake with the raising of Pandemonium from Milton.*

25. Vol. I, pp. 180–81.

anticipation, doric pillars and all, of John Martin's apocalyptic paintings of the next century.

For the Macklin Bible, many of the designs for which are now known only in their engraved form,[26] de Loutherbourg either chose or was assigned most of the subjects that could be associated with the sublime of terror. Some he treated as scenes of disaster virtually indistinguishable from the catastrophic aspect of the natural sublime. Among these are *Christ Appeasing the Storm* (exhib. 1790; engr. W. Bromley), *Jesus Walking on the Sea* (exhib. 1794; engr. J. Fittler) and *The Shipwreck of St. Paul*, (exhib. 1791; engr. B. J. Pouncy). The first two, despite their supernatural subjects, are essentially storm scenes, while the third is a combination of shipwreck and Deluge in which the three-generational motif that goes back at least to Poussin occupies a central place. In *The Destruction of Pharoah's Host* (exhib. 1793; engr. Fittler) two parallel violent scenes are displayed: the solar radiance at the center with the black clouds moiling around, Moses and his people on solid rock with the Egyptians inundated below. As in de Loutherbourg's *Deluge*, the masses of cloud, rocks, and surging waves are presented with dramatic effectiveness. Such renditions of the elements were considered de Loutherbourg's hallmark. "Light and darkness," wrote Peter Coxe in 1812, "the elements of earth, air, fire, and water; over these, from the quiescent state to the extremes of turbulent agitation, he held imitative sway in the powers of his pencil."[27]

The frontispiece of the entire Macklin Bible was an Old Testament scene of divine revelation, *The Creation* (1800, private collection) (Pl. 22), engraved by James Heath. The subject is, however, treated in such a peculiar fashion as to raise doubts as to its actual reference. For the prototype of God de Loutherbourg chose not the Father images of the Sistine Chapel or the Raphael Loggie but Michelangelo's statue of Moses[28], an identification reinforced by the pastoral staff lying on the ground and the sandals on the figure's feet. The presence of five stone tablets and of androgynous-looking angels increases the sense of mystery in this picture. The mystery may, how-ever, be partly resolved by the hypothesis that the painting was not originally intended by de Loutherbourg to illustrate the Creation but was rather a dual affirmation of the existence of God and of His presence in both Testaments. This twofold theme is enforced by the four biblical passages referred to in the text of the engraving[29] – significantly, Genesis is not included – and by the Greek Bible held up by an angel. The five tablets may stand for the Pentateuch, once more relating the subject to Moses.

In some other pictures de Loutherbourg gives a special emphasis to apocalyptic possibilities implicit in the biblical text. Of the many available subjects in II Kings,[30] he chose *The Ascent of Elijah* (exhib. 1791; engr. W. Byrnes) and *The Angel Destroying the Assyrian Camp* (exhib. 1791; engr. William Sharp). In the latter we see a great-winged

26. Some of de Loutherbourg's Bible pictures were put up at auction by Peter Coxe, Burrell, and Foster in the Macklin sale of 5–9 May 1800. Among those offered were *The Angel Binding Satan, Ezekiel's Vision,* and *The Vision of the White Horse.* The last is in the Tate Gallery; the other two are untraced.

27. Peter Coxe, "Observations," *A Catalogue of all the valuable Drawings, Sketches, Sea-Views, and Studies of* that celebrated artist James Philip de Loutherbourg (London: Coxe, Burrell, and Foster, 1812), p. 6.

28. See Joppien, *Philippe Jacques de Loutherbourg,* no. 70.

29. Deut. vi. 4; Josh. i. 8; Matt. xxiii. 10; John v. 29.

30. As we have seen in Chapter II, Henry Fuseli proposed one of two scenes for his contribution to the Macklin Bible; it is hard to believe that the Bible's principal artist was not given the same privilege.

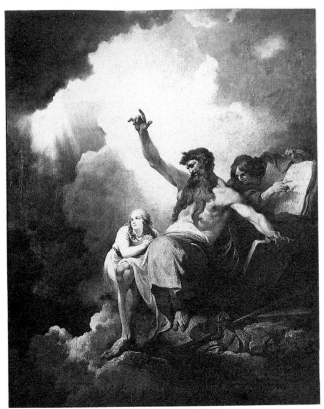

22. Philippe Jacques de Loutherbourg. *The Creation.*

23. J. Fittler after Philippe Jacques de Loutherbourg. *Ezekiel's Vision.*

flying angel, his nimbus fiery against dark clouds, smiting the Assyrians with a laser-like sword. In *The Ascent of Elijah* the wheels of the prophet's chariot seem to have eyes radiating light from their hubs, a detail for which there is no basis in the text of II Kings ii. 11, which refers only to "a chariot of fire, and horses of fire." It may be that de Loutherbourg wanted to associate this chariot of fire with the "wheels ... full of eyes" in Ezekiel x. 12. Blake too would employ the image of eyed chariot wheels as an apocalyptic motif, though not in an Old Testament design but in *Beatrice Addressing Dante from the Car* (Tate Gallery).

However, in *Ezekiel's Vision* (exhib. [?] 1796; engr. J. Fittler) (Pl. 23),[31] de Louther-bourg did not show the prophet's "wheel ... in the midst of a wheel" (x. 10), as Blake did in his contemporary *Night Thoughts* water color 474 (*c.* 1795–97, British Museum), but rather another human form among wave-lashed rocks under a stormy sky. The prophet gazes toward the upper left where a cherub with three visible faces – eagle, man and ox – manifests himself. (The fourth, lion head is presumably on the opposite side of the man's and therefore cannot be seen.) This image is true to the biblical text

31. I have not been able to locate a copy of the Macklin exhibition catalogue of 1796, and so this date is slightly conjectural. However, *Ezekiel's Vision* was not exhibited in 1795, and as Fittler's engraving is dated 1796 (as is the related headpiece), the date seems likely.

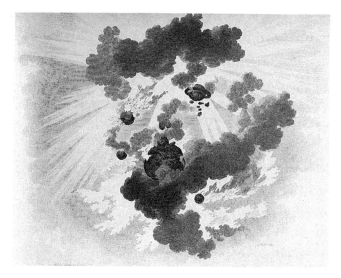

24. J. Heath after Philippe Jacques de Loutherbourg. Headpiece to the Second Epistle General of Peter.

although seldom represented in art. De Loutherbourg also used it for the headpiece for Ezekiel (1796),[32] but this time with the lion head at the right. It is interesting to compare Blake's water color *Ezekiel's Wheels* (Boston Museum of Fine Arts), of *c.* 1803–5, where a diminutive Ezekiel regards an immense cherub with three human faces, the fourth presumably being turned away from the viewer. (*Cf.* the text of Blake's *Jerusalem*, where the "four Faces" that "Ezekiel saw … by Chebar's flood" are described.)[33] In his depiction of Ezekiel's vision, Blake, characteristically, abolishes perspective and relies for sublimity of effect upon the figures' tremendous disparity in size, risking a descent into the grotesque with his multi-faced giant. De Loutherbourg, just as characteristically, invests the scene with theatricality: the sublimity is of a distinctly Burkean kind, depending upon the contrasts of light and shade and of height and depth.

Although the Book of Daniel contains two great apocalyptic moments – Belshazzar's Feast and Daniel's Vision (both, as it happens memorably treated by Rembrandt)[34] – the first of these was given to W. Artaud and the second to William Hamilton. De Loutherbourg did, however, execute a tailpiece for Daniel (1797), showing the first visionary beast of chapter vii – a lion with eagle's wings and human legs. He also designed apocalyptic headpieces for two New Testament Epistles. At the beginning of the Second Epistle General of Peter, he depicted the conflagration of the solar system with an occluded sun and planets bursting into flame amid dark clouds, illustrating chapter iii, verse 10: "But the day of the Lord will come as a thief in the night; in the which the heavens shall pass away with a great noise, and the elements shall melt with fervent heat, the earth also and the works that are therein shall be burned up" (Pl. 24).

32. The drawing, along with all the other headpieces, tailpieces, and vignettes executed by de Loutherbourg for the Macklin Bible, is in the Bolton Public Library. A complete set of photographic reproductions is in the library of the Yale Center for British Art.

33. 12: 58, *Complete Poetry and Prose*, p. 156.

34. *Daniel's Vision* (Dahlem, West Berlin) and *Belshazzar's Feast* (National Gallery, London).

And at the head of the General Epistle of Jude he placed a grotesque, chained Satan – a dark, bat-winged form with one human head and a second, serpent head that turns back to bite its own shoulder. Here we have another instance of de Loutherbourg's precipitating apocalyptic images only latent in the text into a manifest form, for the Epistle of Jude mentions the devil but does not describe him.

De Loutherbourg's most striking examples of the apocalyptic sublime occur, as one would expect, in connection with the Book of Revelation. Here, in addition to a headpiece and a tailpiece, he produced two paintings, one of which, *The Vision of the White Horse* (1798, Tate Gallery; also known as *The Opening of the Second Seal*), is among the Macklin Bible paintings which have survived (Pl. 25). Engraved by John Landseer, it was placed opposite the beginning of Revelation xix, which would later provide the subject of West's *Destruction of the Old Beast and False Prophet* (see Chapter II above). However, it has been pointed out that this design actually represents Rev. v. 2–4,[35] which begins: "And I saw, and behold a white horse; and he that sat on him had a bow; and a crown was given to him: and he went forth conquering and to conquer." This passage is, of course, part of the subject of West's first two versions of *Death on the Pale Horse*, in which the Rider on the White Horse is placed in the right foreground. Since the West pictures were exhibited, respectively, at the Royal Academy in 1784 and in 1796, de Loutherbourg, who became an Academician in 1780, had ample opportunity to be influenced by them. There is, nevertheless, much that is distinctive in de Loutherbourg's treatment of the subject.

For West the central figure is of course Death, who appears later in chapter vi, while de Loutherbourg's interest is in only the first two riders. Where West had placed these in parallel formation riding toward the right end of the picture space, de Loutherbourg sends his Rider on the Red Horse head-on toward the viewer as the first rider traverses the central part of the canvas. Unlike West's horsemen, who ride on the solid ground, de Loutherbourg's appear in a cloudy sky and so give the impression of existing in measureless space. The coloring, bright, even delicate, for the conquering figure, also contributes to the sense of a visionary reality. This rider wears a red cape over an otherwise blue costume with a silvery cuirass, and bears gold arrows. Against a background of ruddy clouds reminiscent of the cannon smoke of battle scenes like de Loutherbourg's *Battle of the Nile* (1802, Tate Gallery), he is a memorable embodiment of the apocalyptic sublime.

De Loutherbourg's other full-scale Revelation painting for Macklin, illustrating chapter xx, verses 1–3, was *The Angel Binding Satan* (exhib. 1792; engr. J. Landseer) (Pl. 27). Although the original is untraced, there is an oil sketch at the Yale Center for British Art which gives us some idea of the coloring de Loutherbourg intended for the finished painting (Pl. 26).[36] In his overall conception de Loutherbourg, like West before him, must have been aware of the traditional precedents; and there were also, of course, the two West paintings exhibited in 1776–7. If we compare the large Trinity College altarpiece with the design executed by West for Beckford in 1798, we find that

35. See Joppien, *Philippe Jacques de Loutherbourg*, no. 69.
36. Dr. Joppien informs me in correspondence that there is another oil sketch of the subject in a private collection. One of these two sketches may have been *Archangel Gabriel* [sic] *Binding Satan* offered in the Peter Coxe auction sale of 1812 (no. 72).

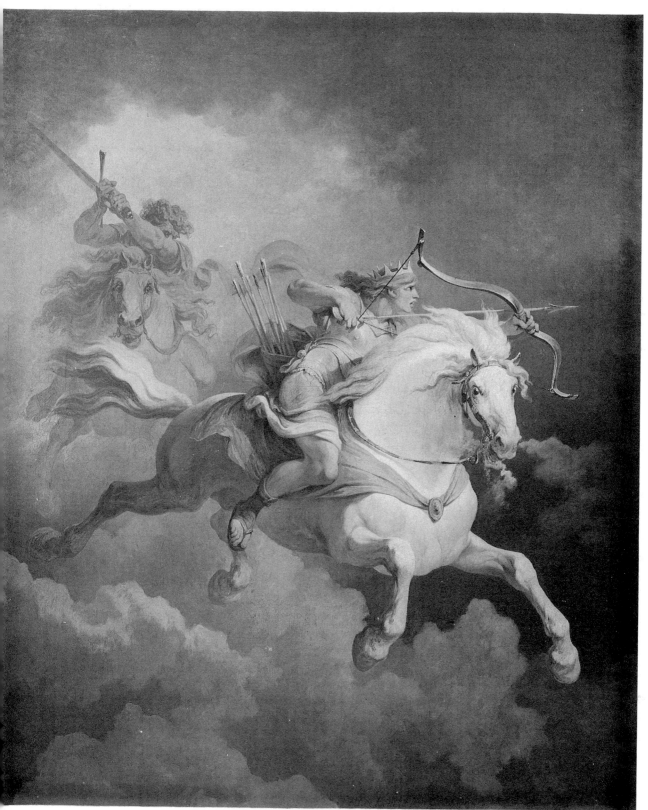

5. Philippe Jacques de Loutherbourg. *The Vision of the White Horse.*

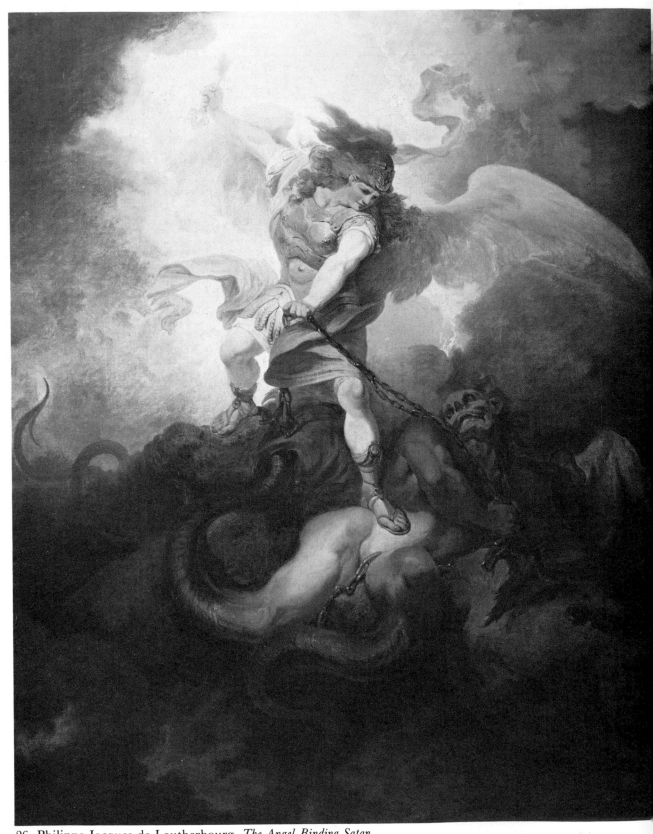

26. Philippe Jacques de Loutherbourg. *The Angel Binding Satan.*

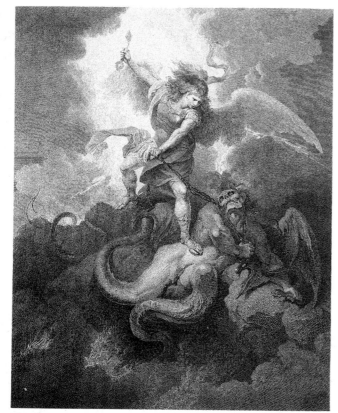

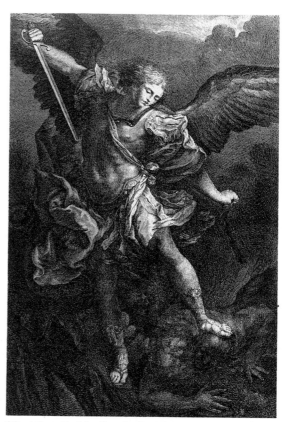

27. John Landseer after Philippe Jacques de Louther-
bourg. *The Angel Binding Satan*.

28. After Guido Reni. *St. Michael*.

de Loutherbourg's rendition has more in common with the earlier West painting. *The Angel Binding Satan* relies less on the dynamic interaction of antagonists than on the aesthetic contrast between beautiful, Apollonian angel and grotesque, skull-headed Satan; in this way it too is more like the treatments of the subject by Raphael, Guido Reni (Pl. 28), and Luca Giordano than it is like Rubens's.

The coloring of the Yale sketch reinforces the basic contrast between angel and devil while at the same time exemplifying some of the questions raised by a number of de Loutherbourg's contemporaries about his palette. The red-plumed angel, holding a golden key, wears a rose-colored swirling garment over silver armor – a combination of colors similar to those used for the Rider on the White Horse. Satan's flesh-colored torso contrasts with his green, serpentine legs below the knees, and the radiant sky of the upper-center is set off against intensely red clouds below. This sort of highly artificial coloring was attacked by some contemporary critics, among them "Anthony Pasquin" (John Reynolds),[37] and was satirized in verse by "Peter Pindar" (John Wolcot) with respect to de Loutherbourg's pastoral landscapes:

> And LOUTHERBOURG, when Heav'n so wills,
> To make brass skies, and golden hills,
> With marble bullocks in glass pastures grazing:

37. "Anthony Pasquin," *Memoirs of the Royal Academicians*
(London, 1796), p. 80.

61

> Thy reputation too will rise,
> And people, gaping with surprise,
> Cry, "Monsieur LOUTHERBOURG is most amazing!"[38]

Even Edward Dayes, who thought de Loutherbourg had "in some parts of the art . . . gone beyond any painter, either living or dead," pronounced "his style of execution too clean and delicate"[39] for history painting; and de Loutherbourg's sometime pupil Sir Francis Bourgeois ascribed his peculiarities of coloring to a deficiency of eyesight: "His Vision being such that he could see but a small part of His pictures and not the whole together," noted Farington. "This accounted for his crude coloring, for His bringing Hot and cold colours together so as to produce a discordant effect."[40]

Despite Bourgeois' contention, it appears that the peculiarities of de Loutherbourg's color combinations were deliberate. Early in his career, he had been criticized for artificial coloration even by the generally admiring Diderot,[41] yet he persisted in this aspect of his style. Indeed, he believed he had made important discoveries about color while still a student in Strasbourg. According to what appears to be an authorized biographical sketch in the *European Magazine*, "As he was strongly attached to chemistry, he found, by following the principles of nature, a method of preparing and blending his colors, unknown to other artists, by which they were rendered more vivid and durable, as one component part did not destroy the effects of the other."[42] His remarks to Farington about vehicles show considerable knowledge and sophistication:

> He uses Poppy, – nut & Linseed oil, – and drying oil only for dark colours but never in skies and in delicate parts. He wishes to do as much with it as He can. He uses turpentine occasionally, but not the Ethereal spirits which becomes [*sic*] sticky in the pencil.[43]

It has also been suggested that the contrasts of hot and cold colors resulted from de Loutherbourg's earlier career as a stage designer,[44] but this may have reinforced rather than created a predilection for such combinations. In any event, whatever the reason, his few surviving apocalyptic paintings, for the most part, share this characteristic with his pastoral landscapes. An exception is *The Deluge*, a generally sombre picture because of its subject,[45] and it is significant that this is the biblical painting most praised by his critics.[46] It may be that the engravings for the Macklin Bible achieved, in de Louther-

38. "Peter Pindar," *Lyric Odes to the Royal Academicians for MDCCLXXXII*. Ode VI. *The Works of Peter Pindar, Esq.* (London: John Walker, 1794), pp. 28–9. Similar strictures are made by "Anthony Pasquin" (John Reynolds) in *Memoirs of the Royal Academicians* (London, 1796), p. 80.

39. Dayes, *Works*, p. 337.

40. *Farington Diary*, vol. IX, ed. Katherine Cave, 1982, pp. 344–5 (3 May 1809).

41. See Joppien, *Szenenbilder*, p. 3.

42. "Anecodotes of Mr. Loutherbourg," *European Magazine*, I (1782), 181.

43. *Farington Diary*, vol. VI, p. 2317 (8 May 1804).

44. C.H.S. John, *Bartolozzi, Zoffany & Kauffmann with Other Foreign Members of the Royal Academy* (London: Philip Alan & Co., 1924), pp. 125–7.

45. Even this painting may have more color contrasts than now appear under its thick, highly reflective glass at the Victoria and Albert Museum. C.H.S. John, who refers to this picture as *The Last Man*, writes: "The glowing flesh-tones of the distracted man with his wife and infant, and the warm greens and yellows of the rocks and foam at their feet, are made to tell with greater intensity by the slatey blue sky and sea against which they are vignetted" (*Bartolozzi, Zoffany, and Kauffmann*, p. 126).

46. See, for example, the newspaper review dated 24 July 1790, cited in Chapter I above; Dayes, *Works*, p. 337.

29. J. Heath after Philippe Jacques de Loutherbourg. Tailpiece to Revelation.

bourg's case, a popularity that could not have been attained by the original paintings.

For the Book of Revelation de Loutherbourg also executed a headpiece showing a, possibly, female angel "having the seal of the living God" (xvii. 2) and a striking tailpiece (Pl. 29). The subject of the latter is the beast "with two horns like a lamb" (xiii. 2) also depicted by West in *The Beast Riseth Out of the Sea* and by Blake in *The Number of the Beast is 666* (c. 1805, Rosenbach Foundation). In his left hand the beast holds a triple crucifix, associated with the pope, and a scroll with six opened seals. His left index finger points to the words "REASON SELF WILL POWER,' and the words 'I will' issue from his mouth. With his upraised right hand, "he doeth great wonders, so that he maketh fire come down from heaven on the earth in the sight of men" (xiii. 13). In front of him are diminutive figures, including a king, two bishops, and a warrior, bowed down in worship and supplication. The enormous difference in scale reinforces the sense of the terrible sublime, as it also does in Blake's *Night Thoughts* water color 201 (c. 1795–97, British Museum), where giant Death sweeps away tiny human figures, and in his design for Rev. x. 1–6, "*And the Angel which I saw Lifted up His Hand to Heaven*" (c. 1805, Metropolitan Museum of Art).

The head of de Loutherbourg's beast is so ugly as to be grotesque, another indication that there is a point where the apocalyptic sublime approaches and even enters an "estranged world," to use Wolfgang Kayser's term.[47] The monster's head has a decentering effect on what might otherwise be a bizarre but illusionistic picture. It makes us reconsider the spatial relations in the design, and in so doing we realize that what at

47. See *The Grotesque in Art and Literature*, trans. Ulrich Weisstein (New York: Columbia University Press, 1981 [1957]), *passim*. This point is further discussed in Appendix 1, "The Apocalyptic Grotesque," and in Chapter IV.

first appeared to be a scene taking place on earth is actually represented on a floating island of turf that can scarcely be differentiated from the dark clouds above and below it. This is also true of *The Vision of the White Horse*. Both jar the viewer by presenting sharply focussed images of beings who inhabit a contrastingly undefined space. In the Revelation tailpiece, furthermore, this visual meaning is supplemented by astrological and kabbalistic symbolism.

The astrological signs that appear in the nimbus of the beast and also on the six opened seals of his scroll are readily identifiable though not so easy to explain with respect to their arrangement.[48] In the nimbus the sun is in the center, surrounded by the conventional signs for, reading clockwise, Mars, Mercury, Venus, the Moon, Jupiter, and Saturn. The same signs, minus Venus, appear on the seals in a different order: from left to right, Sun, Mars, Moon, Mercury, Saturn, Jupiter. There does not seem to be any special significance to these apparently random orders, although it is evident that the scroll with its astrological seals is a demonic parody of the book "sealed with seven seals" that John sees in the right hand of God in Rev. v. 1. The nimbus with its solar system may suggest the material universe that is given for a time to the power of the beast, and the fact that the sign missing from the seals is Venus may suggest the absence of love in the world of Reason-Self-Will-Power.

The opened scroll also bears the Hebrew character *Vav* reiterated three times. As in the gematria this letter signifies the number 6, and as the *Vavs* are interspersed with three sixes, though for some reason not regularly, what we have here is 666 in Hebrew and Arabic numerals. The Hebrew inscription on the Beast's chest is תהו ובהו (*tohu va bohu*).[49] These are words that occur in the second line of Genesis, translated in the Authorized Version as "without form and void," and in Jeremiah iv.23: "I beheld the earth, and it was without form and void; and the heavens; and they had no light." *Tohu va bohu* is also a kabbalistic conception, as de Loutherbourg must have known, and a few words about his knowledge of the Kabbala are pertinent here.

As early as 15 April 1789 the *Morning Post* reported on de Loutherbourg's absorption in Hebrew studies:

> A number of strange stories are in circulation respecting Mr. LOUTHERBOURGH, the ingenious Painter, which we should be sorry to credit, as well for himself as for the sake of his art.
>
> These stories intimate that this Gentleman is so entirely governed at this moment by a degree of *pious* enthusiasm, that he has wholly renounced his profession, and means to devote the remainder of his life to the explication of the HEBREW TEXTS.
>
> Mr. LOUTHERBOURG's talents are so eminent, that his secession from the ROYAL ACADEMY would be a great loss, even if it were in a more prosperous condition – but in its present lamentable state, the retirement of such an artist would indeed be a fatal stab to the Institution.

The journalist seems to have conflated de Loutherbourg's faith healing and

48. I am indebted to Dr. Dena Taylor for information about astrological symbols.

49. For information about the Hebrew inscription, I am indebted to Dr. Thorsten Kälvemark and to Professor Robert Alter.

Hebraic interests; the former did keep him from his painting for a time, but the latter he incorporated into his art. That the *Morning Post* was right about his study of Hebrew, however, is confirmed by the artist's library. Peter Coxe's sale catalogue lists numerous books in and about Hebrew, including the Pentateuch, Gray's Hebrew Grammar (London, 1764), a concordance to the Hebrew Bible, and expositions of the Talmud and of the Kabbala, including the *Kabbala Denudata* of Christian Knorr von Rosenroth (2 vols., Sulzbach, 1677).[50] In the last he would have found definitions in Latin of the *tohu* and the *bohu*. He was also probably conversant with the original Zoharic explanation. The *tohu* is the chaos, "The abode of slime, the nest of refuse" that existed in the earth's early material state. The *bohu* is formlessness, "the finer part of which was sifted from the *Tohu* and rested on it."[51] In the inscription on the beast's chest, de Loutherbourg thus equates the beast of Rev. xiii with the undoing of the creation.

Interestingly, this last design for the seven-volume Macklin Bible also bears a parodic relationship to the first – de Loutherbourg's *Creation*, the frontispiece to volume I. Each centers upon a powerful male figure naked to the waist, wearing a skirt, and holding his right arm elevated. The nearly grotesque apocalyptic figure in the Revelation tailpiece visually embodies the antithesis of the creating Word in the *tohu va bohu* of chaos and formlessness.

De Loutherbourg's use of Hebrew inscriptions and kabbalistic motifs is even more marked in the seventh volume of the Macklin Bible, which was published by Cadell and Davies in 1816, Macklin himself having died in 1800. De Loutherbourg too had died (in 1812) by the time this volume of the Apocrypha appeared. According to Peter Coxe in the 1812 sale catalogue, de Loutherbourg's designs for the Apocrypha were not left over from the 1790s but were executed in later years, at least as regards the head- and tailpieces:

> His knowledge of Oriental Costume, and especially that of the Hebrews, is admirably displayed in the series of vignettes which accompany Macklin's Bible; and of those for the Apocrypha that are now engraving, for Messrs. Cadell and Davies, by the tasteful and masterly hand of Mr. Landseer. These are the very last productions of the pencil of this renowned painter.[52]

We do not know whether the same is true of the full-page designs, of which de Loutherbourg contributed six – more than he did for any other volume of the Bible. All that can be said of these as far as our subject is concerned, is that they are uniformly weaker in conception than many of de Loutherbourg's previous Bible designs and that none of them is on an apocalyptic subject. The head- and tailpieces are, however, another matter.

The vignettes to volume VII are essentially of two kinds.[53] Some are recognizable

50. Lot nos. 72, 73, 80, 129, 131, 134, 199, 200, 201, 206.

51. See *The Zohar*, trans. Harry Sperling and Maurice Simon (London and New York: The Soncino Press, 1933–34), vol. I, p. 66. For information about kabbalistic sources, I am indebted to Dr. Sheila Spector.

52. "Observations," p. 5.

53. It should be noted that a few of these were not designed by de Loutherbourg. The tailpiece for I Esdras is signed: "I. [i.e., John] Landseer inv. & fecit"; that for II Esdras merely: "I Landseer fecit;" that to Judith: "A.W. Devis del I Landseer fecit." Yet in style these vignettes are entirely compatible with de Loutherbourg's.

30. John Landseer after Philippe Jacques de Loutherbourg. Headpiece to The Song of the Three [Holy] Children.

figures from the text of the book illustrated, while others are virtually kabbalistic diagrams. In order to help the reader with de Loutherbourg's symbolism, the publisher included an anonymous eight-page "Explanation of the Head and Tail-pieces to the Apocrypha." These comments are obviously by someone who knew both the artist and the kabbalistic symbols he employed. With respect to the first type of vignette, in which images from the text appear, the commentary is elevated if not strictly necessary. For example, for *The Song of the Three [Holy] Children*, an apocryphal extension of the Book of Daniel that Northrop Frye has termed "a paen of praise to God for his creation,"[54] de Loutherbourg drew a magnificent angel (Pl. 30). The "Explanation," perhaps drawing upon information privately given by de Loutherbourg, comments: "He is here represented in the act of descending, or as if he had reached the furnace, but had not yet alighted there; a moment of choice, which while it displays the present, connects the past with the future by suggesting both."[55] Thus, like Blake's Bard "Who Present, Past, & Future sees," this angel conveys a message of apocalyptic urgency and at the same time raises the reader-viewer to a perception of the sublime. Nevertheless, even without the "Explanation," the reader could associate the angel with the text and form

54. Northrop Frye, *The Great Code: The Bible and Literature* (London: Routledge and Kegan Paul, 1982), p. 193.

55. *The Apocrypha, Embellished with Engravings, from Pictures and Designs by the Most Eminent English Artists* (London: Cadell and Davies, 1816), p. 6.

31. John Landseer after Philippe Jacques de Loutherbourg. Headpiece to Ecclesiasticus.

his own conclusions, something that would be far less likely with respect to some of the other vignettes.

"The subject of the head-piece to Ecclesiasticus," the "Explanation" says,

> is of that mystic kind which so frequently, in this Bible, have called forth at once the pictorial powers and the pious enthusiasm of the late M. de Loutherbourg. To raise the sinful heart toward Heaven, by means of those precepts of Wisdom which emanated from above, is the prime object and purpose for which the book of Ecclesiasticus was compiled.[56]

The images in this design (Pl. 31) are then identified as the divine star of the East, its influence mingled with the light of heavenly wisdom, descending toward "the humble, yet ardent, heart of man." Three Hebrew words represent attributes of God: כתר [Heter], בינה [Binah], and חכמה [Hokemah]. The "Explanation" continues:

> Hokemah, the divine essence of love . . . is sent down by Binah, the source of illumination and spirit of mercy, from Heter, the everlasting crown, or source of all perfection, into the resigned and contrite heart of man, whereon the word Hokemah is again inscribed, and which is depicted as rising from the darkness of fallen nature

56. *The Apocrypha*, p. 4.

67

with the wings of self-will drooping, yet partially elevated by the magnetic influence of inward grace.[57]

It is safe to say that for most readers of the 1816 Apocrypha, the meaning of this design and of a number of others, such as the tailpiece to Ecclesiasticus,[58] would have remained obscure without the "Explanation." In these vignettes, de Loutherbourg has taken a different approach to the apocalyptic sublime than in his paintings. In the latter, the aesthetics of the Burkean sublime operate to raise the viewer to a state of exaltation by means of grand representations of divine revelation. In such vignettes as the head- and tailpieces to Ecclesiasticus, the approach is purely intellectual. If the viewer is to respond at all, it is to the sublimity of the conceptions *as* conceptions. In this way these designs are similar to the otherwise very different ones de Loutherbourg produced for Cagliostro's Egyptian Rite in the late 1780s. Now the viewer must be initiated to the Kabbala, either through prior knowledge or at least by the "Explanation."

Of course, de Loutherbourg painted many non-apocalyptic paintings in the sublime mode, and it is fitting to conclude with a consideration of the place of the apocalyptic sublime in his oeuvre. Perhaps what is most striking about his work as a whole is its extreme diversity. He never entirely abandoned the pastoral scenes in the style of Berchem that had first made his reputation. He was a fine topographical draughtsman, travelling widely in Britain from 1778 to the mid-1780s in order to produce scenes of Derbyshire, the Lake District, and Wales. He painted few portraits, but these are of unusual interest. During the 1790s, when he was engaged by print publishers to execute battle scenes, he found uses for his early training as a military painter in Casanova's studio. He also became renowned for paintings of the natural sublime. In an entirely different vein, his delightful *Midsummer Afternoon with a Methodist Preacher* of 1777 (National Gallery of Canada) provided a precedent for Rowlandson's comic representations of English leisure. When we add to these genres his success in stage scenery, costume design, and the eidophusikon, we can see de Loutherbourg as one of the most versatile talents of his era.

There is indeed something almost disturbing about his versatility. Joppien penetratingly remarks:

The two opposed temperaments and modes of representation in de Loutherbourg's pictorial world, which are located at the poles of Berchem and Rosa, which on the one hand show people in peaceful companionship with nature and their pleasurable

57. *Ibid.*, p. 4.
58. Here the author of "The Explanation" silently conflates the imagery of Ephesians v. 13–17 with that of de Loutherbourg's design, saying that the tailpiece "denotes the triumph of the heart ardent in its aspirations after wisdom, over the sin which insinuates itself even among the armour which religion bids us put on; the shield of faith, breastplate of righteousness, helmet of salvation, & c. Sin is typified by a serpent; and the heart is guided in its ascent by that divine star of the east, or seal of God, as it is styled in Solomon's Song, with which it is impressed" (p. 5).

68

agreement with her, and on the other hand their complete subjection to her power, are corresponding extremes whose alternatives between utopian wish-fulfillment and bare horror mirror back the fantasy-life and wish-fulfillment of the time.[59]

While we should remember that for de Loutherbourg the world of "peaceful companionship" with nature was no doubt as important as that of "complete subjection to her power," it was for the latter that he became celebrated in Britain during the period from his return in 1788 to his death. His name became identified with scenes of the natural sublime like *The Falls of the Rhine at Schaffhausen* (1787–88,[60] Victoria and Albert Museum) and *An Avalanche, or Ice-Fall, in the Alps* (1803, Tate Gallery). Pictures like these impressed J.M.W. Turner, who characteristically challenged them in his own versions of the same subjects (see Chapter V below).

De Loutherbourg was attracted also to subjects of man-made disaster or horror. In *The Great Fire of London in 1666* (1797, Lord Northbrook)[61] he has us see the conflagration through an arch of the old London Bridge. Helpless onlookers gesticulate from under the bridge's piers as incandescent clouds fill the sky. Old St. Paul's is just at the point of burning, bathed in a ruddy glow. Similar colors appear in the powerful *Coalbrookdale by Night* (1801, Science Museum, Kensington), where once more human figures are dwarfed by enormous flames and fire-imbued smoke. Arthur Young had characterized as "altogether sublime" the sight of Coalbrookdale's "flames bursting from the furnaces with the burning of the coal and the smoak of the lime kilns."[62] In the de Loutherbourg painting we have a scene related to the depiction of Hell in the eidophusikon and that of the imagined burning of London in 1666: all three border on the apocalyptic sublime. In the case of *Coalbrookdale by Night* we see the Industrial Revolution as Hell, foreshadowing John Martin's perception of the Black Country as an image of the final conflagration.

Another kind of inferno appears in some of de Loutherbourg's battle scenes of the 1790s. It certainly needs no proving that he was highly conscious of the ongoing war during the period in which he painted his Macklin Bible pictures. In some of his military scenes, just as in *Coalbrookdale by Night*, the apocalypse seems close at hand. For example *The Battle of the Nile* (1802, Tate Gallery) dramatizes the variations of very hot colors in fire, smoke, and cloud with contrasting white smoke. This is not of course to suggest that de Loutherbourg need have consciously planned such a painting, or even *Coalbrookdale*, as apocalyptic in nature; it is to point out the imaginative similarities of these various excursions into the sublime. With respect to the military paintings, however, the fact that the artist was French-born and French-educated presents an interesting complication.

59. "Die beiden entgegengesetzten Temperamente und Darstellungs-weisen in de Loutherbourgs Bildwelt, die sich and den Polen Berchem und Rosa orientieren, die den Menschen einerseits im friedvollen Umgang mit der Natur und seiner lustvollen Überein-stimmung mit ihr, andererseits seine völlige Unterdrückung unter ihre Gewalt zeigen, sind korrespondierende Extreme, deren Alternative zwischen utopischer Lebenserfüllung und blankem Entsetzen das Phantasie- und Wunschleben der Zeit wiederspiegeln." (*Szenenbilder*, p. 2.)

60. See James Henry Kunin, "The date of Loutherbourg's 'Falls of the Rhine at Schaffhausen,'" *Burlington Magazine*, CXIV (1972), 554.

61. A smaller version, which is the one I have seen, is in the Yale Center for British Art.

62. Quoted in connection with *Coalbrookdale by Night* by Leslie Parris in *Landscape in Britain c. 1750–1850* (London: Tate Gallery, 1973), p. 68.

Writing in the mid-nineteenth century of de Loutherbourg's *Glorious Victory of the First of June 1794* (1795, National Maritime Museum, Greenwich), L. Dussieux remarked: "Il est honteux pour un français d'avoir fait un tel tableau, lorsque ses concitoyens, qui montaient le Vengeur, à cette bataille, s'engloutissaient en chantant la Marseillaise plutôt que d'amener leur pavillon."[63] However, the question of de Loutherbourg's national identity is not simple; indeed it provides an interesting parallel to his multiplicity of styles. It is true that he was born in Strasbourg[64] (and not in Fulda, as some biographical sketches state[65]), which was French soil in 1740. However, culturally Strasbourg was as much German as French; de Loutherbourg's birth certificate,[66] in which his name is given as Lautterberger, is in German. The artist's father, a native of Basle, was miniature painter to the court of Darmstadt in Hesse. De Loutherbourg further confused the issue by claiming to be Swiss during his early days in London, and he repeated that claim to Farington in 1804, falsely asserting that Basle was his own birthplace. The "de" was, of course, self-awarded. In one version he claimed that his family had come from Lithuania and settled in the canton of Berne several centuries before;[67] elsewhere he gave out that his ancestors were Polish and had been ennobled by King Sigismund in 1504, the Protestant branch emigrating to Switzerland after the Reformation.[68]

All this fluidity of national identity suggests that he did not have a determined sense of French patriotism. Unlike West, he seems to have regarded the Revolution only as a threatening, though temporary, aberration. To Farington he recommended a scorched-earth policy as a defense against an invading French army, and his view of the future was surprisingly melioristic: "He was of opinion that the troubles in France will end in it being resolved into a limited Monarchy, and he thought it probable that the Duke d'Angouleme, who married the daugr. of the late King, will become King of France."[69] His view of events in Europe seems to have been more detached than West's, and his apocalyptic art, unlike that of his younger contemporary Blake, does not seem to be associated with specific historical events. His apocalyptic paintings for the Macklin Bible both mirror and appeal to the unquiet spirit of the 1790s, while in the symbolism of some of the vignettes he found scope for embodying his researches into the occult in sublime conceptions.

63. *Les artistes Français a l'étranger* (Paris: Gide et J. Baudry, 1856), p. 144.

64. See André Girodie, "Notes Biographiques sur les peintres Loutherbourg," *Archives Alsaciennes d'histoire de l'art*, XIV (1935), 249–55.

65. Fulda is given as de Loutherbourg's birthplace by Lionel Cust in the *DNB* (*s.v.*); by Austin Dobson in *At Prior Park and Other Papers* (London: Oxford University Press, 1925 [1917]), p. 382; and by Burke in *English Art 1714–1800*, p. 382. The reason for the confusion is that de Loutherbourg's father, in an unsuccessful attempt to stop his son's marriage in France, had claimed Fulda to be the birthplace because the baptismal records there had been destroyed in war.

66. Girodie, p. 255.

67. *Farington Diary*, vol. VI, pp. 2291–2 (7 April 1804).

68. "Anecdotes," p. 181.

69. *Farington Diary*, vol. VI, p. 2158 (7 May 1803); p. 2292 (7 April 1804).

CHAPTER IV

William Blake

SO EARLY in his artistic career did Blake come to apocalyptic subjects that his treatment of some of them antedates or is contemporary with comparable works by the considerably older artists West and de Loutherbourg. This testifies to a permanent and distinctive aspect of Blake's imagination – a lifelong engagement with the idea of divine revelation penetrating history and bringing it toward a Day of Wrath and Last Judgment. At first Blake saw this process embodied in the revolutions of his time; later he conceived of it as acting through the artistic imagination, which he equated with the spirit of prophecy. Although Blake's visionary radicalism and the symbolic system set forth in his writings testify to his uniqueness, it is possible to set him off too much from his contemporaries, thus losing sight of his connections with the artistic culture of which he was a part. Fortunately, the tendency of recent scholarship has been in the opposite direction,[1] a direction which may be continued by regarding his works in the perspective of the apocalyptic sublime.

In 1784, while West's *Triumph of Death* was being exhibited at the Royal Academy exhibition, Blake's water color *War unchained by an Angel, Fire, Pestilence, and Famine following* was also shown there. Although this work is untraced, a pen and wash sketch for it (coll. Robert N. Essick) (Pl. 32) reappeared in 1972–73,[2] and so we have some idea of the finished water color. The flying angel who sweeps across the design with his fiery sword seems to come out of Revelation; for him we might adopt Blake's later characterization of the spiritual form of Pitt: "He is that angel, who, pleased to perform the Almighty's orders, rides on the whirlwind, directing the storms of war."[3]

The setting of *War unchained by an Angel* is a mélange of elements bringing together several architectural styles, ancient and modern.[4] At the right, through the portico of a classical temple, we see figures abasing themselves and armed warriors behind them. A

1. I have in mind particularly *Blake in His Time*, ed. Robert N. Essick and Donald Pearce (Bloomington: University of Indiana Press, 1978); Bindman's *Blake As an Artist*; and Bindman's exhibition catalogue *William Blake: His Art and Times* (London: Thames and Hudson, 1982).

2. See Martin Butlin, "Five Blakes from a Nineteenth-Century Scottish Collection," *Blake*, VII (1973), 4–8; and Butlin, *The Paintings and Drawings of William Blake* (New Haven and London: Yale University Press, 1981), no. 186, pp. 71–2.

3. *A Descriptive Catalogue* in *Complete Poetry and Prose* p. 530.

4. On Blake's use of architecture in his art, see my essay "The Fourth Face of Man: Blake and Architecture," in *Articulate Images*, pp. 184–215.

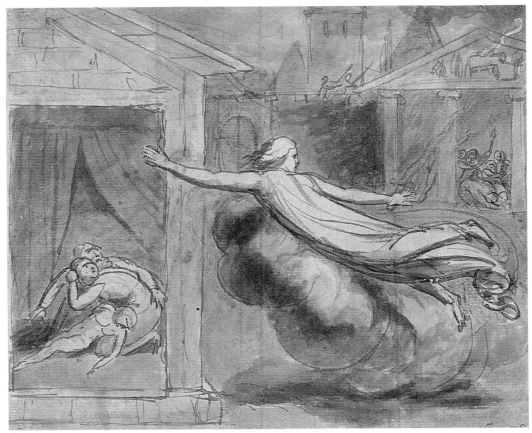

32. William Blake. *War unchained by an Angel.*

plume of smoke is rising from the temple's roof, and thicker smoke is beginning to envelop a pyramid further back. To the left is a tower before which men rush with spears. A peculiar structure combining aspects of a hut, a tent, and a stage set fills the left foreground; inside it we see a family of three, the parents recoiling in fear, the child dying or dead.

Blake's Victorian biographer Alexander Gilchrist perceived that *War unchained by an Angel* and the picture exhibited with it in 1784, *A Breach in a City, the Morning after a Battle,* had a "tacit moral," which was "the supreme despicableness of war, one of which the artist was a fervent propagandist in days when war was tyrranously in the ascendant."[5] Furthermore, if Martin Butlin's dating of the extant sketch as *c.* 1780–82 is correct, then the picture was conceived while the "dark horrors," as Blake put it, of the American War "passed before my face."[6] Like West's *Triumph of Death, War unchained by an Angel* is likely to have topical reference to the war that was concluded by treaty in the year that both pictures were exhibited.

Despite the "terrible" subject matter of *War unchained,* it seems deliberately to avoid the full achievement of the Burkean sublime. The billowing cloud of smoke below the angel is not allowed to obscure the figures; the pictorial depth is shallow and thus does

5. Alexander Gilchrist, *The Life of William Blake,* ed. Ruthven Todd (London: J.W. Dent, rev. ed., 1945), p. 47.

6. Letter to John Flaxman, 12 September 1800, *Complete Poetry and Prose,* p. 708.

not contribute to the illusion necessary for the vicarious experience of fear that Burke would have considered necessary. Blake later wrote that he had read Burke's *Enquiry* "when very Young" but that Burke's theories filled him with "Contempt & Abhorrence."[7] It is unlikely that he had worked out a conceptual alternative as early as 1784, but the nature of that alternative and of Blake's need for it will require consideration in connection with Blake's later apocalyptic art.

At about the time that he sketched *War unchained*, Blake also made a small water color called *Pestilence*, and he soon followed this with a slightly larger one (coll. Robert N. Essick). These two essentially similar designs combine two important strands of subject matter in Blake's early works: the apocalyptic and the historical. In about 1779–80 Blake executed a number of small water colors on subjects from English history,[8] and in his Notebook he listed some of them, including *The Plague*[9] and *The Fire of London*.[10] *Pestilence*, with its black-garbed bellman and the inscription on a door "Lord have mer[cy] on us," is placed in the London of 1666. As Bindman remarks of *War unchained*, *Pestilence*, and *A Breach in the City* (now known only through later versions), all three have as their theme a city suffering the visitation of divine wrath "as a fulfillment of the prophecy of Revelation."[11]

The themes of War, Pestilence, Famine, and Fire, with their inescapably apocalyptic undertones, are virtually omnipresent in Blake's works of the late 1780s and early 1790s. *Pestilence* exists in no less than five water-color versions plus a recently discovered pencil drawing.[12] After the second, the specific reference to London is lost as the architectural setting becomes less defined, and Blake's debt to Poussin becomes more pronounced. Of particular relevance is Poussin's *Peste d'Azdod*, which shows afflicted groups in a classical architectural setting; Blake could have known this work through the engravings of Jean Baron or of Étienne Picart.[13] Probably paired with two of the versions of *Pestilence* are two of *A Breach in a City*.[14] These linked themes culminate in a set of four large water colors executed for Thomas Butts in 1805. Here *War* (Fogg Art Museum) is substituted as a title for *A Breach in a City*, and *Famine* (Boston Museum of Fine Arts) appears as a subject for the first time. The only extant *Fire* (Pierpont Morgan Library) and the last *Pestilence* complete the group. Although the somewhat abstracted neo-classicism of these later pictures distances them from the spectator, they still retain strong suggestions of their apocalyptic origins. Gilchrist praised them

7. Annotations to Sir Joshua Reynolds's *Discourses*, *Complete Poetry and Prose*, p. 660.

8. See David Bindman, "Blake's 'Gothicized Imagination' and the History of England," in *William Blake: Essays in Honour of Sir Geoffrey Keynes*, pp. 21–49.

9. See *Complete Poetry and Prose*, p. 672. This list may be related to *The History of England, a small book of Engravings*, announced by Blake as "now published" in 1793 (*Complete Poetry and Prose*, p. 693) but not known to exist.

10. *The Fire of London*, if executed, is now untraced; for Blake's later *Fire*, see below.

11. See *Blake As an Artist*, p. 32; *William Blake: His Art and Times*, p. 74.

12. Butlin, *Painting and Drawings*, nos. 184, 185, 190, 192, 193. See also Butlin's exhibition catalogue *William Blake* (London: Tate Gallery, 1978), pp. 37–8. On the pencil drawing, see Shelley M. Bennett, "A Newly Discovered Blake at the Huntington," *Blake: an Illustrated Quarterly*, XVIII (Winter 1984–85), 132–9. As the London locale has disappeared in this drawing, Bennett places it in the early 1790s, after the first two water colors.

13. See Georges Wildenstein, *Les gravures de Poussin au XVIIe siècle* (Paris: Presses Universitaires de France, 1957), nos. 23 and 24.

14. The water color exhibited in 1784 is untraced. Butlin pairs nos. 189 and 190 (*c.* 1790–5) and nos. 191 and 192 (*c*, 1795–1800) (*Paintings and Drawings*).

for "Dantesque intensity, imaginative directness, and power of the terrible: illustrative of the doings of the destroying angels that war lets loose ..."[15]

The designs discussed so far, spanning a period of more than twenty years, have, to varying degrees, three planes of reference. There is the biblical past, suggested by the buildings in *War unchained* and by the classical architectural elements in the 1805 pictures. Antiquity is associated with and made parallel to British history and particularly to the great plague and fire of London: the first two *Pestilence* drawings could serve as illustrations for Defoe's *Journal of the Plague Year*. The third level is the contemporary: the American War for the earliest of the war pictures, the war against France for the later ones. The final group of 1805 may also refer with irony to Robert Malthus's recently advanced argument that war, famine, and pestilence were checks on population growth.[16] Thus sacred and secular, past and present, converge in a series of apocalyptic moments.

The apocalyptic themes and images of Blake's early drawings are also to be found in the etched designs for his illuminated books of the 1790s. This is especially true of the only works that Blake himself referred to as Prophecies: *America* (1793) and *Europe* (1794), which together compose a cycle of history from the birth of Christ to the apocalyptic manifestations of the American and French Revolutions. The frontispiece of *America* is a variant of *A Breach in a City*, but here, as David V. Erdman points out,[17] it is the chained revolutionary hero, Orc, who is set in the broken wall in place of the corpses of victims. In the text Albion's Angel accuses Orc of being the dragon of Revelation, saying:

> Art thou not Orc, who serpent-form'd
> Stands at the gate of Enitharmon to devour her children ...[18]

Enitharmon's gate is her womb; she is in this context the Woman Clothed with the Sun threatened by the Great Red Dragon who "stood before the woman which was ready to be delivered, for to devour her child as soon as it was born" (Rev. xi. 4). The words of Albion's Angel are, however, belied by the design on this plate, which shows two children sleeping beside a ram in a paradisal landscape, and on plate 12 the human form of Orc is seen in flames, suggesting the Christ of the Parousia. It is, on the other hand, Albion's Angel himself who as "Albions wrathful Prince" is revealed to be "a dragon form clashing his scales."[19] Blake would later return to this symbolic configuration in a group of powerful water colors illustrating Revelation itself.

Europe reintroduces the bellman of the early *Pestilence* drawing along with the two victims at the left and the inscription on the door: "LORD HAVE MERCY ON US" (plate 10). Other full-page plates have as their subjects famine and war, and the book concludes with fire: a man carrying a woman leads a child away from the flames of a burning

15. *Life of William Blake*, p. 47.

16. See Mark Schorer, *William Blake: the Politics of Vision* (New York: Vintage, 1959 [1946]), p. 278. Malthus's *Essay on Population* was first published in 1798.

17. See "*America*: New Expanses," in *Blake's Visionary Forms Dramatic*, ed. David V. Erdman and John E. Grant (Princeton: Princeton University Press, 1970), p. 99.

18. 7 [9]: 3–4, *Complete Poetry and Prose*, p. 53. Page references to Blake's illuminated books are complicated by the fact that the two principal sources use different numbering systems. In referring to the text, I cite Erdman's plate numbers, but when referring to designs alone, I give numbers from G.E. Bentley, Jr., *Blake Books* (Oxford: Clarendon Press, 1977).

19. 3: 15, *Complete Poetry and Prose*, p. 53.

city.[20] Blake would repeat this last group of figures in reverse in his third *Job* design, bearing the inscription, "The fire of God is fallen from heaven." *America* and *Europe* bring together, as do *War unchained by an Angel, Pestilence*, and *A Breach in a City*, modern history and biblical archetypes in a scenario of apocalyptic revelation and destruction.

Blake's visionary radicalism in *America* and *Europe* is closely related to the millenarian ferment of the early to mid-1790s, years during which Richard Brothers,[21] the self-styled "prince of the Hebrews," prophesied against war and empire; the copper-plate maker William Bryan, who had visited the mysterious Prophets of Avignon, published his spiritual testimony;[22] and Joseph Priestley in a sermon applied Old Testament prophecies to the present state of Europe.[23] William Sharp, who like Blake had once been involved with the Swedenborgian movement, and who was active in the radical Society for Constitutional Information, published Brothers's engraved portrait with the inscription: "Fully believing this to be the Man whom GOD has appointed – I engrave his likeness." However, in the middle of the decade the effects of governmental repression became deeply felt. When the leaders of the radical societies were tried in 1794, they were acquitted, but only after spending ten months in jail without benefit of habeas corpus. Sharp himself was arrested and interrogated, although not charged; Brothers was arrested in March 1795, examined before the Privy Council, and incarcerated in a lunatic asylum for the next twelve years. After 1795 Blake created no new illuminated books for over a decade.

At just this time, Blake was fortunate in finding an employer in the publisher Richard Edwards, who was preparing a folio-sized, illustrated edition of Edward Young's *Night Thoughts*. This commission served Blake as the royal commission, in a grander way, had served West, and as Macklin's had served de Loutherbourg: it enabled him to pursue an ambitious artistic project on subjects of deep interest to him. The fact that the *Night Thoughts* commission was for book illustrations was no impediment: Blake freely introduced his own symbolism and thematic concerns,[24] including some memorable pictures on apocalyptic subjects.

In many instances Young's text itself provided Blake with congenial images. One senses Blake seizing with alacrity the passage in Night II which compares the passage of time to the handwriting on the wall in Daniel v. 26–7. In Blake's vignette[25] we see

20. This group has an interesting resemblance to one in an engraving of the Deluge, signed "Fernando berteh exc.," in the Genesis volume of the Kitto Bible (no. 672).

21. See my essay "William Blake, the Prince of the Hebrews, and the Woman Clothed with the Sun," in *William Blake: Essays in Honour of Sir Geoffrey Keynes*, pp. 260–93.

22. *A Testimony of the Spirit of Truth, concerning Richard Brothers* (London, 1795). On Bryan's life see J.C.F. Harrison, *The Second Coming* (New Brunswick, N.J.: Rutgers University Press, 1979), pp. 69–72.

23. See David V. Erdman, *William Blake: Prophet Against Empire* (Princeton: Princeton University Press, 3rd ed., 1977), p. 265.

24. See my essay "William Blake's *Night Thoughts*: an Exploration of the Fallen World," in *William Blake:*

Essays for S. Foster Damon, ed. Alvin Rosenfeld (Providence: Brown University Press, 1969), pp. 131–57.

25. No. 60. All Blake's *Night Thoughts* illustrations are reproduced in *William Blake's Designs for Edward Young's "Night Thoughts"*, ed. John E. Grant, Edward J. Rose, Michael J. Tolley, and David V. Erdman (Oxford: Clarendon Press, 1980). The engraved designs are conveniently available in *Night Thoughts or The Complaint and the Consolation*, ed. Robert N. Essick and Jenijoy La Belle (New York: Dover, 1975), which includes a reproduction of the Edwards edition of 1797.

Belshazzar, "the Assyrian pale,"[26] dropping a goblet as the prophet breaks through a dark cloud pointing to letters on the wall behind him. Much as Burke may have excited Blake's "Contempt & Abhorrence," this design, in which Belshazzar's hair stands on end in terror and in which darkness obscures most of the background, could easily be taken as an example of the Burkean sublime. It could even be regarded as a transposition to Daniel of an image from a passage in Job that Burke had praised as "amazingly sublime,"[27] and that Blake himself would use as the epigraph for his ninth *Job* engraving: "Then a spirit passed before my face. The hair of my flesh stood up."

In the *Night Thoughts* series, Blake seems to have been especially receptive to finding Revelation subjects, and so on page 45 of Night IX he is quick to capture the reference Young took from Rev. vi. 14 to "this Manuscript of Heav'n, / ... like a Parchment-Scroll, shrunk up by Flames ..." The scroll Blake drew is structured as a huge inverted 'S', an apocalyptic parody of Hogarth's Line of Beauty, in the curves of which men, animals, sun, and stars, fall. Other such designs, though none so brilliantly conceived or richly colored as this one, are found in Night IX, where the text on pages 9ff. of the 1745 edition that Blake used is concerned with the Last Day.

Blake illustrated eleven of these pages with straightforward treatments of Young's apocalyptic themes. In water color 426 he shows a giant figure chained in flames, his position contorted like Los's on plate 7 of *The Book of Urizen*: this is "*Conflagration*," who is "chained in Caves" (away from Deluge, who is also chained), to be let loose

> When Heav'ns inferior Instruments of Wrath,
> *War, Famine, Pestilence,* are found too weak
> To scourge a world for her enormous Crimes ...[28]

Another personification, "final *Ruin*," appears in 427, female as in Young's text, ploughing under men and women in fulfillment of the prophecies of Micah and Jeremiah.[29] (This theme of ploughing as a prelude to the Last Judgment would later recur in Night IX of *The Four Zoas* and in *The Spiritual Form of Pitt.*) The figure of "A swift Archangel," his back to the viewer, "sweeps Stars and Suns aside" in 428 (p. 10); and then in 429 (p. 11) Man awakes to the Last Day, to find "our World on Fire! / All Nature struggling in the pangs of Death!" A family group very similar to that of the last plate of *Europe* (*cf.* also the fleeing family at the lower left of *America* 5) vainly attempts to escape the flames in 430.

The sequence of apocalyptic subjects is briefly broken after 430, to resume with the ruins and corpses of 432 and the ugly, chained Satan of 433. Next are pictured the allegorical deaths of Time, falling on his scythe, and of Death, impaled by his own dart. The female personification of Eternity stands on both in 535, and in 436 she throws the adamantine key to Hell into the abyss. A frieze of angels choirs in 437, ending the second half of this apocalyptic sequence.

Probably the speed with which Blake executed these eleven designs accounts for

26. Edwards edition, p. 32. The engraved design appears on p. 33, but in the edition that Blake used when making his water color series, this passage appears on the same page as the comparison with Belshazzar (on p. 33 in Edwards).

27. *Enquiry*, p. 63. Burke quotes this in the context of Job iv. 13–17.

28. P. 9 of the 1745 edition that Blake used.

29. See Damon, *A Blake Dictionary* p. 329.

their rather slapdash quality. Later he would use elements of some of them for other pictures: the scowling head of Satan in "*He Cast Him Into the Bottomless Pit and Shut Him Up*" (see below), the corpses of Time and Death for the *Paradise Lost* design *Michael Foretelling the Crucifixion* (Boston Museum of Fine Arts), and the choiring angels of *Job* 14. In the last it is the Creation that the angels greet, but this is also present in Young's text, in which the Concave rings "louder far, than when Creation rose" (p. 19). Details such as this indicate how faithfully Blake, who could, in his *Night Thoughts* series, range far from the Young poem, illustrated the apocalyptic section of Night IX, no doubt because he shared Young's interest in its eschatalogical theme. These designs, however, are not as memorable as two in which Blake introduced apocalyptic subject matter only tenuously related to passages in Young: water colors 78 and 345, which rank among Blake's most powerful designs.

Significantly, these two water colors are title pages for individual Nights – III and VIII. Blake seems to have given his *Night Thoughts* title pages considerable attention, probably because, knowing that only a relatively few of his drawings would be engraved, he assumed that the title pages would necessarily have to be among these. This was true of the 1797 edition, comprising four Nights, in which 78 appears in engraved form on page 43; had the Edwards edition been continued, it would no doubt have been true for the remaining Nights as well. The title pages for Nights III and VIII take as their real subjects the Woman Clothed with the Sun threatened by the dragon of Rev. xii and the whore and the beast of Rev. xvii. Although, as we have seen, Young worked the Day of Wrath and Last Judgment into Night IX, Nights III and VIII are free of apocalyptic subject matter, and it is Blake who introduces it.

The title page of Night III (Pl. 33) bears Young's title "Narcissa," and the young woman who is the central figure is therefore to be identified with Young's poetic name for the stepdaughter whose untimely death he laments. At the same time, she is the Woman Clothed with the Sun, standing on the crescent moon and wearing a diadem of stars. The fact that her diadem comprises seven stars rather than the twelve of Rev. xii. 1 may be an attempt to link her with the Pleiades and thus to classical myth as well as to Revelation. In that case, she may also embody the goddess Cynthia, as has been suggested by W.J.T. Mitchell, who points out that early in Night III, Young addresses the Duchess of Portland as "Thou who didst lately borrow Cynthia's form" (at a masquerade).[30] This aspect of the design involves, in Mitchell's words, "a transformation of his [Young's] stoic, latitudinarian morality, stale Greek mythology, and urbane social flattery into a visionary, enthusiastic and apocalyptic statement."[31] It is not necessary to choose between Cynthia and Narcissa here, as Blake conflates both into the Woman Clothed with the Sun aspiring towards Eternity while the serpent of Time tries to envelop her in its folds.

In Young's text (pp. 47–8 of Edwards), the creature threatening Narcissa is a raven, but to complete his apocalyptic configuration, Blake chose a giant serpent much like the Orc serpent of the title page of *Europe*. The anonymous "Explanation of the Engrav-

30. Edwards, p. 46. See Mitchell's review of the Oxford *Night Thoughts* edition, *Modern Philology*, LXXX (1982), 202–3.

31. *Ibid.*, pp. 202–3.

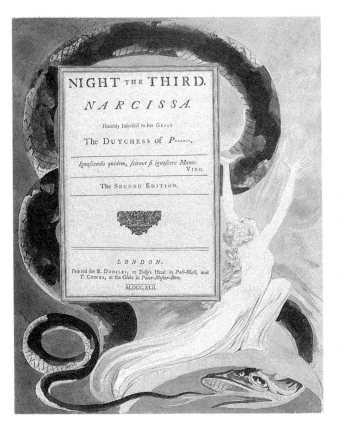

ings" attached to some copies of the Edwards edition takes this serpent as a symbol of Eternity, but, as I have pointed out elsewhere,[32] there are two concepts of Eternity represented in Blake's picture. One is the true Eternity suggested by the aspiring, radiant female figure. The other is the cycle of historical recurrence that presents an illusion of time going on forever: a false conception of Eternity that is suggested by the folds of the Orc serpent in *Europe*, later elaborated in "the twenty Seven/Folds" of Orc in *The Four Zoas*, which in turn become "the Twenty-seven Heavens & their Churches" in *Jerusalem*.[33] Narcissa herself anticipates the Jesus of *Jerusalem* 75, who, after the Churches of history are named and after Rahab, the Whore of Babylon, is revealed, "breaking thro' the Central Zones of Death and Hell/Opens Eternity in Time & Space; triumphant in Mercy."[34]

Although the Dragon and the Woman was a frequent subject of apocalyptic illustration from early in the Christian era,[35] there is no certainty that Blake was familiar with any of the traditional representations save that of Dürer (Pl. 35), whose woodcut does not, however, seem to have influenced Blake's *Narcissa*. A little closer to Dürer in spirit is the Night VIII frontispiece with its grotesque dragon (Pl. 34), but Blake's whore is vapidly ugly rather than seductive-looking, as is Dürer's, and Blake's rendering is

32. "Blake's *Night Thoughts*," pp. 152–3. See also Essick and La Belle, p. xii.

33. *The Four Zoas*, IX, 119:3–4, *Complete Poetry and Prose*, p. 388; *Jerusalem* 75: 10, *Complete Poetry and Prose*, p. 230.

34. 75: 22–23, *Complete Poetry and Prose*, p. 230.

35. See Frederick van der Meer, *Apocalypse*: Visions from the Book of Revelation in Western Art (New York: Alpine Fine Arts Collection, 1978), *passim*.

33 (facing page left). William Blake. Young's *Night Thoughts*: Night III, title page.

34 (facing page right). William Blake. Young's *Night Thoughts*: Night VIII, title page.

35. Albrecht Dürer. *The Woman Clothed With the Sun. Apocalypsis cum figuris.*

iconographically highly individual. Evidently Blake's pretext – a very thin one – for introducing the apocalyptic situation was Young's title for Night VIII:

<div align="center">

VIRTUE'S APOLOGY

OR,

The MAN of the WORLD Answer'd

In which are Considered
The Love *of* This Life;
The Ambition and *Pleasure*, with the *WIT*
and *WISDOM* of the *WORLD*.

</div>

It is a long way from this to Rev. xvii, but the subject is obviously one that Blake longed to execute, and he became the first British artist of his time to do so, anticipating West by two or three years.[36]

"The Beast & the Whore rule without controls," Blake wrote on the verso of the title page of Bishop Richard Watson's *Apology for the Bible*, published in 1797.[37] For Blake, Watson's *Apology* and Young's *Virtue's Apology* were rationalizations of a dead existing order and the projection of that order onto the world to come. Accustomed to think in

36. There are also later pictures of it attributed to John Martin (see Chapter VI) and by Richard Westall (in *Illustrations of the New Testament* by Westall and John Martin, 1836).

37. *Complete Poetry and Prose*, p. 611.

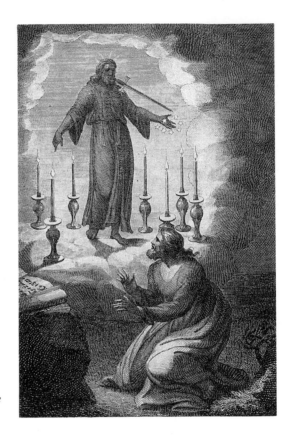

36. William Blake after Bernard Picart. *The Vision of the Seven Golden Candlesticks.*

terms of the Apocalypse, Blake wrote and drew his interpretation of the reality underlying such conceptions, using images from Revelation. The result in the frontispiece to Night VIII is one of Blake's most memorable pictures. The Whore of Babylon, whom Blake will call Rahab in *The Four Zoas*, is dressed in scarlet and rides on the dragon's back. In her left hand she holds her cup of abominations, which corresponds to the goblet signifying debauchery all through the *Night Thoughts* series, as in the picture of Belshazzar and Daniel. She wears the spiked crown that also runs through the series, an emblem of dominion. As in Rev. xvii. 5, there is an inscription beginning with the word "Mystery" on her forehead. The beast has seven wonderfully grotesque faces, each of which can be identified by its headgear. From right to left they are a judge (judicial wig), warrior (helmet), king (crown), pope (tiara), emperor (crown), bishop (mitre), and priest (biretta). Blake's daring antinomian strategy is to make the seven-headed beast represent the institutions of Church and State that conjoin with the worldly corruption represented by the whore. The dragon's red tail undulates against a background of stars, reminding us of the configuration in Night VIII of *The Four Zoas*, where "Orc augmented swift/In fury a Serpent wondrous among the Constellations of Urizen" and "the dark shadowy female . . . spread herself through all the branches in the power of Orc."[38]

38. 101 (first portion): 7–8, 25, p. 373.

80

In 1782 Blake had executed a drawing (British Museum) and an engraving illustrating John's Vision of the Seven Golden Candlesticks for the *Royal Universal Family Bible* (Pl. 36). But since this design has been shown to be after an earlier Bible illustration by Bernard Picart,[39] it can be said that Blake's first original Revelation designs unmediated by another text, whether Young's or his own, were executed for his friend and patron Thomas Butts. If Richard Edwards was to Blake, on a somewhat smaller scale, what Macklin was to de Loutherbourg, Butts was, on a greatly reduced scale, what Beckford was to West: a patron who allowed the artist to embody in a series of pictures his particular bent for apocalyptic subject matter.

Among the many biblical pictures by Blake purchased by Thomas Butts, ten are Revelation subjects and two more are Last Judgments. Among the former, two present scenes from John's vision too limpidly calm to be classified with the apocalyptic sublime, so these require only brief mention here. The glowingly colored *The Four and Twenty Elders Casting their Crowns before the Divine Throne* (c. 1803–5, Tate Gallery), illustrating Rev. iv. 2–10 and v. 1, is an extremely symmetrical composition structured along the lines of a triangle surmounted by an arch.[40] In the four figures who stand beside the throne and whose faces are also glimpsed behind it, Blake has characteristically conflated his symbolism with John's: these are at the same time the "four beasts filled with eyes" of Revelation and Blake's own Zoas. (Blake would introduce four similar figures into his much later Dante illustration *Beatrice Addressing Dante from the Car* [Tate Gallery], in which Revelation is treated as the subtext of the end of the *Purgatorio*.) Likewise, *The River of Life* (Tate Gallery), with its curvilinear human forms, undulating river, and pastoral details reminiscent of the *Songs of Innocence*,[41] is an example of what might be called the apocalyptic beautiful.

The first of Blake's Revelation pictures for Butts was either *Death on a Pale Horse* (Pl. 37) or *"He Cast Him Into the Bottomless Pit and Shut Him Up,"* both executed c. 1800.[42] Both are strongly linear drawings representative of Blake's adhesion, in his own particular way, to what Robert Rosenblum has termed "the international Style of 1800."[43]

It is instructive to compare Blake's *Death on a Pale Horse* (Fitzwilliam Museum, Cambridge) with the previous treatments of the subject by Mortimer and by West, as well as with de Loutherbourg's *Vision of the White Horse*. Blake's design eschews the theatricality of the others, presenting instead a highly stylized, two-dimensional appearance. Iconographic details are imported from Blake's illuminated books and *The Four Zoas*: Death, white-bearded and crowned, is Urizen; his archetypal nature is emphasized by his improbable costume – heavy armour and a sandal. The Rider on the Black Horse wears scaly armor that seems virtually part of his body, as do a number of Blake's other demonic warriors, such as the central figure of *Europe* 8.[44] Sharply con-

39. As Michael J. Tolley discovered; see Robert N. Essick, *William Blake Printmaker* (Princeton: Princeton University Press, 1980), p. 48n.
40. See Anne K. Mellor, *Blake's Human Form Divine* (Berkeley and Los Angeles: University of California Press, 1974), p. 197.
41. See Bindman, *Blake As an Artist*, p. 145.
42. See Butlin, *Paintings and Drawings*, nos. 517 and 524.

43. See Rosenblum's New York University dissertation, *The International Style of 1800: A Study in Linear Abstraction*, 1956 (New York and London: Garland, 1976). Blake is discussed on pp. 99–114.
44. On Blake's sources for this type of armor, see my essay "'Wonderful Originals' – Blake and Ancient Sculpture," in *Blake in His Time*, pp. 175–6.

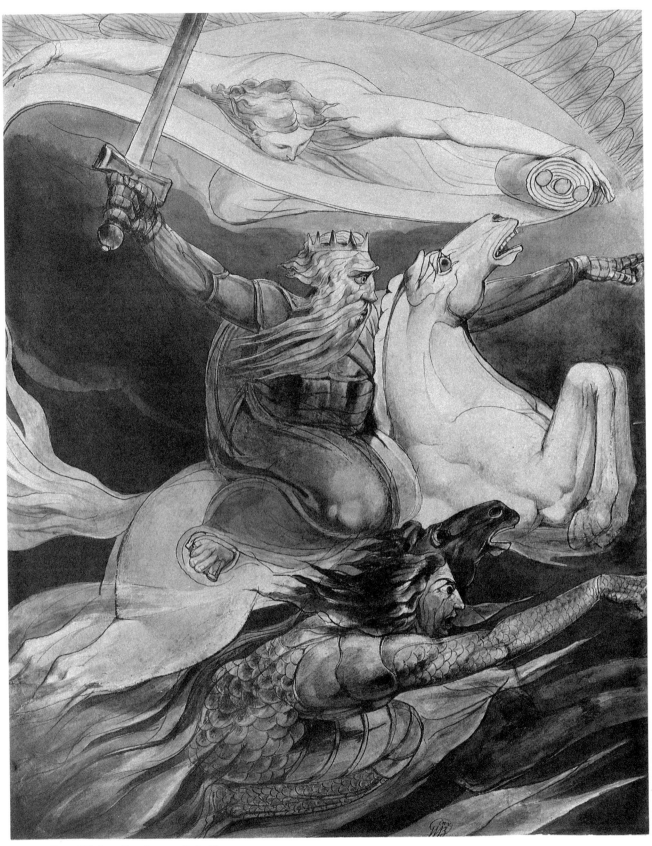

37. William Blake. *Death on a Pale Horse*.

trasted with these two near-grotesques is the graceful angelic form unfolding a scroll above them. Three seals of the scroll remain unopened, since Death makes his appearance after the opening of the fourth seal. As Martin Butlin remarks, the pictures by Mortimer, West, and de Loutherbourg "are all relatively naturalistic, the figures being shown as three-dimensional corporal realities in a definable space, whereas Blake has produced a flat, emblematic composition, all the more convincing for its lack of naturalistic elements."[45]

One detail of this picture that has not been discussed previously is the feathers that emanate from the disc of the sun in the upper part. Feathers are not mentioned in Revelation, but Blake may be making a cross-reference to Psalm 91 here: "He [God] shall cover thee with his feathers, and under his wings shalt thou trust; his trust shall be thy shield and buckler" (v. 4). There may alternatively or additionally be a reference to Malachi iv. 2: "But unto you that fear my name shall the sun of righteousness arise with healing in his wings,"[46] lines that were adapted by Charles Wesley in his great hymn "Wrestling Jacob." Such a reference to Malachi iv would be especially appropriate because the first verse of that chapter reads: "For behold, the day cometh, that shall burn as an oven; and all the proud, yea and all that do wickedly shall be stubble: and the day that cometh shall burn them up, saith the Lord of Hosts, as it shall leave them neither root nor branch." In the editorial arrangement of the Christian Bible, moreover, Malachi is the last book of the Old Testament as Revelation is of the New. It seems likely, then, that the yellow feathers in *Death on a Pale Horse* suggest both the shield and buckler of Psalm 91 and the healing of Malachi, countering the sword wielded by Death in this picture and healing the wounds that it deals.[47]

"*He Cast Him Into the Bottomless Pit and Shut Him Up*" (Fogg Art Museum) (Pl. 38) was once known as *Michael Binding Satan*, but Butlin points out that inscribed on the mount in a copperplate hand are the words "Rev^ns: ch: 20th: v. 1 & 2," with the title written out above and the rest of the text below.[48] The subject then is not, as has been suggested,[49] Michael's casting Satan out of heaven (Rev. xii. 7–9) but John's vision of an angel with a key and a chain who "laid hold on the dragon, that old serpent, which is Satan, and bound him a thousand years, and shut him up . . ." These two episodes are of course very similar when visualized, and it is interesting to compare Blake's picture with de Loutherbourg's Macklin Bible illustration, which Blake is likely to have known at least through John Landseer's engraving, and with an interesting group of illustrations to Rev. xx. 1–3 by Edward Francis Burney. De Loutherbourg's design, as we have seen, follows the tradition of Raphael and of Guido Reni[50] in presenting a scene

45. *William Blake*, p. 184.

46. I thank Dr. Bo Ossian Lindberg for this suggestion. It also seems to me that the feathered head in the upper part of *Jerusalem* 62 may be an anguished sun of righteousness.

47. It should be noted that the sun of righteousness in Malachi was in some medieval commentaries identified as Christ. See *The Jerusalem Bible*, ed. Alexander Jones (London: Darton, Longman, and Todd, 1966), p. 1547, n.j.

48. *Paintings and Drawings*, no. 524, p. 371.

49. See E. J. Rose, "Ut Pictura Poesis and the Problem of Pictorial Statement in William Blake," in *Woman in the Eighteenth Century and Other Essays*, ed. Paul Fritz and Richard Morton (Toronto: Hakkert & Co., 1976), pp. 294–5.

50. Blake could also have known the Raphael and Reni designs through engravings. In the Kitto Bible (Huntington Library), for example, there are engravings of the subject by Chatillon after Raphael (no. 11047) and by two anonymous engravers after Reni (nos. 11043 and 11044).

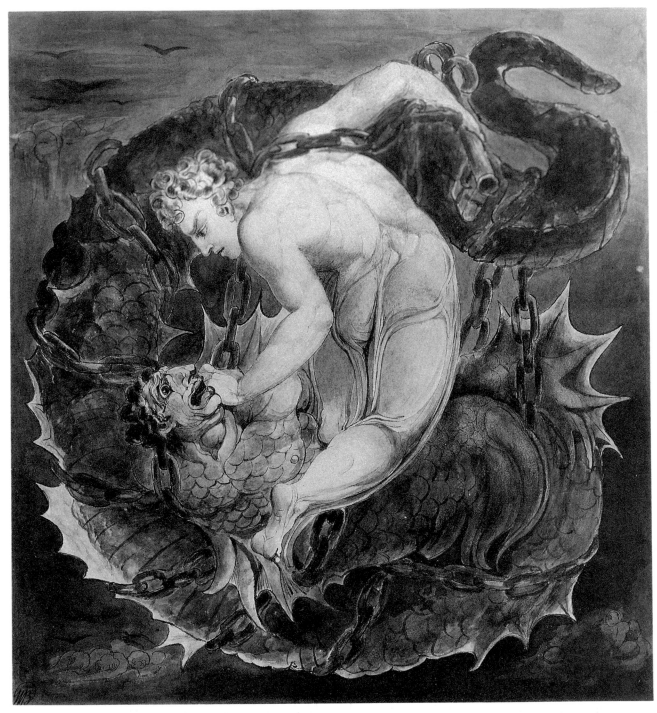

38 William Blake. *"He Cast Him Into the Bottomless Pit and Shut Him Up"*.

of heroic action in which the idealized Michael is a powerful vertical figure contrasted with the defeated Satan below him. Burney's conception is of a beautiful, feminine angel who, evincing great delight, lays hold of, binds, casts in, and locks up a muscular, armed warrior; here the contrast is between the delicate cursiveness of the white-

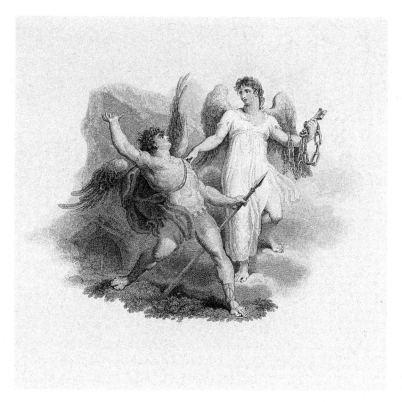

39. J. Fittler after
Edward Francis
Burney. *Satan seized by
the Angel.*

gowned angel and the powerful but impotent masculinity of Satan (Pl. 39).[51] Blake's
design, in contrast, conveys neither heroism nor desire. His Satan is a caricature who
looks unhappy at being entrapped not so much by the angel's chain as by his own
reptilian body, and the antagonists are enclosed in a circular composition that has
reminded some commentators of capital letters in medieval manuscripts.[52] Such a
degree of stylization and abstraction precludes an emotional response to the picture,
which can instead be perceived intellectually as a demonstration of interrelatedness,
like the *yin* and *yang* of the well-known Taoist figure.[53]

Another angel-centered picture for Revelation is "*And the Angel Which I Saw Lifted Up
His Hand to Heaven*" (Metropolitan Museum of Art), often known as *The Angel of
Revelation* (Pl. 40). Dated by Butlin as *c.* 1805, this water color is closely related to an
Old Testament composition for Butts, *Ezekiel's Wheels* (Boston Museum of Fine Arts),
which may be a year or two earlier.[54] In *Night Thoughts* 474 Blake had portrayed Ezekiel
as kneeling before the visionary wheels ringed with eyes, but for Butts he drew a tiny
Ezekiel viewing an enormous cherub above him. Such a dramatic contrast in size is
frequently a characteristic of the sublime and is once more emphasized in the illustra-
tion to Rev. x. 1–6. In this instance the gigantic figure is in the position of the Colossus
of Rhodes, an image that Blake may have derived from Heemskerck[55] or from Fischer

51. See Appendix 2, "Edward Francis Burney."
52. See Blunt, *The Art of William Blake*, p. 60 and pl. 59b;
Mellor, p. 269.
53. See S. Foster Damon, *William Blake: His Philosophy
and Symbols* (Boston: Houghton Mifflin, 1924),
p. 222; see also W.J.T. Mitchell, "Metamorphoses
of the Vortex: Hogarth, Turner, and Blake," in
Articulate Images, p. 158.
54. For dating, see Butlin, *Paintings and Drawings*, nos.
468 and 518.
55. See Bindman, *Blake As an Artist*, p. 247, n. 9.

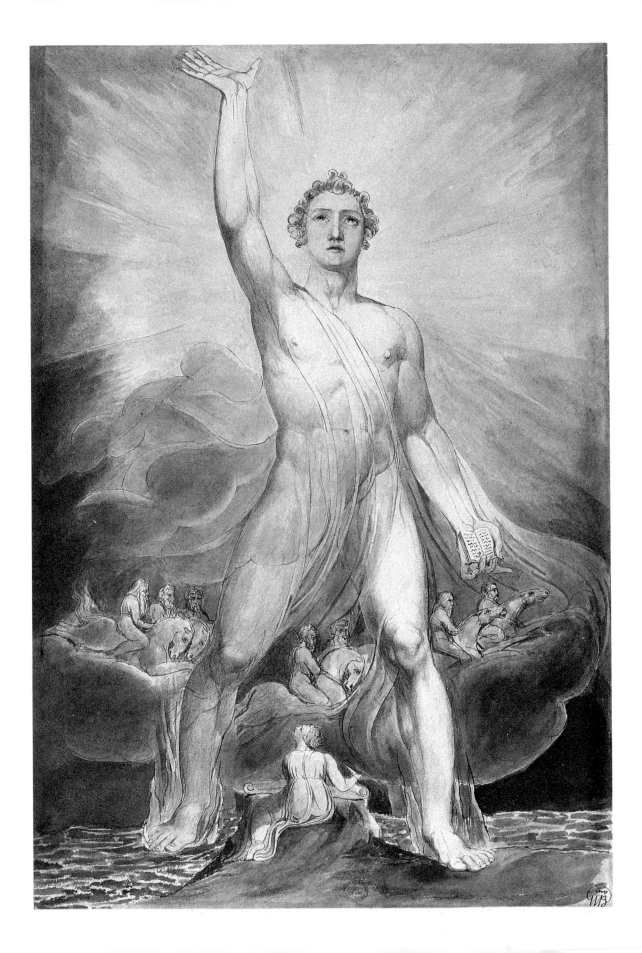

von Erlach:[56] legs spread apart and right arm upraised. In his left hand he holds the book that John will eat in Rev. x. 10 – a subject that Dürer chose for one of his Apocalypse woodcuts. In thick clouds behind the angel we see the "seven thunders" of John's vision personified as horsemen.[57] John himself sits at a sort of natural desk formed by the rock of the isle of Patmos. He is in the posture in which he is often traditionally represented (see p. 41 above) with a quill pen in his hand, regarding the vision he is about to describe in writing.

Perhaps the most dramatically striking of the Butts Revelation designs are four water colors related to texts in chapters xii and xiii. "In no other case," Butlin observes, "does Blake devote so many illustrations to a mere two chapters of the Bible."[58] These designs were not executed *seriatim* but, as has been suggested, as two pairs: 519 and 521, then 520 and 522.[59] Since, however, these four pictures were produced for a single patron over a period of not more than three years we may assume that in Blake's mind they constituted a series, and they are best discussed as such – as scenes from an "apocalyptic theatre"[60] in which Blake dramatized symbolic meanings that he also elaborated in his own illuminated poems.

In *The Great Red Dragon and the Woman Clothed with the Sun* (c. 1803–5, Brooklyn Museum) (Pl. 41), Blake presents a composition very different from that of West's picture, which Blake would have seen exhibited at the Academy a few years before. Blake's dragon towers with his back to the viewer. Three of his seven heads (which Blake has given crowns) are visible, connecting him with the three-headed Satan of Dante's *Inferno*, later illustrated by Blake, and with the Satanic accuser Hand in *Jerusalem*:

> His bosom wide & shoulders huge overspreading wondrous
> Bear Three strong sinewy Necks & Three awful & terrible Heads
> Three Brains in contradictory council brooding incessantly.
> Neither daring to put in act its councils, fearing each-other,
> Therefore rejecting Ideas as nothing & holding all Wisdom
> To consist. in the agreements & disagree[me]nts of Ideas.
> Plotting to devour Albions Body of Humanity & Love.[61]

A frontal view of this three-headed monster, dwarfing the white cliffs of Dover which form his seat, is given on the lower part of *Jerusalem* 50.

The gigantic size of Blake's Great Red Dragon is suggested by his more than filling the picture space. His tail, with which he "drew the third part of the stars of heaven" (Rev. xii. 4), is powerfully emphasized. Its lower part curves off to the left in a serpentine manner (*cf.* the title page to Young's Night III), while the upper part becomes part

56. See my "The Fourth Face of Man," p. 186 and plates 8–1 and 8–2.
57. See Harvey Stahl, *William Blake: the Apocalyptic Vision* (Purchase, N.Y.: Manhattanville College, 1974), no. 21.
58. *William Blake*, p. 95.
59. See Martin Butlin, "Thoughts on the 1978 Tate Gallery Exhibition," *Blake: An Illustrated Quarterly*, XIII

(1979), 19–20; and Robert N. Essick, Review of Butlin's *Paintings and Drawings*, *Blake*, XVI (1982), 41.
60. This term, employed by Joseph Mede with reference to Revelation, is applied to Blake's work in my *The Continuing City: William Blake's "Jerusalem"* (Oxford: Clarendon Press, 1983).
61. 70: 3–9, *Complete Poetry and Prose*, p. 224.

40. William Blake. "*And the Angel Which I Saw Lifted Up His Hand to Heaven.*"

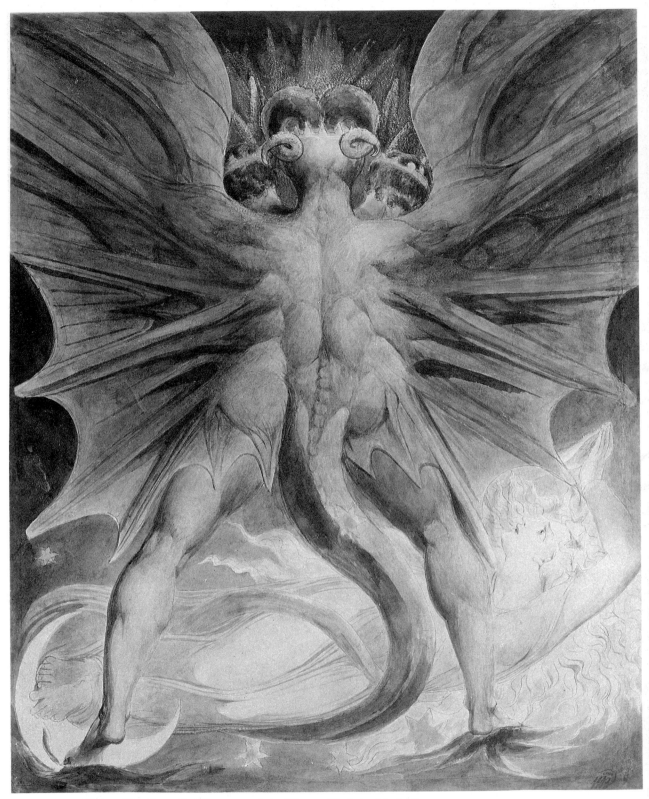

41. William Blake. *The Great Red Dragon and the Woman Clothed with the Sun.*

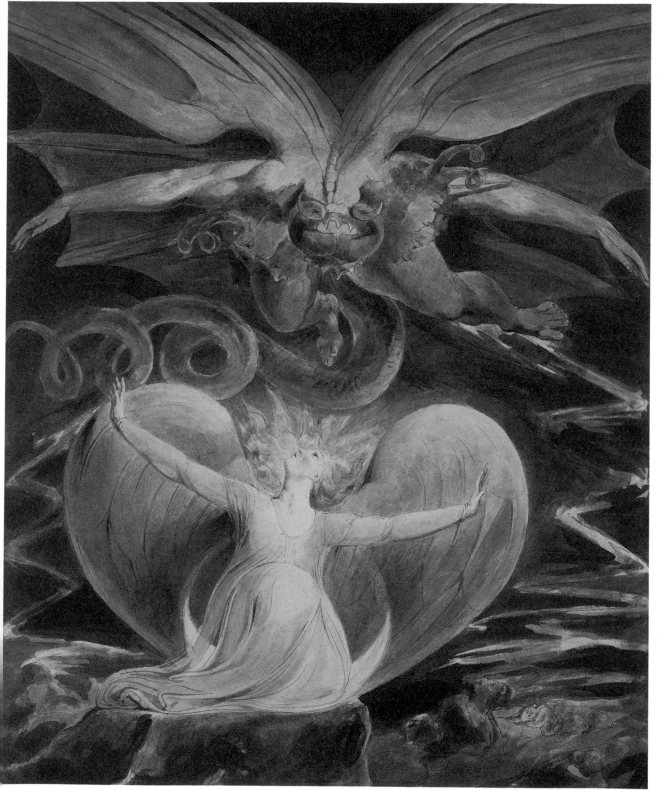

III. William Blake. *The Great Red Dragon and the Woman Clothed with the Sun: "The Devil Is Come Down."*

of the dragon's spine, recalling images associated with the formation of the material world in the Lambeth books:

> In a horrible dreamful slumber;
> Like the linked infernal chain;
> A vast Spine writh'd in torment
> Upon the winds . . .[62]

> . . . Los beheld
> Forthwith, writhing upon the dark void
> The Back bone of Urizen appear
> Hurtling upon the wind
> Like a serpent![63]

This spine/backbone configuration troped into chain and serpent, suggesting imprisonment in the material world and in cyclical time, reappears in the spine and tail of the Great Red Dragon. His bat-like wings also recall images from the illuminated books – for example, the Spectre's bat wings in the designs to *Jerusalem* 6 and 37/33. The central head of the dragon also resembles that of the *Jerusalem* 6 Spectre: each is like the greatly magnified head of a house fly.

The Woman Clothed with the Sun in this picture is horizontal, the dragon's victim, her face expressing, as Janet Warner had pointed out, "astonishment," as in one of LeBrun's diagrams.[64] In "*The Devil Is Come Down*" (National Gallery of Art, Washington, D.C.) (Col. Pl. III), the woman is turned upright and is, in accordance with Rev. xii. 13, "given the wings of a great eagle." These wings are, however, more cursive than an eagle's could possibly be, and therefore they contrast all the more with the sharp angularity of the dragon's bat wings. His fly-like central head, jointed spine, and serpentine tail have become even more prominent than in the previous design. The juxtaposition of dragon and woman is again reminiscent of the lower design of *Jerusalem* 37/33, where bat-winged Spectre hovers over bird-winged Jerusalem. In "*The Devil Is Come Down*", however, there is a certain complementarity in the postures of the two figures, as if they were, in Warner's words, "two aspects of the same psyche . . . an image of the demonic and regenerative impulses of fallen man . . ."[65]

Blake's characteristic depiction of monsters borders on the grotesque, for reasons that have been discussed in connection with the Leviathan and Behemoth of *Job*[66] and that are equally applicable to the Great Red Dragon and other "beasts" of Revelation in the Butts water colors: such gigantic embodiments of earthly power are in Blake's view jokes on their own existences. This can again be seen in the third of the four "Beast" water colors, *The Great Red Dragon and the Beast from the Sea* (National Gallery of

62. *The [First] Book of Urizen* 10: 35–38, *Complete Poetry and Prose*, p. 75.

63. *The Book of Los*, 5: 12–16, p. 93.

64. See Janet Warner, *Blake and the Language of Art* (Kingston and Montreal: McGill-Queen's University Press, 1984), p. 40–42. Blake's professed dislike of LeBrun need no more than his professed dislike of Burke have prevented him from adapting whatever he wanted from the ideas of either.

65. *Ibid.*, p. 104.

66. See Milton O. Percival, *William Blake's Circle of Destiny* (New York: Columbia University Press, 1938), p. 270; and Morton D. Paley, *Energy and the Imagination* (Oxford: Clarendon Press, 1970), pp. 196–7.

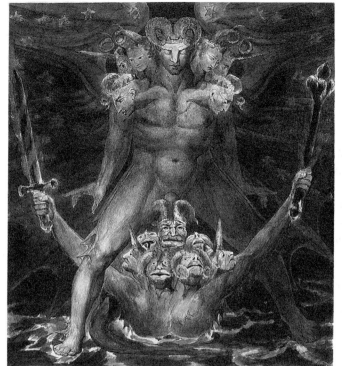

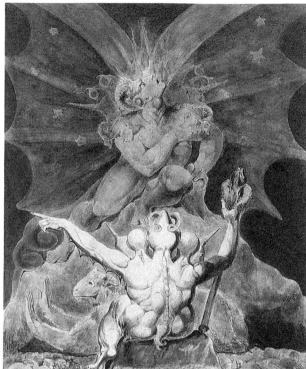

42. William Blake. *The Great Red Dragon and the Beast from the Sea.*

43. William Blake. *The Number of the Beast Is 666.*

Art, Washington, D.C.) (Pl. 42). Here Blake has scrupulously rendered the precise number of heads given in the text: ten for the upper figure, seven for the lower. With so many heads, not to mention horns and crowns, the grotesque, that uncomfortably close neighbor of the sublime, is inevitable. This is true also of *The Number of the Beast Is 666* (The Rosenbach Museum and Library, Philadelphia) (Pl. 43), in which the perspective of the preceding episode is reversed. We now have a rear view of the Beast from the Sea while the Great Red Dragon faces us with his bat wings outspread. Each wing has on it seven stars, a detail not in the biblical text here but no doubt to be associated, as the stars in the frontispiece to Young's Night VIII, with the stars of Urizen. Between these two beasts is placed a newcomer, one who "had two horns like a lamb" (Rev. xiii. 11). Blake has given him the body of a lamb as well, except for the human hands he extends in a gesture of false blessing, for "he deceiveth them that dwell on the earth by the means of those miracles which he had power to do in the sight of the beast" (14).

As *The Number of the Beast Is 666* illustrates the same text as West's *Beast Riseth Out of the Sea*, a picture Blake had the opportunity to see at the Royal Academy exhibition of 1798, it is interesting to compare the two. West's monsters are as grotesque as Blake's, but West introduces a contrast in the human figures on the foreshore, three of which – two women and an infant – can be said to embody the Burkean beautiful. In Blake's rendition, the tiny human figures beneath the altar create a different kind of contrast; as in de Loutherbourg's Revelation tailpiece, these diminutive worshippers induce a sense of the apocalyptic sublime by creating an enormous difference in scale. Furthermore, West gives considerable contour to the beasts, a three-dimensionality that Blake's lack. The difference is like that between a scene in de Loutherbourg's

91

eidophusikon, where one marvels at the ingenuity of the figures, and an "apocalyptic theater," a theater of the mind in which we never lose sight of the symbolic nature of the events represented.

Considering the importance to Blake of the harlot and the beast of Revelation xvii. 1–6, it is probably inevitable that he would make this the subject of an illustration to the Bible. In *The Whore of Babylon* (*c.* 1809, British Museum), the dragon has seven ugly human heads; the plump whore, stripped to the waist, rides him side-saddle holding her golden cup out of which fly personified "abominations and filthiness and fornications." The major figures have more contour than did those in the Beast subgroup, but there is still no attempt at versimilitude. Once again the appeal is to the mind through the eye. The viewer is made aware of the typological nature of the figures and is stimulated to extend their meaning to his own time, as in the "spiritual portraits" of two modern "heroes" that Blake exhibited in his one-man show of 1809.

During the years in which he produced the last of his Revelation illustrations for Butts, Blake was also painting two ambitious temperas in which he combined eschatological imagery from the Bible with figures from contemporary history. These were *The Spiritual Form of Nelson guiding Leviathan* (Pl. 44) and *The Spiritual Form of Pitt guiding Behemoth*. These were probably painted some time between the deaths of his subjects in 1805 and 1806 respectively and Blake's exhibition with its accompanying *Descriptive Catalogue* of 1809. At some point these two were joined by the now lost *Spiritual Form of Napoleon* to compose an unholy trinty in which the apocalyptic forces of history are seen acting through leaders who neither control nor understand the events that they seem to guide.

As I have discussed the *Pitt* and *Nelson* paintings at length elsewhere,[67] consideration of them here can be concentrated upon their relation to the apocalyptic Bible illustrations with which they are roughly contemporary. Blake writes of his Pitt

> ... he is 'that Angel who, pleased to perform the Almighty's orders, rides on the whirlwind, directing the storms of war: He is ordering the Reaper to reap the Vine of the Earth and the Plowman to plow up the Cities and Towers.'[68]

As in *Death on a Pale Horse*, Blake seems to be conflating Old and New Testament references into a single apocalyptic statement: the activity of reaping the vine of the earth and pressing the grapes is the subject of Rev. xv. 15–20, while the figures of the plowman and the treader of the grapes are part of the description of the Last Days in Amos ix. 13.[69] Similarly, in Night IX of *The Four Zoas* the activities of plowing and reaping are a prelude to the Last Judgment. The difference between the spiritual portraits and the Bible illustrations is of course that the former feature contemporary historical characters; the similarity is in the appearance of seemingly sublime, angelic forms and grotesque monsters in visions of the Last Days.

The spiritual form of Pitt occupies the role of the angel in "*And the Angel that I saw Lifted His Hand to Heaven*" – a gigantic figure towering over tiny humans as the angel

67. See *Energy and the Imagination*, pp. 170–99.

68. *A Descriptive Catalogue in Complete Poetry and Prose*, p. 530.

69. On the derivation of the plowman, see Lindberg, *William Blake's Illustrations to the Book of Job*, (Åbo, Finland: Åbo Akademi, 1973), p. 309.

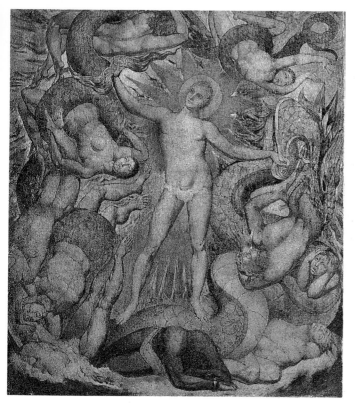

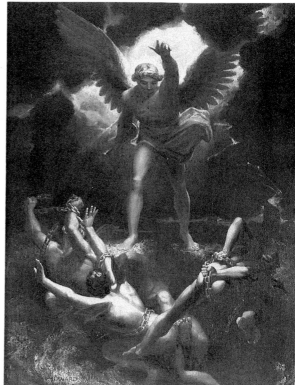

44. William Blake. *The Spiritual Form of Nelson guiding Leviathan.*

45. Henry Howard. *The Sixth Trumpet Soundeth.*

towers over John. The monster Behemoth, who in *Jerusalem* is identified as "the War/by Land astounding,"[70] takes the place of the apocalyptic beasts in *The Great Red Dragon* and its successors. The *Nelson* is similarly characterized by the conjunction of an angelic-looking, central figure and a grotesque monster, in this instance Leviathan, who is in *Jerusalem* "the War by Sea enormous."[71] It is as if in this picture Blake had rearranged the figures of "*He Cast Him Into the Bottomless Pit and Shut Him Up*" so as to make them collaborators instead of antagonists. There is also a strong compositional similarity to Henry Howard's painting *The Sixth Trumpet Soundeth* (Royal Academy), exhibited in 1804, in which the angel of Rev. ix. 13–15 stands above four naked figures forming an arc beneath him (Pl. 45). In the two temperas, however, the angelic figures are ironical parodies of the sublime, directing the Armageddon that is, unknown to them, a prelude to the Last Judgment and the descent of the New Jerusalem.

The frequent proximity of Blake's apocalyptic sublime to the grotesque has been mentioned but deserves further comment. In some ways, Blake's apocalyptic beasts and his Leviathan and Behemoth can be seen as creating the "estranged world" that Wolfgang Kayser sees as characteristic of grotesque works of art.[72] Indeed, Kayser places Blake in the line of Bosch, Bruegel, Grandville, Bresdin, and Redon as an artist

70. 91: 39–40, *Complete Poetry and Prose*, p. 251.
71. 91: 39, *Complete Poetry and Prose*, p. 251.
72. Wolfgang Kayser, *The Grotesque in Art and Literature*, trans, Ulrich Weisstein (New York: Columbia University Press, 1981), *passim*.

of what he terms the "fantastic" grotesque.[73] Pictures like *The Number of the Beast Is 666* and *"The Devil Is Come Down"* could be taken as illustrations of "images of a world in the process of dissolution and estrangement,"[74] paradoxically characterized by their "remarkable emphasis on realistic details"[75] (there is nothing vague or obscure in Blake's rendering of the text of Revelation). Indeed, Kayser's examples of the grotesque in art and literature frequently involve apocalyptic subject matter.[76] There is, however, one important way in which Blake's art never becomes completely grotesque in Kayser's sense. No matter how strange, Blake's monsters are always part of a structure of meaning. Far from creating that sense of the dissolution of all meaning that constitutes purely groteque art according to Kayser, they are signifiers of the oncoming final definition of all meanings that Blake calls the Last Judgment.

For Blake's contemporaries *the* Last Judgment was of course Michelangelo's Sistine Chapel fresco. According to Blake's friends Fuseli and Flaxman, the uniqueness of the Michelangelo was twofold: its sublimity and its variety. Fuseli, in one of the lectures he published in 1801 with an engraving of Michelangelo by Blake, wrote:

> He [Michelangelo] is the inventor of epic painting, in that sublime cycle of the Sistine Chapel, which exhibits the origin, the progress, and the final dispensation of theocracy ... In the last judgment, with every attitude that varies the human body, [he] traced the master-trait of every passion that sways the human heart.[77]

Flaxman, who had spent the years 1787–94 in Italy, later wrote of the Michelangelo *Last Judgment* as superior to Rubens's *Fall of the Angels*

> in the sublimity and extent of character and action – in the gradations of sentiment and passion, from exalted beatitude to the abyss of hopeless destruction – in the kinds and species of those degrees, – in relations to the theological and cardinal virtues, opposed to the seven deadly sins, – in uncommon, original, distinct and fit appropriation in the groups or separate figures.[78]

When Blake came to render his own versions of the subject, he too would incorporate the characteristics of sublimity and variety – but, as ever, with a difference.

Since, unlike Fuseli and Flaxman, Blake never had an opportunity to see Michelangelo's original, he would have had to rely on engravings for his knowledge of the composition. The early rendition by Julio Bonasone[79] in the collection of Blake's friend George Cumberland may have been of particular interest to him, because, in Cumberland's words, "It gives the truest idea of any print extant, of that sublime performance, and being done before the figures were *apron'd*, is doubly interesting."[80] It is also

73. *Ibid.*, p. 173. Kayser distinguishes this from the "satiric" grotesque, of which (though not mentioned in Kayser's study), Gillray would be a good example.

74. *Ibid.*, p. 43.

75. *Ibid.*, p. 73.

76. See for example *ibid.*, pp. 34, 55, 61.

77. Henry Fuseli, *Lectures on Painting*, Delivered at the Royal Academy, March 1801 (London: J. Johnson, 1801), p. 62. See also p. 129.

78. John Flaxman, *Lectures on Sculpture* (London: John Murray, 1829), pp. 182–3. Flaxman commenced his Royal Academy lectures in 1810, after Blake's Last Judgment drawings had been executed, but of course the two friends had ample opportunity to discuss the subject any time after Flaxman's return from Italy.

79. Cumberland's *Some Anecdotes of the Life of Julio Bonasone ... Accompanied by a Catalogue of the Engravings* was published in 1793.

80. *Ibid.*, p. 61, item 78.

possible that Blake knew other, earlier Last Judgments through drawings and engravings. He was evidently familiar with a Last Judgment engraving of *c.* 1530 by Cesare Reverdino, as he appears to have borrowed a figure from it for one of his *Job* designs.[81] He could easily have seen Flaxman's Pisan sketches of the *Triumph of Death* and the *Last Judgment* then attributed to Orcagna.[82] Another early Last Judgment that might especially have interested him was that of Luca Signorelli. Blake would have known that, according to Vasari, Signorelli's Orvieto frescoes had been a source for Michelangelo.[83] Both Flaxman and William Young Ottley (who would become one of the original purchasers of *Jerusalem* three decades later), journeyed to Orvieto to see and sketch the Signorelli frescoes.[84] Ottley later praised them in *The Italian School of Design*,[85] but with the qualification that "This great work is not exempt from that dryness of manner which characterizes the period of art at which it was executed, and it is deficient in delicacy of finishing"[86] – a criticism that would have made Blake favor the work even more. Fuseli in his *Lectures* of 1801 remarked of Signorelli:

> He seems to have been the first who contemplated with a discriminating eye his object, saw what was accident and what was essential; balanced light and shade, and decided the motion of his figures. He foreshortened with equal boldness and intelligence, and thence it is, probably, that Vasari fancies to have discovered in the last judgment of Michael Angelo traces of imitation from the Lunette, painted by Luca, in the Church of the Madonna, at Orvieto ...[87]

As Ottley mentions engravings of the Orvieto frescoes published at Rome in 1791,[88] it is possible that Blake knew these. There are in any event two striking similarities of detail between the Signorelli *Resurrection of the Flesh* and two of Blake's Last Judgment designs. One concerns the presence of a naked couple embracing in both Signorelli's *Resurrection of the Flesh* and in the lower left of Blake's Last Judgment illustration for Blair's *Grave*. This unusual feature for a Last Judgment picture would have had for Blake the meaning expressed in *Jerusalem*: "Embraces are Cominglings: from the Head even to the Feet";[89] in his later versions, however, he represented the couple more decorously. Also, at the bottom center of Blake's last drawing of the subject, there is a skeleton re-animating, and such skeletons are a prominent feature of the Orvieto *Resurrection of the Flesh*. In general it can be said that while for Blake, as for Fuseli and Flaxman, the Sistine *Last Judgment* was paramount, he tempered the influence of Michelangelo with a "primitive" manner approximating that of artists of the earlier Renaissance.

81. As pointed out by Lindberg, p. 208 and fig. 79.

82. See David Irwin, *John Flaxman 1755–1826* (London: Studio Vista/Christie's, 1979), pp. 41–2.

83. Blake could have known this through Fuseli's lectures, but Vasari's *Life of Michael Angelo* was available in English translation in William Aglionby's *Paintings Illustrated in Three Dialogues* (London, 1685) and in Aglionby's *Choice Observations upon the Art of Painting* (London, 1719).

84. See Irwin, pp. 41–2; and Giovanni Previtale, "Alle Origini del Primitivismo Romantico," *Paragone*, XIII (1962), 32–51. I thank Joel Miles Porte for translating the Italian.

85. London: Taylor and Hessey, 1823 (issued in parts starting in 1805).

86. *The Italian School of Design*, p. 16.

87. Pp. 57–8.

88. Ottley mentions a "book of prints intended to accompany Padre della Valle's *Storia del Duomo del Orvieto*" (*The Italian School of Design*, p. 4n.).

89. 69: 43, *Complete Poetry and Prose*, p. 223.

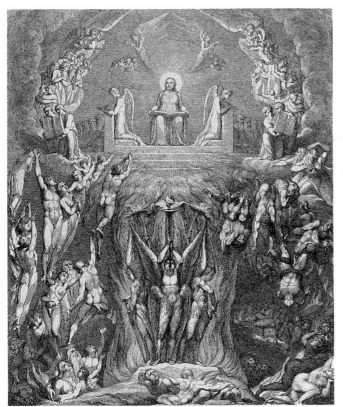
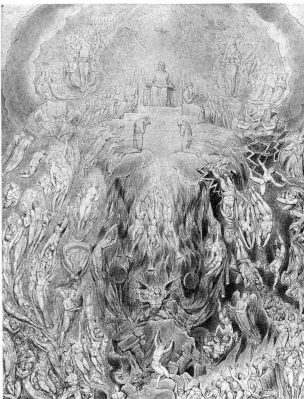

46. Louis Schiavonetti after William Blake. Robert Blair's
The Grave: The Day of Judgment.

47. William Blake. *The Last Judgment.*

Blake's first Last Judgment was almost certainly the drawing, now lost and known only, through Louis Schiavonetti's engraving (Pl. 46), that he made in 1805 or 1806 for the 1808 edition of Blair's *Grave*.[90] Unlike Young, Blair devoted no long passage of his poem to the Last Day, but Blake, still at work on *The Four Zoas* with its longest Night devoted to the Last Judgment, was much preoccupied with the subject. A few lines of Blair's about the last trump and the resurrection of the dead were sufficient to allow him to take advantage of the opportunity. (He also drew a highly finished water color *Resurrection of the Dead* [British Museum] that was not used for *The Grave*, whatever may have been the original intention.[91]) The Blair engraving contains some "Michelangelesque" figures, but neither the overall conception nor many of the details are directly indebted to those of the Sistine fresco.

Michelangelo's composition is essentially organized on three horizontal planes with Christ at a focal point at the median. Blake's, in contrast, displays strong bilateral symmetry, the three upright angels blowing their trumpets downward forming a vertical axis, with the enthroned Christ above them. In contrast to the athletic Christ of Michelangelo, Blake provides a robed, haloed, hieratic figure enthroned with the Book of Judgment on his lap. This is a medieval conception, and Blake's rendering is

90. See Robert N. Essick and Morton D. Paley, *Robert Blair's "The Grave" Illustrated by William Blake* (London: Scolar Press, 1982), pp. 64–6. 215–16.

91. *Ibid.*, pp. 71–2. As pointed out there, in this design the youth bearing scales and a scroll with a dangling seal seems related to Rev. vi. 5.

strikingly similar to that of the celebrated "Judgment Porch" at the south entrance of Lincoln cathedral, later reproduced as plate 39 of Flaxman's *Lectures on Sculpture*. There, too, Christ sits holding a book with angels on either side;[92] and winged angels form a Gothic arch over Christ in both compositions, but Blake adds eyes to their wings as an allusion to the "beasts full of eyes" in Rev. iv. 6. Below the throne, figures rise, mostly in family groups, on the left, and others fall individually on the right. Among these are images from Revelation that are as foreign to Michelangelo's design as to Blair's text, and these recur with additions in Blake's later, more elaborate Last Judgments.

In the years 1806–*c*. 1809, Blake produced three more Last Judgment drawings.[93] The first of these (Pollok House, Glasgow) (Pl. 47) is dated 1806 and therefore must have followed soon after the *Grave* drawing; however, the composition is somewhat altered and there are many more figures, a number of which refer to Revelation. Already in the *Grave* design were pictured at the lower right the harlot Mystery, the seven-headed beast, the "armies of the kings of the earth" (xix. 19) and "those who hid themselves in the dens and in the rocks of the mountains (vi. 15); the demon at the bottom center is probably Apollyon, "the angel of the bottomless pit" (ix. 11).[94] In the Pollok House picture Blake added the Woman Clothed with the Sun with the crescent moon beneath her feet and a diadem of stars. She is presented as a traditional Caritas-figure like Blake's Jerusalem, "Mother of myriads,"[95] surrounded by infants. In the upper part of the picture are added the four-and twenty elders of Rev. iv. 4, seated on either side of Christ and facing away from him. The harlot now appears in the bottom center. Two grotesque heads emerging to her right may belong to "the beast that ascendeth out of the bottomless pit" of Rev. xi. 7. Above them is the seven-headed dragon, who now has bat wings as in the Butts water colors. To our right falls Satan, his serpent form entwining his human as in the *Grave* picture,[96] and further to the right an angel with a fiery sword, probably Michael, drives the rebel angels downwards.

Of course, Blake made numerous other changes and additions in the Pollok House picture. As this was conceived for Butts with the idea of having *The Fall of Man* (1807, Victoria and Albert Museum) as a pendant, Adam and Eve are seen kneeling before Christ's throne, which has become a Gothic structure. Many more figures, mostly biblical, have been added, and this tendency toward amplification is further increased in the even more ambitious version commissioned by the Earl of Egremont through the intermediacy of the painter Ozias Humphry (Pl. 48). The upper part of the design here is considerably elaborated, incorporating further details from Revelation such as the "seven lamps of fire burning before the throne, which are the seven lamps of God" (iv. 4). Above these, in Blake's words, are:

92. Blake has turned these angels so that they are writing with their backs to Jesus.

93. These are reproduced with comments by W.J.T. Mitchell in a supplement to *Blake* published for the annual meeting of the Modern Language Association in December 1975.

94. See Essick and Paley, p. 64.

95. *The Four Zoas*, Night IX, 122:20, *Complete Poetry and Prose*, p. 391. In his letter to Ozias Humphry (January–February 1808) describing the (later) Petworth picture, Blake identifies this figure as the Christian Church. See *Complete Poetry and Prose*, p. 553.

96. And also in the *Paradise Lost* illustration *Satan Watching the Endearments of Adam and Eve* (Boston Museum of Fine Arts).

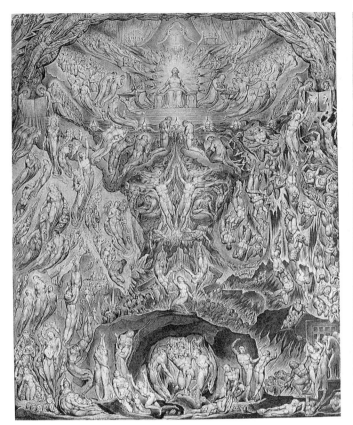

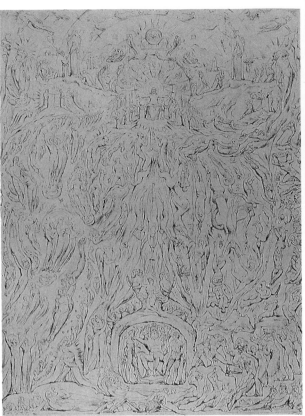

48. William Blake. *The Last Judgment.*　　49. William Blake. *The Last Judgment.*

the Four Living Creatures filled with Eyes attended by the Seven Angels with the
Seven Vials of the Wrath of God & above these Seven Angels with the Seven
Trumpets these compose the Cloud which by its rolling away displays the opening
seats of the Blessed on the right & left of which are seen for Four & Twenty Elders
seated on Thrones to Judge the Dead[.][97]

The four-and-twenty elders have been turned so as to face Christ, thus making him
even more the point of greatest emphasis. In the lower part of the picture, Blake has
constructed a grotto for the seven-headed dragon and has placed the harlot on top of it.
The overall composition now resembles the blossom of a flower like a morning glory
coming out of the earth, with figures in upward motion to its right and falling
downward to its left.

While he was working on these Last Judgment drawings, Blake was planning a large
tempera of the subject. Intending to exhibit it in 1810, he wrote a detailed interpretive
description of it in his Notebook. Perhaps discouraged by the failure of his exhibition of
1809, he did not show the picture; however, George Cumberland's sons saw it (or
another painting on the same subject) at Blake's house in South Molton Street in
1815.[98] In the last year of Blake's life, John Thomas Smith saw what he described as "a

97. Letter to Ozias Humphry, p. 553. I have omitted　98. See Bentley, *Blake Records* pp. 235–6.
some deleted words.

Fresco painting of the Last Judgment, containing upwards of one thousand figures, many of them wonderfully conceived and grandly drawn."[99] It is one of the tragedies associated with Blake's obscure situation in his later years that this painting has been lost. Its composition is, however, known from a drawing in pen and wash over pencil (National Gallery of Art, Washington) (Pl. 49) that Blake evidently made in conjunction with it, and which corresponds in most respects to the details of Blake's Notebook description.[100]

In this latest Last Judgment drawing there are further important changes. Adam and Eve are now standing in adoration before the throne rather than kneeling in humility. Christ's arms have been extended outward in that cruciform, palms-up gesture that Blake repeatedly used to signify self-sacrifice.[101] Around him Blake represents "the Heavens opening ... by unfolding the clouds around his throne"; as in Rev. xxi. 1, "the Old H[eaven] & old Earth are passing away & the New H[eaven] and N[ew] Earth descending"[.][102] There are numerous added figures, and the design as a whole has even greater symmetry than its predecessors. The finished tempera would have been in effect a pictorial epitome of the sort that Blake did for James Hervey's *Meditations Among the Tombs* (*c.* 1820–25, Tate Gallery) – a pictorial epitome of the Bible with special emphasis on the Book of Revelation.

The leading characteristics of Michelangelo's *Last Judgment*, which were, according to Fuseli and Flaxman, comprehensive variety and sublimity, are embodied in Blake's version of the subject in his own characteristic fashion. Variety is represented not only by the number of figures but by what they represent: "States Signified by those Names the Individuals being representatives or Visions of those States as they were revealed to Mortal Man in the Series of Divine Revelations as they are written in the Bible..."[103] Thus Blake's *Last Judgment* is a representation of all States possible to humanity. The Last Judgment itself is meant as both individual and collective. Collectively, it occurs at a crisis in cultural history: "When Imaginative Art & Science & all Intellectual Gifts all the Gifts of the Holy Ghost are looked upon as of no use & only Contention remains to Man then the Last Judgment begins ..."[104] For the individual, it may occur at any time, for "Whenever any Individual Rejects Error & Embraces Truth a Last Judgment passes on that Individual[.]"[105] It is in this comprehensive conception rather than in Michelangelo's *terribilità* that the sublimity of Blake's *Last Judgment* consists.

Despite Blake's antipathy to Burkean aesthetics, the subject matter of his work does incorporate some aspects of Burke's "terrible" sublime. It is in the non-illusionistic

99. *Ibid.*, pp. 467–8, from *Nollekens and His Times*, 1828.

100. The figures are identified by Damon in a pictorial key in *A Blake Dictionary*, plate 1. For a comprehensive discussion of the drawing, see Albert S. Roe, "A Drawing of the Last Judgment," *Huntington Library Quarterly*, XXI (1957–58), 37–55. Roe, however, dates the picture somewhere between 1820 and 1825, which seems far too late.

101. For other examples, see Warner, p. 102.

102. "For the Year 1810/Additions to Blakes Catalogue of Pictures &c," *Complete Poetry and Prose*, p. 556.

103. *Ibid.*, p. 556. The "Names" in this particular context are Moses and Abraham, but the statement is clearly meant to apply to all the figures.

104. *Ibid.*, p. 554. I have eliminated some editorial symbols.

105. *Ibid.*, p. 562.

nature of his art that Blake establishes a different kind of sublimity, one that does not derive its effect, as does Burke's, from vicarious esperience. The negative aspect of this involves a rejection of Burkean obscurity. In his *Discourses*, Reynolds characterized obscurity as "one source of the sublime"; in the margin of his own copy of the book, against this passage, Blake wrote: "Obscurity is Neither the Source of the Sublime not of any Thing Else."[106] Blake's emphasis upon form, clarity, and "the hard and wiry line of rectitude and certainty"[107] is related to his neo-classical training and has some elements in common with traditional views of the sublime such as those of Mengs[108] and Barry. However, we must also bear in mind what Morris Eaves has called "the obstinately metaphorical nature of Blake's linearism."[109] For Blake, the determinate outline is inseparable from the ability to define and discriminate. The artist's definition of forms results in the visual identification of their meanings, and all human forms will be identified at the Last Judgment, that ultimate sublime event.

106. Annotations to Reynolds in *Complete Poetry and Prose*, p. 658.
107. *Descriptive Catalogue* in *Complete Poetry and Prose*, p. 550.
108. See Blunt, *The Art of William Blake*, pp. 13–14.
109. See Morris Eaves, *William Blake's Theory of Art* (Princeton: Princeton University Press, 1982), p. 43. Eaves's discussion of Blakean sublimity (pp. 59–60) is also germane here.

CHAPTER V

J.M.W. Turner

AT ABOUT THE TIME that West was exhibiting his Revelation subjects for Beckford, that de Loutherbourg was preparing his *Vision of the White Horse* for Macklin, and that Blake was engraving the *Narcissa* frontispiece to *Night Thoughts*, the greatest British painter of the age was also turning to apocalyptic subjects. Turner was by both inclination and training a landscape painter, and so in his works we can expect to find a different emphasis than in the figure-centered art of West and Blake. De Loutherbourg had, as we have seen, painted sublime landscapes and had included landscape elements in some of his paintings for Macklin, but it was Turner, an innovator in this way as in so many others, who was the true initiator of the apocalyptic landscape.

In Turner's Calais Pier Sketchbook, which seems first to have been used in the later 1790s, we find a note for a never-executed subject called "the seas running with blood" and a pencil study for "Water turned to blood." The latter, had it been painted, would have been an illustration of Exodus vii. 20–21, showing the first plague of Egypt. The pen-and-ink and black chalk sketch on blue paper shows a bearded figure, possibly Moses, standing with his arms and hands outstretched, palms up, and other figures below him. The same sketchbook contains a black-and-white chalk drawing possibly related to the much later *Shadrach, Meshech, and Abednego in the Burning Fiery Furnace*, a large study for *The Deluge*, a sketch of an old man fleeing with women that may be a study for *The Destruction of Sodom and Gommorah*, and a drawing of an avenging angel (Pl. 50).[1]

This efflorescence of images of violent episodes from sacred history reflects something deeply ingrained in Turner's imagination, but his choices of subjects can be related to those of paintings exhibited by West and de Loutherbourg. Turner was looking for a major historical subject at this time, and the examples of the President of the Royal Academy and of the contemporary painter who at this period seems to have

1. The last so termed, and I think rightly, by A.J. Finberg in *A Complete Inventory of the Drawings of the Turner Bequest* (London: His Majesty's Stationery Office, 1909), vol. I, p. 218, no. 167.

interested Turner most must have reinforced his own predilection for the apocalyptic.[2] In 1800, the year in which the Macklin Bible was published, he exhibited at the Royal Academy his first history painting: *The Fifth Plague of Egypt*.

The Fifth Plague of Egypt (Indianapolis Museum of Art) actually shows the seventh plague – hail and fire. For its pictorial tradition it goes not to de Loutherbourg but to Richard Wilson, as critics of the day were quick to see, and to Poussin. "The grandest and most sublime stile of composition, of any production since the times of *Wilson*," said the *St. James Chronicle*.[3] As Wilson's *Niobe* (Pl. 51), which could then have been seen in the collection of Sir George Beaumont,[4] was one of the first paintings to reflect the Burkean aesthetic of the sublime, we have a twofold source for the sublimity of *The Fifth Plague*: Wilson's darkly agitated scene and Turner's own, firsthand conception. The influence of Poussin is, in contrast, seen in the stable architectural forms set in the landscape of the middle distance.[5]

Unlike West or de Loutherbourg, each of whom would have made the figures dominant in a biblical history painting, Turner presents the mantically gesturing Moses and the cowering Aaron as small details to the right and concentrates his interest upon the apocalyptic qualities of the landscape itself. The whorl of fiery smoke ascending from the pyramid in the middle distance and the somber colors of the rest combine to produce a genuinely disturbing effect. Appropriately, this painting was immediately bought by William Beckford[6] for Fonthill, where it joined West's Revelation pictures.

In 1802 Turner exhibited another Plague subject, this time *The Tenth Plague of Egypt* (Tate Gallery) (Pl. 52), showing the death of the firstborn; and, as with the *Fifth Plague*, he received the praise of contemporaries for successfully achieving the terrible sublime.[7] Again the coloration is predominantly very somber, and the influence of Poussin is even more pronounced.[8] The dominant aspect of the picture is its dark, clouded sky, with cloud shapes ranging in color from one yellow area, suggestive of a supernal realm, at the upper left, to dark gray below, to violet tints at the upper center and dark blue at the upper right. *The Tenth Plague* is perhaps even more disturbing than *The Fifth Plague* because in the latter Moses is seen controlling destructive forces aimed at distant architectural forms, whereas here we see human beings, particularly the two

2. Turner is even said to have moved to Hammersmith Terrace in order to be near de Loutherbourg, who lived there. See Walter Thornbury, *The Life and Correspondence of J.M.W. Turner* (London: Chatto and Windus, rev. ed., 1877), p. 112. Thornbury gives the year as 1808; however, Turner was living at Upper Mall, Hammersmith, by January 1807 and probably had moved there late in 1806. See Patrick Youngblood, "The Painter As Architect," *Turner Studies*, II (1983), 34, n. 9. Thornbury (p. 115) is also the source of the anecdote that Mrs. de Loutherbourg became alarmed that the younger painter was stealing her husband's secrets and barred him from the house. Presumably the secrets she feared for were de Loutherbourg's formulas for pigments.

3. As quoted by Martin Butlin and Evelyn Joll, *The*

Paintings of J.M.W. Turner (New Haven and London: Yale University Press, rev. ed., 1984), vol. I, no. 13, p. 11.

4. *Ibid.*, no. 13, p. 11.

5. See Jerrold Ziff, "Turner and Poussin," *Burlington Magazine*, CVI (1964), 316.

6. From a note in the South Wales Sketchbook, it appears that Beckford commissioned a Plague subject from Turner in 1796 or 1797, although it was not necessarily this one. See John Gage, *Colour in Turner: Poetry and Truth* (New York and Washington: Praeger, 1969), pp. 136, 247; Butlin and Joll, vol. I, p. 11.

7. See Butlin and Joll, vol. I, no. 17, p. 17.

8. See Ziff, "Turner and Poussin," p. 316.

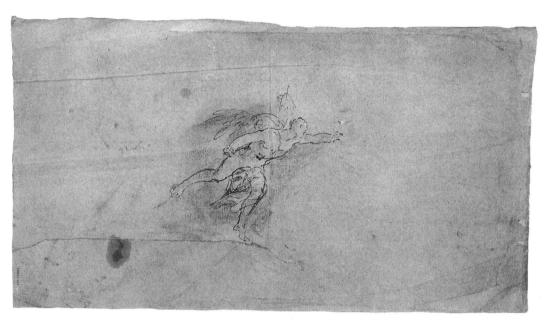

50. J.M.W. Turner. *An Avenging Angel.*

51. Richard Wilson. *The Destruction of Niobe's Children.*

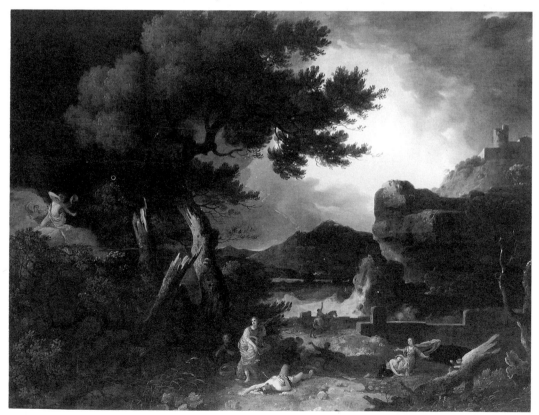

52. J.M.W. Turner. *The Tenth Plague of Egypt*.

53. J.M.W. Turner and Charles Turner after J.M.W. Turner. *The Fifth Plague of Egypt*.

women discovering a dead baby at the left, overshadowed by their louring destiny. Though very different in their mode of execution from Blake's Plague pictures, Turner's have in common with them the sense of people succumbing to destructive forces that they can neither resist nor understand.

Turner's continuing esteem for both of his Plague paintings is indicated by his including them in the *Liber Studiorum*. The etched proof of *The Fifth Plague* (British Museum) shows neither clouds nor lightning; these sublime features were added by engraving. Turner even directed the engraver, Charles Turner: "Make the lightning quite white – this is the best by far."[9] The resulting differences from the painting in the published engraving (1808) (Pl. 53) look forward, as Andrew Wilton suggests, to Turner's later industrial subjects.[10] It was perhaps this presentiment of modernity that led Ruskin, in his discussion of the *Liber Studiorum*, to condemn *The Fifth Plague* as "a total failure," claiming "the pyramids look like brick-kilns, and the fire running along the ground like the burning of manure."[11] The engraving of *The Tenth Plague* fared no better in *Modern Painters*. Ruskin found in it "awkward resemblances to Claude" and associations with the circus performer and Egyptian explorer Belzoni rather than with Moses.[12] These acerbic criticisms seem misplaced, for the resemblance, not at all awkward, is to Poussin rather than to Claude, and the sense of melodrama implied by the reference to Belzoni seems entirely lacking in this static, brooding picture. Rawlinson's remarks on the sense of "horror and terror … something beyond any mere physical cause of terror and awe"[13] seem far more appropriate to its eerie quality.

In addition to the two *Plagues*, Turner also planned or exhibited several other pictures on semi-apocalyptic themes in the early 1800s. *The Army of the Medes Destroyed in the Desart by a Whirlwind* (1801) was accompanied by a reference to Jeremiah xv. 32–3 (almost certainly a mistake for xxv. 32–3[14]), showing that this event was to be seen not as merely secular history but from a prophetic perspective.

> Thus saith the LORD of hosts. Behold, evil shall go forth from nation to nation, and a giant whirlwind shall be raised up from the coasts of the earth.
>
> And the slain of the LORD shall be at that day from one end of the earth even unto the other end of the earth: they shall not be lamented, neither gathered, nor buried; they shall be dung upon the ground.

The painting has been lost, but drawings in the Calais Pier and Dinevor Castle Sketchbooks showing tangled human figures and a storm are probably related to it.[15] Yet another biblical painting portraying the effects of divine wrath, *The Destruction of Sodom* (Tate Gallery), was probably shown at Turner's gallery in 1805. Here was an

9. See W.G. Rawlinson, *Turner's "Liber Studiorum"* (London: Macmillan and Co., 2nd ed., 1906), p. 47.

10. Andrew Wilton, *Turner and the Sublime* (London: British Museum Publications, 1980), pp. 133–5.

11. John Ruskin, *Modern Painters* in *The Works of John Ruskin*, ed. E.T. Cook and Alexander Wedderburn (London: George Allen, 1908), vol. III, p. 240. His later mention of the painting is noncommital; see *Works*, vol. XIII, p. 407.

12. *Modern Painters* in *Works*, vol. III, p. 240. In this case Ruskin found the painting "finer than the study" [the *Liber Studiorum* plate?] but still uninteresting." (*Ibid.*, p. 241.)

13. *Turner's "Liber Studiorum,"* p. 125.

14. See Jerrold Ziff, "Proposed Studies for a lost Turner Painting," *Burlington Magazine*, CVI (1964), 328–32.

15. Reproduced in Ziff, "Proposed Studies for a Lost Turner Painting," pp. 331–2; and in Butlin and Joll, vol. II, pls. 556–8.

important precedent for John Martin, with massive architecture falling in flames upon diminutive fleeing humans. Far more important, however, for Turner's development as a painter was another picture of 1804–5: his challenge to Poussin, *The Deluge*.[16]

We have seen (Chapter I) that when Turner visited the Louvre in 1802 he carefully studied Poussin's *Deluge* and condemned it for lack of grandeur, although he considered its coloring sublime. Later he returned to this subject in his Royal Academy lecture "Backgrounds, Introduction of Architecture and Landscape."[17] Again, Poussin's color alone is singled out because of "the uniformity with which he has buried the picture under one deep toned horrid interval of approaching doom in gloom, defying definition yet looking alluvial, calling upon those mysterious ties which appear wholly dependent upon the associations of ideas . . ."[18] In approaching the subject for his own painting, Turner evidently determined to display the cataclysmic violence he found lacking in Poussin's rendition without emulating the one aspect of the work that he admired.

At first Turner conceived of an architectural setting for his subject. In a black-and-white chalk study in the Calais Pier Sketchbook, figures try to climb up a columned building at the left while the Ark, highlighted in white chalk, floats away at the center. A sketch in pen and ink with pencil, probably made slightly later,[19] shows lingering traces of architecture but concentrates upon interlaced human figures trying to cling to a floating tree trunk. In the oil painting (Tate Gallery), architecture has disappeared completely and the disaster takes place in a completely natural setting. At the center a group tries desperately to scramble out of the water into a swamped boat; to the left among the drowning humans a heron too is drowning and a convoluted serpent swims in the foreground. At the right a fainting woman is supported by a powerful black man wearing a gold-colored garment. Next to them is a variant of the three-generational group that we have encountered in a number of Deluge pictures. Coming from the far right, an enormous wave is about to inundate everything in the scene. The Ark is far off at the center left, and a smudge of sunset reddens the distance.

Turner's *Deluge* was a bold endeavor in which he challenged comparison with both predecessors and contemporaries. The sensuously rich colors, so different from those of Poussin's painting, probably derived from Turner's studies after Titian and Veronese at the Louvre.[20] He also departed from the examples of de Loutherbourg (1789) and West (1791, 1803–5) by presenting numerous figures in a violently agitated landscape and giving equal importance to both elements. Amédée Pichot, a French traveler in Britain during the early 1820s, compared the result favorably to a celebrated French, figure-centered Deluge, that of A.-L. Girodet-Trioson (Louvre), first exhibited in 1808:

> One of our painters in imitation of Poussin has attempted to give an idea of the deluge by the agony of a single family on the point of being swallowed up. Turner has

16. On the dating of *The Deluge*, see Butlin and Joll, vol. I, no. 55, p. 43, where it is hypothesized that the painting was shown at Turner's Gallery in 1805; see also Wilton, *Turner and the Sublime*, pp. 136–9.

17. Probably written 1809–10, first delivered February 1811; see Ziff, "Turner and Poussin," p. 315.

18. *Ibid.*, pp. 319–20.

19. *C.* 1804 according to Wilton, *Turner and the Sublime*, p. 136. For other sketches, see Butlin and Joll, vol. I, no. 55, p. 44.

20. See Butlin and Joll, *Ibid.*, no. 55, p. 44 and John Gage in the Grande Palais Turner exhibition catalogue, *J.M.W. Turner* (Paris: Éditions de la Réunion des musées nationaux, 1983), p. 71.

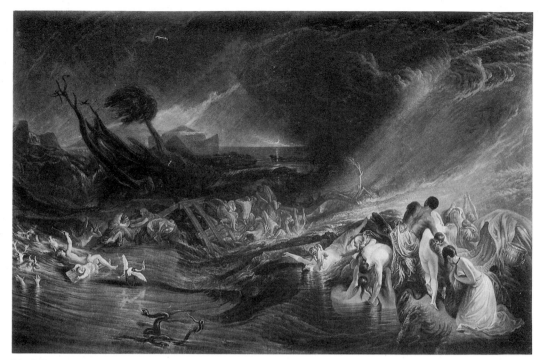

54. I.P. Quilley after J.M.W. Turner. *The Deluge.*

represented the whole spectacle of the inundation of the earth. In Girodet's episode we tremble for a few solitary victims; in Turner's picture we behold the danger of the whole human race.[21]

Ruskin, who considered Poussin's painting to suffer from "meanness and apathy," placed Turner's "at a just medium" between that and (no doubt referring to Martin's *Deluge*, exhibited in 1826) "the extravagance, still more contemptible, with which the subject has been treated in modern days."[22] Ruskin also distinguished between Turner's mode of treating the subject and that in which "the sea, and all other adjuncts, are entirely subservient to the figures, as with Raffaelle and M. Angelo."

Turner liked his *Deluge* so much that he sent it to the Royal Academy in 1813. With the catalogue entry he printed lines from Book XI of *Paradise Lost*, and if we take this as an indication of his original inspiration for the picture, then the land mass with trees in the middle distance may be the Garden of Eden, which, a little later in Book XI (ll. 827–35), is washed away by the Flood and becomes an island. *The Deluge* was also included in the *Liber Studiorum*, and a large engraving after it by I.P. Quilley was published in 1828 (Pl. 54), making the design known to a new and wider audience.

For the *Liber Studiorum*, Turner produced a preliminary drawing quite different from the painting, but in the end he did not use it.[23] He did, nevertheless, alter his design in some ways. In the final state of the print he entirely eliminated the victims in the left and central parts of the painting, keeping only some of those to the right. The Ark has

21. Amédée Pichot, *Historical and Literary Tour of a Foreigner in England and Scotland* (London: Saunders and Otley, 1825), p. 129.

22. *Modern Painters, Works*, vol. III, p. 519.

23. See Wilton, *Turner and the Sublime*, p. 137.

been made very indistinct and the huge wave eliminated. The serpent that swam in the painting slithers away on land in the print. At least some of these changes may be owing to the requirements of showing a great cataclysm in a small space – $8\frac{13}{16}$ by $11\frac{13}{16}$ inches instead of $56\frac{1}{4}$ by $92\frac{3}{4}$. Reducing the number of figures makes us concentrate on those that remain, and the great wave at the right of the painting might have seemed ineffective when diminished. The changed position of the serpent, however, appears to have iconographical significance, as in other Deluges: this creature would not disappear with the Flood.

This *Liber Studiorum* print remained for some reason unpublished,[24] and the large ($14\frac{15}{16} \times 22\frac{11}{16}$ in) mezzotint that Turner authorized was the only version that would have been known to these who had not seen the original. Quilley followed the painting except for a few changed details, the most important of which is that the Ark now looms almost as prominently as in West's painting. At this particular time Turner may have wished to remind the public that his own *Deluge* considerably antedated John Martin's recent version of the subject,[25] or he may have been responding to Francis Danby's *Delivery of Israel out of Egypt*, exhibited at the Royal Academy in 1825;[26] or both. By 1828, however, Turner himself had passed to a far different manner of representing the apocalyptic sublime.

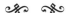

Snowstorm: Hannibal and His Army Crossing the Alps (Tate Gallery), exhibited in 1812, is justly regarded as marking an epoch in Turner's career (Pl. 55). In this painting appears for the first time the famous Turnerian vortex, and the canvas is structured according to principles that govern many subsequent works as well. As Michael Kitson puts it, "He broke down the stable architectonic harmonies of classical landscape painting, putting in their place an unstable, shifting system of ovals and parabolas, suggestive of flux."[27] Furthermore, in connection with this picture appear for the first time verses identified as from Turner's fragmentary poem *The Fallacies of Hope*. Both painting and verses suggest a cyclical view of history that becomes even more explicit in *Dido Building Carthage* (National Gallery) and *The Decline of the Carthaginian Empire* (National Gallery), exhibited in 1815 and 1817 respectively. As is widely recognized, in these three paintings Turner adumbrated the fates of the empires of his own time, and, more specifically, in *Hannibal* he had in mind Bonaparte's crossing of the Alps in 1800 in order to attack Italy. The latter reference is made all the more likely by the fact that in 1802 Turner had seen Jacques-Louis David's *Napoleon Crossing the Saint-Bernard* (Versailles), in which the name of Hannibal is inscribed on a rock beside those of Charlemagne and Napoleon.[28]

24. The two examples in the British Museum are posthumous. Rawlinson (no. 88) notes the existence of an original engraver's proof.

25. See Butlin and Joll, vol. I, p. 44.

26. See Wilton, *Turner and the Sublime*, p. 137.

27. Michael Kitson *J.M.W. Turner* (London: Blandford Press, 1964), p. 73.

28. *Farington Diary*, vol. V, p. 1898 (3 October 1802). As Gage observes, Turner's memory could have been refreshed by George Cooke's engraving, published in 1807, after this painting (*J.M.W. Turner*, p. 90). Later, Turner drew explicitly on David's design when illustrating the Battle of Marengo for Samuel Rogers's *Italy* (1830); see Lynn R. Matteson, "The Poetics and Politics of Alpine Passage: Turner's *Snowstorm: Hannibal and His Army Crossing the Alps*," *Art Bulletin*, LXII (1980), 385–97.

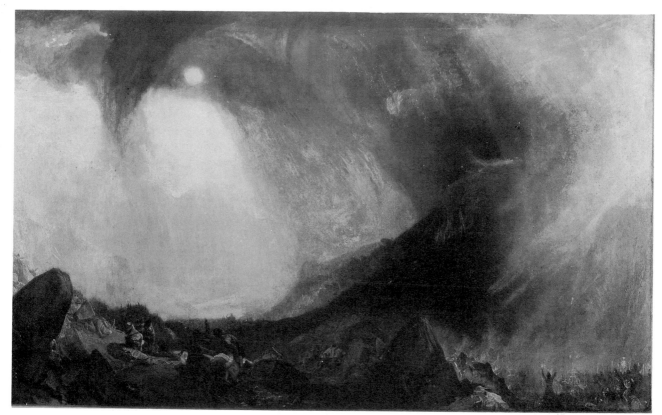

55. J.M.W. Turner. *Snowstorm: Hannibal and His Army Crossing the Alps.*

In the *Hannibal* painting a scene from ancient history is presented with modern historical reverberations in a natural landscape whose sublime violence borders on the apocalyptic. "In his picture of Hannibal crossing the Alps," Pichot wrote, "the captain and his troops, who in history shook the colossal power of Rome at every step they advanced, are represented as mere pigmies, whom the genii of the mountains might annihilate by a few flakes of snow: yet the scene is as grand as though the artist had hurled the frightful avalanche upon the Carthaginians."[29] The story of the genesis of this work is well known. The subject had been on Turner's mind, as reflected in his sketchbooks for a decade or more;[30] it crystallized for him in 1810 or 1811 while he was staying in Yorkshire with the reformist, abolitionist M.P. Walter Fawkes. Fawkes's son, F. Hawksworth Fawkes, later told Water Thornbury that as a thunderstorm came over the valley, Turner began busily making notes on the back of an envelope.

He was absorbed – he was entranced. There was the storm rolling and sweeping and shafting out its lightning over the Yorkshire hills. Presently the storm passed, and he finished.

"'There,! Hawkey,' said he. 'In two years you will see this again, and call it 'Hannibal crossing the Alps.'"[31]

29. Pichot, p. 129.

30. See Matteson, "The Poetics and Politics of Alpine Passage," fig. 3; and Gage, *J.M.W. Turner*, p. 90.

31. Thornbury, p. 239.

It seems likely that during Turner's stay with Walter Fawkes conversation turned to the great issues of the day – the war (which Fawkes denounced in a speech celebrating the election of Sir Francis Burdett in 1812[32]), and domestic agitation for Reform. A storm gathering over Yorkshire could for Turner become the storm over England and over all of Europe, as rendered in the turbulent sky of *Hannibal* which dwarfs the army beneath.

A brief passage from Fawkes's *The Englishman's Manual* will indicate the spirit of his political views:

> The question then is now come to this, Shall such a system, fraught with abominations of every kind, be suffered to continue any longer? The voice of the people, I trust, will declare, *No!* The spectres which, on every assertion of Constitutional rights, haunt the feverish and self-condemned conscience of corruption, cry aloud, that *it ought not* – while those who look for direction in all their worldly affairs to Providence, will do well to consider, that to countenance a system which commences in bribery and perjury, and is fostered throughout by corruption, can never be considered as "Obedience to God."[33]

It would be tempting to impute to Turner the kind of ethical liberalism upheld by Fawkes, and elements of such of a view can be found scattered through Turner's writings and conversation, as well as implied by some of his pictorial works. While staying at Farnley Hall, Turner wrote to John Britton: "Why say the Poet and Prophet are not often united? – for if they are not they ought to be."[34] In touching a proof of an engraving of Wycliffe's birthplace, Turner introduced a burst of light to show "the light of the glorious Reformation" and explained the geese in the picture as "the old superstitions which the genius of the Reformation is driving away."[35] In a poem accompanying his water color *Caernarvon Castle* (1800), Turner celebrates the Welsh Bard who opposed "the tyrant [who] drench'd with blood the land,"[36] very much as Gray had done previously and as Blake would do a little later. Yet to isolate this strand of Turner's thought from all others would be to distort his attitude toward history. His one indubitable reference to Reform occurs in Sketchbook CCCLXIII, where he wrote: "Geese with Goslings hissing at Pigs – the Reform Question."

Although there must have been political sympathy between Turner and Fawkes, the artist's view of history seems always to have been deeply tinged with pessimism. In the verses accompanying *Hannibal*, "Plunder seiz'd/The victor *and* and captive" [emphasis mine].[37] In the second fragment of *The Fallacies of Hope* to be printed, accompanying *The Battle of Fort Rock* in 1815, Turner's verses describe natural forces vainly trying to stop Napoleon's invading army, which is then itself troped to a river bed fed by a glacier – an image of the terrible sublime. "Arts and the Love of War," written in

32. See Jack Lindsay, *J.M.W. Turner. His Life and Work* (London: Cory, Adams & Mackay, 1966), p. 180.

33. Walter Fawkes, *The Englishman's Manual; or, a Dialogue Between a Tory and a Reformer* (London, 1817), p. 36.

34. *Collected Correspondence of J.M.W. Turner*, ed. John Gage (Oxford: Clarendon Press, 1980), p. 51.

35. See Lindsay, p. 140.

36. J.M.W. Turner, *The Sunset Ship. The Poems of J.M.W. Turner*, ed., with an essay, by Jack Lindsay (Lowestoft: Scorpion Press, 1966), p. 77.

37. *Ibid.*, p. 81.

1811, celebrates Magna Carta but its syntax becomes so muddled that one cannot tell whether it is worth it that since then "all have died" for freedom.[38] Some of the paintings display similarly dark ambiguities. *Slavers throwing overboard the Dead and Dying* (Cleveland Museum of Art) was painted in 1840, two years after the abolition of slavery in the last British territories, and so is not so much a protest as a holocaust memorial. The very late *Undine giving the Ring to Massaniello* (Tate Gallery), exhibited in 1846, has a republican hero as its subject, but its theme is his betrayal.

In *Hannibal* we sense a dimension beyond secular history, and one clue to this is the depiction of the army at the lower right. The soldiers are evidently being addressed by a figure with arms upraised toward the sky – a situation reminiscent of Satan calling up his legions in *Paradise Lost*. The posture of the gesturing figure, presumably meant for Hannibal, resembles that of Satan in representations of this scene by Fuseli and by Sir Thomas Lawrence. Fuseli's rendition, as engraved by Bromley for an edition of *Paradise Lost* in 1802, was probably the better known; but Lawrence's *Satan Summons His Legions*, in which the figure is turned fully toward his listeners as in Turner's detail, was the artist's diploma picture at the Royal Academy in 1797, and so Turner could easily have seen it there.[39]

Turner did not systematize his view of history into anything like Blake's Orc cycle, but he does nevertheless represent the historical process as a cyclical one. Beyond this cycle is the abyss, and so the appropriate image for it is vortical – not a circle but a gyre. Perhaps the most astute comment on the *Hannibal* by a contemporary was the mistake made and recorded by the painter's friend Elizabeth Rigby, Lady Eastlake, after a visit to Turner's Gallery. Seeing a painting "with all the elements in a uproar," she asked: "The end of the world, Mr. Turner?" – "No, ma'am; Hannibal crossing the Alps."[40] Also appropriate is Hazlitt's comment in 1816: "'*pictures of nothing and very like.*'"[41] In the sky of *Hannibal* we do see something like the end of the world, a picture of nothing. It is the apocalyptic sublime only partially accommodated to secular history and shares something of the Wordsworth's description of his own crossing of the Alps, written only a few years before:

> And everywhere along the hollow rent
> Winds thwarting winds, bewildered and forlorn,
> The torrents shooting from the clear blue sky,
> The rocks that muttered close upon our ears –
> Black drizzling crags that spake by the wayside
> As if a voice were in them – the sick sight
> And giddy prospect of the raving stream,
> The unfettered clouds and region of the heavens,

38. *Ibid.*, p. 109.

39. I am grateful to Dr. Shelley Bennett for calling the Lawrence painting to my attention. Both designs are reproduced by Marcia Pointon in *Milton and English Art*, figs. 104 and 105.

40. *Journals and Correspondence of Lady Eastlake*, ed. Charles Eastlake Smith (London: John Murray, 1895), vol. I, p. 188 (20 May 1846).

41. "On Imitation," *Complete Works of William Hazlitt*, p. 76. The source of the quotation has not been identified. Hazlitt remarks further: "The artist delights to go back to the first chaos of the world, or to that state of things, when the waters were separated from the dry land, and light from darkness, but as yet no living thing nor tree bearing fruit was seen on the face of the earth."

Tumult and peace, the darkness and the light,
Were all like workings of one mind, the features
Of the same face, blossoms upon one tree,
Characters of the great apocalypse,
The types and symbols of eternity,
Of first, and last, and midst and without end.[42]

Hugh Honour remarks that Turner's whole art lies between his plan for *The Water Turned to Blood* and the very late *Angel standing in the Sun*, exhibited in 1846.[43] It is true that in pictures like *The Burning of the Houses of Lords and Commons. October 16, 1834* (Philadelphia Museum of Art) we sense the presence of vast forces beyond the physical conflagration, and the same may be said of so many Turners that it would be useless to enumerate them. However, as far as biblical subjects are concerned, Turner returned to the apocalyptic only occasionally before the 1840s. He painted what may be a *Death on a Pale Horse c.* 1830, and in 1832 he exhibited *Shadrach, Meshech, and Abednego in the Burning Fiery Furnace*.

Death on a Pale Horse (Tate Gallery), sometimes referred to as "A Skeleton Falling Off a Horse," is a puzzling painting in several respects. Turner would have been familiar with West's *Opening of the Seals* in the collection of his friend and patron the Earl of Egremont at Petworth House,[44] and his initial impulse may have been to challenge comparison with West's treatment of the subject. The ruddy clouds at the upper left and the white ones at the upper right, along with the indefinite orientation of the scene as a whole, also recall de Loutherbourg's *Vision of the White Horse*. Yet the position of the skeleton, thrown sideways across the horse's back, is not that of a conqueror, even though the skeleton is crowned. It may be, as Lawrence Gowing suggests,[45] that this picture is a response to the death of Turner's beloved father in 1829. If that is so, the oddness of the conception, the unfinished state of the picture, and the unusual amount of rubbing and scratching of the wet paint[46] may indicate an inability to come to terms with this traumatic emotional event at the time.

There are no such puzzles about *Shadrach, Meshech, and Abednego* (Tate Gallery). Turner's friend George Jones tells how this was "Another instance of Turner's friendly contests in art."[47] Jones, who had exhibited in 1816 a Revelation subject (untraced) called *The Ascension of the Prophets*,[48] agreed with Turner that for the Academy exhibition of 1832 each would produce a painting of the episode in Daniel in which the three true believers are cast into the furnace and miraculously survive. In Jones's *Burning Fiery Furnace*, later engraved by J.B. Allen, the chief dramatic subject is Nebuchadnezzar, whose pointing left arm provides a firm diagonal thrust toward the furnace in the rear. There three dark figures are seen with one light one – the fourth, whose form "is

42. William Wordsworth, *The Prelude*, ed. Jonathan Wordsworth, M.H. Abrams, and Stephen Gill (New York and London: W.W. Norton, 1979), p. 218, Book VI (1805 version), ll. 559–73.

43. Hugh Honour, *Romanticism* (Harmondsworth, Middlesex, 1981 [1979]), p. 97.

44. As noted by Andrew Wilton, *J.M.W. Turner: His Art and Life* (Rizzoli: New York, 1979), p. 210.

45. See Lawrence Gowing, *Turner: Imagination and Reality* (New York: Museum of Modern Art, 1966), p. 27.

46. See Butlin and Joll, vol. I, no. 259, p. 158.

47. George Jones, "Recollections of J.M.W. Turner," *Collected Correspondence of J.M.W. Turner*, pp. 5–6.

48. Illustrating Rev. xi. 12–13; see Matteson, *Apocalyptic Themes*, p. 208.

like the Son of God" (Dan. iii. 25). In contrast, Turner's picture is dominated by the red glare at the right; three men in the furnace are only dimly glimpsed with one angel beside them and another slightly nearer the bystanders. The opulent court party in the foreground, costumed in Turner's Rembrandtesque-historical vein, is significantly oblivious of the supernatural event occurring behind their turned backs. That this painting was exhibited in the year of the First Reform Bill may be pertinent[49] – but Turner has left any possible contemporary application to the viewer, citing in the Royal Academy catalogue only the text of Dan. iii. 26.

In the 1840s Turner returned to the subject of the Deluge, but, as one would expect, he treated it in a far different manner than he had earlier. It may have been the example of Martin's *Eve of the Deluge* and *Assuaging of the Waters*, both exhibited in 1840, that led Turner to paint his own *Evening of the Deluge* (National Gallery, Washington D.C.),[50] probably in 1843. In this painting Turner captures the feeling of a calm before an infinite storm with warm colors for the tents in the foreground, a pale yellow sky, the Ark floating securely in the distance, and an ominous flight of birds issuing like a reversed 'C' from the horizon to the upper sky. It is hypothesized[51] that not long after executing this, Turner decided to link his conception with the theory of colors propounded by Goethe in his *Farbenlehre*, which had recently been published in an English translation by Turner's friend Sir Charles Eastlake[52] and which Turner annotated with sometimes critical and sometimes appreciative comments.[53]

The extent to which Turner accepted Goethe's views about color has been debated,[54] but at the very least he allowed that "Goethe leaves us ample room for practice even with all his theory."[55] In *Shade and Darkness – the Evening of the Deluge* (Tate Gallery) and *Light and Colour (Goethe's Theory) – the Morning After the Deluge – Moses writing the Book of Genesis* (Tate Gallery), both exhibited in 1843, he set out to explore that ample room in his own unique way (Pls. 56, 57).

Goethe divides the colors into "Plus" – yellow, red-yellow (orange), and yellow-red (minium, cinnebar) – and "Minus" – blue, red-blue, and blue-red – with all subject to qualification according to their combinations.[56] These colors are further provided with "Moral Associations," and it is these that Turner draws upon. The preponderant coloring of *Shade and Darkness* is "passive." It is dominated by the "cold, melancholy" blue with the "restless, susceptible, anxious" combinations of red-blue and blue-red also present. In *Light and Colour* the dominant coloring is made up of the "quick, lively, aspiring" yellow and yellow-red – "the active side in all its energy." According to Goethe, this combination has "a serene and magnificent effect," and thus is appropriate to Turner's subject, just as in *Shade and Darkness* "Blue still brings a principle of darkness with it." Even the green in the lower center of *Light and Colour* is sea-green,

49. As suggested by Lindsay in *The Sunset Ship*, p. 61.
50. See Butlin and Joll, vol. I, no. 443, p. 280.
51. *Ibid.*, no. 443, p. 280.
52. Charles Eastlake, *Goethe's Theory of Colours* (London: John Murray, 1840).
53. See "Turner's Annotated Books: 'Goethe's Theory of Colours,'" ed. with an introduction by John Gage, *Turner Studies*, IV (1985), 34–52.

54. See R.D. Gray, "J.M.W. Turner and Goethe's Colour-Theory," in *German Studies Presented to Walter Horace Bruford* (London: Harrap, 1962), pp. 112–60; Gage, *Colour in Turner*, pp. 173–80.
55. "Turner's Annotated Books," p. 51.
56. See Eastlake, pp. 306–12.

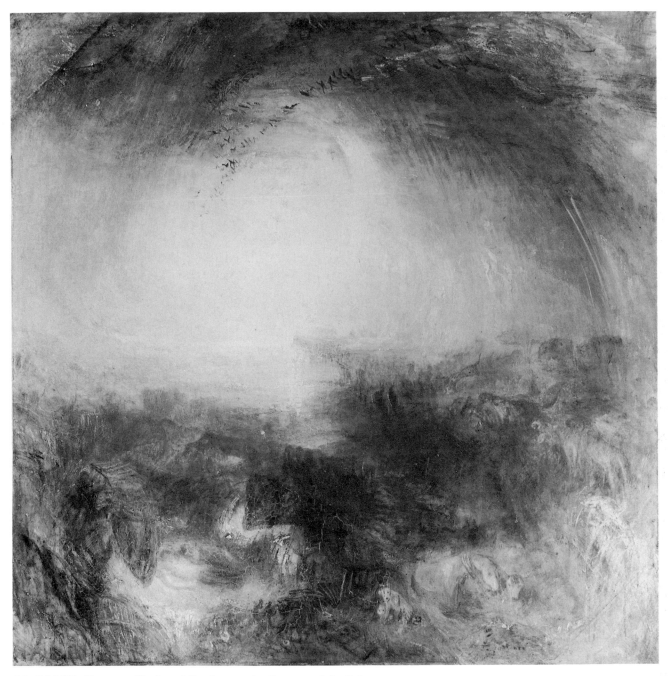

56. J.M.W. Turner. *Shade and Darkness – the Evening of the Deluge.*

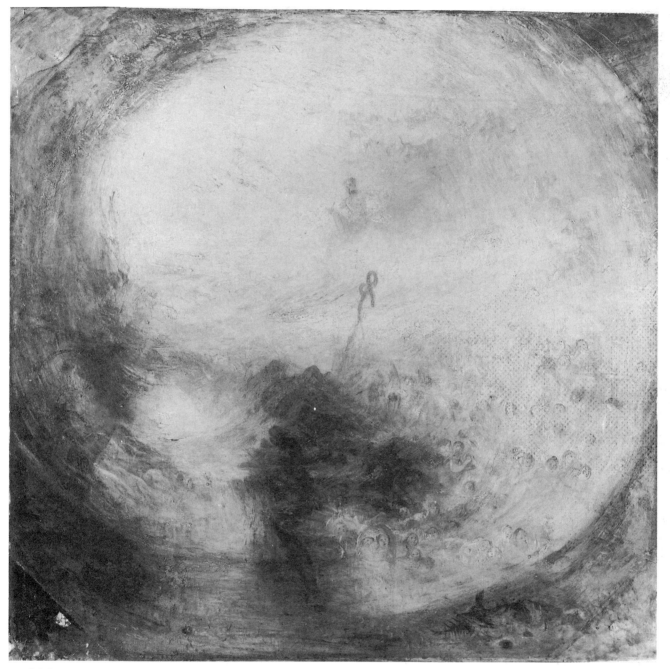

57. J.M.W. Turner. *Light and Colour (Goethe's Theory) – the Morning after the Deluge – Moses writing the Book of Genesis.*

which Goethe says is "a rather pleasing colour" in which blue for once partakes of the plus side of the color wheel. In these two paintings Turner in effect takes up the invitation that Goethe extends: "If our doctrine of colours finds favour, applications and allusions, allegorical, symbolical, and mystical, will not fail to be made, in accordance with the spirit of the age."[57]

Since in both paintings individual details are subordinated to overall effects, what details there are must carry considerable significance. The presence of the Ark in the center background of *Shade and Darkness* presents a salvational motif counter to the prevailing pessimism of the scene. This positive note is also sounded in the lines from *The Fallacies of Hope* that conclude with the beasts wading to the Ark while "disobedience [the tent-dwellers of the left foreground] slept."[58] In the sequel, Moses is seen writing his account of the Deluge while below him stands the brazen serpent that he would erect on a pole in the wilderness and that would later become an object of idolatrous worship.[59] As Turner probably knew that in John iii. 14 this serpent is an antetype of Christ, what we have in this image is a cycle of history going from the aftermath of the Deluge to the Crucifixion.

The cyclical nature of events is also emphasized by the compositions of the two paintings, both of which were completed as octagons and each of which has a circle within it. *Shade and Darkness* presents the by-now familiar vortical composition in its most intense form, but, as Wilton points out, *Light and Colour* occupies a shallower space, something like a circular dish.[60] Just as *Shade and Darkness* contained its own antithesis, so the prevailing optimism[61] of *The Morning after the Deluge* has its counter-statement in the swarm of bubble-faces:

> each in prismatic guise
> Hope's harbinger, ephemeral as the summer fly
> Which rises, flits, expands, and dies.[62]

Thus the Rainbow of the Covenant becomes another Fallacy of Hope. The two pendants oscillate not only in their relation to the "Plus" and "Minus" sides of Goethe's color diagram but also in their intermixed themes of salvation and recurrence.

Turner's culminating apocalyptic statement is *The Angel standing in the Sun* (Tate Gallery) (Col. Pl. IV), exhibited in 1846. Here again, Martin, who had designed several angels of Revelation for the Martin–Westall Bible illustrations of 1836[63] as well

57. *Ibid.*, p. 352.

58. *The Sunset Ship*, p. 87.

59. On the role of this symbol in Blake's works, see Northrop Frye, *Fearful Symmetry* (Princeton: Princeton University Press, 1947), p. 213.

60. See Wilton, *J.M.W. Turner*, p. 216, comparing the composition with baroque ceilings that Turner would have seen in Italy. There is also a relation between these and the vignettes that Turner executed for book illustrations in the 1830s. See Adele M. Holcomb, "The Vignette and the Vortical Composition in Turner's Oeuvre," *Art Quarterly*, XXXIII (1970), 27–8.

61. This aspect is stressed by W.J.T. Mitchell, "Metamorphoses of the Vortex: Hogarth, Turner, and Blake," in *Articulate Images*, p. 147. For a more pessimistic interpretation, see Gage, *Colour in Turner*, pp. 173–80. My own view is that each painting represents, respectively, the negative and the positive but that each also contains within itself its opposite.

62. *The Sunset Ship*, p. 88.

63. See Graham Reynolds, *Turner* (New York: Abrams, 1969?), pp. 202–3, The Martin designs are discussed in Chapter VI below.

as publishing his own mezzotint of a Plague subject, *The Destroying Angel*, in the same year, may have provided a stimulus. Turner could also have known West's *Angel in the Sun*[64] of 1801 and Francis Danby's angelic *Subject from Revelation* (coll. Robert Rosenblum), exhibited in 1829. Both paintings were in the collection of William Beckford. What these other angels have in common is their materiality, and this is particularly true of Martin's; they produce their effect through their enormous size, conveyed by the difference in scale between themselves and their surroundings. This is of course a Burkean phenomenon, but by the 1840s Turner had long abandoned the Burkean sublime. His angel, too, would be characterized by size and power, but there would be nothing material about its sublimity. It would be an embodiment of the Turnerian sublime, almost icon-like in its disregard of illusory conventions.

An impetus for this conception may have come from the young Ruskin, who in the first volume of *Modern Painters* wrote of

Turner – glorious in conception – unfathomable in knowledge – solitary in power – with the elements waiting upon his will, and the night and morning obedient to his call, sent as a prophet of God to reveal to men the mysteries of His universe, standing like the great angel of the Apocalypse, clothed with a cloud, and with a rainbow upon his head, and with the sun and stars given into his hand.[65]

This passage, savagely parodied by Turner's old critical adversary the Reverend John Eagles[66] and then withdrawn by Ruskin from subsequent editions,[67] may well, as has been suggested,[68] have put Turner in mind of producing a prophetic painting on the text of Rev. xix. 17–18:

And I saw an angel standing in the sun; and he cried with a loud voice, saying to all the fowls that fly in the midst of heaven, Come and gather yourselves together unto the supper of the great God;
That ye may eat the flesh of kings, and the flesh of captains, and the flesh of mighty men, and the flesh of horses, and of them that sit on them, and the flesh of all men, both free and bond, both small and great.

The composition of *The Angel standing in the Sun* is once again circular. The angel's sword points to the wheeling birds of the air, which in turn lead the eye down the left side of the canvas to a painted arc that closes off the small figures in the area below. In the lower world, we see on the left Adam and Eve mourning over the dead body of Abel while Cain flees – a group that bears an interesting resemblance to that in Blake's *Body*

64. See Charles F. Stuckey, "Turner, Masaniello, and the Angel," *Jahrbuch der Berliner Museen*, XVIII (1976), 166. The West painting is now known only through a related drawing; see Chapter I above.
65. *Works*, III, p. 254. The painting itself, however, was one of those that Ruskin denigrated much later as "painted in a period of decline," their execution "indicative of mental disease." (*Works*, XIII, p. 407.) Fortunately, Ruskin, who also considered the erotic drawings by Turner that he pruriently destroyed as indicative of unbalance in the artist, has not been the

final arbiter, and Turner's *Angel* has long been recognized as one of his most powerful late works.
66. See *Blackwood's Edinburgh Magazine*, LIV (1843), 492. The review is anonymous but has generally been taken as Eagles's work.
67. See George P. Landow, "Ruskin's Revisions of the Third Edition of *Modern Painters*, Volume I," *Victorian Newsletter*, no. 33 (1968), 13–14.
68. See Lindsay, p. 213.

of Abel Found by Adam and Eve (Fogg Art Museum).[69] Behind these figures a skeleton, holding one hand to its head as if dazed, looks on. Further to the right, Delilah, bare-shouldered, bends over the sleeping Samson in a position that Turner seems to have found attractive (*cf.* the woman in the right foreground of the 1805 *Deluge*). Next, to the right, a helmet with a red plume lies on the ground, and Judith hands her handmaid the severed head of Holofernes, whose bleeding trunk lies behind them. At the lower center is a chained serpent, linking the apocalypse of this painting with the post-diluvian world of *Light and Colour*.

The scenes in the world below the angel represent fratricide, betrayal, and bloody murder. The subjects of two of the three scenes involve the savagery of women towards men, which Charles Stuckey has plausibly traced to Turner's traumatic memories of the reputed violence of his insane mother.[70] The chained serpent, however, reminds us that all this will have an end:

> And I saw an angel come down from heaven, having the key of the bottomless pit and a great chain in his hand.
>
> And he laid hold of the dragon, that old serpent, which is the Devil, and Satan, and bound him a thousand years. (Rev. xx 1–2).

Towering over that imminent ending is the apocalyptic angel, golden against a golden background. He is not a clearly defined material being as in the pictures of West, Danby, and Martin, but an apparition that virtually melts into the sky behind him.[71]

The meaning to be attached to Turner's *Angel* is amplified by the second quotation that Turner printed in the Royal Academy catalogue entry, two lines from Samuel Rogers's *Voyage of Columbus*:

> The morning-march that flashes to the sun;
> The feast of vultures when the day is done[.]

Although it has been suggested that these lines might have been intended for Turner's *Massaniello* in the same exhibition,[72] there are strong thematic links between Rogers's poem and Turner's painting, especially when one considers some of the designs Turner executed for Rogers's works. Engravings after these were inserted into the fourth edition of Moxon's *Poems by Samuel Rogers* in 1838, but they had originally been published in 1833 as a separate portfolio.[73] Turner and Rogers were friends; considerable rapport existed between them, and Turner was given a free hand in his choice and interpretation of subjects.[74]

69. See Gerald Finley, "Turner, the Apocalypse, and History; 'The Angel' and 'Undine'," *Burlington Magazine*, CXXI (1979), 687–8. There are two pictures by Blake on this subject, but Turner is unlikely to have seen the one (Tate Gallery) that was probably in the possession of the Butts family at that time. The Fogg picture was then was owned by John Linnell, who also made a copy of it.

70. "Turner, Masaniello, and the Angel," p. 174.

71. As Ronald Paulson observes, this picture represents a culmination of Turner's tendency to make the viewer look directly into the sun. See *Literary Landscape: Turner and Constable* (New Haven and London: Yale University Press, 1982), p. 9.

72. See Stuckey, pp. 172–3.

73. See W.G. Rawlinson, *The Engraved Designs of J.M.W. Turner, R.A.*, (London: Macmillan & Co., 1913), II, p. 239.

74. See Mordechai Omer, *Turner and the Poets* (London: Greater London Council, 1975), n.p.

58. E. Goodall
after J.M.W.
Turner. Samuel
Rogers's *The Voyage
of Columbus: A
Tempest.*

Rogers represents Columbus as a kind of apocalyptist who was sent by heaven to lift the veil that covered half mankind. In contrast to those who sing exploits like those of the two lines cited by Turner, the poet says he will "sing a Man amidst his sufferings here,/. . . gentle to others, to himself severe." Early in the poem occur lines that may well have given Turner an early stimulus for his *Angel*:

> And glorious as the regent of the sun,
> An Angel came! He spoke, and it was done!

These are accompanied by a footnote reference to the first line of the Revelation text that Turner would later use. Rogers's angel brings the east wind that fills Columbus's sails. In contrast, Canto VI of the poem is devoted to "The Flight of an Angel of Darkness." After the failure of this dark angel to stop the voyage, yet another angel appears in Canto XII – an angel from the throne who has come to tell Columbus: "The glorious work is done:/A spark is thrown that shall eclipse the sun!" Although Turner did not portray any of the angels in the relevant cantos of *The Voyage of Columbus*, his design (engr. E. Goodall) for Canto XI shows a winged, angel-like figure with a nimbus of light about his head, holding up a torch in the sky. Armed men are all about him, and a storm-tossed ship is below. This engraving is entitled *A Tempest* (Pl. 58), and might conceivably refer to the lines:

> Now, in a night of clouds, thy Foes prepare
> To rock the globe with elemental wars,
> And dash the floods of ocean to the stars . . .

However, there is no angel-like figure in this passage, although it is *spoken* by the Angel

59. W. Miller after
J.M.W. Turner. Milton's
*Poetical Works: Shipwreck
of Lycidas.*

from the Throne. It may be that Turner, his imagination stimulated by the several angels in *The Voyage of Columbus*, seized the opportunity not taken elsewhere to picture one of them here, even though the text did not demand it. Years later, Rogers's poem, remembered and no doubt reread, seems to have had an important role in the conception of *The Angel standing in the Sun*.

Other vignettes of the 1830s also seem related to Turner's *Angel*. For *The Pleasures of Hope* by Thomas Campbell, Turner produced a design (engr. E. Goodall) illustrating "Sinai's thunder, pealing from the cloud," which shows the arms and head of a gigantic human figure above the sun. Even more pertinent is his *Shipwreck of Lycidas*, engraved by W. Miller for Milton's *Poetical Works* (Pl. 59).[75] This design reflects Turner's interest in the subject of St. Michael's Mount, Cornwall, as shown in landscapes dating back to *c.* 1811;[76] it also demonstrates Turner's reading of Thomas Warton's explanation of the lines concerning "the great Vision of the guarded Mount," reprinted in the notes to the 1835 edition.

Warton seems to have been the first to explain lines of "Lycidas" in the sense according to which they are now understood.

A stone lantern, in one of the angels of the tower of the church, is called St. Michael's Chair. There is still a tradition, that a vision of St. Michael, seated on this crag, or St. Michael's chair, appeared to some hermits; and that this circumstance occasioned the founding of the monastery dedicated to Saint Michael . . . This great vision is the

75. *The Poetical Works of John Milton*, ed. Sir Egerton Brydges, Bart. (London: John Macrone, 1835), titlepage to volume VI. Stuckey (p. 173) identifies the angel of the 1846 painting as Michael and links him to the notes to this edition (see below) but does not compare the designs.

76. A sketch of that period was engraved for the *South Coast* series of 1814, a water color exhibited in 1822. See Finberg, *Life of J.M.W. Turner*, p. 483.

120

famous apparition of St. Michael, whom he with much sublimity of imagination supposed to be still throned on this lofty crag of St. Michael's Mount, looking toward the Spanish coast ...[77]

In his oil painting *St. Michael's Mount, Cornwall* (Victoria and Albert Museum), exhibited in 1834, Turner had shown a glowing natural landscape,[78] but in the "Lycidas" design he introduced the supernatural vision of St. Michael armed with a lance or spear, standing – not seated as in Warton's note – against the disc of the sun.

Thus we can see that Turner went back, at least in memory, to some of his vignettes of the 1830s in framing the design of his own apocalyptic angel – a figure of supernatural power in the sky. It may be that he identified himself with the angel, but an alternative possibility, one raised by Ronald Paulson,[79] is that the artist is in the position of St. John seeing and recording the angelic vision. This possibility is one that Turner's picture shares with treatments of apocalyptic subjects by other artists, where the images are present, whether consciously or by implication, as if seen from the point of view of the prophetic visionary. In this respect as well as a number of others, we gain a certain perspective on Turner's work by viewing it in relation to that of his fellow practitioners of the apocalyptic sublime, without becoming any the less aware of the magnitude and the uniqueness of his accomplishment.

77. Milton, *Poetical Works*, vol. VI, pp. 633–4.
78. See Butlin and Joll, vol. I, no. 358, and vol. II, plate 361.
79. See *Literary Landscape*, pp. 187–8.

CHAPTER VI

John Martin

In 1816, four years after the exhibition of Turner's *Hannibal*, John Martin showed at the Royal Academy his *Joshua Commanding the Sun to Stand Still upon Gibeon*, a work as different in its way from Turner's as Turner's pictures were from de Loutherbourg's. Martin's son-in-law Peter Cunningham later wrote: "The 'Joshua' attracted, as it deserved to do, very great attention, from the new and highly imaginative manner in which the sublime incident from Scripture was sought to be embodied."[1] Martin's new manner consisted typically in showing with a marvellously clear sense of perspectival illusion terrible disasters overtaking hordes of hapless victims in vast natural or architectural settings. "His is the highest order of the material sublime," wrote Charles Lamb,[2] and this expression is appropriate if what is understood is the means that Martin used to achieve his effects. The ends could, however, be in some ways similar to Turner's and even to Blake's. Although Martin's work was sometimes denigrated as belonging to what we might today call popular culture, at its best it displays both considerable accomplishment and seriousness of purpose. Before discussing Martin's powerful apocalyptic paintings, we must consider Martin's political and religious beliefs, for the spectacular nature of his *oeuvre* sometimes obscures the fact that he conceived his paintings as statements about God, man, and society.

The real nature of Martin's views on these subjects has virtually to be reconstructed. Of the two most valuable contemporary accounts, one, that of Martin's friend Ralph Thomas, now exists only in fragments quoted in an early biography,[3] while the other, that of the artist's son Leopold,[4] is at times colored by a desire to protect John Martin's good name. Sometimes, seeming discrepancies demand resolution. For example, to

1. "The British Institution," *Illustrated London News*, XIV (1849), 153.
2. Charles Lamb, "Barrenness of the Imaginative Faculty in the Productions of Modern Art," in *Collected Essays*, with Introduction by Robert Lynd and notes by William Macdonald (London: J.M. Dent, 1929), vol. II, p. 266. This essay first appeared in 1833.
3. Mary L. Pendered, *John Martin, Painter. His Life and Times* (London: Hurst and Blockett, 1923). The manuscript diary from which the quotations from

Thomas were taken disappeared some time after Miss Pendered used them.
4. Leopold Martin's *Reminiscences of John Martin, K.L.* were published *seriatim* in Supplements to the *Newcastle Weekly Chronicle* for 1889, occupying the first page of each from 5 January (no. 6,494) through 20 April (no. 6,509). Pendered's quotations from this source are not entirely reliable and citations here are from the original in the Newcastle City Library.

Leopold, John Martin was "a man of piety and strong religious impressions,"[5] while to Ralph Thomas he was "a thorough Deist."[6] Each statement can be shown to be true in its way; each represents an aspect of Martin that is reflected in his work.

John Martin's mother, Isabella, claimed descent from the Protestant martyr Nicholas Ridley,[7] whom Martin was to paint in Paradise. Her parents' household was a pious one in which two prayer meetings were held daily. John's brother William learned that on her deathbed Isabella heard heavenly music and also "told her nurse, one of her nieces, that waited upon her that her family's name would sound from Pole to Pole."[8] According to Leopold, Martin himself, while sketching in Westminster Abbey, was overcome "when the glorious anthem burst out from the organ and the choir," and so got down on his knees to pray and worked no further that day.[9] Leopold's characterization of his father as "a deeply spiritual, enthusiastic worshipper of the Bible" seems accurate enough,[10] but not even Leopold could make John Martin out to be a churchgoer:

> His religion was that of a nature born from above, grounded alone on the works of our Redeemer. The Sabbath was with him consecrated to God, not in frequenting church, but with outdoor worship of his glorious works.[11]

In other words, Martin's Sundays were spent in country walks, sketching and talking to friends, and Ralph Thomas has left delightful accounts of these. What Thomas called "Deist" about Martin seems to have been Thomas's own word for the artist's conviction that "all good flows from a God" to the exclusion of "anything not good, merciful, or great."[12] Thomas was shocked by some of Martin's views, such as that David was an Old Testament Henry VIII, that God could not have commanded the sacrifice of Isaac, and that Jacob was the thief of Esau's patrimony – but such judgments, along with Martin's interest in the evidence of fossils and of geology, exhibit a disbelief in the Bible only as an interpretation of literal facts.

Some of Martin's ideas about the Bible have much in common with Blake's visionary radicalism. At times Martin seems also to have entertained spiritualist notions that would not have seemed out of place in de Loutherbourg. After the death of his friend and teacher Boniface Musso, Martin, carrying out an agreement that they had made, attempted to make contact with Musso's spirit "in solitude, at midnight, and on a foggy, misty moor."[13] Martin may also have had millenarian interests, as did Blake, and there was even an advertisement for a book supposedly illustrated by Martin entitled *The Gathering Standard of the World, Seen in the British Flag. The Threefold Banner of the Holy Bible, The Ensign of the Messiah's Coming.*[14] Although this book has not been

5. *Reminiscences*, 9 March 1889.

6. Pendered, p. 231.

7. Leopold Martin, *Reminiscences*, 5 January 1889.

8. William Martin, *A Short Account of the Philosopher's Life* (Newcastle, 1833), pp. 13, 14. See also Richard Welford, *Men of Mark 'twixt Tyne and Tweed* (London: Walter Scott, Ltd., 1895), p. 171.

9. *Reminscences*, 5 January 1889.

10. *Ibid.*

11. *Ibid.*

12. Pendered, p. 231.

13. *Ibid.*, p. 233.

14. See Ruthven Todd, *Tracks in the Snow* (London: Gray Walls Press, 1946), p. 105. Todd found the advertisement in another millenarian publication, *A Divine and Prophetic Warning to the British Nation (First Published July, 1832), to which is added A Prophetic Vision of the Heavenly Jerusalem, and the Downfall of Babylon* (London: Christian Magia [*c.* 1845?]).

IV. J.M.W. Turner. *The Angel standing in the Sun.*

V. John Martin. *The Last Judgment.*

found, Martin did execute, possibly for engraving with other illustrations of the New Testament, a water color entitled *Christ's Glorious Coming;*[15] and the last great project of his life was three paintings showing the Day of Wrath, the Last Judgment and the Millennium.

Martin's political beliefs were as independent as his religious ones, and he was not afraid to risk embarrassment and even violence in maintaining them. At the time when the Regent's attempt to divorce Queen Caroline had engendered a political contest between liberals and conservatives, Martin hissed when the National Anthem was played at a concert, causing his companion, the artist C.R. Leslie, to leave in embarrassment.[16] Again, at the commemoration of the birthday of Robert Burns in the year of the First Reform Bill, 1832, Martin hissed the speakers for what he considered their Tory expressions:

When I hissed [said Martin] some person cried out, "Knock that fellow down." I looked for the utterer and scowled at Mr. Logan, who had turned savagely at me. I

15. See William Feaver, *The Art of John Martin* (Oxford: the Clarendon Press, 1975), pl. 145. The location of this picture is unknown, but Feaver reproduces it from a photograph and suggests that it may have been intended for the Westall–Martin New Testament illustrations (on which see below).

16. The source is Ralph Thomas, quoted by Pendered, p. 98. Pendered thinks this took place after Queen Caroline's death, but Thomas Balston *John Martin* (London: Gerald Duckworth, 1947), pp. 82 and 162, is probably right in placing the incident in 1821.

said to him, smilingly, knowing him, "How do you do, Mr. Logan," while the Tory boasts were persisted in.[17]

Then, when Allan Cunningham remonstrated that Burns had been well off on seventy pounds a year, Martin rejoined: "He had gained a world's admiration by his independent writings, but he lost the support of the rich, and men must be prepared to suffer if they indulge in the luxury of independent expressions." One senses Martin identifying with Burns here and assuming his role as a spokesman for the unrepresented. According to Ralph Thomas, Martin was "a radical reformer in politics."[18] The close friendship between the two men was in a way a testament to this, for Serjeant Thomas became a defense counsel for the Chartists and at the end of their trial, according to his son, spoke seven hours on their behalf.[19] Some further indications emerge from two anecdotes concerning the philosopher William Godwin.

The first record of Martin's association with Godwin is Godwin's diary entry dated 14 June 1830, when the older man visited the artist for tea.[20] But Godwin had previously recorded seeing *The Fall of Nineveh* on 19 May 1828 and "Visions of J Martin" on 22 June. His diary noncommittally reports a total of fifty meetings with Martin over a period of six years. The place was often Martin's house; some of the other meetings were at the home of the portrait artist H.W. Pickersgill. Among those present at various times were the two Landseers, Allan Cunningham, John Knowles, Henry Fuseli, Leigh Hunt, Charles W. Dilke, James Hogg, George Cruikshank, Sir David Wilkie, Benjamin Robert Haydon, and J.M.W. Turner. The last time Godwin saw Martin, as far as the diary's evidence goes, was on 9 March 1836.

Thus we can see that Martin's association with Godwin took place over the years immediately preceding and following the First Reform Bill, and this provides a context for the two anecdotes, which in turn tell us a good deal about Martin's political values. One of these is recounted in Leopold's *Reminiscences*:

> Well I remember an arrangement made by him with my father to accompany him to visit the burial ground of Bunhill Fields at Finsbury, the Campo Santo of the Dissenters. Godwin's anxious wish was to show my father what little or how litttle there was or now remained to mark what he termed the hallow'd spots of the earth! ... Godwin expressed the greatest indignation, when pointing out the place where John Bunyan ... was buried, that no inscription marked the place of interment ... Godwin was also in high indignation at there being no memorial to the memory of George Fox ... My father seemed, however, in my opinion, to be much more interested in the memorial to the memory of Thomas Hardy, secretary to the London Corresponding Society, but better known by the trial for treason in 1794, in company with John Horne Tooke.[21]

17. See Pendered, pp. 175–6. It should be mentioned that Martin was a friend of Burns's son, who sometimes used to sing at the artist's evening gatherings.

18. Pendered, p. 176.

19. Ralph Thomas, *Serjeant Thomas and Sir J.E. Millais, Bart, P.R.A.* (London: 1901, printed for the author), n.p.

20. Information concerning entries in Godwin's diary (Bodleian Library) was given to me by Professor Anne K. Mellor, to whom I am extremely grateful.

21. 19 January 1889.

Leopold seems unaware of the irony of the situation – it was the state trials of 1794, held when his father was in his fifth year, that elicited from Godwin his celebrated defense of the indicted radicals.

Again, in Charles Macfarlane's *Reminiscences of a Literary Life*, is related an incident in which Martin appeals to Godwin, who is playing cards, for support in an argument about Reform. Although Macfarlane stage-manages the sketch so that Godwin's anti-Reform views have the better of it, one glimpses the tenacity with which Martin supported the popular cause.

> "But," said Martin, "we have had the march of intellect, progress of education, intellectual development, throwing off prejudices, and now the Nation, the People, thinks."
>
> Old Godwin, now beginning to lead in trumps and transparently annoyed at the interruption, yet still as calm and cool as a cucumber, said "I don't think a whole *People* can think." "Then," said Martin, "you throw up the whole democratic principle?" "Perhaps I do," said Godwin, making a trick.[22]

Godwin became alarmed when people like his late son-in-law Percy Bysshe Shelley actually tried to realize some of the ends proposed in *Political Justice*, and to be fair, the condemnation of all forms of political association is consistent with his views in that book. He believed that the existence of social institutions was in itself to blame, while Martin wanted to see improvements in political representation, in transportation, in water supply. His ambitious proposals concerning the last sometimes take on a Radical tone, as when he writes of unemployment in 1846:

> The distress which for a long period prevailed in our country, and which in some parts still continues to exist to a painful extent, is now admitted to arise mainly from want of adequate employment amongst the labouring and productive classes, causing that which should be the wealth of a nation – a crowded and rapidly augmenting population – to be regarded as a real evil, for which there is no apparent remedy but emigration.[23]

In Martin's brother Jonathan, the York incendiary, we see elements of the artist's thought as in a distorting mirror. In his first letter to the clergy in York, Jonathan combines millenarian zeal with at least the suggestion of French radicalism in an unconscious Joycean pun, threatening that "the Sun of Boney part is preparing for you and he will finish the work his Father has left undone."[24] An apocalyptic dream worthy of one of John's paintings appears in Jonathan's autobiography:

> I dreamed again, that being in a field alone, *I looked up and saw as it were a sea of fire coming towards me, and found myself shortly surrounded with it. I thought surely the world was at an end and I should be eternally lost. I awoke crying out for pardon and time to repent.*[25]

22. Charles Macfarlane, *Reminiscences of a Literary Life* (London: John Murray, 1917), pp. 98–9.

23. John Martin, *Thames and Metropolitan Improvement Plan* (1846), p. 1.

24. See Thomas Balston, *The Life of Jonathan Martin* (London: 1945), p. 56.

25. *The Life of Jonathan Martin of Darlington, Tanner. Third Edition, Considerably Improved, with Engravings by the Author* (Lincoln, 1828), p. 11.

The contrast between the brothers' ways of thinking is similar to that between William Blake's and Richard Brothers's: it is the difference between artistic vision and delusion. Jonathan Martin went on to set fire to York Minster; John painted *Belshazzar's Feast*.

<p style="text-align:center">❦ ❦</p>

In 1834 Martin himself gave an account of the origin of the painting that made him famous. The idea had come from Martin's friend the brilliant young American Washington Allston, whom Coleridge had called "a painter born to renew the sixteenth century."[26] Allston, Martin wrote,

> was himself going to paint the subject, and was explaining his ideas, which appeared to me altogether wrong; I was explaining my conception; he told me there was a prize poem at Cambridge, written by Mr. T.S. Hughes, which exactly tallied with my notions, and advised me to read it. I did so, and determined on painting the picture.[27]

This conversation probably took place after Allston had completed two oil sketches of Daniel interpreting the handwriting on the wall, one of which he described to Washington Irving in a letter dated 9 May 1817:

> I think the composition the best I ever made. It contains a multitude of figures, and (if I may be allowed to say it) they are without confusion. Don't you think it a fine subject? A mighty sovereign surrounded by his whole court, intoxicated with his own state, in the midst of his revellings, palsied in a moment under the spell of a preternatural hand suddenly tracing his doom on the wall before him; his powerless limbs shrunk up to his body, while his heart, compressed to a point, is only kept from vanishing by the terrified suspense that animates it during the interpretation of his mysterious sentence. His less guilty, but scarcely less agitated, queen, the panic-struck courtiers and concubines, the splendid and deserted banquet-table, the holy vessels of the temple (shining, as it were in triumph over the gloom), and the calm, solemn contrast of the prophet, standing like an animated pillar in the midst, breathing forth the oracular destruction of Empire![28]

Amongst previous treatments of the subject, two would have been especially important to Allston. One was Rembrandt's (National Gallery, London), which John Opie had singled out in a Royal Academy lecture of 1807 for its expressive coloration – "the bloodless, heart-appalling hue, spread over his Belshazzar's Vision of the Handwriting on the wall."[29] The other was Benjamin West's (Museum of the Berkshires, Pittsfield, Mass.), and Allston early in his career was a great admirer of West. Like numerous other American artists, Allston had sought West out upon coming to England, and , as we have seen, he had expressed particular admiration for the oil sketch of *Death on the Pale Horse*.[30]

26. See Jared B. Flagg, *Life and Letters of Washington Allston* (New York: Charles Scribner's Sons, 1892), p. 136.

27. *The Athenaeum*, VII (1834), 459.

28. Flagg, pp. 71–2.

29. *Lectures on Painting*, p. 157.

30. Letter to Charles Fraser, 25 August 1801, Flagg, pp. 43–4.

60. Valentine Greene after Benjamin West. *Belshazzar's Feast.*

Although Allston later modified his praise for West, it seems likely that he would have taken note of the only significant treatment of *Belshazzar's Feast* by a contemporary (with the exception of Artaud's insipid design for the Macklin Bible, exhibited in 1793). Even if he had not seen the painting he would no doubt have known, as Martin too would have, one or more of the engravings after it, whether Valentine Greene's of 1777 (Pl. 60) or the comparatively recent ones by Tomlinson (1809) and by H. Moses (1815). The bodily posture of Daniel in Allston's painting certainly resembles that in West's, although Allston's design is immeasurably more powerful.

Allston never completed his twelve-by-seventeen-foot painting of *Belshazzar's Feast,* but the two oil sketches that he did execute are actually small finished paintings and splendid works of art in their own right. This is especially true of the fully colored version in the Boston Museum of Fine Arts (Pl. 62), probably executed later than the monochrome now in the Fogg Art Museum (Pl. 61), since at the lower left in the former the Temple vessels stand in the place of the boys in the latter, and we know that Allston intended to keep this detail in the large painting. Belshazzar is shown shrinking back

> O'er that high festival,
> A thousand cups of gold,
> In Judah deem'd divine –
> Jehovah's vessels hold
> The godless Heathen's wine![34]

Since Leopold tells us that Byron was John Martin's favorite modern poet, the likelihood of such a direct connection is increased.[35]

From Allston's sketch Martin retained certain motifs but expanded them on a tremendous scale: the pillars of the architectural setting, the crowd of figures in the background, the pagan god set in a recess, and the light streaming from the wall. However, as for Martin the scene was a vast panorama, the size of the human figures had to be reduced in relation to the architecture of the material sublime. C.R. Leslie, who disapproved of Martin's plan from the start, wrote sardonically to Allston in America: "He is now employed on your subject of Belshazzar, making it an architectural composition with small figures, the writing on the wall to be *a mile long*."[36]

The picture that astonished London in 1821[37] was painted predominantly in red – the one warm color that Burke would allow to be sublime (Col. Pl. VI).[38] The titanic architectural setting, powerful contrasts of light and shadow, and frightened human gestures all contribute to the sublime of terror. Even the reiterated pillars receding into the picture are a Burkean feature, for their succession creates what the *Enquiry* terms "the artificial infinite."[39] Coming more than six decades after the publication of Burke's treatise, Martin's *Belshazzar's Feast* is an almost perfect example of the effects it describes.

Martin was very deliberate about the creation of these features, as the pamphlet he wrote to accompany the exhibition of the painting testifies. Here he speaks of the "intellectual mechanism" of "shadows opposed to lights" and of "a perspective of light, and (if the expression may be allowed) a perspective of feeling"; and he approvingly quotes a newspaper review that employs a typically Burkean formula: "The soul experiences an instant exaltation of its faculties in the contemplation of the beautiful and sublime objects."[40] He also divides the painting into three parts, giving it the structure of another sublime art-form, the tragic drama.

In the writing at the upper left of the painting, Martin locates the "Prostasis":

> The characters, in strokes of the most intense light, send forth an indescribable effulgence, such as would be in the blaze of lightnings, could they be fixed on the dark

34. George, Lord Byron, *Poetical Works*, ed. Frederick Page, rev. John Jump (Oxford: Oxford University Press, 1970), p. 81.
35. See Martin, *Reminiscences*, 12 January 1889.
36. Flagg, p. 162; letter dated 3 March 1820. Allston's own reaction was more generous; see Flagg, p. 171.
37. This original, now in a private collection in England, was badly damaged in a railway accident. My discussion is based on the smaller painting, in excellent condition, at the Yale Center for British

Art. On the various versions of *Belshazzar's Feast*, see Appendix 3.
38. *Enquiry*, p. 81.
39. "Succession and Uniformity," p. 106.
40. *A Description of the Picture, Belshazzar's Feast, Painted by J. Martin, Which Gained the Highest Premium at the British Institution in London* (42nd ed., 1825 [text dated 12 May 1821]), pp. 5–15. The pamphlet includes an etching with a numbered key.

ground of the angry clouds from which they emanate – their scintillating beams fill the whole of the Atrium with awful resplendency, and the whole assembly with horror and distress. Like arrows of flame they dart across the hall, and as a shower of fire, alight upon every object.[41]

The second act, or "Epistasis," focusses on the reactions of the king ("astonishment and horror"), the queen ("an agony of terror"), and the spectators ("eagerness and curiosity"). The "Catastrophe" of the third act is concentrated on the figure of Daniel himself. Martin was concerned to find the appropriate "semantic gesture," to use Kester Svendsen's term,[42] for Daniel; it was ultimately suggested to him by a pose struck by a Shakespearean actor, Charles Young, who visited Martin's studio with the aged Sarah Siddons.[43] Nevertheless, the mantic attitude of Martin's Daniel has much in common with the postures of both West's and Allston's Daniel – what is dramatically different is the extent to which Martin subordinates even the prophet to the overpowering effect of the scene as a whole.

In trying to make his setting imaginatively true, Martin incorporated much of what was then known about Eastern architecture.[44] There is an enormous central atrium, on two sides of which run rows of columns with "Indian" capitals supporting the hanging gardens above them. In the right foreground are massive "Babylonian" capitals topped by a vast "Egyptian" entablature. The third wall combines architectural detail with symbolism: "The Stones joined in a manner giving the strength of an arch, without being one."[45] A sense of exoticism is heightened by details like the serpent-entwined Jupiter Belus, the signs of the zodiac above the lower colonnades, and a ziggurat in the background. Further away is the Tower of Babel, which Martin, always precise about his perspectival arrangement, reckons to be seven miles high. Martin was indeed the master of the material sublime.

The enormous success of *Belshazzar's Feast* is typified by Edwin Atherstone's comments in the *Edinburgh Review*, where the painting is appreciated in Burkean terminology of the sort that Martin himself employed:

> But when to the grand and the gigantic we superadd some powerful moral association, – when we give to it the hoariness of antiquity, – when we deepen its solemnity by the obscurity of night, – when, by concealing its limits, we lead the imagination to draw out the vast almost into the infinite, – then, indeed, do we awake to a sense of awe and sublimity, beneath which the mind seems overpowered.[46]

41. *Ibid.*, p. 9.

42. Svendsen uses the term in discussing one of Martin's *Paradise Lost* mezzotints; see "John Martin and the Expulsion Scene of *Paradise Lost*," *Studies in English Literature*, I (1961), p. 73.

43. See Martin, *Reminiscences*, 26 January 1889.

44. On this subject, see Norah Monckton, "Architectural Backgrounds in John Martin," *Architectural Review*, CIV (1948), 81–4.

45. Martin, *A Description*, "References to the Etching."

46. Review of Allan Cunningham's *Lives of the Most Eminent British Painters, Sculptors and Architects*, *Edinburgh Review*, XLIX (1829), 471. Martin knew Atherstone and had illustrated his poem, *A Midsummer Day's Dream*, in 1824.

From the very first, however, there was a division between the painting's popular appeal and the judgment of at least some artists and literary critics.

David Wilkie, writing to Sir George Beaumont, managed to give expression to both types of view. Of the various artists showing at the British Institution, Wilkie wrote:

> . . . Martin is certainly the first, both in effort and in success. His picture is a phenomenon. All that he has been attempting in his former pictures is here brought to its maturity; and although weak in all those points in which he can be compared with other artists, he is eminently strong in what no artist has attempted. Belshazzar's Feast is the subject; and in treating it, his great elements seem to be the geometrical properties of space, magnitude, and number, in the use of which he may be said to be boundless. The great merit of the picture, however, is perhaps in the contrivance and disposition of the architecture, which is full of imagination.[47]

However, Wilkie went on to add, "Artists, so far as I can learn from the most considerable and important of them, do not admit its claims to the same extent." By and large, despite Benjamin West's early encouragement of Martin's work, the considerable and important artists of the Royal Academy remained indifferent or even hostile to Martin, to the extent of naming his imitator Francis Danby an Associate in 1825 while this honor was never extended to Martin himself.

Martin was also the subject of a memorable attack by Charles Lamb, who, like Ruskin later,[48] found *Belshazzar's Feast* vulgar and bombastic. According to Lamb, in the biblical text, contrary to Martin's representation, "the appearance was solely confined to the fancy of Belshazzar, that his single brain was troubled." Martin therefore erred in showing "all this huddle of vulgar condemnation."[49] Furthermore, in giving such extensive details, down to the jewelry of the ladies, Martin tried to delineate what should only have been suggested. "But in a 'day of judgment,' or in a 'day of lesser horrors, yet divine,' as at the impious feast of Belshazzar, the eye should see, as the actual eye of an agent or patient in the immediate scene would see, only in masses and indistinction."[50] In a gleeful spirit, Lamb compares the painting to an imagined episode at the Brighton Pavilion, where the future George IV throws his guests into confusion by suddenly displaying "a huge transparency . . . in which glittered in gold letters — 'BRIGHTON — EARTHQUAKE — SWALLOW-UP-ALIVE!' "[51]

Lamb's attack deserves scrutiny. Does the biblical text support his view that the writing on the wall was the king's hallucination? "In the same hour came forth fingers of a man's hand, and wrote over against the wall of the king's palace: and the king saw the part of the hand that wrote" (v. 5). In Rembrandt's painting, which Lamb admired, the king reacts to the inscription and the others to the expression on his face, but Lamb is simply wrong in saying that no one else, not even Daniel, saw the writing afterwards:

47. Letter dated 16 February 1821, in Allan Cunningham's *Life of Sir David Wilkie* (London: John Murray, 1843), pp. 56–7.

48. See *The Bible of Amiens* in *Works*, vol. XXXIII, p. 157.

49. "On the Barrenness of the Imaginative Faculty," p. 267–8.

50. *Ibid.*, p. 268.

51. *Ibid.*, p. 266.

Then came in all the king's wise men; but they could not read the writing, nor make known to the king the interpretation thereof . . .

Then Daniel answered . . . yet will I read the writing unto the king, and make known to him the interpretation.[52]

Lamb's account, in which he refers to "the scroll, which the king saw," is as much a fictionalization as his Brighton anecdote, and his condemnation of Martin's painting seems related to his more general rejection of the artistic representation of literary material. "I am jealous of the combination of the sister arts," he wrote to Samuel Rogers about the Boydell Shakespeare. Let them live apart."[53]

Another hostile critic, writing in the *Westminster Review*, attacked *Belshazzar's Feast* for its theatricality:

Belshazzar is Wallack the actor, in an affected attitude, with a common-place look of fear; the prophet is the Reverend Mr. Irving; the soothsayers resemble the vocal priests of the opera, arrayed in cumbrous draperies; and the concubines are a mob of females with preposterous trains, fainting in the most extravagant postures. Instead of "the fingers of a man's hand writing over against the candlestick on the plaster of the wall of the king's palace" there is a pyrotechnic display of colossal hieroglyphs on the marble frieze of a stupendous temple . . .[54]

The individual elements of this criticism are curiously pertinent. Daniel's pose if not Belshazzar's was indeed, as we have seen, suggested by an actor; Martin's ideas do have something in common with those of the millenarian Irving; and there *is* something operatic about Martin's painting – the setting could serve for Verdi's *Nabucco*. What the critic misses, as does Lamb, is that such theatricality may have serious import.

Martin, like Verdi after him, embodied his most passionate convictions in theatrical conceptions. Considering what we have seen of Martin's political and religious views, and especially his dedication to the cause of Reform, this painting, executed just two years after Peterloo, has an inescapably Radical resonance. The setting could indeed be a transformation of Prinny's Brighton Pavilion, which had recently been orientalized by Nash, and the prophet Daniel could be a personification of the artist himself, revealing to a corrupt and unjust society the existence of another order of values. Daniel's message would coincide with Martin's view of the world represented by the Prince Regent: "thou art tried in the balance and found wanting."

If this interpretation of *Belshazzar's Feast* is correct, how does it square with Martin's later dedication of his mezzotint engraving (1826) of the subject to George IV? There is a twofold answer to this, one part lying in the conventions and economics of print publishing. Hogarth, for example, seems to have felt no incongruity in attempting to dedicate the engraving of *The March to Finchley* to George II, and he may have been genuinely surprised by the King's refusal. Blake inveighed against the Female Will and criticized Dante because "Dante Gives too much to Caesar he is not a Republican,"[55]

52. Dan. v. 8, 17.

53. *The Letters of Charles Lamb*, ed. E.V. Lucas (New Haven: Yale University Press, 1935), vol. III, p. 394.

54. XV (1834), 455.

55. Annotations to Boyd's *Historical Notes on Dante* in *Complete Poetry and Prose*, p. 633.

but he nevertheless wrote dedicatory verses to Queen Charlotte to accompany his designs for Blair's *Grave*, and he proposed to accompany this poem with an engraving. The royal dedication was an important selling point in Martin's time too, and he would not have been unique in feeling that if the King sponsored a picture that was really a symbolic attack on him and all he stood for, so much the better.

The dedication does, nevertheless, bring out a characteristic inconsistency in Martin. Despite his principled and even courageous advocacy of Reform, he was always eager to associate with the titled. Apparently impartial as to questions of the French succession, he treasured equally Napoleon's candlesticks (a gift of Joseph Bonaparte), a gold medal from Charles X, and Sèvres porcelain from Louis-Philippe. Leopold Martin's account of Prince Albert's visits to his father's studio have something of the flavor of Lady Margaret's description in *Old Mortality* of Charles I taking his "*disjune*" at Tillietudlem. Martin was eager to become a Belgian knight when invited to do so after King Leopold of the Belgians explained why he could not purchase Martin's painting *The Fall of Nineveh*, successfully exhibited at Brussels in 1833. (Martin had to pay the British government one hundred guineas for the privilege of accepting.) If there is a certain pathos in the quest for such distinctions on the part of an artist who was a self-made man never officially honored by his own government, it should neither detract from the sincerity of his convictions nor obscure the originality of his accomplishments.'

Belhazzar's Feast also provided the subject for the first mezzotint engraving to be completed by John Martin (Pl. 65). Richard Godfrey has observed, "Martin's work in mezzotint represents the most sustained effort by a painter in scraping his own designs."[56] Yet, as Leopold Martin put it, Martin became "an engraver by compulsion."[57] This is because he had engaged Charles Turner, one of the engravers of the *Liber Studiorum*, to execute a plate after *Joshua Commanding the Sun to Stand Still*,[58] but was so dissatisfied with Turner's progress that he decided to engrave the subject himself. It was completed in 1827, by which time Martin had already published *Belshazzar's Feast* (1826). From this time on, engraving was almost as important as painting to Martin. Like his predecessors Hogarth and Blake, he acted as his own publisher, eliminating the middle man. His house at Allsop Terrace contained, according to Leopold, "a substantial private printing establishment," and so Martin was able to exercise total artistic control of his graphic works from the earliest stages to the last.

Martin began *Belshazzar's Feast* on copper but when Thomas Lupton developed the steel plate mezzotint, Martin took up the new medium and used it for his illustrations to *Paradise Lost*, engraved for Septimus Prowett (1825–27). He also abandoned his *Belshazzar* plate and started anew on steel, advised by Lupton himself. The result was important for Martin's art as well as for his fortune and reputation. His sense of melodrama and his use of vast spatial perspectives were ideally suited to mezzotint. In *Belshazzar's Feast* the vivid contrast of darks and lights that mezzotint can provide is brilliantly exploited in the radiance streaming from the writing on the wall, and at the

56. Richard Godfrey, *Printmaking in Britain* (Oxford: Phaidon, 1978), p. 85.

57. *Reminiscences*, 30 March 1889.

58. Leopold's memory seems to have misled him into thinking that *Joshua* was first, but see Balston, pp. 100–101.

136

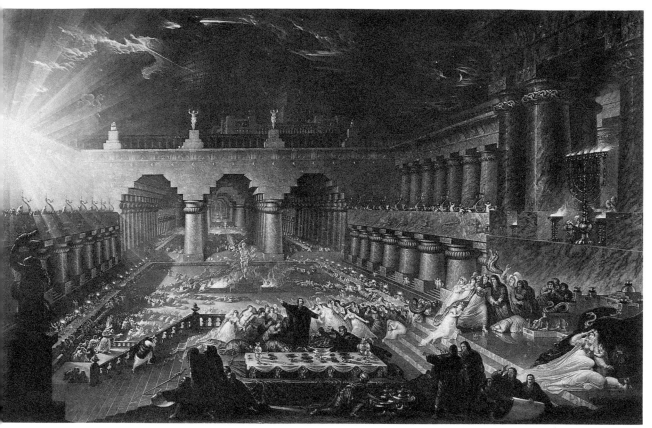

65. John Martin. *Belshazzar's Feast.*

same time the vast recession of the hall is partly created by tonalities of darkness. In this and other Martin mezzotints we perceive a fundamentally dark reality illuminated by surprising bursts of light, which is a property of the mezzotint process itself.

Not content merely to absorb what Lupton had to teach him, Martin experimented with the materials and methods of engraving, and particularly with inks. Some of his techniques were recorded in Leopold's memoir:

> As an engraver, my father was truly an experimentalist. He did much in instructing printers in their art. To some, however, he was greatly indebted, for the effects of his chief engravings were often the result of printing. The glorious blaze of lights, the handwriting on the wall in the engraving of "Belshazzar's Feast," the splendid burst of sunlight in "Joshua Commanding the Sun to Stand Still," the awful light in "The Deluge," are chiefly the results of printing under his own eye and direction. Very much depended upon the ink used.[59]

59. *Reminiscences*, 30 March 1889.

Elsewhere, Leopold goes into more detail about these inks and the ways in which his father employed them.

At the outset he would pull a plain proof of the plate, using ordinary ink; then work or mix the various inks. First, he made a stiff mixture in ink and oil; secondly, one with oil and less ink; and thirdly, a thin mixture both of ink and oil. Lastly, he worked up various degrees of whiting and oil with just the slightest dash of burnt umber, just to give a warm tint to the cold white. In working or inking the plate, the thick ink (No. 1) went to the darkest tints, No. 2 to the medium ones, No. 3 to the lighter shades; the inks consisting chiefly of whiting, the most difficult to work and the most artistic. Separate dabbers were required for each description of ink. The greatest attention was needed in the use of the canvas when wiping off, so as to blend or harmonize the various inks, especially those of whiting.[60]

Thus the deepest shadows would be conveyed by a mixture of Frankfurt black and burnt oil; for the medium darks more burnt oil would be added to the mixture; and for the medium lights still more. The lights would be scraped out and then inked by adding a very little burnt umber or Frankfurt black to a mixture of burnt oil and whiting. In this manner the dramatic tones of *Belshazzar's Feast*, going from the deepest black of the sky to the rays blazing from the wall, were achieved.[61] From *Belshazzar's Feast* on, until Martin's eyesight began to weaken in the 1840s, the idea of a personally executed mezzotint became closely associated with the plans for each of his major paintings.

With *Belshazzar's Feast* Martin had established his title as, in the words of "Christopher North" (John Wilson), "KING OF THE VAST,"[62] and he continued to explore the mode of the Burkean sublime in *The Destruction of Pompeii and Herculaneum* (1822). He may not have been entirely pleased with this classical-historical subject; at any rate he never completed the mezzotint he proposed to execute after it. In 1824 he approached the apocalyptic again with *The Seventh Plague of Egypt* (Boston Museum of Fine Arts), in which he tried to out-Turner the agitated sky of Turner's mistitled *Fifth Plague*.

Like Turner, Martin places Moses and Aaron in isolation from the rest of the scene, while the architectural coulisse seems derived from Turner's *Decline of the Carthaginian Empire* (Tate Gallery), exhibited in 1817, although raised to a *martinienne* scale. The semantic gesture of Moses' arms raised toward the sky, and the horde of tiny figures gesticulating in fear would both have been recognized as Martin trademarks. The luminous glare at center right, like the Turnerian vortex of *Joshua*, suggests divine forces dimly apprehended just beyond the natural world. This territory – the point at which the natural, catastrophic and the apocalyptic sublimes meet – had become characteristically Martin's. It was, then, only to be expected that he would paint a Deluge and that it would occupy an especially prominent place among his works.

60. *Ibid.*, 9 March 1889.
61. I am indebted to Dr. Bo Ossian Lindberg for a demonstration of these techniques.

62. *Noctes Ambrosianae* (no. lxiv, November 1832), ed. R. Shelton Mackenzie (New York: Worthington, 1863), p. 177.

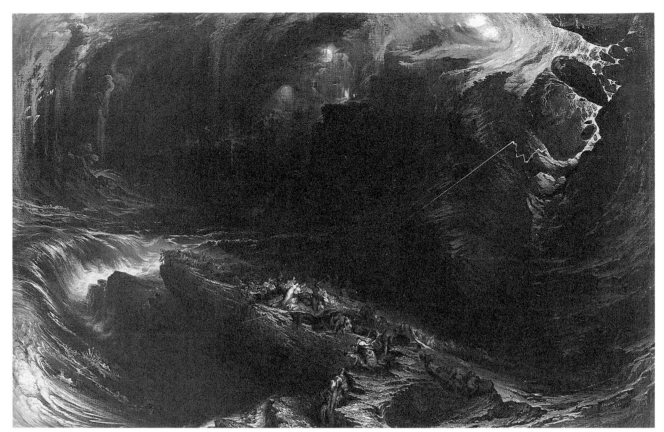

66. John Martin. *The Deluge.*

Writing to Edwin Atherstone on 12 November 1841, Martin refers to *The Deluge* as "my favou[ri]te picture."[63] The original, which was exhibited at the British Institution in 1826, has been lost,[64] but in 1834 the artist painted a second version (Yale Center for British Art) (Pl. 66). This second version incorporates compositional changes that Martin had introduced into his mezzotint *Deluge* of 1828.[65] In contrast to *Belshazzar's Feast* and *The Seventh Plague*, the setting of *The Deluge* is an entirely natural one: a flooded rocky valley that may, as Balston suggests,[66] derive from the artist's native valley of the South Tyne. Although Francis Danby charged Martin with plagiarizing the basic composition from Danby's *Attempt to Illustrate the Sixth Seal*,[67] it seems doubtful that *The Deluge*, so much in the vein that Martin had established from *Joshua* on, was taken from any other artist. Turner's influence is, however, once more evident in the huge watery

63. Extra-annotated copy of Balston's *John Martin* (Victoria and Albert Museum), tipped in between pp. 88 and 89.

64. The picture may have disappeared very early; Martin in 1829 was trying to locate it so that he could send it to Newcastle, and he expressed fear that an accident had happened (MS letter to William Nicol-son dated 13 July 1829, Victoria and Albert Museum).

65. See Martin's *Descriptive Catalogue of the Engraving of the Deluge* (London, 1828), p. 3.

66. *John Martin*, p. 18.

67. See discussion in Chapter VII below.

vortex that sweeps the sides of the picture space and in the avalanche of rocks falling at the right.[68]

Martin had no doubt seen Turner's *Deluge* when it was exhibited at the Royal Academy in 1813, since Martin himself showed *Adam's First Sight of Eve* in that exhibition. His decision not to follow Turner in some important respects is at least as important as his indebtedness. Where Turner delineates the effects of the Flood upon a relatively few figures who share with the landscape the emphasis of the painting, Martin's tiny human forms are, in contrast, entirely dominated by the elemental turmoil around them. Where Turner's images establish their own meaning, some of Martin's depend upon verbal explanation while others are so undramatically placed as to risk being missed entirely. Without the text of Martin's *Descriptive Catalogue* we might not know that the man standing in the center with arms reaching upward is "a blasphemer; his wife placing her hand upon his mouth to prevent his imprecations."[69] Nor would we be likely to guess that the old man toward the right is Methuselah, whose age, Martin carefully calculates, means that he was alive at the time of the Flood.[70] As for the Ark, it is inconspicuously ledged high on a mountain in the middle background.

Martin's *Deluge* so successfully conveys a sense of cosmic forces rendering humans insignificant that it requires an act of imagination to construe what is going on in the painting. Such a way of seeing, in which the spectator virtually collaborates in establishing visual meanings, is ingeniously recreated by "Christopher North" (John Wilson), speaking through James Hogg, the Ettrick Shepherd, in the *Noctes Ambrosianae* for March 1829:

> As to the Deluge, yon picture's at first altogether incomprehensible. But the langer you glower at it, the mair and mair intelligible does a' the confusion become, and you begin to feel that you're loking on some dreadfu' disaster. Phantoms, like the taps o' mountains, grow distincter in the gloom, and the gloom itself, that at first seemed clud, is noo seen to be water. What you thocht to be snawy rocks, become sea-like waves, and shudderin' you cry out, wi' a stifled vice, "Lord preserve us, if that's no the Deluge!"[71]

The Shepherd goes on to notice "a fearsome moon, a' drenched in blood, in conjunction with a fiery comet," details that were pointed out in the key to Martin's *Descriptive Catalogue*: "the sun, moon, and a comet in conjunction." Martin was very serious about combining scientific accuracy with poetic invention,[72] and he was especially gratified when he learned that the Baron Cuvier had seen and admired his painting. Although Leopold's account and that of Ralph Thomas differ in details, they agree

68. With respect to the falling rocks, William Feaver points out that they are also to be found in Martin's illustration to *A Midsummer Day's Dream* by Edwin Atherstone, published about two years before Danby's *Sixth Seal* was begun. See *The Art of John Martin*, p. 92 and fig. 65b. Martin liked this detail of *The Deluge* so much that he mounted it separately in the album he made of pieces cut from his mezzotints (Victoria and Albert Museum).

69. Martin, *Descriptive Catalogue*, p. 9.

70. *Ibid.*, p. 3.

71. Vol. III, p. 229.

72. As Lynn R. Matteson remarks, *The Deluge* is in this respect something of a *Gesamtkunstwerk*. See "John Martin's *The Deluge*," *Pantheon*, XXXIX (1981), 227.

in describing the importance to Martin of the geologist's approval.[73] Furthermore, the Deluge and the future end of the world were, Cuvier told Leopold, closely related in his view, as they also are in certain works of the imagination. Balzac, for example, in *La peau de chagrin*, describes Cuvier's undertaking as a reverse apocalypse:

> Cuvier n'est-il pas le plus grand poète de notre siècle? Lord Byron a bien reproduit par des mots quelques agitations morales; mais notre immortel naturaliste a reconstruit des mondes avec des os blanchis ... Après d'innombrables dynasties de créatures gigantesques, après des races de poissons et des clans de mollusques, arrive enfin le genre humain, produit dégénéré d'un type grandiose, brisé peut-être par le Créateur. Echauffés par son regard rétrospectif, ces hommes chétifs, nés d'hier, peuvent franchir le chaos, entonner un hymne sans fin et se configurer le passé de l'univers dans une sorte d'Apocalypse rétrograde.[74]

Balzac's pairing of Byron and Cuvier reminds us that as Cuvier could be called the scientific point of reference for Martin's *Deluge*, Byron was the poetic one. In his *Descriptive Catalogue* Martin reprinted from Byron's *Heaven and Earth*, which had been published just a few years earlier, a passage concluding:

> Where shall we fly?
> Not to the mountains high;
> For now their torrents rush with double roar
> To meet the ocean, which, advancing still,
> Already grasps each drowning hill,
> Nor leaves an unsearched cave.[75]

Martin wrote that Byron's lines display "a sublime imagination of the horrible event,"[76] and in his painting he tried to combine the biblical sublime as projected by Byron with the scientific catastrophism of (among others) Cuvier. Like *Belshazzar's Feast, The Deluge* was meant to seem all the more terrible because it was true.

The critical reception of *The Deluge* was, once more, divided, although this seems to have had no effect on Martin's popular renown. Edward Bulwer-Lytton, whose *Last Days of Pompeii* (1834) shows the stimulus of Martin's art, spoke for those who saw Martin as he wished to be seen. "With an imagination that pierces from effect to the

73. According to Leopold Martin (*Reminiscences*, 26 January 1889), Cuvier visited the studio in the artist's absence, gazed a long time at *The Deluge*, exclaimed "*Mon Dieu!*" and left his card, expressing regret that he had to return to France on the next day. In Thomas's account (Pendered, pp. 133–4), Martin relates a conversation he had with Cuvier. These sources may of course refer to two different occasions.

74. Paris: Gallimard (Pléiade), 1965, pp. 29–30. I owe this reference to Cornelia E. Brown.
 Is not Cuvier the great poet of our century? Lord Byron has well reproduced some moral turbulence in words; but our immortal naturalist has reconstructed worlds with whitened bones ...

After the innumerable dynasties of gigantic creatures, after races of fish and clans of molluscs, mankind finally arrives, degenerate offspring of a grandiose classical model, ruined perhaps by the Creator. Excited by his retrospective glance, these puny men, born yesterday, can go beyond chaos, break into an endless hymn, and shape the past of the universe for themselves in a sort of retrograde Apocalypse.

75. Martin, *Descriptive Catalogue*, p. 4. See Byron, *Poetical Works*, p. 559 (where the punctuation differs slightly).

76. *Ibid.*, p. 559.

ghastly and sublime agency," he wrote, "Martin gives, in the same picture, a possible solution to the phenomenon he records, and in the gloomy and perturbed heaven you see the conjunction of the sun, the moon, and a comet."[77] The Quaker poet Bernard Barton, in a poem of ten quatrains reprinted by Martin, attempted to recreate the experience of seeing the engraving in 1828:

> The floodgates of the foaming deep
> By pow'r supreme asunder riven!
> The dark, terrific, arching sweep
> Of clouds by tempests driven![78]

In contrast, the critic of the *Westminster Review* condemned the picture in terms approximating Lamb's:

> The groups are in the most extravagant and unnatural attitudes, and awaken no feelings of sympathy or horror. The blank desolation and leaden aspect of all nature in Poussin's Deluge, convey the idea of a vast flood, and a sense of universal calamity; but in this picture we only perceive the efforts of the artist to bear down the senses with substantial evidences of destruction.[79]

This anonymous critic makes the interesting connection of Martin, Fuseli, and Blake more than a century before Ruthven Todd's monograph, but it is only to condemn Martin on the same ground as the other two artists:

> His pictures are opium dreams, a phantasmagoria of landscape and architecture, as Fuseli's and Blake's designs were of human beings. His style is to the true and genuine art, what the hallucinations of the visionary are to the realities of life.[80]

Perhaps Martin shares with the other two not only a predilection for the sublime and the visionary but also a need for some prior commitment from the viewer, for that willing suspension of disbelief that constitutes poetic faith.

When *The Deluge* was exhibited in Paris at the Salon of 1834 and awarded a gold medal, the reaction was as polarized as it had been in England. Théophile E.J. Thoré, writing under the pseudonymn of Willem Bürger, later contrasted Martin's reception at the Salon with that of Constable ten years earlier; his remarks recall Wilkie's comments on the twofold response to *Belshazzar's Feast*:

> *Le Déluge* fait sensation à Paris, mais non pas dans le même sens que les paysages de Constable. Constable avait impressioné les artistes. Martin enthousiasma les curieux et les gens du monde, mais il fut assez justement apprécié par la critique.[81]

As an example of that just criticism, Thoré refers to Gustav Planche's *Salon de 1834*

77. Edward Bulwer-Lytton, *England and the English* (London, 1833), p. 212.

78. Martin, *Descriptive Catalogue*, p. 6. The poem was published in Barton's *A New Year's Eve and Other Poems* (London: John Hatchard and Son, 1828).

79. XX (1834), 459.

80. *Ibid.*, p. 464–5.

81. Willem Bürger, *École Anglais* in *Histoire des Peintres de Toutes les Écoles* (Paris, 1863); passage reprinted in Balston, *John Martin*, p. 267.

> The Deluge created a sensation in Paris, but not in the same sense as the landscapes of Constable. Constable had impressed the artists. Martin made the curious and society people enthusiastic, but he was assessed justly enough by the critics.

according to which Martin is not a painter but a mysterious power – "C'est le peintre des poètes, c'est le poète des peintres, et pourtant il n'est ni un peintre ni un poète."[82]

One new element in the French criticism of *The Deluge* was a tendency to compare the painting unfavorably with Martin's own magnificent engraving, published in 1828. Théophile Gautier found the painting "un mauvais lavis" and derided its admirers: "ce fût un concert unanime d'éloges, l'on se récria, l'on fit des oh! et des ah! admirable talent, talent biblique, apocalyptique, etc., etc."[83] Nevertheless, Gautier remained an admirer of Martin's mezzotints. "Il n'existe pour John Martin que deux couleurs," explained Gautier, "qui ne sont que les négations de la couleur, le blanc et le noir . . ."[84] Such praise of Martin the engraver at the expense of Martin the painter was, as Jean Seznec has shown, continued by later French critics.

Five years after the exhibition of *The Deluge* in France, Prince Albert visited Martin's studio and urged him to make that painting the middle one of a series. As Balston points out, however, Martin had already conceived of the other two pictures.[85] The 1840 *Eve of the Deluge* (Royal Collection, Kensington Palace) was preceded by Martin's engraving of 1833 for an "original tale" by John Galt, Benjamin West's biographer, in *The Ouranoulogos: or The Celestial Volume*. Perhaps what is most interesting about this design is the extent to which it ignores Galt's story. According to the text, "the wise and learned of the town" go to the house of Methuselah to consult him about "the dreadful pageants that nightly glare in the skies," but he tells them he is unable to interpret the portents and dies. Martin's engraving, however, is an outdoor scene, showing that by 1833 he already had an idea of what *The Eve of the Deluge* would look like. In the oil painting of 1840,[86] family groups are going up a hill, at the top of which Methuselah, in white, is almost lying on the ground. Beside him are two elders. In his published description of the scene Martin indicates what is happening:

> Methuselah . . . has directed the opening of the scroll of his father Enoch whilst agitated groups of figures, and one of the giants of those days, are hurrying to the spot where Noah displays the scroll; and Methuselah having compared the portentous signs in the heavens with those represented on the scroll, at once perceives the fulfillment of the prophecy, that the end is come, resigns his soul to God.[87]

In the sky, which was a remarkably fresh quality, we see the new moon with the old moon in its arms, a descending comet, and the murky red sun setting.

The Assuaging of the Waters (General Assembly of the Church of Scotland) was anticipated by a water color of the subject, exhibited in 1838. The oil painting is compositionally very similar to *The Eve of the Deluge*, with a high rock at the left replacing Methuselah's hill and the middle distance occupied by the subsiding but still surging

82. *Ibid.*, p. 266. Some unequivocally positive remarks about Martin's art, however, appear as part of a "Notice sur J.-M.-W. Turner," *L'Artiste* (Paris), XII (1836), 137. *Belshazzar's Feast* and *The Fall of Nineveh* but not *The Deluge* are mentioned. The review is signed "R."

83. Quoted by Jean Seznec, *Jean Martin en France* (London: Faber and Faber, 1964), pp. 37–8.

It was a unanimous concert of praise, they cried out in admiration, they made *ohs* and *ahs*, admirable talent, biblical talent, apocalyptic, etc.

84. *Ibid.*, p. 38.

85. See Balston, *John Martin*, pp. 147–8, 203.

86. Martin also painted a small version of the subject (formerly coll. Thomas Balston).

87. From extra-illustrated Anderdon Catalogue (British Museum), "Royal Academy 1840," no. 393.

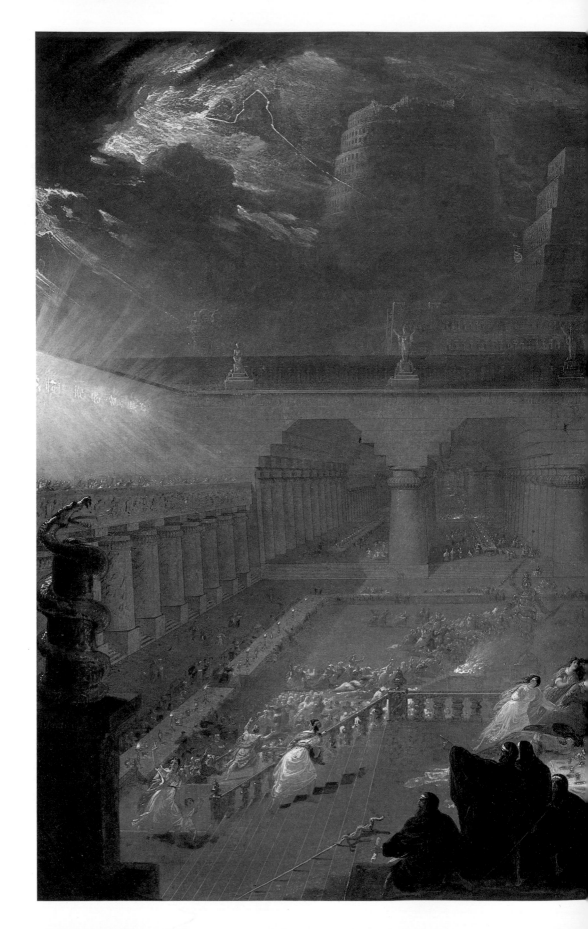

VI John
Martin.
*Belshazzar's
Feast*.

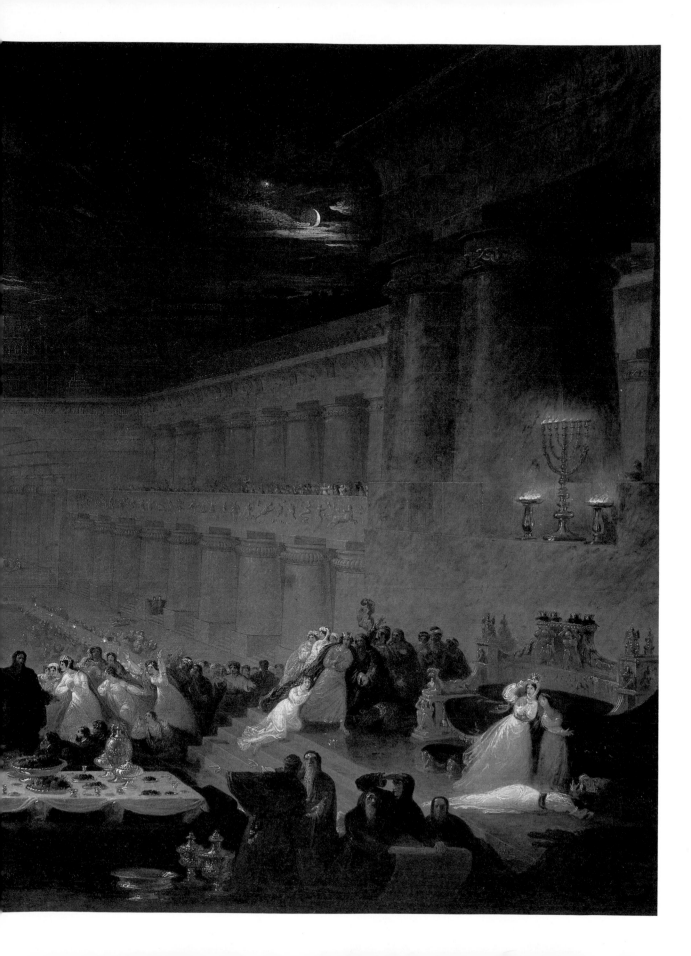

67. John Martin. "*And a mighty angel took up a stone like a great millstone, and cast it into the sea.*"

68. C. Gray after John Martin. *The Angel with the Book.*

sea instead of an Edenic valley. Both raven and dove are seen, along with various forms of marine life, in the foreground; and a drowned serpent, "the original cause of the Deluge,"[88] droops from a branch, thus connecting this painting with an iconographical tradition that goes back through Joshua Shaw, de Loutherbourg, and West to Poussin. There is little doubt, too, that *The Assuaging of the Waters*, with its companion, extended that tradition still further by stimulating Turner to execute his own very different treatments of their subjects, in the second of which the serpent is upraised on a pole.

❧ ☙

Considering the apocalyptic bent of his imagination, it is curious that Martin painted no Revelation subjects in oil before his three "grand and solemn" pictures of 1851–52.[89] Before these he did execute several small Bible illustrations, one large mezzotint, and possibly a painting on glass illustrative of Revelation. It is as if he were unconsciously anticipating an enormous effort concerning Revelation subjects at the end of his life and prepared for it with these relatively minor works.

Since Martin had been trained as a painter on glass, it may well be that a window at Kingston House, Knightsbridge, was by his hand. The subject had been described by H.G. Davis in 1859 as "a large window representing a garden scene by John Martin when a pupil of John Muss the enamel painter."[90] However, in 1937, shortly before Kingston House was pulled down, Christopher Hussey found no garden scene but a

88. Quoted from Martin's pamphlet in Pendered, p. 138.

89. The expression is from the title of the pamphlet that accompanied the paintings when they were exhibited; see note 98 below.

90. Quoted from *Memorials of the Hamlet of Knightsbridge* in Christopher Hussey, "Vanishing London: Kingston House, Knightsbridge," *Country Life*, LXXXI (1937), 304–5; the picture is reproduced on p. 302.

painted window with a central panel inscribed "Woman Cloathed with the Sun, Revelations chap. XII i–vi." Unfortunately this glass painting is not known to have survived and is only known from a photograph published with Hussey's article. Not much detail can be seen in this photo. The woman occupies most of the middle part of the design, there are dragon heads (one crowned) at the lower right, and the dragon's tail spirals up the right hand side. The composition appears somewhat like West's for this subject and even more like Blake's *Narcissa* title page (which Martin could easily have seen in the 1797 edition of Young's *Night Thoughts*, not a rare book at that time). If Davis was right about the time of its execution, *Woman Cloathed with the Sun* would be Martin's first venture into the apocalyptic sublime.

It was not until 1826 that Martin executed his first Revelation engraving, for one of the annuals that had suddenly become popular in the 1820s: *The Amulet: or Christian and Literary Remembrancer*. His subject was the angel foretelling the destruction of Babylon in Rev. xviii, 21: "And a mighty angel took up a stone like a great millstone, and cast it into the sea, saying Thus with violence shall that great city Babylon be thrown down, and shall be found no more at all." In this design, Martin achieves a surprising effect of vastness in small compass, with a gigantic radiant angel standing over the city and flinging a boulder like a top (Pl. 67). This motif of the gigantic angel also appears in two of the four wood engravings after Martin executed for the Martin and Westall *Illustrations of the New Testament*, published by Edward Churton in 1836.[91] In *The Angel with the Book* (engr. C. Gray), the figure of John, separated from a city by a bay, is dwarfed by a huge, winged, robed angel who holds his left arm raised and carries a book in his right hand (Pl. 68). Another Martinesque motif appears in *Satan Bound in the Bottomless Pit* (engr. T. Mosses): the vast crevasse into which a great cowled angel thrusts the chained, bat-winged Satan, as the diminutive John watches, hands upraised in wonder. Great falling rocks dominate the other two designs. *The Opening of the Sixth Seal* (engr. T. Slader) takes up the subject of Danby's painting of 1826 but shows whole mountains, one with a city on it, upended and falling on crowds below. In *The Opening of the Seventh Seal* (engr. W.T. Green), the mountains fall into the sea as John watches. These five small pictures, with the water color Last Judgment entitled *Christ's Glorious Coming*, display Martin's ability to achieve the sublime in works of limited size. Nevertheless, Martin was more at home on a grander scale.

In the wake of his own large *Illustrations of the Bible* (1831–35), he issued several other biblical mezzotints, among them the very dramatic *Destroying Angel* (1836). (This Exodus subject had previously been engraved by the artist's son Alfred in 1835.) In Martin's mezzotint a huge angel again dominates the scene. The Destroying Angel seems to float down through a diaphanously layered sky over an ancient city. Thunderbolts, as in West's *Death on the Pale Horse*, emanate from his clenched fist, and terrified victims huddle below. In addition to the contrasting darks and lights and vast differences of scale, the elements of repetition and succession in the city's architecture

91. In W.A. Chatto's *Treatise on Wood Engraving* (London: Charles Knight, 1839), Samuel Slader and Charles Gray, who engraved some of Martin's apocalyptic designs for this Bible, are listed among those living wood engravers entitled to honorable mention; the name "J. Martin" also appears (p. 633). The date of the Churton Bible is here given as 1833, but this appears to be a mistake. For further issues of these Bible illustrations, see Balston, *John Martin*, pp. 152–3.

contribute to the sublime effect of this engraving, once more creating with repeated columns the effect of "the artificial infinite."

A year after the Martin–Westall New Testament illustrations, Martin published a large mezzotint version of one of its subjects: *The Opening of the Seventh Seal* (Pl. 69). This engraving, measuring 15½ by 19¾ inches at the platemark, is Martin's most ambitious treatment of a Revelation subject before *The Last Judgment*. The subject is Rev. viii. 8-9, beginning: "And the second angel sounded, and as it were a great mountain burning with fire was cast into the sea; and the third part of the sea became blood." John stands on a rocky promontory with his arms upraised from the elbows, once more a "semantic gesture" gesture of visionary rapture. In one sense the viewer sees from John's perspective, across a sea of huge, surging billows, three gigantic slabs of rock falling at a diagonal from the right. In another sense, the tiny, astonished observer is part of what the viewer sees, and so a double perspective is established, one inside and the other outside the picture, creating a further sense of disorientation.[92] The intense darks of most of the print are dramatically set off by the lights of the marbly waves in the foreground, the vivid white hole in the sky through which shoot rays of lightning, and the eerie shafts of light flung across the sea in the background. In this way Martin once more fully exploits the sublime-of-terror possibilities inherent in the mezzotint medium.

<p style="text-align:center">❦ ❦</p>

Seldom can an artist's career be seen leading to a final subject as inexorably as Martin's does to the Last Judgment. It is as if the material sublime demanded the end of all material things in the end. He apparently formed his initial conception no later than his outline drawing of 1845.[93] This design differs considerably from the final one especially in that the idea of having identifiable historical figures among the saved on the left had not yet occurred. An outline engraving was produced in 1851 to accompany the painting, which was probably finished in that year (Col. Pl. V).[94] Although *The Last Judgment* (Tate Gallery) was in the hands of the print publisher Thomas Maclean early in 1851, the engraving by Charles Mottram was not published until 1 January 1857 (Pl. 70), by which time all three Last Judgment paintings had been exhibited.

Martin (unlike Blake) eschewed the example of Michelangelo for his Judgment scene – a considered choice, as Martin owned engravings of the Sistine Chapel fresco, as well as prints by William Young Ottley after treatments of the subject then attributed to Orcagna.[95] One thing Martin's picture does have in common with traditional Last Judgments, however, is its division into three horizontal parts. The upper plane presents Christ with the twenty-four elders of Revelation and is similar in this respect to Blake's drawings of the Last Judgment.[96] Even further above, however, is the

92. *Cf.* Ronald Paulson's contrast of the sublime effects of avalanche paintings by de Loutherbourg and Turner in *Literary Landscape*, pp. 77–8.

93. This picture is now known only through the reproduction in Ruthven Todd's *Tracks in the Snow*, plate 37a.

94. I follow Balston's chronology (*John Martin*, p. 234).

95. See *Catalogue of the Library of Capital Modern Furniture and Collections of Works of Art of that Distinguished Artist, John Martin, Esq., K.L.* (London: Christie and Manson, 4–5 July 1854), nos. 79 and 102.

96. *Cf.* Figs. 47, 48, and 49 above.

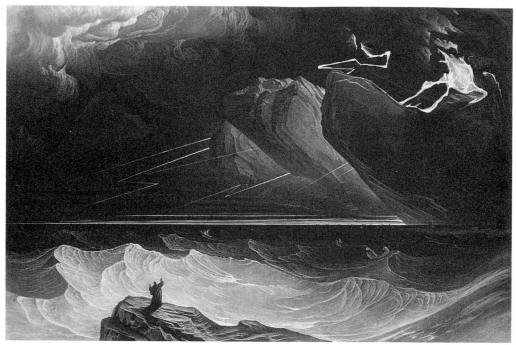

69. John Martin. *The Opening of the Seventh Seal.*

70. Charles Mottram after John Martin. *The Last Judgment.*

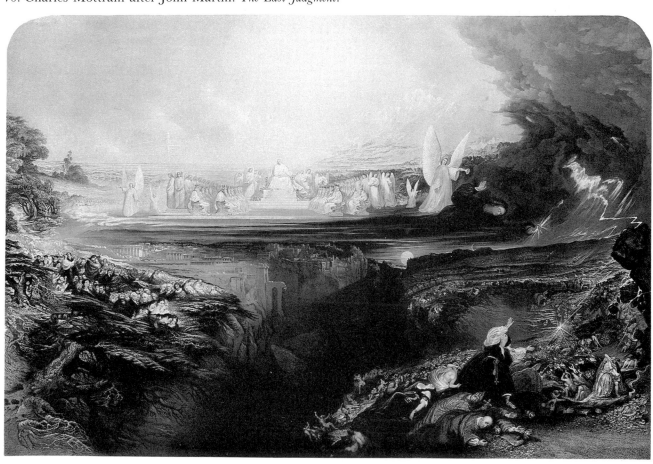

Celestial City, an especially Martinesque touch, with enormous domes recalling the eighteenth-century visionary architecture of Etienne-Louis Boullée.[97] The lower half of the painting is riven by an enormous chasm dividing "the accursed gathering in the Valley of Jehosophat, and the blessed upon Mount Zion."[98] Over the right-hand side hovers the dark avenging angel, in contrast to the white-clad angel above, who floats through the air with eyes glaring and thunderbolts issuing from his clenched left fist, very like the Destroying Angel of Martin's mezzotint.

On the right of the picture Armageddon is shown in progress: the banners of Gog and Magog are raised; elephants advance, and troops arrive by train – the Satanic aspect of technology – only to fall into the bottomless pit. (On the railway cars are inscribed the names of cities: MOSCOW, [word illegible], LONDON, PARIS, ROME, KAHIRA (the old name for Cairo). Not one Whore of Babylon but three appear in the foreground. One lies in a faint with a missal at her belt; another, semi-nude and wearing a pearl tiara, hides her eyes; the third, whose crucifix dangles from a belt of pearls, attempts to flee. A pope crawls, clutching his crucifix. A king lies fallen, his crown on the ground, gold coins pouring out of his money bag. Further back, two mitred bishops are falling. At the far right, under collapsing mountains, are naked figures reminiscent of Michelangelo and of Blake.

On the left are the saved, who gather on Mount Zion under the neo-classical facades of Martin's Jerusalem. Among these are embracing couples and little children, again recalling Blake's Last Judgments, including the one Martin could easily have known through Schiavonetti's engraving for *The Grave*. Portrayed in this gathering and identified in a one-sheet "Descriptive Key" are a selection of great men of the past.[99] Martin probably got this idea from James Barry's painting *Elysium and Tartarus or the State of Final Retribution* (Society of Arts, London).[100] Barry's canvas is divided into two vertical areas, following Michelangelo and the general Last Judgment tradition, with the saved on the viewer's left and the damned on the right. Associated with the Burkean sublime is the dramatic contrast of radiant Elysium and gloomy Tartarus.[101] Though nowhere near the size of Barry's picture – and it is important to realize that Martin's works are not especially large for their mode and period – *The Last Judgment* is enormous in scale, encompassing a myriad of figures and comprehending celestial heights and abysmal depths.

Martin's pantheon is, as one might expect, heavily weighted toward the arts, but it also comprises patriots, astronomers and philosophers, and "Holy Martyrs, Christians &c." The last group is one especially favorable to Protestants, including Wycliffe, Luther, Ridley, Latimer, Cranmer, John Knox, and John Wesley; the Protestant's favorite saint, Sir Thomas More, is also present. The patriots, selected for libertarian

97. A resemblance that also occurs elsewhere: Jean Seznec compares Martin's *Paradise Lost* mezzotint of Satan presiding at the infernal council with Ledoux' titanic domes in *Projets d'Architecture*, published by Vaudroyer in 1806.

98. *Descriptive Key to the Three Grand and Solemn Pictures, Namely, "The Last Judgment," "The Great Day of His Wrath," and the "Plains of Heaven"* (London: Leggatt, Hayward, and Leggatt, 1855), p. 2.

99. The only copy I have seen is displayed with the painting at the Tate Gallery.

100. See Feaver, p. 191.

101. See William L. Pressly, *The Life and Art of James Barry* (New Haven and London: Yale University Press, 1981), p. 114.

principles or wise state management, include Alfred, Canute, Washington, Hampden, Sully, Colbert, and Sir Philip Sidney. Martin's faith in the benevolent aspects of technology, a counterbalance to the Gog–Magog troop train, is indicated by the inclusion among "Astronomers and Philosophers' of Franklin, Gutenberg, and Watt, along with Copernicus, Galileo, Newton, and Locke. If the assemblage seems provincial compared to Barry's – the only non-European identified is George Washington – it nevertheless conveys a feeling of deep conviction.

Martin's group meeting on Zion is an embodiment of international peace, social equality, and racial brotherhood:

> The high-caste Indian clasps the low-caste African, the European, the American, philanthropists, patriots . . . all who have benefited mankind, and served the cause of peace and Christianity, are here without distinctions of sect uniting in brotherly love.[102]

In the abyss are secular and religious tyrants, and "War, with its hideous engines and vain trophies, mammon, avarice, usury, wordly pride, pomp, hypocrisy, pretended religion, false sanctity, false humility, and all sins adverse to Christian doctrine await destruction."[103] The whole could serve as an illustration to passages of the apocalyptic Night IX of Blake's *Four Zoas*. Evil must be "identified" (to use Blake's term) in order to be cast out, and, as in *Belshazzar's Feast* Martin identifies that evil with corrupt religious and political institutions in *The Last Judgment*.

The presence of Nicholas Ridley among the saved on Mount Zion is a reminder of Martin's relation to the Protestant martyr, a connection that his mother had stressed and one that was important to him as well. He even executed a pencil-and-wash drawing which he inscribed as follows to his mother's sister, Mrs. Thomas Wilson: "A Sketch of our great ancestor Ridley with his compeers in holy Martyrdom Cranmer and Latimer as they stand in a group on Mount Zion in my Picture of the Last Judgment."[104] This mention of martyrdom in turn brings to mind a book that must have been in the household of the devout Isabella Martin – John Foxe's *Actes and Monuments*, otherwise known as *The Book of Martyrs*. We can imagine how Martin as a child would have been deeply impressed by Foxe's description of the burning of Nicholas Ridley:

> Yet in all this torment he forgot not to call unto God, still having in his mouth, Lord have mercy upon me, intermingling his cry, Let the fire come unto me, I cannot burn. In which pains he labored till one of the standers by with his bill pulled off the faggots above, and where he saw the fire flame up, he wrested himself unto that side. And when the flame touched the Gun-powder, he was seen stirre no more, but burned on the other *side*, falling down at Master Latimers feet.[105]

Although we can only speculate on the possible effect of Foxe's account upon John Martin, it seems likely that these terrible flames had a powerful impact on the future

102. *Descriptive Key*, p. 2.

103. *Ibid.*, p. 3.

104. Extra-annotated copy of Balston's *John Martin* (Victoria and Albert Museum), on blank leaf facing p. 230. The drawing, now untraced, was once in the collection of Mrs. Robert Frank.

105. John Foxe, *The Third Volume of the Ecclesiasticall Historie: Containing the Actes & Monuments of Martyrs* (London, 1641), pp. 503–4.

artist's imagination, to be transformed in apocalyptic manifestations like *The Great Day of His Wrath* as if in fulfillment of Latimer's celebrated words to Ridley: "We shall this day light such a candle, by God's grace, in England, as I trust shall never be put out."

Thanks to Leopold Martin, we know that for his scene of the end of the world the artist was inspired by trips through the Black Country:

> Often have I heard my father state that, deeply as he was imbued by all that was grand and sublime in Milton's descriptions of the infernal regions, nothing had so powerfully impressed him with awe as a journey more than once taken in the dead of night through the town of Wolverhampton, or rather the "Black Country," as it is usually termed. The glow of the furnaces, the red blaze of light, together with the liquid fire, seemed to his mind truly sublime and awful. He could not imagine anything more terrible even in the "regions of everlasting punishment." All he had done or attempted in ideal painting fell far short, very far short, of the fearful sublimity of effect when the furnaces could be seen in full blaze in the depth of night.[106]

Thus *The Great Day of His Wrath* can be seen as bringing out the latent meaning of de Loutherbourg's *Coalbrookdale by Night*. Whereas the implications of the final end reverberate through de Loutherbourg's painting of 1802 without becoming its manifest meaning, Martin's work translates the flames of the Industrial Revolution into an image of that horror.

Like *The Last Judgment*, *The Great Day of His Wrath* (Tate Gallery) is a two-sided composition, with a great chasm in between, but this time both sides are scenes of destruction. On the left stands a robed figure with arms ineffectually raised to heaven. On the right crouches a man garbed in what Martin may have thought the costume of a high rabbi. But the most prominent places among the victims are given to women. One, wearing only a pearl tiara, falls naked into the abyss; two others, both half-clothed, make the same helplessly self-protective gesture as the scarlet woman in *The Last Judgment*. The white shoulders of several others are especially striking in Mottram's mezzotint (Pl. 71). It is as if the Burkean beautiful were being overpowered by the Burkean sublime and buried by enormous mountains and boulders falling in both sides of the picture.

Martin's depiction of mountains falling on crowds of people may have received some stimulus from Danby's *Attempt to Illustrate the Sixth Seal* (see Chapter VII below), in which case Balston would be right in saying that he "chose to plagiarize his plagiarist";[107] however, as we have seen, Martin had employed this motif in *The Deluge*, exhibited earlier than Danby's painting. The image is an appropriate pictorialization of the text from Rev. vi. 9–17, printed in the accompanying pamphlet and reading in part: "And said to the mountains and the rocks, Fall on us, and hide us from the face of him that sitteth on the throne, and from the Wrath of the Lamb."[108] Martin goes even further than Danby by placing whole cities *on* the mountains that are falling from the

106. *Reminiscences*, 6 April 1889.
107. *John Martin*, p. 235.
108. *Descriptive Key*, p. 5.

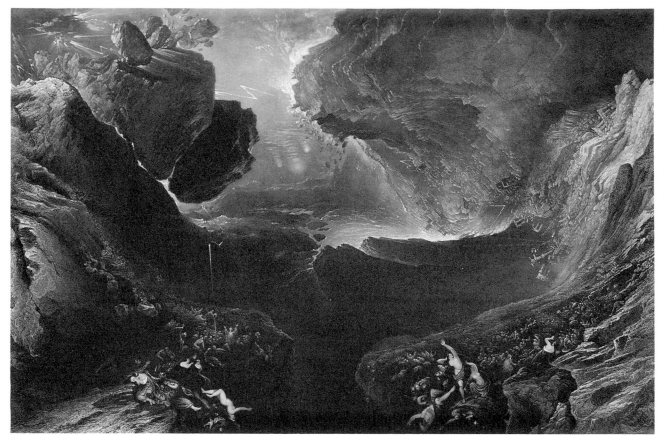

71. Charles Mottram after John Martin. *The Great Day of His Wrath*.

right, giving the viewer a sense of vertigo as he tries to relate to architecture seen on a vertical axis.

With *The Plains of Heaven* we seem to have passed to the other side of the Celestial City, whose great domes rise in the background. The sun, which was setting in the center of *The Last Judgment* occupies the same position here, but in its full strength, and there is another source of light to the right – perhaps because the glory of God lightens the city in Rev. xxiii, and "there shall be no night there." In this example of what, with Blake's *River of Life*, might be called the apocalyptic beautiful, there appear some curious similarities to details in works Martin is unlikely to have known. The putti among flowers recall those in Philipp Otto Runge's apocalyptic *Morning* of 1808 (small version, Hamburger Kunsthalle), while the wraithlike females floating upward are similar to figures in Samuel Colman's *Destruction of the Temple* of *c.* 1835 (Tate Gallery). One painter whose influence is certainly present is Claude, whose idealized mode of landscape was the basis of earlier works by Martin like the *Rivers of Bliss* mezzotint for *Paradise Lost*.

The nightmare of Berlioz in which the charity children's concert at St. Paul's was transformed into Martin's *Satan Presiding at the Infernal Council* is well known. Having

come to London in 1851, where he was to serve as a judge for the Great Exhibition, Berlioz was moved to tears by the children's rendition of the hymn *All People That on Earth Do Dwell*. That night, however, he had a Martinesque nightmare that took place in the interior of the Cathedral.

> Il était, par une bizarre transformation, changé en pandemonium: c'était la mise en scène du célèbre tableau de Martin; au lieu de l'archevêque dans sa chaire, j'avais Satan sur son trône; au lieu de milliers de fidèles et d'enfants groupés autour de lui, des peuples de démons et de damnés dardaient du sein des ténèbres visibles regards de flamme, et l'amphithéâtre de fer sur lequel ces millions étaient assis vibrait tout entier d'une manière terrible, en répandant d'affreuses harmonies.[109]

Berlioz' dream interprets the dual aspect of Martin's imagination. The Crystal Palace, itself possibly directly influenced by some of Martin's architectural images, would not have been out of place in the Celestial City of *The Last Judgment*. Its demonic contrary is the Pandemonium of Martin's *Paradise Lost* illustration, and just as Martin in his three last paintings presents the annihilation of the Last Day more memorably than the pleasures of the blessed, so in his brilliant dream Berlioz penetrates beyond the towering idealizations of Victorian London to the seething energies of Martin's apocalyptic sublime.

109. Hector Berlioz, *Les Soirées de l'orchestre* (Paris: Michel Levy Frères, 1852), pp. 263–5.

It was, by a bizarre transformation, changed into Pandemonium: it was the setting of Martin's celebrated picture: in place of the archbishop in his pulpit, I had Satan on his throne: in place of the thousands of the faithful and the children grouped around him, crowds of demons and damned souls shot visible glances of flame from within the shadows, and the iron amphitheatre in which these millions were seated vibrated all over in a terrible way, while giving out frightful harmonies.

Samuel Colman and Francis Danby

ALTHOUGH JOHN MARTIN founded no school and had no distinguished students, the effect of his work was felt widely among other artists. The two who most notably responded to his influence were otherwise of strangely contrasting temperaments. Samuel Colman was a religious dissenter active in nonconformist congregations. He worked in great obscurity but persevered in painting apocalyptic subjects until close to the end of his career. Francis Danby, in contrast, seems to have had no religious interests of his own and to have regarded the apocalyptic sublime as popular mode that he pursued only sporadically. While Danby was a practitioner of the Burkean sublime, Colman, for the most part, achieved his effects through his personal version of biblical iconography. Despite their great differences both in motive and in style, however, it is hard to imagine what the most important works of Colman and the best known ones of Danby would have been like if it had not been for Martin's example.

Of all the artists of the apocalyptic sublime, Samuel Colman remains the most shadowy figure. Until recent years, the very nature of his oeuvre was obscured by false attributions. Two of his most important paintings, *The Delivery of Israel Out of Egypt* (City Art Gallery, Birmingham) and *Belshazzar's Feast* (Oldham Art Gallery), bear false signatures of John Martin; a third, *The Edge of Doom* (Brooklyn Museum), was once thought to be the work of the American Samuel Colman of the Hudson River School. Colman's identity as an artist may be said to have been established only since the 1970s, with the acquisition of three of his works by the Bristol Art Gallery, the exhibition of four apocalyptic paintings at the Tate Gallery, and publications by Francis Greenacre, Ronald Parkinson, and Margaret Whidden.[1] Thanks to these, Colman can now be recognized as a powerful imaginative painter with affinities to Danby and to Martin but with an independent style more primitive than theirs and with distinctive individual preoccupations. Because so little is known about Colman and his career as an artist, a brief consideration of some of his non-apocalyptic works is necessary in order to establish a context for the discussion of his apocalyptic paintings.

1. Francis Greenacre, *The Bristol School of Artists* (Bristol: City Art Gallery, 1973), pp. 203–9; Ronald Parkinson, *Samuel Colman fl. 1816–1840. Four Apocalyptic Themes* (London: Tate Gallery, 1976); and Margaret Whidden, *Samuel Colman. Belshazzar's Feast. A Painting in Its Context* (Oldham: Oldham Art Gallery, 1981). At the time of this writing, Margaret Whidden is completing a University of Edinburgh doctoral dissertation on Colman, *Samuel Colman, 1780–1845.*

In Colman's charming and almost naive *Sunday Morning, Going to Church* (Bristol Art Gallery), well-dressed people are on their way to Sunday service, two carriages are leaving the chapel door, a street sweeper is at work, and a man is exhorting a (literally) fallen woman to go to church but is at the same time giving her a coin. It is now known that this picture commemorates Zion Chapel, Bedminster, to which Colman and his wife belonged in 1833, having previously been members of the Castle Green Independent Chapel.[2] Thus Colman, alone among the painters considered in this book, was an active member of a nonconformist congregation. We can therefore see some of his characteristic themes as related to the views of his sect. With respect to the Zion Congregationalist Church (as it came to be called), these include typical dissenting concerns such as opposition to Roman Catholicism, to episcopy, and to tithes; advocacy of political reform; and agitation on behalf of the abolition of slavery. (The founder of Zion Chapel, John Hare, had his windows broken because of his support of Reform, and a pro-slavery mob broke into his floor cloth factory and vandalized it.[3]) Colman conveyed his messages on these and other, related beliefs in works of art produced in Bristol from 1821 on.

St. James's Fair, Bristol (Bristol Art Gallery), signed and dated 1824, is a veritable anthology of those beliefs. This oil painting shows the strong influence of Hogarth – the overall conception is closely related to *Southwark Fair* – and also perhaps of Edward Francis Burney in the superclarity, combined with a slightly grotesque distortion, of some of the subjects' faces. The Hogarthian manner is also seen in the means by which Colman delivers his moral message. Above the bookseller's stall we read: "In the Press/Slavery/A Poem," and further to the left: "Just Published/The origin of Tithes." To the right are a bawd and a young girl straight out of the first plate of *A Harlot's Progress*. Behind them an old woman holds a handbill showing a hanged man whose "Dying Speech" has been printed, and there are two signs over the bawd's head. One reads "[ven]ereal/[com]plaints" and the other "Theatre/Road to Ruin." The first of these concerns the hue and cry against the fair as a scene of vice and profligacy,[4] while the second has a double message. *The Road to Ruin* by Thomas Holcroft, which had been performed in Bristol in 1821, is a play about a prodigal son who nearly ruins his father's bank and consequently almost marries a rich widow for her money; but to the Nonconformist the theater was itself the road to ruin.

To the left of the center of the painting is a churchwarden, keys in pocket, probably the warden of St. James's Church, which permitted its grounds to use for the Fair. He has in his pocket a paper with the words "New Marriage Act." This act of 1823 (4 Geo IV, *c.* 76) shortened the length of residence required for those applying for a marriage license to fifteen days, and it made it more difficult to prosecute clergymen who offici-ated at minors' marriages without parental consent; at the same time, it failed to allow dissenters to marry in their own churches. To the mind of a Nonconformist like Colman, the act, although in some ways a reform, would have seemed doubly unsatis-

2. See Whidden, p. 4.

3. See Henry B. Cozens, *The Church of the Vow: a Record of the Zion Congregationalist Church, Bedminster, Bristol, 1830–1930* (Bristol: St. Stephen's Press, 1930), p. 13.

4. See Greenacre, p. 205.

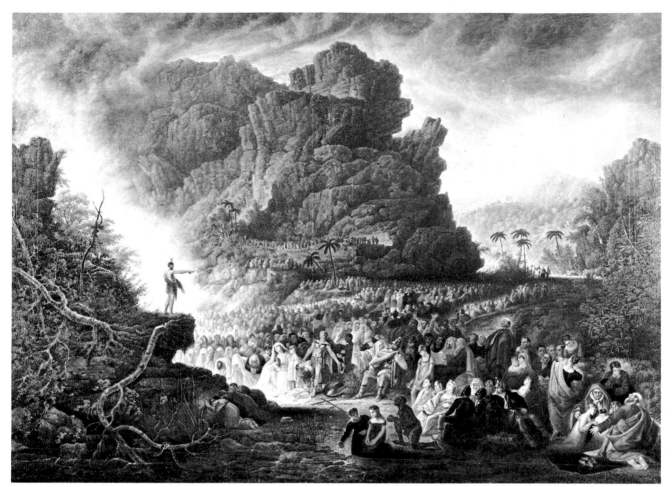

72. Samuel Colman. *St. John Preaching in the Wilderness*.

factory, and that dissatisfaction is evidenced by a hand slipping a ring to a young woman without the churchwarden's attempting to prevent it. Further to the left is a traditional Vanitas-figure: a woman regarding herself in a mirror. The town-crier is reading off a handbill: "Lost at/Vanity Fair/Miss Chastity." All these and other[5] details indicate how Colman was working in a deliberately provincial English mode that Ronald Paulson has described in relation to Hogarth.[6] Formal unity here is less important than a rich collection of visual signifiers conveying themes by means of inscriptions, emblems, and visual quotations.

One of Colman's visual quotations in *St. James's Fair* is self-referential. Behind the auctioneer is a small picture representing Colman's *St. John Preaching in the Wilderness* (Pl. 72). Although this painting itself was rediscovered only after the Bristol exhibition of 1973, it happens to be his best documented religious painting – one might almost say the only well-documented one, having been advertised, reviewed, and accompanied by a printed pamphlet. It therefore merits attention as an introduction to our consideration of Colman's apocalyptic works.

5. For some additional observations, particularly concerning emblem literature, see Whidden, p. 18.

6. See Ronald Paulson, *Book and Painting* (Knoxville, Tenn.: University of Tennessee Press, 1982), pp. 96–8.

St. John Preaching in the Wilderness (Bristol Art Gallery) is signed and dated 1821; it was exhibited in Bristol in that year and at the Royal Academy in 1822.[7] It was accompanied by a descriptive brochure which, although brief, is the unique published writing of Colman's known to us.[8] Although the influence of another *St. John Preaching*, attributed to Salvator Rosa and known through an engraving by John Browne published by Boydell in 1768, is evident, Colman's treatment of the subject is distinctively his own. John the Baptist is presented as standing on a rocky promontory, wearing the traditional "raiment of camel's hair," with his right arm outstretched horizontally toward the listening crowd and his left vertically toward heaven. A large number of figures – about seven hundred according to the artist – fills the middle distance and part of the background. The further background is largely closed off by fantastic rock formations, above which a cloudburst is occurring. "The effect," Colman wrote, "intended to be produced is a wild sublimity."[9]

Since Luke's account of John's preaching in the country about Jordan is not rich in descriptive details, Colman was free to invent what he wished in order to bring out the significance he intended. The position of John's arms goes back at least to Raphael's St. Paul in the cartoon *The Blinding of Elymas*, and was employed by, among others, Charles LeBrun for his *Moses*,[10] and Hogarth, imitating Raphael, for his *Paul Before Felix*. Both the Raphael and the Hogarth were well known in engraved form. In addition, Colman may have known through some engraving or even verbal description that the gesture of the extended right arm with palm downward had been used for John the Baptist by Jean-Antoine Houdon in a pendant to his celebrated *St. Bruno* in Sta. Maria degli Angeli, Rome;[11] he may even have seen one of the numerous plaster reproductions of Houdon's *Écorché au bras étendu*, which the sculptor used as a model for his own *St. John the Baptist*.[12] Details in the crowd below are introduced by the artist in order to bring out his thematic concerns.

The priests who are seen trying to divert some of the listeners from John's message are not part of Luke's account, as Colman recognizes: "The activity of the Priests in opposing the Preacher's doctrine, it is presumed may be allowed, each of these circumstances agitating the scene, and assisting in producing the intended effect."[13] Also among "these circumstances" are "a converted Soldier breaking his spear" and a convert, "clothed in purple and scarlet," shown "clothing the naked with his own mantle."[14] It is significant that the figure being clothed is a black man and that another black man is shown kneeling on one knee in the right foreground. The bodily attitude of the latter is strikingly similar to that of a manacled slave in a famous design bearing the semi-circular motto "AM I NOT A MAN AND A BROTHER." This was first produced by

7. Information from Margaret Whidden, private communication.

8. Samuel Colman, *A Description of Mr. Colman's Pictures of St. John Preaching in the Wilderness: Taken from the Third Chapter of Luke* (Bristol, n.d. but presumably 1821).

9. *Ibid.*, p. 7.

10. As noted by Bo Ossian Lindberg with reference to the very similar gesture of Elihu in plate 12 of Blake's *Job*; see *William Blake's Illustrations to the Book of Job*,

p. 371. Lindberg reproduces (fig. 122) *Moses and the Brazen Serpent*, anonymously engraved after LeBrun "from a Bible printed in Oxford in 1728."

11. See Louis Réau, *Houdon: Sa vie et son oeuvre* (Paris: F. de Nobele, 1964), no. 17 (p. 16) and plate xxii. The plaster statue was destroyed in an accident in 1895, but there is a small model in the Borghese Gallery.

12. *Ibid.*, no. 16, pp. 15–16.

13. *A Description*, p. 7.

14. *Ibid.*, p. 5.

73. Samuel Colman. *The Deluge.* 74. Samuel Colman. *Vision of St John.*

Josiah Wedgwood, who manufactured it in large numbers as a cameo; it was subsequently published as an engraving in Erasmus Darwin's *Botanic Garaden*[15] and became a virtual icon of the anti-slavery movement.

Thus we can see that into *St. John Preaching in the Wilderness* Colman introduced messages concerning the opposition of prophet to priest, the original pacifism of Christianity, and the Christian obligation to oppose slavery – all themes that reappear in later paintings. At this point in sacred history sin has been weakened but not yet destroyed, and so we have a serpent "recovering from a deadly blow" on the lower branch of a "withered tree cut down,"[16] alluding to John's words in Luke iii. 9: "And now also the axe is laid unto the root of the tree; every tree therefore which bringeth not forth good fruit is hewn down, and cast into the fire." This situation is presented as a prelude to the fulfillment of the millenarian prophecy of Isaiah. Therefore, according to the artist, it required "*partial* brilliancy of colouring, from the Dispensation bringing with it 'Glad tidings of great joy'; or, in the luxuriant language of Prophecy, that 'the desert shall rejoice and blossom as the rose.'"[17]

Although *St. John Preaching* was attacked in the Bristol *Mercury* for 25 August 1821 as a "debased recollection" of Salvator Rosa,"[18] Colman was undeterred and continued to execute paintings and drawings on biblical subjects. There is a small ($10\frac{3}{4} \times 14\frac{3}{4}$ in) water color of *The Deluge* (coll. Mrs. Alison Palmer) (Pl. 73), much indebted in its composition to Turner's painting, which Colman could have known through Quilley's engraving, if not at first hand: a great wave is coming from the right to engulf those on the foreshore while the Ark floats serenely in the background. Another water color is *The Vision of St. John* (Andrew Wyld), which shows the rapt visionary on a rock framed by Edenic foliage on either side and a tall white angel showing him a vision of the New Jerusalem (Pl. 74). Colman also painted in oil *The Destruction of Pharoah's Host* (Bristol Art Gallery). This small ($24 \times 19\frac{5}{8}$ in) picture, dominated by a towering beam of light,

15. London, 1791, facing p. 87 (engr. T. Holloway).

16. Colman, *A Description*, p. 6.

17. *Ibid.*, p. 7.

18. Information from Margaret Whidden, private communication.

75. Samuel Colman. *The Coming of the Messiah and the Destruction of Babylon.*

is probably a preliminary study for a much larger treatment of the same subject (see below). But his chief accomplishment as a painter of apocalyptic subjects comprises five large oil paintings, each about 54 by 78 inches in size, on apocalyptic subjects.[19] Executed over approximately a decade beginning *c.* 1828, these five pictures may have been purchased over the years by a single patron, very likely a Bristol Nonconformist like Colman himself. All of them have as their themes the destruction of an old order and, either directly or by implication, a divine revelation leading to the establishment of the Kingdom of God either in this world or the next.

The first of Colman's major apocalyptic pictures was probably *The Coming of the Messiah and the Destruction of Babylon* (Bristol Art Gallery), conjecturally dated *c.* 1828–31 (Pl. 75). As the title suggests, this painting has more than one subject; in it are illustrated texts from Isaiah,[20] Matthew, Philippians, Revelation, and several other books of the Bible. The result is a mélange, typical of Colman's work, of generally

19. Greenacre notes that the three of these known in 1973 have these dimensions (p. 204). Subsequently, *Belshazzar's Feast* was attributed to Colman (see Whidden, p. 24, n. 1) and *The Destruction of the Temple* was acquired by the Tate Gallery; these are likewise about 54 × 78 in.

20. Eric Adams remarks that this picture "illustrates to the letter all the metaphors in at least nine verses of the prophecies of Isaiah, besides other texts." (*Francis Danby: Varieties of Poetic Landscape* (New Haven and London, 1973, p. 148, n. 14). Some of these references are documented by Ronald Parkinson (*Samuel Colman*, p. 11).

accessible biblical typology with other symbolism about the meaning of which we can only speculate.

The central figure is the Christ of the Parousia (Matt. xxiv. 30), represented as a young man with his right arm extended sideways, an oratorical gesture reinforced by the toga-like garment he wears. This Christ is beardless, unusual in Colman's time but having a strong precedent in Michelangelo's *Last Judgment*. His extended arm indicates a group in the process of fulfilling the most famous of all millenarian prophecies: "The wolf shall also lie down with the lamb, and the leopard shall lie down with the kid; and the calf and the young lion together; and a little child shall lead them" (Isaiah xi. 6). Another child, to the left of the Messiah, probably illustrates verse 8 of the same chapter: "And the suckling child shall play on the hole of asp, and the weaned child shall put his hand on the cockatrice' den." This central group presents the vision of a regained paradise straightforwardly and even naively, in such a way as to invite comparison with the *Peaceable Kingdom* paintings of the American Quaker artist Edward Hicks.[21] These two contemporaries were almost certainly unknown to each other; the resemblance may be explained in part by affinities of religious tradition and of temperament, but there is probably a common prototype here as well – Richard Westall's frequently reproduced Bible illustration of the same passage, *The Peaceable Kingdom of the Branch*.[22]

In the central foreground of Colman's painting a king in a purple gown kneels in the act of laying down his crown and scepter as he regards the open book. The words "At 'The Name of Jesus/[K]nee' Shall bow" are visible, alluding to Philippians ii. 10: "That at the name of Jesus, every knee should bow, of things in heaven, and things in earth, and things under the earth."[23] Scattered about on a red cloth and on the ground are implements of war, agriculture and the arts. A lyre is set upon a roll of music bearing the words: "shall feed his flock like a Shepherd." This leads us back to Isaiah xi, where "He shall feed his flocks like a shepherd; he shall gather his lambs with his arm, and carry them in his bosom, and shall gently lead those that are with young" (11) – a text that is being enacted in the picture by Christ and a flock of sheep to the right of the kneeling king. To his left are placed shields, swords, spears and a plow, in accordance with Isaiah ii. 4, where "they shall beat their swords into plowshares, and their spears into pruning hooks: nation shall not lift up sword against nation, neither shall they learn war any more."

The millenarian message of the central portion of *The Coming of the Messiah* is reinforced by details in the right middle distance. There John the Baptist, his left arm upraised towards a natural cross formed by two trees, teaches Roman soldiers the meaning of the Crucifixion; while higher up on the wooded hill stands Moses with a serpent elevated on a cross – an antetype of the Crucifixion according to John iii. 14 (*cf.*

21. A comparison made by Margaret Whidden in her work-in-progress.

22. See Alice Ford, *Edward Hicks: Painter of the Peaceable Kingdom* (Millwood, N.Y.: Kraus Reprint Co., 1973 [Philadelphia: University of Pennsylvania Press, 1952]), pp. xii, 42, and 119; and Eleanore Price Mather, *Edward Hicks: His Peaceable Kingdoms and Other Paintings* (Newark: University of Delaware Press, 1983), pp. 21–3, 46–7. Westall's influence on Colman is suggested by Whidden in her work-in-progress.

23. See Parkinson for this and some other biblical allusions.

Turner's *Light and Colour: the Morning After the Deluge*). Another aspect of the Millennium is indicated by the contrasting vegetation in the picture. At our right the tree in the foreground is damaged and the one behind the Good Shepherd is lopped, for "The Lord, the Lord of hosts shall lop the bough with terror . . . And he shall cut down the thickets of the forest with iron . . ." (Isaiah x. 33–4).[24] However, the immediately following passage of Isaiah is: "And there shall come forth a rod out of the stem of Jesse, and a Branch shall grow out of his roots" (xi. 1). This messianic prophecy is reflected in the Edenic vegetation illuminated by divine radiance on the left side of the painting. The arboreal imagery once more recalls Edward Hicks, with respect both to the primitive luxuriance of the trees of the regained Paradise and to the contrasting image of the lopped tree, which occurs in several of his versions of *The Peaceable Kingdom*.[25] Colman's paradisal foliage is also reminiscent of Blake's with its luxuriant arabesques, but once more this is probably a matter of common sources such as Jan ("Velvet") Bruegel,[26] Paul Bril, and Adam Elsheimer. However, if *The Coming of the Messiah* indeed dates from 1828 or later, the depiction of Eden in John Martin's *Paradise Lost* mezzotints could have been an immediate influence.

The background of Colman's painting is concerned with the destruction of Babylon as prophesied in Isaiah xiii and described in Revelation xviii. A bolt of lightning strikes a ziggurat derived from Martin's *Belshazzar's Feast* as, below, a column of soldiers in nineteenth-century costume marches up toward Babylon. This army is followed by a figure wearing a miter and bearing a crozier in his left hand and books under his right arm. Whether this ecclesiastic be the Pope or the Archbishop of Canterbury, he must be associated with the hierarchy and dogma that Colman rejected; he seems to be on his way to Armageddon with the troops of Gog and Magog. All of them are in danger of being trapped in the falling architecture and billowing smoke of the burning city. Further to our right on an open terrace, an agitated mob is surging around a statue-like, draped figure standing on a globe and holding an upraised trumpet – perhaps either one of the seven angels with trumpets seen by John (Rev. viii. 2) or the angel who cries "Babylon the great is fallen, is fallen" (Rev. xviii. 2).

In *The Coming of the Messiah* unity of effect is sacrificed to the conveying of a message through several, almost independent parts of the painting. The themes are the apocalyptic manifestation of the Messiah and his millennial kingdom, the violent destruction of a corrupt worldly order, and the yielding of temporal power to spiritual dominion. These may be said to be the real subject matter of all five of Colman's major apocalyptic paintings, whether they freely combine a number of biblical situations, as *The Coming of the Messiah*, or limit themselves to a single event.

In 1830, Colman advertised in Bristol newspapers the exhibition of *The Israelites' Passage Through the Red Sea, with the Overthrow of Pharoah and His Host*.[27] He had already painted a smaller oil, *The Destruction of Pharoah's Host* (Bristol Art Gallery), in which the

24. This allusion is identified in Whidden's work-in-progress.

25. Five are reproduced in the catalogue of Hicks's works by Dorothy Canning Miller and Eleanore Price Mather published in Mather (nos. 2, 3 [and plate II], 4, 5, and 6).

26. See Adams, p. 83.

27. Information from Margaret Whidden, private communication. Mrs. Whidden has discovered one advertisement in the Bristol *Mercury* in which the painting is said to have been "painted under very peculiar circumstances."

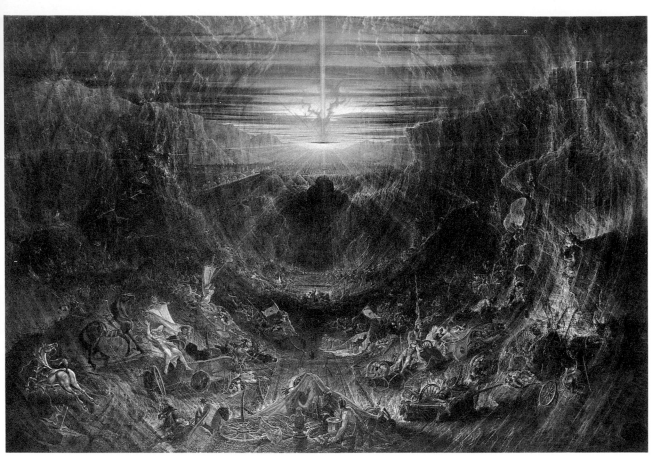

76. Samuel Colman. *The Delivery of Israel Out of Egypt.*

chief elements are Moses and Miriam, Pharoah on his chariot engulfed with his men by the waves, and a lurid pillar of light. This may have been a sketch for the more ambitious picture of 1830, which is now known as *The Delivery of Israel Out of Egypt* (Birmingham, City Art Gallery) (Pl. 76). Here the opposition between worldly and spiritual power is traced in the axis that can be drawn vertically from the pillar of fire at the top center through Moses' upraised arm (see Ex. xiv. 21), to Pharoah lower in the center. Whereas the king in *The Coming of the Messiah* was voluntarily setting down his crown, Pharoah, whose heart was hardened, is literally losing his. On the two sides of the central axis rises an enormous vortex, the curving lines of which do not even stop at the top of the canyon-like waves but continue into the sky and out of the picture space. Warriors, chariots, and banners are caught up in this vertically turned maelstrom and swept along its lines of force.

Colman's immediate stimulus for his *Delivery of Israel* was probably Danby's painting of the same title (Harris Museum and Art Gallery, Preston).[28] In 1824, while still living in Bristol, Danby had begun work on this subject with a sepia study.[29] He exhibited his finished painting at the Royal Academy in 1825; but even if Colman did

28. Adams, pp. 74, 75, 173–4.

29. *Ibid.*, cat. no. 99 and fig. 112.

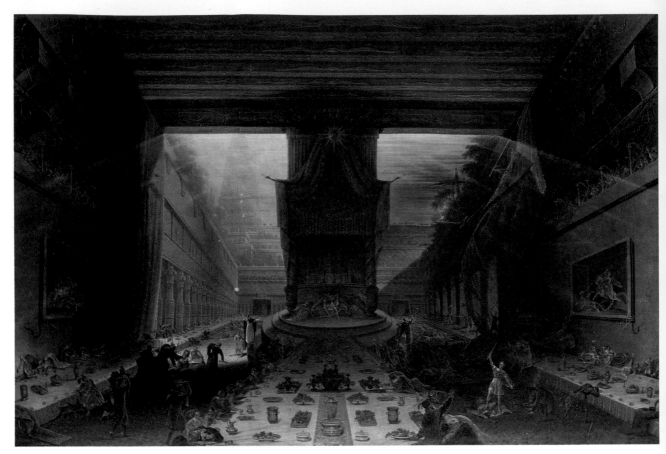

VII. Samuel Colman. *Belshazzar's Feast*.

not see the original, he could have known G.B. Phillips's mezzotint after it, published in 1829. Danby's brightly colored landscape with its many figures rendered in clear detail is, however, an illusionistic picture entirely unlike Colman's. There are many affinities between Danby's *Delivery of Israel* and the popular diorama,[30] including the way in which the pillar of fire is introduced looking like a pale elongated lens turned sideways. This aspect of his picture links it with the vicarious terror of the Burkean sublime. For Colman, the apolcalyptic element is, in contrast to Danby, everything. The nimbus of light radiating in lines from a point just below the pillar of fire dominates Hebrews, Egyptians, chariots, horses, and even the walls of the sea. There is no attempt on Colman's part to attain verisimilitude. This is not to say that his *Delivery of Israel* is a better painting than Danby's – Colman never attained the technical proficiency evident in Danby's best work – but rather that in Colman's picture the apocalyptic element is the *raison d'être* while in Danby's it is the pretext for a catastrophic landscape.

30. *Ibid.*, pp. 74–5.

164

Although John Martin, whose work influenced Colman in so many ways, executed a water color of *The Destruction of Pharoah's Host* (Laing Art Gallery, Newcastle-upon-Tyne) in 1830, his picture has little in common with Colman's, having its emphasis upon a solitary Moses. If there is any other artistic presence here, it is Turner's. Colman could, of course, have known any number of Turner's designs through engravings, but it is reasonable to suppose that he had also seen some of the originals. If he went to London for the exhibition of his *St. John Preaching*, for example, he would also have been able to visit Turner's new gallery, which opened in the spring of 1822, and to see, among other paintings, *Snowstorm: Hannibal and His Army Crossing the Alps*.[31] The great swirling lines of force in *The Delivery of Israel* do seem to be a more schematic transformation of the sky in *Hannibal*. In what was almost certainly Colman's next important painting, however, it is the influence of Martin that dominates.

Colman was probably stimulated to paint his own *Belshazzar's Feast* (City Art Gallery, Oldham) by the exhibition of Martin's picture in Bristol at the Gallery of Arts on St. Martin's Quay in 1825.[32] His version, however, is more of a challenge than an imitation (Col. Pl. VII). He kept to Martin's conception of a vast banqueting hall with pillars establishing a deep recession, as well as of an atrium with the Tower of Babel seen beyond. However, he modified the basic composition by enthroning Belshazzar on a great central dais. The ruddiness that dominates Martin's painting may be reflected in the hangings at the sides and center of Colman's, but Colman's color scheme is otherwise much different, with green for the carpeting and lower background and yellow for the table coverings and upper background. Unlike Martin, who conceived his painting as a three-act drama but only hinted at what was to come, Colman presents Cyrus and his troops bursting in at the very moment that Daniel is interpreting the handwriting on the wall. And like Martin's brother William, who thought that the hand should have been represented in the act of writing, Colman shows this detail at the upper left, even though in the biblical account it appears before the entrance of Daniel. In Colman's *Belshazzar's Feast* everything happens in apocalyptic simultaneity, and overall unity of effect is once more subordinated to an urgent message delivered iconographically.

The scene is of a gluttonous banquet where some of the revellers have already fallen over, drunk or sick. Their meal consists of grapes, wine (presumably) in golden pitchers, and small, round, greenish objects that could be apples.[33] The golden vessels from the Temple distributed along the length of the tables suggest the chalice of the Eucharist, and the banquet seems a travesty of that sacrament. Considering what we know of Colman's nonconformist affiliation, this aspect of the painting may be viewed as a rejection of Roman Catholic and high Anglican Church ritual, an interpretation reinforced by the detail of the incense bearer on the right, who seems about to fall stupefied by fumes from his censer. Cyrus comes to overthrow all this, much in the

31. Amédée Pichot saw *The Deluge* and *Hannibal* at Turner's gallery in the early 1820s; see above, Chapter V, p. 106–7, 109. If Colman did go to London in the spring of 1822, he could also have seen the twenty-six works that John Martin was showing at the Egyptian Hall.

32. Whidden, p. 12.

33. Margaret Whidden, in correspondence, suggests unripe walnuts. Another possibility would be the green pears and plums still served with drinks in the East.

spirit of Blake's Los, who wants to "overthrow their cup,/Their bread, their altar-table, their incense & their oath."[34]

The juxtaposition of true and false religion is rendered by the figures to either side of the royal dais. On the left is Daniel, considerably like Martin's figure turned sideways, who reads out the divine word with his arms making the double gesture of Colman's John the Baptist. He is clad in simple black and white in contrast to everyone else. To the right a priest holding a serpent-entwined staff powerlessly faces the oncoming Medes and Persians. Between these embodiments of true prophet and false priest, the collapse of royal power is manifested in the seated Belshazzar, who is, like Pharoah in *The Delivery of Israel*, losing his crown as he gestures in terror toward the triumphant Cyrus. His bodily posture is a deliberate quotation of Hogarth's celebrated portrait *David Garrick in the Character of Richard III*, which was well known in engraved form.[35] As in Martin's picture, this king could suggest George IV surrounded by the opulence of his court,[36] a suggestion deepened by the visual and moral parallel with Richard III.

The victorious Cyrus seems an armed variant of the central figure of *The Coming of the Messiah and the Destruction of Babylon*. This messianic figure comes to bring not peace but a sword. He stands with one foot on the prostrate body of a courtier whose ermine gown is decorated by little crowns. His upraised sword leads our eye to one of his soldiers limned in an extraordinary manner against a red wall hanging that is ballooning inward. Similarly silhouetted against the wall-hanging on the opposite side of the picture is the hand writing with its obscure characters. Thus, much in the manner of medieval saints' lives in which all significant episodes appear in a single tableau, Colman conflates Martin's Protasis, Epitasis, and Catastrophe.

In addition to being an attack upon religious ceremony and monarchy, *Belshazzar's Feast* may refer to the contemporary issues of slavery and of Reform. The abolition of slavery in British territories (as distinguished from trading in slaves, which had been illegal since 1807) was being vigorously argued by Wilberforce, Clarkson, and their supporters *c.* 1832–33 when Colman is thought to have painted this picture. As Whidden has shown, some early nineteenth-century Protestant commentators regard Cyrus as "the type of the Great Redeemer" because it was under his reign that the Jews were restored to Jerusalem and the Temple rebuilt.[37] On this level, dissenters could regard the liberation of the Jews from their Babylonian servitude as the antetype of the freeing of the slaves in their own time. On another level, they could consider themselves, excluded from political life by the Test and Corporation Acts until 1828,[38] as having been in the situation of Daniel's people. Cyrus here may have reference to the First Reform Bill, introduced in 1831 and, after tumultuous debate both in and out of Parliament, carried in 1832. Depending on its date of execution, Colman's *Belshazzar's Feast* may be regarded as either a prophecy of Reform or a celebration of its triumph.

The Destruction of the Temple (Tate Gallery), conjecturally dated *c.* 1835, presents more problems of interpretation than any other Colman painting (Pl. 77). Neverthe-

34. *Jerusalem* 91: 12–13, *Complete Poetry and Prose*, p. 251.
35. Whidden, p. 10.
36. *Ibid.*, p. 17.
37. *Ibid.*, p. 20. The quotation is from *The Evangelical*

Expositor by Thomas Haweis, Rector of Aldwinckle, Northants. (Glasgow, 1819).
38. Whidden, p. 17.

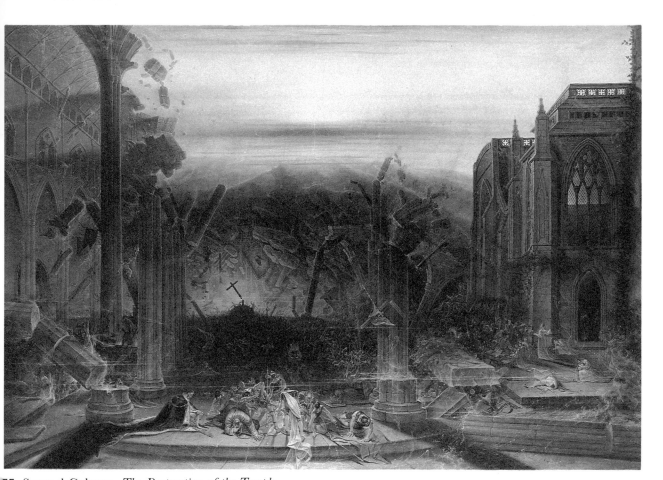

77. Samuel Colman. *The Destruction of the Temple.*

less, the central situation is clear. The structure whose destruction occupies more than half the picture is the Temple at Jerusalem, represented as a Gothic cathedral with five aisles and rib vaulting. The subject is the prophecies in the Gospels in which Jesus says that the Temple will be destroyed immediately before the coming of the Son of Man, as, for example, in Luke xxi. 5–6:

> And as some spake of the Temple, how it was adorned with goodly stones and gifts, he said,
> As for those things which ye behold, the days will come, in the which there shall not be left one stone upon another, that shall not be thrown down.

In Matthew, where Jesus also prophesies the destruction of the Temple (xxiv. 1–2),[39] there occurs the parable of the wise and foolish virgins (xxv. 1–13). This is illustrated by Colman on the right, as an admonition to be ready for "the hour when the Son of Man cometh." In the center foreground appear figures associated with the Crucifixion, including the soldiers who cast dice for Christ's garment, now seen in attitudes of

39. See Ronald Parkinson, "The Destruction of the Temple," *Illustrated Catalogue of Acquisitions* (London: Tate Gallery, 1974–76), p. 15; and *Samuel Colman*, pp. 7–8.

167

shame and fear, Pilate washing his hands, and Judas Iscariot about to hang himself. Beyond these, with his back turned to us, a robed figure holds up an opened book, and further to the right appears, above a scroll inscribed "PROPHECIES," a book inscribed "BOOK OF MART" – presumably Foxe's *Actes and Monuments*. At the base of a column is the inscription IHS. Perhaps the implication is that in this church, now being destroyed according to prophecy, Jesus was buried and new martyrs created. Wraithlike figures, produced by a very thin application of paint, are seen rising from the ground, probably in fulfillment of Matt. xxvii. 52, where, after the Crucifixion, "the graves were opened; and many bodies of the saints which slept arose."

Kneeling on the left is a figure like that of the king in *The Coming of the Messiah*, in a virtually identical position. His ermine-trimmed gown is adorned with royal symbols, like the fallen courtier's in *Belshazzar's Feast*. As in *The Coming of the Messiah*, his crown and scepter have been laid down. Once more, royal power must yield to the imminent coming of the King of kings. The overthrow of Charles X, a real (and Roman Catholic) king, in France in 1830 may have given Colman the immediate stimulus for introducing this image here.

The building on the right, only part of which is included in the picture space, is also a Gothic church; but this one is intact, and a vine grows up its walls. This representation of the True Church may be a glorious Gothic idealization of the Zion Chapel of Colman's painting of 1832. The vine suggests Christ, who says "I am the true Vine" in John xv. 1. Although the presence of any church here is puzzling (since according to Rev. xxi. 22 there will be no temple in the New Jerusalem), perhaps it should be regarded as enduring only through the destruction preceding the descent of the New Jerusalem from heaven.

The enormous violence of the collapsing Temple, with pillars and masonry falling upon helpless priests and worshippers and a Roman Catholic cross falling from where the altar should be, is evidently indebted to the cataclysmic scenes of John Martin. However, the intensity with which the destruction is conveyed here and in the subsequent *Edge of Doom* also suggests a personal response to catastrophic events, notably to the Bristol Riots of 1831. It is hard to imagine Colman as being untouched by these. The riots occurred in the wake of the throwing out of the First Reform Bill by the House of Lords. Their immediate occasion was the arrival for the April assize of the unpopular anti-Reform recorder Sir Charles Wetherell.[40] This was followed by the recruitment as special constables of some two hundred "very young men, zealous anti-reformers, who, according to a contemporary historian, 'viewed the lower classes with contempt, as a troublesome rabble, and rather relished an occasion for defying and humbling them.'"[41] Soon afterwards there arrived troops of dragoons and hussars who were quartered in the city. Despite such precautions – or perhaps in part because of them – an enormous mob raged through Bristol in the following days. They burst into the

40. My source for this summary is John Latimer, *The Annals of Bristol in the Nineteenth Century* (Bristol: W. and F. Morgan, 1887), pp. 146–79.

41. *Ibid.*, p. 149. Latimer's source is "a contemporary historian," identified by Whidden as W.H. Somerton, author of *A Narrative of the Bristol Riots* (Bristol, 1831).

city's two prisons, liberated the prisoners, and set fire to the buildings. They then proceeded to burn down the Mansion House, the Bishop's Palace, and the Custom House. Whole parts of the city were set ablaze, and the fires raged unchecked by firemen.

Charles Kingsley witnessed the Bristol Riots as a boy and later described the destruction:

> One seemed to look down upon Dante's Inferno, and to hear the multitudinous moan and wail of the lost spirits surging to and fro amid that sea of fire . . . Higher and higher the fog was scorched and shrivelled by the fierce heat below, glowing through with red reflected glare till it arched itself into one vast dome of red-hot iron – fit roof for all the madness below; and beneath it, miles away, I could see the lovely tower of Dundry, shining red.[42]

It seems almost certain that Kingsley's recollections formed the basis of the memorable mob scene in his novel *Alton Locke* (1850), and Colman too must have transformed these bloody events – one officer estimated that he saw 250 rioters killed or wounded on the final day – into his artistic statements. Several contemporary Bristol artists recorded the shocking events and their aftermath literally. Samuel Jackson produced a lithograph of *A View of Bristol during the Riots* (1832); both James Baker Pyne and William James Muller painted the burning of the New Gaol; and Muller also painted *The Burning of the Mansion House, Queen Square* and three views of the burning of the Custom House.[43] Subsequent happenings are the subject of Pyne's oil painting *Prisoners Escorted by Torchlights* (1832)[44] and of Rolinda Sharples' *The Trial of Colonel Brereton* (1834).[45] Of this group of pictures, all in the Bristol Art Gallery, the most interesting to compare to *The Destruction of the Temple* is *The Burning of the Bishop's Palace*, a water color by William James Muller.[46] The palace is afire on the left side of the picture, and great billows of smoke issue toward the center, most of which is occupied by the Gothic mass of Bristol Cathedral, unaffected by the flames. Colman's painting could almost be considered an imaginative transformation of this situation, and the entire episode of the riots, in which buildings housing the institutions of law, government, and commerce were destroyed, can be seen as a background for Colman's final apocalyptic statement.

Colman's last apocalyptic painting, signed twice and dated 1836 and 1838, is now known as *The Edge of Doom* (Brooklyn Museum) (Pl. 78). The title would appear to allude to Shakespeare's sonnet 116, which says of Time: "Love alters not with his brief hours and weeks/But bears it out even to the edge of doom." The statue of Shakespeare indeed occupies the center of this picture, and the figure of Time is seen falling directly to his right. However, the painting has nothing to do with "the marriage of true minds," which is the sonnet's subject, and the text that does appear here is from *The Tempest*. Indeed, the present title appears to have no claim to historical validity. The

42. Latimer, p. 167.

43. Greenacre, nos. 185 (Jackson), 264, 265 (Pyne), and 273, 274, and 276 a, b, and c (Muller).

44. *Ibid.*, no. 263.

45. *Ibid.*, no. 252 Colonel Brereton, commanding officer of the troops involved in the Bristol Riots, was tried for negligence and consequently committed suicide.

46. *Ibid.*, no. 275, reproduced on p. 228.

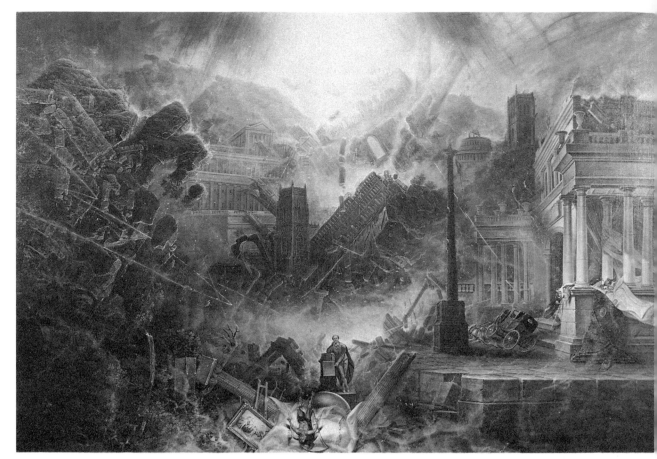

78. Samuel Colman. *The Edge of Doom.*

earliest reference to this picture is in a sale catalogue of 1889, where it is referred to as *The Crack of Doom – the End of All things and the Immortality of Shakespeare.*[47] This too has a Shakespearian reference: to the scene in *Macbeth* where, seeing the pageant of kings descend from Banquo, Macbeth exclaims: "Will the line stretch out to the crack of doom?"[48] Although *The Crack of Doom* may be merely a dealer's title, it has the advantage of reminding us that there is no necessary connection between *The Edge of Doom* and Shakespeare's sonnet. If any Shakespearian text has relevance here, it is the one actually inscribed in the picture.

The Shakespeare who appears in *The Edge of Doom* is not an imagined representation of the man but rather a rendering of Peter Scheemakers' statue (after a design by William Kent) in Westminster Abbey. This explains, in addition to his cross-legged leaning position, the partial "Van Dyck" costume that he wears in the painting.[49] It also explains the choice of text, which is the same as that in the sculpture:

47. *Sale of Paintings belonging to G.B. Hodges of Southlands, Clapham Park, at Foster's, on 6 and 7 February 1889.* Lot 239. Information from Brooklyn Museum records.

48. Act IV, scene i, line 117.

49. See Margaret Whinney, *Sculpture in Britain 1530–1830* (Baltimore: Penguin Books, 1964), p. 97.

170

> The cloud-capt towers, the gorgeous palaces,
> The solemn temples, the great globe itself,
> Yea, all which it inherit, shall dissolve,
> And, like the baseless fabric of a vision,
> Leave not a rack behind[.][50]

In Colman's painting Shakespeare is presented as a Prospero-figure whose prophecy of the final end is being fulfilled all around him. The pageantry alluded to in Prospero's speech becomes a metaphor of the real world, and its dissolution in flame and ruin is a prelude to the time to come.

At the right side and in the lower center of *The Edge of Doom* we see falling objects, some of which have already appeared with emblematic significance in Colman's previous works. On the right are gold plates, goblets, a large chalice, scales, and a sword; near the center a chain, a crown, and a scepter (its fleur-de-lys point broken so as to form a cross) on a large folio volume; to our left a painting, an easel, and a lyre. Thus on the great day of His wrath are seen to vanish symbols of the arts, of war, of slavery, of empire, and of the Roman Catholic Church. Falling upside down is the figure of Time with his hourglass and scythe – a conventional representation except that he is half-naked and muscular, strangely resembling a cigar-store Indian.

The falling painting has been identified as Guido Reni's *Aurora*, not in fact an easel painting but a ceiling fresco in the Casino Rospigliosi, Rome. Its subject is the goddess of the dawn, with Apollo surrounded by his train driving the chariot of the sun. For Colman this picture no doubt represented paganism in art, and if he knew that the fresco had been commissioned by the Cardinal Scipio Borghese, this would no doubt have linked the pagan subject with Roman Catholicism.[51] Here the false dawn falls on the Last Day, and the false god of the sun will shortly be replaced by the true Son at the Last Judgment.

The architecture catastrophically collapsing in *The Edge of Doom* owes an obvious debt to Martin, but in no painting before the later *Great Day of His Wrath* did Martin make such extensive use of buildings at the very moment of their destruction. Even in *The Fall of Babylon* and *The Fall of Nineveh* most of the buildings are intact. Martin characteristically shows buildings at the moment before the final catastrophe. The great falling mass to the left, however, owes something to Danby's *Sixth Seal* (see below). Colman would have seen this picture exhibited at the Bristol Institution in 1835–36, and he could also have referred to the large mezzotint engraving by G.H. Phillips, published by Colnaghi in 1830. One interesting detail is the church tower still erect near the center of the picture. Could this structure be a fancifully distorted reconstruction of the tower of St. Mary Redcliffe, Bristol, before the later addition of its upper spire? Even "the fairest, the goodliest, and the most famous parish church in England"[52] would not survive the Last Day.

50. *The Tempest*, Act IV, scene i, lines 152–6. However, the fourth line should read: "And, like this insubstantial pageant faded"; "the baseless fabric of a vision" was transplanted from a point earlier in the passage. For an exact transcription of the text in the statue, see Whinney, p. 97.

51. As mentioned in Margaret Whidden's dissertation.

52. The words of Queen Elizabeth I, quoted in *The Blue Guide to England*, ed. Stuart Rossiter (London: Ernest Benn, 1972), p. 173.

The carriage tipping over on the right bears three crests or crowns, indicating that aristocratic or kingly power too will fail on the Last Day. One other fact about it compels interest: it has no occupants. This in turn makes us aware of the fact that there are no human beings in *The Edge of Doom*. Shakespeare is a statue and Time an emblem. The city that is being destroyed has already been depopulated, and our gradual realization of this adds greatly to the eeriness of the painting.

<p align="center">ಊ ಊ</p>

Although Colman received little recognition in his lifetime, he is recognized today as a painter of considerable imaginative accomplishment, one whose work presents some interesting parallels to William Blake's, among which is the avoidance of the illusionism that characterizes Burkean-sublime painting. In contrast to the obscure Colman, Francis Danby was for a time one of the most popular painters of his day. He even came within a single vote of becoming a Royal Academician, a distinction that was never within the reach of Martin, who, as Constable put it, "looked at the Royal Academy from the Plains of Nineveh."[53] His first great popular success was *The Delivery of Israel Out of Egypt* (City Art Gallery, Birmingham), already discussed in relation to Colman's rendition of the same subject. Danby originally sketched this subject with the visual emphasis on Moses, standing with his staff raised in his right hand and some diminutive Hebrews behind him at the lower right. The rest of the drawing (ex coll. Walter A. Brandt) is occupied by the vast waters of the sea. Apparently, the resemblance to Moses' figure in Martin's *Seventh Plague of Egypt* is coincidental; although Martin executed his water color in 1823,[54] his finished painting was not exhibited until April 1824, and Danby's sketch is dated February 1824.[55] However, the general indebtedness of Danby's painting is evident: Gustav Waagen, Director of the Royal Gallery in Berlin, matter-of-factly characterized *The Delivery of Israel* as "a picture painted for effect, in the style of Martin."[56]

Danby's major change from sketch to painting was the addition of a very large number of miniscule figures, evidently in an attempt to capitalize on Martin's similar use of crowds in *Belshazzar's Feast* and elsewhere.[57] The compositional similarity of Turner's *The Field of Waterloo* (exhib. 1818, Tate Gallery), which also shows a large group in the foreground and a column of light, has also been suggested.[58] A more original effect, probably indebted to the popular diorama, is the very wide horizon.[59] The intensely conceived scene with its combination of churning sea, clouded sky lit at the horizon by sunset, and rocky shore testifies to Danby's skill as a painter of imaginary landscape. This aspect of his talent later earned the praise of Turner himself: when Ruskin denigrated Danby's accomplishment, Turner replied: "You have only to look at the truth of the landscape; Mr. Danby is a poetical painter."[60]

53. According to Ralph Thomas's diary; see Pendered, p. 180.
54. See Feaver, p. 221, n. 13.
55. Adams, no. 99, p. 187.
56. From Gustav Waagen, *Art Treasures of Great Britain* (*1854–57*), cited in Balston *John Martin*, p. 186.

57. This is, however, denied in *Men of the Time* (London: David Bogue, 1856), p. 191, where the example of Allston's *Jacob's Dream* (Petworth House) is cited.
58. Wilton, *Turner and the Sublime*, p. 156.
59. Adams, pp. 74–5.
60. Gage, *Colour in Turner*, p. 244, n. 48.

With the exhibition of *The Delivery of Israel Out of Egypt* at the Royal Academy in 1825, Danby's prospects suddenly became dazzling. The painting was bought for five hundred guineas by the Marquis of Stafford, a prominent collector who was also President of the British Institution. In November Danby was elected an Associate of the Royal Academy. His rising star was celebrated in a verse address to painters by Danby's Bristol friend John Eagles, who also took occasion to slap at Constable:

> – Embody from the sacred page,
> Stories of patriarchal age –
> – Or theme sublime – the fiery rain,
> Departing hot, the blazing plain;
> Heaven's vengeance upon Egypt dealt;
> It's blood, – it's darkness to be felt;
> These, these are the themes, that may proclaim,
> So Danby finds, an artist's fame.
> Learn this, ye painters of dead stumps,
> Old barges, and canals, and pumps ...[61]

Constable, as Geoffrey Grigson points out with respect to this passage, had the year before exhibited his great canal scene *Dedham Lock*, which indeed includes a barge, dead stumps, and a pump.[62] In addition to demonstrating Eagles's consistent tendency to be wrong as an art critic, this passage contains an unconscious prophetic irony, for when Constable achieved his long-delayed election to Royal Academician, it was Danby who was the runner-up.

In 1825, however, Danby was flush with success and sketching new expeditions into sublime territory.[63] He planned both a Deluge and a large painting of a Revelation subject, but gave precedence to the latter and before the end of the year produced an oil sketch for *An Attempt to Illustrate the Opening of the Sixth Seal*. On 14 October Danby wrote to his Bristol friend and patron John Gibbons about the work he had in hand:

> The third Picture is a subject that I fear I ought to blush for venturing upon, but though it cannot be painted with entire truth, yet it is the grandest subject for a Picture, I think, in the Bible, it is the opening of the Sixth Seal in the Revelations of St. John: the great day of wrath, Chapter 6, from verse 12 to the ending of the chapter.[64]

Gibbons had already paid substantial advances to Danby for *An Enchanted Island* and *The Embarkation of Cleopatra*, and Danby must have been hoping for a further advance for *The Sixth Seal*. He continued:

61. From John Eagles, "Rhymes by Themaninthe-moon," in *Rhymes Latin and English* (Bristol: Felix Farley [Eagles's own pseudonym], 1826); text from Edward Malins, "Francis Danby in Bristol 1814–24," in *James Smetham and Francis Danby* (London: Eric & Joan Stevens, 1974), p. 11. The poem was written in Latin but was published with an English translation by J.M. Gutch.

62. See Geoffrey Grigson, "Some Notes on Francis

Danby, A.R.A.," in *The Harp of Aeolus* (London: Routledge, 1948), p. 70.

63. *The Israelites Passing Through the Wilderness* (Bristol Art Gallery), a rocky landscape with diminutive figures, was once thought to be Danby's and was conjecturally dated 1825, but it is now known to be a work by William West exhibited at the Royal Academy in 1840. See Greenacre, no. 237 (repr. p. 25).

64. *Ibid.*, p. 64.

My picture is already sketched and a great deal of it is in effect upon the canvas, it is a little larger than my picture at the Marquis of Stafford's, those who have seen this consider it to be the best arrangement and the best subject I have yet had. I am determined at all events, to pursue it with indefatigable labour, if I fail entirely it will be from sheer want of talent and consummate conceit ...

Despite Danby's exhortation to read the passage, which the artist pronounced "fine," Gibbons seems to have been for once unencouraging, and on 28 October Danby wrote to him more frankly:

I need not tell you that this subject is not one after my own heart, so far from it that I should not be able to bear it, except for the opportunity it affords of good incidents of figures and grand atmospheric effect in a Mountainous Country. I own I am not good enough to choose the subject from any religious feeling; but it is a fine dream; the principal reason I have for choosing the subject is to do something in harmony with my last picture (Delivery of Israel Out of Egypt), which sort of picture I am at present most likely to sell.[65]

And in 1828, the year in which his *Sixth Seal* was exhibited at the Royal Academy, Danby wrote even more candidly to Gibbons that he disliked the class of pictures he was now painting and that his only reason for doing them was "the rage for novelty in the public."[66] These remarks bring out a curious aspect of Danby's role as a painter of apocalyptic subjects. The motivation of the other painters discussed in this book was in the broadest sense religious. They could not have existed as artists without commissions or sales, but they seized opportunities to paint themes of intensely personal importance. For Danby, however, it was the public taste for the apocalyptic sublime that led to his choice of subject matter, and one senses this lack of conviction in what Adams terms Danby's "lack of a natural gift for the sublime."[67] Nevertheless, *The Sixth Seal* exhibits a brilliance of visual conception that explains the sensation it made in 1828.

Although *The Sixth Seal* (National Gallery of Ireland) has suffered much deterioration,[68] the figures and landscape are clearly rendered in the large ($19\frac{1}{4} \times 27$ in. at the platemark) mezzotint of G.H. Phillips (Pl. 79). The text is Rev. vi. 12-17, and an illustrated key issued for the exhibition of the picture in Bristol in 1835 further explains the significance the artist wished to attach to some of the images.[69] The basic conception is of a crowd gathered on a shelf of rock at the moment of the "great earthquake" of Rev. vi. 12. These momentary survivors are, however, about to be destroyed by a great mass of rock falling from their left. Lightning strikes the surrounding mountains, and they are, in the words of Danby's description, "rent with fire." All these rock formations are handled with great skill, testifying to the good use that Danby made of his

65. *Ibid.*, p. 65.

66. *Ibid.*, p. 65.

67. *Francis Danby*, p. 83.

68. T.S.R. Boase described it as "blackened into dull insignificance" (*English Art 1800–1870*, p. 107), but according to Adams, "recent cleaning has proved that its condition is not so bad as suggested by Boase" (p. 175).

69. *Now Exhibiting at the Bristol Institution, Park Street, Danby's Celebrated Painting, Opening of the Sixth Seal, from the Collection of W. Beckford, Esq., of Fonthill.*

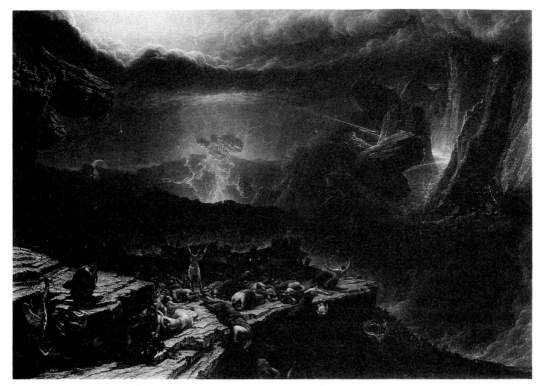

79. G.H. Phillips after Francis Danby. *An Attempt to Illustrate the Opening of the Sixth Seal.*

observations of the mountains of Norway in 1825. "In the middle distance," as the descriptive key says, "is represented the confusion consequent upon the awful dissolution of a great city – palaces, pyramids, and all the pomp of monuments, crumbling into the yawning chasms of earth's consuming fires." The moon veiled in blood sets for the last time, and the heavens gathering as a scroll are represented by huge cloud masses. As much as any of Martin's works, this painting could serve as an example of the Burkean sublime as it was conceived in the nineteenth century.

Most of the people in the foreground of the picture are either lying on the ledge or falling from it, and a few of these are singled out in the descriptive key for special attention. According to Rev. vi. 15, "all the kings of the earth, and the great men, and the rich men, and the chief captains, and the mighty men, and every bondman, and every free man, hid themselves in the dens and in the rocks of the mountains." We indeed see a king whose crown and scepter lie on the ground and, in Danby's words, "a steel-bound warrior . . . aghast with fear and trembling," with treasure scattered near him. However, there is a contrast made between these and the only upright figure in the entire group – a former slave, shaking his broken manacles in a triumphant gesture. The fallen king, says Danby, "may be supposed as the final doom of pride, oppression, and power"; while the liberated slave is "a poetical representation of the freedom of the oppressed." Danby was evidently willing to go against the biblical text owing to the tradition of libertarian themes in the apocalyptic art of his time. However, unlike Blake, Turner, Martin, and Colman, all of whom frequently introduced such themes

175

into their works, Danby does not seem to have pursued them any further. One may assume that he included them here because at a time of agitation for Reform and for the complete abolition of slavery he thought the public expected them. The fact that they *were* expected is itself of interest, for by this time there seems to have been a conscious recognition that the apocalyptic sublime was immediately related to the great upheavals of the period.

With *The Sixth Seal* Danby's reputation took another great leap forward. The *Examiner* went so far as to compare his accomplishment as a painter of poetic landscape not only with Martin's in *The Creation*, but also with Claude's in that perpetual favorite among British connoisseurs, *The Enchanted Castle*.[70] John Eagles later characterized it, in the *Blackwood's* article in which he condemned Turner, as "the most impressive picture ever painted."[71] Colnaghi paid £300 for the engraving copyright before the painting was completed, William Beckford purchased the original for £500, and the Collins workshop later produced a stained-glass version for Redbourne Church, Lincolnshire. With the encouragement of Beckford, who told Henry Venn Lansdown that "Martin is very clever, but a friend of mine, Danby, far surpasses him,"[72] Danby went on to plan further apocalyptic designs.

Two of Danby's apocalyptic subjects, meant to go over doors at Beckford's house in Lansdown Crescent, Bath, were exhibited at the Academy in 1829. Only one of these is known to exist today:[73] *Subject from Revelations* (coll. Robert Rosenblum) (Pl. 80). The text illustrated is the same (Rev. x. 1–6: the angel with the book) as that executed by Blake in "*And the Angel Which I Saw Lifted His Hand to Heaven,*" and it would later be the subject of one of Martin's small pictures for the Westall and Martin New Testament designs. Danby could not have known Blake's water color, but he may have found a source in John Flaxman's Dante illustration, *The Old Man of Crete*, showing the statue of four metals from the *Inferno*.[74] Danby's angel has long hair but is not female. He stands against a murky sky, the little book in his right hand, and a rainbow arches from one of his upstretched arms to the other. The setting sun casts a ruddy glow over his legs. The picture's intensity of color is striking, and its design is thought to have influenced Turner's vignettes of the 1830s.[75] Nevertheless, the two scenes from Revelation were coolly received when they were shown in 1829.[76] This may explain why Beckford did not buy them after all. Indeed, at this point Beckford vanishes from the life of his friend Danby, to whom he gave no further commissions and whose *Sixth Seal* he had sold by the time it was exhibited in Bristol in 1835.

70. 15 May 1825, cited in Adams, p. 71.

71. *Blackwood's Edinburgh Magazine*, LIV (1843), 496.

72. Henry Venn Lansdown, *Recollections of the Late William Beckford, of Fonthill, Wilts; and Lansdown, Bath*, ed. Charlotte Lansdown (privately printed, 1893) p. 20. Lansdown did not agree. "Martin," he wrote, "was undoubtedly the inventor of the singular style of painting in question . . ."

73. In the Arts Council Danby exhibition catalogue of 1961, no. 22 is called "Apocalyptic Subject," but this picture is no longer attributed to Danby.

74. See Gage, *Colour in Turner*, p. 244, n. 99. Both designs are reproduced together in the exhibition catalogue

John Flaxman R.A., ed. David Bindman (London: Royal Academy, 1979), p. 17. Adams (p. 177) suggests that Danby would have known Allston's *Uriel in the Sun* (Boston University), then in the Marquis of Stafford's collection, but in Allston's painting the angel (which probably derives from a similar figure in Barry's *Elysium and Tartarus*) is seated.

75. Gage, *Colour in Turner*, p. 97.

76. See Adams, pp. 84, 173. The critic of the *Gentleman's Magazine*, however, wrote: "The colouring is in Danby's peculiar style, and the reflection from the warm blood streaks of the darkened sun's light on the angel, is particularly good." (XCIX (1829), 443.)

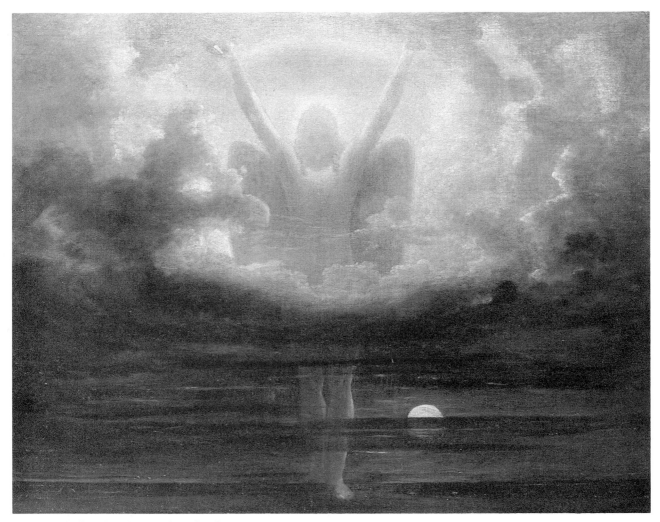

80. Francis Danby. *Subject from Revelations.*

The loss of Beckford's patronage was not the only reversal Danby suffered in 1829. Earlier in the year he had been defeated by one vote by Constable for the vacant seat in the Royal Academy. There subsequently occurred a personal scandal that caused him to leave England.[77] Except for a brief return to London in January 1830, Danby was to reside on the Continent for the next eight years. There he continued to paint, but he did not resume what had once been his most popular vein until 1837, when he took up a subject that he had put by over a decade before – the Deluge.

Danby had been planning a Deluge during the winter of 1825–26. In March, rumors, which must have been started by Danby himself, began circulating to the effect that Danby's idea had been stolen by John Martin. Danby's Bristol friend George Cumberland, Sr. wrote to his son on 21 March: "I am sorry to hear it reported that Martin

77. The circumstances were ingeniously reconstructed by Geoffrey Grigson as "an exchange of wives" with the artist Paul Falconer Poole ("Some Notes on Francis Danby, A.R.A.," pp. 86–9). Adams (pp. 86–9), although pointing out that "Poole had apparently no wife to exchange," accepts Grigson's hypothesis as "substantially correct," and documents the chronology of events.

has copied Danby's great picture in a little print – if so it is infamous, but I would finish it for all that if I were he, to shew him up to the public."[78] Evidently Cumberland had confused some of the details, as there is no small Martin print of this time that could be a candidate, and George Jr. replied to his father in some puzzlement. In the same month, the poet Thomas Lovell Beddoes wrote from Germany to Bryan Waller Procter ("Barry Cornwall"):

> Have you seen Martin's Deluge; do you like it? And do you know that it is a rascally plagiarism upon Danby? D. was to have painted a picture for the King: subject the opening of ye sixth seal in ye revelations: price 800 guineas: he had collected his ideas and scene, and very imprudently mentioned them publicly to his friends & foes – it appears; Like Campbell and Lord B: and lo! his own ideas stare at him out of Martin's canvass in the institution – this is the Last man again – and why does he not paint a last Man?[79]

This too is a muddled account, as Danby never had a royal commission for *The Sixth Seal* or any other painting; and although there is some general compositional similarity between Martin's *Deluge* and Danby's *Sixth Seal*, it was not his Revelation painting but his *Deluge* that Danby thought Martin had stolen.

A letter from Danby to John Gibbons dated 13 February 1826 makes Danby's view clear. Danby says that at Martin's house (probably at one of the evening gatherings of the 1820s) he told Martin that he had been making plans for a Deluge for some years but had temporarily laid them aside for *The Sixth Seal*. He continues:

> I told him *all the incidents which I am now sorry for*: a short time after this I heard Martin had commenced the Deluge. This surprised me but I thought it not of much consequence until a gentleman called one day on me and on seeing my Picture he said this is exactly like Martin's Picture in every line – this I thought impossible as Martin and myself had made a mutual agreement not to look at each others work until they were completed, but on strict enquiry to the servants I found he called one evening when I was out, and was brought to the painting room. All this proves he was not so noble as I thought. As sanguine as [I] was in my subject, I immediately gave it up and commenced another picture.[80]

Whether this charge is justified or to what extent will probably never be known, since Martin, apparently ignorant of Danby's complaint, had no opportunity to reply. Furthermore, *The Deluge* (York Art Gallery) sometimes attributed to Danby and hypothetically dated *c.* 1828 is probably not by Danby at all and may in fact be indebted to Martin's painting for some of its details.[81]

78. Adams, p. 62. Cumberland, it is worth noting, was one of Blake's oldest friends, and this link may account for the apparent influence on Danby of some of Blake's designs.

79. *The Works of Thomas Lovell Beddoes*, ed. H.W. Donner (London: Oxford University Press, 1935), p. 615. Byron had been accused of plagiarizing from Thomas Campbell's poem "The Last Man"; as it turned out it was Martin who later painted both a water color (Laing Art Gallery, Newcastle) and an oil painting (Walker Art Gallery, Liverpool) on Campbell's subject.

80. Greenacre, pp. 45–6.

81. See Adams, pp. 174–5. Adams calls the attribution to Danby "problematical" and remarks that the picture is "unlike any known painting by Danby."

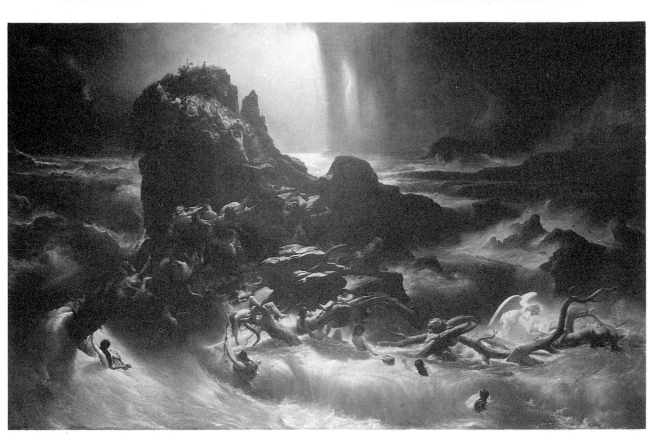

81. Francis Danby. *The Deluge*.

In summary: Danby was working on a large Deluge by the middle 1820s but claimed Martin stole his idea and that he had given it up for that reason. (According to *Men of the Time*, "This subject was engraved so far back as 1824, from an early sketch,"[82] but no such engraving is known to exist.) Toward the end of his self-imposed Continental exile, Danby turned to the subject again, reconceived it completely, and finished *The Deluge* (Tate Gallery) after returning to London in 1838 (Pl. 81). It was in effect Danby's announcement of his re-emergence, and in 1840 it was privately exhibited in Piccadilly, where it had great critical success. Among its admirers was William Makepeace Thackeray, who preferred it to the versions by Turner and Martin. Writing in *Fraser's* under the name of "Michael Angelo Titmarch," Thackeray declared:

> He has painted *the* picture of "The Deluge"; we have before our eyes still the ark in the midst of the ruin floating calm and lonely, the great black cataracts of water pouring down, the mad rush of the miserable people clambering up the rocks; – nothing can be finer than the way in which the artist has painted the picture in all its innumerable details, and we hope to hear that his room will be hourly crowded, and his great labour and genius rewarded in some degree.[83]

82. *Men of the Time*, p. 193.

83. "A Pictorial Rhapsody," *Fraser's Magazine*, XXII (1840), 122.

Like Turner, Danby had found Poussin's *Deluge* inadequate to the imagination and he set out to render the event on a cataclysmic scale.[84] In addition to the number of the figures, their nakedness is very striking, and so is the extraordinary number of mothers with babies – if painted in a different vein, this could almost have been an allegory of motherhood. Here the three-generational motif of other Deluges is reiterated several times over. The enormous serpent entwined on a broken tree in the foreground is another tribute to the Deluge tradition. The giants who were in the earth in those days are also here and, in what seems the strangest aspect of the painting, two of them are mourned by an equally gigantic angel at the far right.

In a description that he gave to Thackeray, Danby accounts for this last detail:

> . . . on the right, floating on a hastily constructed raft, are the bodies of a giant and a female (crushed by a fallen tree), over whose pallid forms weeps an Angel of Light, who, though not involved in the ruin, may, with a heart of heavenly mould, drop a tear of more than diamond purity and brightness over that once divine and glorious human race, once bright as he, and who were still so beautiful, though fallen, that the "Sons of God saw that the Daughters of Men were fair, and chose from amongst them such as they loved."[85]

There is something about this overstrained prose that parallels the form of the Angel of Light, which might well be a plaster angel in a cemetery – neither is very convincing. One cannot help thinking of Danby's earlier letters to Gibbons about the appeal of such subjects to the public taste and their unsuitability to his own. What makes this painting effective is not its supernaturalism but its structure – the pyramidal shape that is assumed by the human beings attempting to swarm up the huge rock, a structure suggested to Danby by Géricault's *Raft of the Medusa*.

Danby had been influenced by Géricault's great painting even before he saw it. In his *Sunset at Sea After a Storm* (exhib. 1824, Bristol Art Gallery) he painted a luridly colored scene of men on a liferaft – his first picture to be sold in London, and the buyer no less a figure than Sir Thomas Lawrence, P.R.A.[86] Five years later, after having seen *The Raft of the Medusa* at the Louvre, Danby wrote: "although I have never seen it in England I highly respected it for I heard it described and most highly praised by a man of the first taste, I mean Frank Gold of Bristol, a man of great genius . . . I stored what he said of this picture up in my memory."[87] In October 1837 Danby, writing to Gibbons, characterized *The Raft of the Medusa* as "the only instance of a noble and sublime French picture."[88] There seems little doubt that he stored in his mind what he had learned from Géricault's painting and that this was the basis of his new conception for *The Deluge*.

Although Danby continued to paint and exhibit for twenty years after the exhibition

84. See Adams, p. 102, quoting a letter from Danby to Gibbons of October 1837.

85. "A Pictorial Rhapsody," pp. 121–2.

86. This painting, long untraced, was rediscovered in 1982. See *Francis Danby in Bristol* (Exhibition Hand-list, City of Bristol Museum & Art Gallery, 1983), no. 35.

87. *Ibid*. The Raft of the Medusa was exhibited in London in 1820.

88. Adams, p. 104.

of *The Deluge*, he appears to have abandoned such subject matter completely[89] and to have concentrated on his true métier, ideal landscape. This of course reinforces the view that his ventures into the apocalyptic sublime were purely exploitative, but there may nevertheless be another reason for his attraction to subjects like the Sixth Seal. The circumstances in County Wexford where Danby was born *c.* 1793 must have seemed terrifyingly violent. Ireland was racked by civil and religious strife in the 1790s, and in 1798 occurred the Wexford Rebellion in which a number of Danby's relatives were killed or narrowly escaped. "My family like many others," he wrote to Gibbons, "were destroyed by political and party feeling, many of them lost their lives on both sides of the unhappy question."[90] Danby's father, a Protestant Loyalist in a Catholic county, moved with his family to Dublin some time later. The effect of these events on a small child can scarcely have been less than traumatic, and Danby described his childhood as "filled by fear, distress, and bloodshed."[91] It may well have been the recollections of his early years, recast in the imagery of the Bible, that provided Danby with a personal impetus for his apocalyptic art.

89. Unless *The Eve of the Deluge*, now untraced, followed. This painting and a pen drawing related to it were included in Danby's sale, Foster's, 15 May 1861, nos. 50 and 6 respectively (see Adams, p. 179).

90. Letter dated 2 January 1833, Greenacre, p. 33.
91. *Ibid.*

EPILOGUE

DELUGE AND Deluge-related subjects continued to interest artists in the middle years of the century, though not for long after that. In 1848 William Westall painted a Deluge (Tate Gallery) in which the influence of Turner's painting is still strong, one with a houseboat-type Ark, tropical vegetation, and a strange pinkish ring about the sun. 1848 was also the year of John Linnell's colorful *Noah: The Eve of the Deluge* (Cleveland Museum of Art), which shows the patriarch and his family looking out over a pastoral valley while clouds begin to gather overhead. Linnell must have seen Martin's *Eve of the Deluge*, to which his painting shows considerable similarity. Two years or so later a much younger artist, John Everett Millais, executed a pen-and-ink wash drawing (British Museum) in anticipation of a painting on this subject that he hoped to show at the Royal Academy exhibition of 1851. By the end of January 1851, however, he had given up the idea,[1] and this decision seems to reflect an intuition that the day of the apocalyptic sublime was over. So it was – with a few rule-proving exceptions.

In the late 1860s G.F. Watts began working on a series of pictures of the four riders of Revelation vi. One of these was a large (60 × 43 in.) oil painting, *The Rider on the White Horse* (St. George's Cathedral, Capetown). This was exhibited at the Grosvenor Gallery in 1883, and in the 1880s Watts also completed a group of smaller paintings (all about 26 × 21 in.), showing individually each of the four riders. There are two versions of each painting, except *The Rider on the Red Horse*, and a complete set of four in the Walker Art Gallery, Liverpool. Earlier in the century, a painter attempting these subjects would have thought of combining them in a single ambitious painting, but evidently that was never Watts's intention. Although a little dramatic interest is occasionally generated in these pictures, as where the hell-hound in *The Rider on the White Horse* bares his teeth, they are strangely static designs for horsemen, and they fail to engage the imagination.

The most grandiose apocalyptic project of the late Victorian period was part of an ambitious plan for the mosaic decoration of the inside of the dome of St. Paul's Cathedral. For this scheme, eight roundels were to be executed by Lord Leighton. The first

1. See catalogue entry by Malcolm Warner in *The Pre-Raphaelites* (London: 1984), no. 171. Millais did exhibit *The Return of the Dove to the Ark* (Ashmolean Museum, Oxford) in 1851, but there is nothing remotely apocalyptic about this picture, and without the title, one might think it simply a portrait of two sisters embracing with a dove.

182

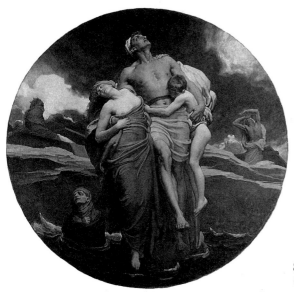

82. Frederic, Lord Leighton. "*And the Sea Gave Up the Dead Which Were in It.*"

and only one of these to be painted was the Revelation subject, "And the Sea gave up the dead which were in it." An enormous cartoon 22 feet in diameter was prepared and displayed, but it was not well received, and the whole project was abandoned in 1885.[2] Leighton, however, liked his subject too well to give it up entirely, and so he painted it in oil and exhibited it at the Royal Academy in 1892 (Pl. 82). This circular picture, 90 inches in diameter (Tate Gallery), shows a family of three rising up from the sea in the foreground as other corpses begin to animate in the water around them. Although the *Magazine of Art* called it "the high-water mark of his mental conception,"[3] the more recent critical judgment that "the design as a whole fails to sustain its apocalyptic character" seems a more balanced one.[4]

By the late nineteenth century, the apocalyptic sublime was no longer a viable artistic mode. It had also ceased to interest the public, and there began the downward spiral of prices that culminated in the sale of John Martin's *Last Judgment*, *Great Day of His Wrath*, and *Plains of Heaven* for the combined sum of £7 in 1935. It may be dangerous to speculate about the root causes of changes in taste, but it is incontrovertible that the rise of apocalyptic art in England occurred during a time of domestic unrest and foreign wars, that it continued to flourish during the period of Chartist agitation, and that not long after 1848 it virtually disappeared. The mode seems to have served as a means of displacing the sense of dislocation and disquietude of an era. After it became clear that England would not have a violent revolution but would, however slowly, institutionalize change, the need for apocalyptic subjects seems to have left both artists and public. Painters like Watts and Leighton who failed to recognize this development ignored it at the peril not only of their public reception but also of the vitality of their artistic conceptions. The apocalyptic sublime had been a mode of central importance in its time, but that time – to use the words of John of Patmos – was "finished" before the end of the nineteenth century.

2. See Leonée and Richard Ormond, *Lord Leighton* (New Haven and London: Yale University Press, 1975), pp. 123, 166, 179.

3. 1892, p. 220. quoted in Ormond, p. 124 n. 19.

4. Ormond, p. 124.

APPENDIX 1

The Apocalyptic Grotesque

GILLRAY's *Presages of the Millennium* (Pl. 83),[1] dated 4 June 1975, is especially brilliant in that it sets a contemporary political event against the pattern of Mortimer's *Death on a Pale Horse* and, furthermore, pretends to be a vision not of John of Patmos but of Richard Brothers. Gillray had previously satirized Brothers and his followers in a print dated 5 March 1795, the day after Brothers's arrest.[2] There "The Prophet of the Hebrews – the Prince of Peace," as Gillray calls him, is seen trampling the dragon of Revelation, on whose heads two royal crowns and a papal tiara can be seen. In one hand Brothers holds both the Book of Revelation and a fiery sword while the other he gestures toward the Gate of Jerusalem, which is shown in reality to be the triple gallows. His face is grotesquely distorted, presumably to indicate mental derangement, and beams of light, the "horns" of Moses, emanate from his head. In the "Bundle of the Elect" that he carries on his back, the heads of Charles James Fox (unshaven as ever in Gillray), William Wilberforce, and other advocates of peace are identifiable. Assignats bulging from Gillray's pocket betray him to be a French agent, and the bleeding sun wears the red cap of Liberty. In this scene Gillray conflates apocalyptic vision with national and international events. So, of course, did Brothers, but in Gillray's view the New Jerusalem of contemporary millenarians is a mask for subversive activity on behalf of revolutionary France.

This idea of masking, of a "low" reality lurking behind a "high" one, has its aesthetic correlative in the relation of the grotesque to the sublime, although in the world of caricature that relation is considerably simplified.

In one of the great documents of Romanticism, the preface to *Cromwell*, Victor Hugo discusses the sublime, the beautiful, and the grotesque, separate categories in the arts of antiquity, as necessary complements to one another in the arts of the moderns:

> Le sublime sur le sublime produit malaisement un contraste, et l'on a besoin de se reposer de tout, même du beau. Il semble, au contraire, que le grotesque soit un

1. See Mary Dorothy George, *Catalogue of Political and Personal Satires Preserved in the Department of Prints and Drawings in the British Museum* (London: British Museum Publications, [1942] 1978), vol. VII, no. 8655.

2. *Ibid.*, no. 8637.

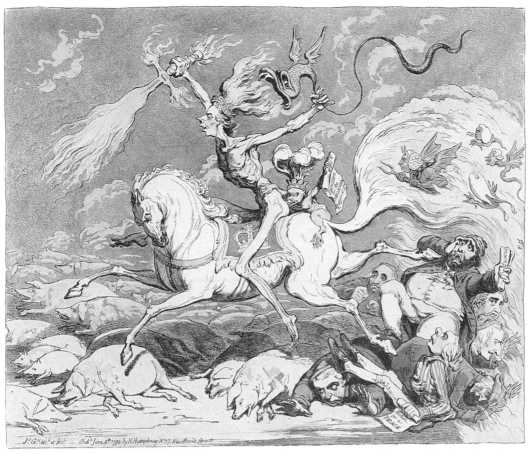

83. James Gillray. *Pressages of the Millennium.*

temps d'arrêt, un terme de comparison, un point de départ d'ou l'on s'éleve vers le beau avec une perception plus fraiche et plus excitée.[3]

As Kayser remarks, this means that the sublime and the grotesque become polarities between which art may establish a relationship.[4] We have seen that such a relationship exists in certain apocalyptic works by West and by Blake, among others – Blake's "*He Cast Him into the Bottomless Pit and Shut Him Up*" is virtually a paradigm of this. Although *The Prophet of the Hebrews* does not parody any particular painting, Brothers and the dragon strongly suggest the *topos* of Michael overcoming Satan. Thus we can see how in Gillray's world of caricature the relation of the sublime to the grotesque is simplified as a "high" reality masking a "low" one, with the latter emerging in the design.

3. *Préface de "Cromwell"*, ed. Pierre Grosclaude (Paris: Libraire Larousse, 1949), p. 29.

The sublime on the sublime produces a contrast with difficulty, and one needs rest from everything, even the beautiful. It appears, on the contrary, that the grotesque is a time of rest, a term of comparison, a point of departure from which one raises one's self towards the beautiful with a fresher and more excited perception.

4. *The Grotesque*, p. 58.

In *Presages of the Millennium* the low reality is twofold. In addition to attacking the advocates of peace with France once more, this print satirizes the settlement that Pitt had arranged for the Prince of Wales's future marriage. (The plumed demon[5] kissing the posterior of Pitt/Death holds a paper inscribed "Provision for the Millennium £125 000 pr. An.") Mortimer's Pale Horse has been transformed into the white horse of Hanover, identifiable by the royal crown on its saddle blanket. Among the demons flying in Pitt's train, Burke is recognizable by his spectacles, and the pigs being trampled in the foreground, in place of Mortimer's human figures, are the "swinish multitude" of Burke's *Reflections on the Revolution in France*.[6] Unshaven Fox, holding a petition for peace, falls back from a terrible kick from the horse, which has made his face bleed profuse red drops. Further to the right are the flames of Hell, which match the orange flames issuing from the spectral rider's brandished sword.

Where Mortimer's design was projected from the "high" perspective of John of Patmos, Gillray's is seen "as revealed by R: Brothers, the Prophet, & attested by M.B. Hallhead Esq."[7] From this "low" perspective, Gillray alleges corruption on the part of the Establishment and treason on that of the Opposition; and the perverse nature of such a reality is effected by the transformation of a sublime subject into a grotesque one.

Having said this, one must add that Gillray's art is not fully grotesque in Kayser's sense. The true grotesque would not establish any relational meanings, for it mirrors "our agonizing fear of the dissolution of the world."[8] While it is true that these caricatures do not present any normative values, they do by omission imply them. The distortion of the human figures indicate departures from some standard that is not present, just as by implication there ought to be an ethical standard established by statesmen who are neither opportunists nor traitors. This may of course be said of satire in general. Swift's Little-Endians and Big-Endians imply the possibility of a society in which such absurd exaggerations do not exist, and it is a truly Swiftian characteristic of Gillray – one that makes him a great satirist and not a mere political cartoonist – that he is able to do something like this in visual terms. Gillray's art approaches the grotesque and at times presents the grotesque as a parody of the sublime, but it never divorces itself from an implied structure of (absent) meaning.[9]

5. George points out that he wears the feathered coronet of the Prince of Wales with its motto "Ich di[ien]."

6. See Draper Hill, *Mr. Gillray the Caricaturist* (London: Phaidon, 1965), p. 55, n. 5.

7. Halhed was Brothers's sole Parliamentary supporter.

8. *The Grotesque*, p. 31.

9. Also of interest in this regard is William O'Keefe's caricature published 26 March 1797 with the title, *A Vision – Vide – The Monster of Slaughter, The Distress of Nations*. Pitt is depicted as the Great Red Dragon of Revelation. Beneath him dead bodies with swords in them lie under a deluge of blood.

Edward Francis Burney

In the Victoria and Albert Museum are engravings of five Revelation subjects by Edward Francis Burney.[1] Burney's Milton illustrations are well known,[2] but as these apocalyptic ones are not, they are worth noting here, even though they do not in any sense attempt the sublime. They are catalogued by the Museum under the following titles, and two bear inscriptions from Revelation:

1. *Satan seized by the Angel* (Pl. 39).
 E.F. Burney del. J. Fitler, A.R.A., sculp.
 An Angel came down from Heaven, having the key of the bottomless Pit/and a great chain in his hand; and he laid hold on the Dragon, that Old
2. *Satan Being Bound by the Angel* (Pl. 84).
3. *Satan Being Thrown Into the Pit*
4. *Satan Confined* (Pl. 85)
 N. Scarlett, Invent. E.F. Burney, del. J. Fitler, A.R.A., sculp.
 Satan Confined [in Gothic lettering]
 The Angel shut Satan up in the Abyss, and set a seal thereon; that he/might deceive the Nations no more, till a thousand years should be completed./rev. xx. 1–3
 [Door in the design inscribed: *Shut/For a/Thousand/Years*]
5. *Satan let loose*
 E.F. Burney del. A. Smith, A.R.A., sculp.

Patricia Crown suggests that the engravings may be after pictures exhibited in 1802 at the Royal Academy, where they were designated *The Laying Hold, Binding, Casting in, and Confining of Satan for One Thousand Years*.[3] (In that case, one of the prints listed above is after an unexhibited picture.) The inscription, "N. Scarlett Invent." on the fourth engraving is intriguing: Scarlett was a bookseller and an active Universalist who in 1798 published *A Translation of the New Testament from the Original Greek: Humbly attempted by Nathaniel Scarlett, Assisted by Men of Piety and Literature*. However, this book

1. I thank Patricia Crown for bringing these to my attention.
2. See Pointon, *Milton in English Art*, pp. 88–90, 151–60.

3. *Edward F. Burney: An Historical Study in English Romantic Art*. Ph. D. dissertation, University of California, Los Angeles, 1977, pp. 98–9.

84. J. Fittler after Edward Francis Burney. *Satan Being Bound by the Angel.*

85. J. Fittler after Edward Francis Burney. *Satan Confined.*

(copy in the Sterling Library, Yale University) has no illustrations by Burney and is in fact not illustrated at all save for a small cut at the beginning. The text from Revelation under two of the prints above follows neither the Authorized Version nor Scarlett's translation.

This was not the first time that Burney had been involved in an illustrative project with millenarian overtones. In the British Museum, Department of Prints and Drawings, is an engraving inscribed as follows:

Invented by W. Huntington/Painted be E.F. Burney/Engraved by E. Terry.

An Hieroglyphic Print of the Church of God in her Fivefold State,/Including the Holy Jerusalem. Together with/A Scriptural Exhibition of the numerous Artists, Mechanicks, and Manufacturers, Engaged in their Respective Pursuits/*For promoting the various Branches* of Natural Religion. N.B. This Print is accompanied with another Print *Containing the* Ground Plot *of the* Heavenly City, *together with a Key to ye Whole*

Pubd. Jan. 1. 1791, for W. Huntington and G. Terry.

188

APPENDIX 3

Versions of *Belshazzar's Feast* by John Martin

THERE ARE four versions of *Belshazzar's Feast* that are generally accepted as by the hand of John Martin. The original exhibition picture, now in a private collection in England, was badly damaged in an accident at a railway crossing in 1854. There is an almost full-size copy, described by Feaver as "garishly painted,"[1] in the Mansion House, Newcastle. In the Wadsworth Athenaeum (Hartford, Conn.) is an oil painting measuring 32 by 47 inches, its coloring rather wan, and its architectural lines very pronounced, as if ruled. "J. Martin" is lettered on a pillar to the left. Another small oil painting, this one measuring $37\frac{1}{2}$ by $47\frac{1}{2}$ inches, is at the Yale Center for British Art. It is in excellent condition and is therefore the version reproduced in this book. These last two pictures are probably the ones referred to by Martin in a printed wrapper to the catalogue for the engraving, where he says the engraving "is formed upon two finished sketches made for the Picture, exhibited in the British Gallery, with subsequent original variations."[2]

A glass painting at Syon House, seat of the Duke of Northumberland, has sometimes been attributed to Martin himself. Martin was trained as a painter on glass and is reputed to have done the glass painting *Woman Cloathed with the Sun* discussed in Chapter VI, so the supposition is not unreasonable. Despite a crack sustained during bombing in World War II, it is a splendid piece of work. The colors are very bright and fresh, and the perspective is very clearly rendered (for example, the statue of Jupiter Belus can be seen repeated five times in recession). The effect of **myriads** of figures is even greater than in the oil paintings, and there are some highly successful special effects, such as the wind blowing a man's purple cape upward at the right. However, this glass painting is almost certainly the work of Hoadley and Oldfield which was described by a writer calling himself "Philotechnicos" in 1837–38:

> The many other beautiful specimens of stained glass produced by these artists would really deserve a separate notice for each, were it not for the fear of occupying too much space; we will therefore only briefly notice a few of them, and perhaps the one of "Belshazzar's Feast" after Martin, may be considered the most interesting; the size is thirty inches by nineteen. The figures are drawn with the most minute and

1. *The Art of John Martin*, p. 220, n. 75.

2. Extra-annotated Balston, *John Martin*, excerpt from a printed wrapper inscribed to the Earl of Lonsdale.

astonishing correctness, and the magnificence of the architecture and surrounding scenery is wonderfully enhanced by the modulation of tints, consequent upon the use of so transparent a medium as glass. It is painted upon one sheet of glass; and for variety of hue, brilliancy of effect, and excellence of workmanship, perhaps was never before equalled. This *ne plus ultra* of art was purchased by the Duke of Northumberland; and in order to preserve it from damage, it was enclosed between two thick sheets of plate glass, and secured in a strong frame. A second copy was likewise painted by the same artist, and purchased by an American![3]

Martin published two engravings of *Belshazzar's Feast*, in 1826 and 1832. The first of these was finished while Charles Turner was still attempting to engrave *Joshua*, and this is perhaps why, more than fifty years later, Leopold Martin thought that his father had executed the *Joshua* mezzotint first. A sketch once in the possession of Mrs. Charlotte Frank has been associated with one or the other mezzotint. The engraving by Martin for his Bible illustrations of 1831–35 is rather different from and less memorable than the other two.

Martin's brother William engraved the design on tin (Victoria and Albert Museum) in 1831, reversing the composition and introducing numerous other changes, one of which is a bullet-shaped "hand" with light streaming from it writing on the top of wall. Everything in this print is very soft-looking: the figures look as if they were made of chocolate, and the surface gives the impression of a graphite drawing.

For the Westall-Martin *Illustrations of the Bible*, the design was engraved on wood by W.H. Powis.

The diorama exhibited by Hippolyte Sebron at the Queen's Bazaar, Oxford Street in June 1833 was unauthorized by Martin, who unsuccessfully attempted to obtain an injunction against it. The subject has of course been engraved and otherwise reproduced countless times since.

3. *The Civil Engineer and Architect's Journal*, I (1837–38), p. 156.

INDEX

All numbers given are page references. Italicized numbers indicate location of illustrations.